Jean Dubuffet, Bricoleur

Jean Dubuffet, Bricoleur

Portraits, Pastiche, Performativity

Stephanie Chadwick

BLOOMSBURY VISUAL ARTS
LONDON • NEW YORK • OXFORD • NEW DELHI • SYDNEY

BLOOMSBURY VISUAL ARTS
Bloomsbury Publishing Plc
50 Bedford Square, London, WC1B 3DP, UK
1385 Broadway, New York, NY 10018, USA
29 Earlsfort Terrace, Dublin 2, Ireland

BLOOMSBURY, BLOOMSBURY VISUAL ARTS and the Diana logo are trademarks of
Bloomsbury Publishing Plc

First published in Great Britain 2022

Cover image: Bertelé bouquet fleuri, Portrait de parade (Bertelé as a Blossoming
Bouquet, Sideshow Portrait), 1947, Jean Dubuffet, 1901–1985
© ADAGP, Paris and DACS, London 2021

A catalogue record for this book is available from the British Library.

A catalog record for this book is available from the Library of Congress.

ISBN: HB: 9781501349454
 ePDF: 9781501349478
 eBook: 9781501349461

Typeset by RefineCatch Limited, Bungay, Suffolk
Printed and bound in Great Britain

To find out more about our authors and books visit www.bloomsbury.com
and sign up for our newsletters.

Contents

Illustrations

Plates

Figures

Acknowledgments

Many thanks to Gordon Hughes, my doctoral advisor, and to committee members Graham Bader and Bernard Aresu for all of their help and support during the research and writing of my dissertation and ultimately this book. I would also like to thank the Brown and Wagoner Foundations for research grants and scholarship awards that made this work possible. Special thanks also go to the Rice University Department of Art History and the Graduate Program in the School of Humanities for providing a significant subvention award to obtain image files and permissions. I would also like to offer thanks for the following outside sources of support: the Getty Research Institute for a Library Research Grant that enhanced my postgraduate research, the Lamar University New Faculty Research Award for advancement of upcoming scholarship, and the reviewers of early chapter drafts who provided valuable insights and advice. I also offer special thanks to Jennifer Ravey and Casey Ford for assistance with feedback and copyediting; Cécile-Laure Kouassi and Caitlin Duerler for assistance with in-depth French translations; and Ines Alvidres for assistance with inquiries in Spanish. Finally, I would like to thank the Covarrubias estate and the directors and helpful staff at the following archives, libraries, and museums: in France, the Fondation Dubuffet; Bibliothèque Nationale de France, François-Mitterrand; Bibliothèque Nationale de France, Richelieu Library; Bibliothèque Nationale de France, Musée de l'Opéra; Bibliothèque Littéraire Jacques Doucet, Sorbonne; Bibliothèque Armand Salcrou, Le Havre; L'Institut National d'Histoire de l'Art; Musée des Arts Décoratifs; Musée du Quai Branly; Musée National d'Art Modern, Centre Pompidou; in Germany, the Prinzhorn Collection, University Hospital Heidelberg; in the Netherlands, the Tropenmuseum, Amsterdam; in Switzerland, the Archives de la Ville de Genève and the Collection de l'Art Brut, Lausanne; in the United States, the Asia Society, the Art Institute, and the Newberry Library, Roger and Julie Baskes Department of Special Collections, Chicago; the Getty Museum and Research Institute, Los Angeles; the Morgan Library and Museum, the Museum of Modern Art, and the New York Public Library Dance Division, New York; and the Peabody Essex Museum, Salem. The gracious assistance of all of these individuals and institutions helped bring this book to fruition.

LES GENS SONT BIEN PLUS BEAUX QU'ILS CROIENT

VIVE LEUR VRAIE FIGURE

à la Galerie René Drouin

17, Place Vendôme

PORTRAITS

à ressemblance extraite, à ressemblance cuite et confite dans la mémoire, à ressemblance éclatée dans la mémoire de

Mr Jean DUBUFFET

PEINTRE

DU 7 AU 31 OCTOBRE 1947

CAUSETTE

Ce qui m'intéresse à moi ça n'est pas les gâteaux c'est le pain. Une fois de temps en temps un gâteau je ne dis pas non mais alors un petit gâteau modéré, une brioche tout au plus, qui ne souvienne de sa farine et de son pétrin.

A Paris on admet ça difficilement qu'un monsieur soit comme ça excentrique d'aimer mieux le pain que les gâteaux. On pense alors que ça peut être pour faire l'intéressant, pour se faire remarquer. Ou bien plutôt pour faire une farce. On a très peur des farces à Paris. On est toujours en train de faire attention qu'on ne vous fasse pas une farce.

Si on se mettait à aimer mieux le pain que les gâteaux ça porterait tort au pâtissiers mais je ne veux pas dire seulement les pâtissiers mais aussi des institutions comme par exemple les musées, les marchands de tableaux les critiques d'art etc. qui sont justement une spécialité parisienne qui fait vivre beaucoup de monde. En effet on peut faire des musées de gâteaux mais des musées de pain on ne peut pas vu que le pain est très commun et somme toute toujours presque pareil, d'aspect peu varié. Sur les pâtisseries de grand gala et les belles pièces montées des déjeuners de nocees on peut discourir et disputer à n'en plus finir, on peut conférencer, on peut faire des sectes et même financer des missions mais du moment que les gens viendraient à prendre cette idée, je veux dire mon idée ridicule, mon idée farce, que n'importe quel boulanger de campagne en sait plus long que tous ces clercs à haute toque, alors ça ferait du chômage dans la profession.

Pensons aussi à tous ceux qui ont acheté à un million la pièce des mokas fourrés et sava-

Figure 1.1 Catalogue de l'exposition "Portraits" à la Galerie René Drouin du 7 au 31 octobre, 1947. Fondation Dubuffet, Paris / © 2020 Artist Rights Society (ARS), New York—ADAGP, Paris. Photograph courtesy of the Fondation Dubuffet, Paris. Reproduced in *Catalogue des travaux de Jean Dubuffet*, Fascicule III (Paris: Fondation Duffet, 2003), 13–16, no. 01–04.

Introduction. Learning How to Smear: How to Paint a Portrait in Postwar Paris

Crude marks, mask-like faces, cryptic gestures: such are the features we encounter in Jean Dubuffet's post-World War II portraits. Producing at least 188 of these enigmatic renderings during a one-year project, Dubuffet depicted twenty-two friends with whom he dined at weekly luncheons.[1] He then exhibited select portraits, the contents of which are a veritable who's-who of the Parisian art and intellectual scene, from August 7 to October 3, 1947 at the Galerie René Drouin. "These Gentlemen are More Attractive than They Think," Dubuffet proclaimed in his ironic exhibition flyer that resembled a faux newspaper replete with snippets of folksy art theory and caricatures of his sitters (Figure 1.1).[2] These were not sitters in the usual sense, however; the flyer announced that Dubuffet had rendered his portraits from memory. As opposed to exact likenesses or psychologically stirring portrayals, these ungainly figures, many of which appeared to have been scrawled into thick, fleshy or muddy surfaces, served as creative expressions. Their oddly humorous, yet disquieting, demeanors reconfigured the genre of portraiture, staging intriguing encounters and upsetting all expectations about the relationships between the viewer, the painting, and the subject.

Dubuffet's vaudevillian announcement set a provocative tone for an exhibition that would generate a din of critical disapproval. One review derided Dubuffet as the "*pompier*" (vulgar emulator) of childish painting while another chided: "the portraits look more like 22 victims."[3] Most of Dubuffet's sitters shared his goal to radically transform art in the postwar era but some, at least, were offended. In a reversal of one of Dubuffet's famous puns, one source even reported that writer Paul Léautaud threatened to strike the painting *Paul Léautaud on a Caned Chair* with his cane.[4] The gallery's employment of guards to protect the art from disgruntled viewers only heightened the sensationalism of the show.[5]

As much as the rudimentary, quasi-comic, and unflattering qualities of the portraits, the theatrics surrounding their exhibition led contemporary critics,

and many subsequent scholars, to discuss these works primarily in relation to caricature. Commencing inquiries into the intersections between Dubuffet's portraits and the literary pursuits of his sitters, scholars such as Susan Cooke, Kent Minturn, and Andrea Nicole Maier have debated to what degree, if any, these paintings participated in the goals of caricature and expressed postwar political views.[6] I begin my exploration of Dubuffet's portraits by acknowledging his engagement with the genre of caricature in work which, as Cooke observes, challenged "a world where traditional humanistic values [and their edifying genres, including portraiture] no longer seemed secure."[7] But the ambitions of this book and, I argue, of Dubuffet's portraits, exceed the purview of both caricature and portraiture. Instead, Dubuffet created his portraits to subvert all the expectations of painting—as an established convention, as a privileged art form, as a medium—beyond the confines of any particular genre. For Dubuffet, in fact, genres—classifications of any kind, really—were part of the cultural apparatus he sought to subvert with his art.

Methodology and conceptual mapping

Taking into account Dubuffet's "anticultural" writings in his biography, correspondences, and texts such as "Anticultural Positions," "In Honor of Savage Values," and "Notes for the Well-Read," this book investigates the interplay of verbal, visual, and theatrical sources for Dubuffet's portraits.[8] Crucially, this book explores the portraits in tandem with the critical output of a few of Dubuffet's key portrait subjects—writers and visual artists such as Michel Tapié, Antonin Artaud, and Henri Michaux—who shared Dubuffet's vision for a more dynamically creative artistic future.

Considering also the twentieth-century artistic and cultural theories that impacted Dubuffet's art, particularly those produced within the Surrealist cultural milieu, this book draws upon the writings of Dubuffet's friends André Breton and Jacques Lacan, and of acquaintances such as Claude Lévi-Strauss and Georges Bataille (via Georges Limbour), as well as philosophers including Gaston Bachelard. This book thus explores Dubuffet's art as the product of a kind of "anticulture culture"—a culture (or at least a subculture) of artists, writers, and other intellectuals who celebrated the idea of "primal" creativity and sought to materialize its traces in their work. In addition to considering the ideas that inspired the inter- and postwar eras, this book looks closely at Dubuffet's

portraits, interrogating their unwieldy forms to reveal the workings of a collage aesthetic in his painting.[9]

To investigate Dubuffet's collage aesthetic—the combining of disparate images and perspectives to create disjunctive art that subverts Western artistic norms—this book considers the undeniable impact of Cubism on mid-twentieth-century art and on certain aspects of the interwar Surrealism that inspired Dubuffet's practice. This book also considers Dubuffet's process in relation to Lévi-Strauss's concept of bricolage, which positioned the art of tinkering to create from disparate elements as both opposed to the refinement of high art and also necessary to the creative process. Indeed, Lévi-Strauss's seminal text *The Savage Mind* (1962) contrasts the work of the ostensibly "primitive" bricoleur to the trained habitude of the civilized engineer and conceives of the artist (situated somewhere in between the two) as a tinkerer who employs any available means to achieve creative goals.[10] Although Dubuffet prized originality, he took a comparable approach to a creative process he believed to be latent within all human beings.[11]

Minturn has begun exploring the affinities between Dubuffet's and Lévi-Strauss's writings in calling attention to the interaction between the two men in 1948.[12] During that year Lévi-Strauss visited an exhibition of Art Brut—the term Dubuffet coined to describe the raw, untrained art of mental patients, folk artists, and other purported outsiders he had begun collecting after the war. "As I was saying yesterday to André Breton," Lévi-Strauss commented in his reply to a letter from Dubuffet, "your enterprise appears to me the only valuable one in the face of the bankruptcy of so-called professional art, and I shall follow its development with the most sympathetic and warmest of interest."[13] It is easy to see why Lévi-Strauss would gravitate toward Dubuffet's Art Brut enterprise (and, presumably, the artist would admire the anthropologist's work); the two men use strikingly similar terms to discuss the ostensibly untamed creativity found outside of Western cultural institutions. The same, it is worth noting, could be said of Breton, who also supported Dubuffet's Art Brut exhibitions. The writings of all three of these men combined the notion of a "primitive" impetus to create with the methods of collage as a way to conceptualize creative processes that rely, in turn, upon the procedures of signification.

For Lévi-Strauss, the bricoleur (think Dubuffet's "common man") "makes do with whatever [material] is at hand" to construct something new.[14] Poststructuralist philosopher Jacques Derrida later critiqued Lévi-Strauss's writings on bricolage for bolstering and depending upon the binary opposition between the bricoleur and the engineer—the very opposition Dubuffet sets up

between outsider and cultured artist.[15] Yet, Lévi-Strauss too recognized that the engineer who trains and consciously strives to specialize using the full set of advances in his or her field—a "relationship between nature and culture definable in terms of his particular period and civilization and the material means at his disposal"—must also work as a bricoleur in the sense that he or she must compose using available concepts, signs, and materials.[16] These ideas inform the following pages, which explore the often contradictory comingling of the nature/culture divide and the collage aesthetic in Dubuffet's practice—a combination instigated, at the outset, by Surrealism's passion for juxtaposing lived (exterior) and imagined (interior) experience.

Dubuffet dropped out of art school in his youth and initiated his professional art career late in life, not long before he began investigating and collecting Art Brut. Because he nevertheless had a lifetime of art and cultural exposure among his acquaintances in the Parisian avant-garde, we might say his work fit somewhere in between untrained and cultured (perhaps in a realm somewhat comparable to that he later described as "New Invention," in which art escapes its cultural reins in vibrantly impactful ways).[17] We might even say that he cultivated an artistic persona in the vein of untamed creativity that, despite his placement somewhere along this creative spectrum, relied heavily upon the clearly articulated, if entirely problematic, nature–culture dichotomy. He was much like Lévi-Strauss's engineer, we could say, but one who longed to reconnect with the unmediated experience of nature that he, paradoxically, imagined to have belonged to the bricoleur who existed prior to the advent of Western modernity. Lévi-Strauss asserts that "the artist [generally speaking] is both something of a scientist and a bricoleur" who combines scientific knowledge with "magical or mystical thought"—an idea that easily applies to Dubuffet and that can also be found in Breton's writing.[18] For Breton argues in "Communicating Vessels" that the artist or poet "vacillates" between lived and imagined experience.[19] For Dubuffet this turning back—this tapping into mythical/primal creativity—conflated with an approach Rosalind Krauss has described more generally as the "Modernist myth" of originality, causing him to appreciate the making-do of bricolage primarily in terms of unorthodox materials and methods (hence the blunt materiality of his Art Brut-inspired work).[20] His artistic and intellectual bricolage was nevertheless always in play and he, like Lévi-Strauss, emphasized its agility, adaptability, and creative momentum. The ideas of embodied perception, physicality of action, and active viewing found in Maurice Merleau-Ponty's phenomenology also informed Dubuffet's appreciation of creative movement and the materiality of the creative process, just as they would also

appeal to one of the artist's primary interlocutors, art historian and theorist Hubert Damisch. This book explores the ways in which these diverse ideas, particularly Bachelards' and Breton's understandings of creativity as a duality of lived and imagined experiences, materialized in Dubuffet's portraits.[21]

The structuralist theories of Sassure, Levi-Strauss, and others formulated during the interwar years, began relinquishing the sense of presence and interiority that Dubuffet and other artists believed to imbue authentic art. Nevertheless, these emerging theories provided even more motivation for artists such as Dubuffet to interrogate the effects of enculturation, which they continued to pit against artistic creativity as their predecessors had done since the Romantic era. As well read as Dubuffet was known to be, moreover, and considering that he would count Lévi-Strauss among his acquaintances, it is likely that he kept abreast of such ideas and incorporated them into his own art theory. It bears mentioning here that Dubuffet's ideas, in turn, became a model for thinking about an internal creative impetus in relation to culture that has left its stamp on generations of artists and thinkers. His writings of the mid- and late-twentieth century certainly suggest his critical engagement with discourses on signification and processes of enculturation.

In teasing out the complexities of Dubuffet's aporetic and appropriative art practice, and considering that his writing suggests he continued to investigate linguistic and cultural theories into the latter half of the twentieth century, the following pages will also draw upon the late-twentieth-century critical theory of Derrida, whose elaboration of representation as a process of citation and grafting and of performativity—the ability of representation to transform life—is already foreshadowed by Surrealist theory and the philosophy of Bachelard.[22] Homi K. Bhabha's postcolonial discussions of Eurocentric cultural and political dynamics, hybridity—the complex cultural overlapping instigated by colonialism, and the concept of "interstitial perspective"—the postcolonial desirability of adopting multiple points of view also play a role in shaping this inquiry.[23] The following pages will thus draw from a broad range of intellectual sources, many of which were available to Dubuffet, to elaborate upon his postwar probing of art's subversive and transformative potential.

This look at Dubuffet's portraits also relies heavily upon the notion of "ethnographic Surrealism"—a term coined by James Clifford to describe the Cubist- and Surrealist-inspired passion for cultural relativity and juxtaposing culturally dissimilar imagery that, as Clifford shows, informed the artistic and cultural collecting, exhibiting, and publishing of France's interwar period.[24] The following pages consider the ways in which the passion for Surrealist ethnography

remained active, for Dubuffet, after the war and fueled his exploration of a kind of hybridization in his portraits—figures that combine elements of Western and ostensibly outsider art, ordinary visual culture, and a variety of Oceanic (Papuan and Austronesian) visual sources to stage disquieting encounters.

Collage effects and Cubist echoes

It would be difficult to deny the impact of Cubism on much of the art produced in its wake—indeed much of the art of the twentieth century. "I found inspiration in Cubist paintings," Dubuffet wrote of his youthful artistic exploration, "which became so stimulating for me that I felt compelled to imitate them."[25] During his long career, Dubuffet mingled with notable Cubists in both the gallery and salon ateliers. His acquaintances among the pioneers exploring the tensions between abstract forms and the structure of painting itself included Cubist founder George Braque and the art dealer and theorist Daniel-Henry Kahnweiler. Representing the latter group among Dubuffet's acquaintances who exhibited their brand of Cubism in the French salons were Juan Gris and Fernand Léger.[26] The comingling of art and the elements of everyday life in Picasso's and Braque's experimental collage also had a major impact on Dubuffet, particularly collages such as Picasso's 1932 *Composition*, in which the organic elements of leaves, grass, and a butterfly are immersed into a painted surface.[27] Dubuffet's interwar art (the few pieces he did not destroy in an effort to remake his artistic persona) speak to his blending of folk and academic styles—and thus also combined "high" art and real world elements. Some of this art, particularly his *Self-portrait with Bowler Hat* (Figure 1.2), exhibits hints of Cubo-Futurist fragmentation and the suggestion of movement, here applied to the idea of identity as an unstable and layered construct. Such traces and, significantly, their Surrealist juxtapositions remain, transformed, in his corporeal postwar figuration.

Contributing, in his way, to the postwar search for a ground zero from which to begin anew—a search Dubuffet shared with other artists and writers at this time, including (not coincidentally) those he depicted in his portraits—Dubuffet began both defacing and radically remaking the human figure. As the following pages elaborate, however, his radical reconfiguration retained the imprint of both interwar Cubism and Surrealism. Indeed, the portraits examined here appear to be conglomerates. They are comprised of Cubist- and Surrealist-inspired visual sources, particularly those that suggest fragmentation, and related

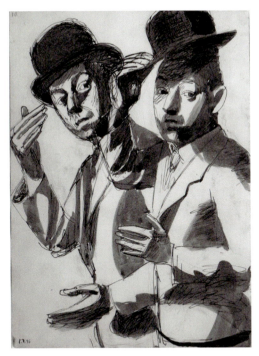

Figure 1.2 Jean Dubuffet, *Double autoportrait au chapeau melon* (Double Self-Portrait with Bowler Hat), 1936, China ink on paper, 31.5 × 23 cm. (12.4 × 9 in.). Fondation Dubuffet, Paris. © 2020 Artist Rights Society (ARS), New York—ADAGP, Paris. Photograph courtesy of the Fondation Dubuffet, Paris. Reproduced in *Catalogue des travaux de Jean Dubuffet*, Fascicule I (Paris: Fondation Dubuffet, 2003), 35, no. 99.

artistic processes, especially the conjoining of disparate elements (ordinary face/mask, cultured art/visual culture, and Western academic/non-academic and non-Western conventions).

Surrealism and its resonances

The Surrealists had also looked to Cubism, as well as the theories of Sigmund Freud, for inspiration. In the 1928 text "Surrealism and Painting," the movement's founder André Breton affirmed the impact of Cubism to the Surrealist project, celebrating Picasso's greatness as a "primitive," a dreamer, and a radical re-orienter of perspectives and proclaiming that despite the differences in artistic objectives "on account of these many considerations, we [the Surrealists] emphatically claim his as one of us."[28]

Many of the artists, writers, and intellectuals Dubuffet had acquainted with since his emergence at the periphery of the interwar French artistic scene had affiliated with Surrealism, which was the dominant avant-garde movement between the wars. In his youth he had developed "collegial relationships" with Surrealists such as André Masson and, indeed, maintained long-standing friendships with numerous artists, writers, and other intellectuals who participated in Surrealism as an artistic and cultural phenomenon.[29] Dubuffet attended high school with budding Surrealist writers Georges Limbour, Armand Salacrou, and Raymond Queneau in their home town of Le Havre and remained friends with them during and after the 1920s when they each moved to Paris. In the company of Limbour and other Surrealists, Dubuffet pursued a variety of interwar studies, including literature, photography, and ethnography, while periodically managing his family wine business.[30] He had frequented Masson's Montparnasse studio, which was a nexus of activity for Surrealist poets, painters, and multicultural art enthusiasts between the years 1921 and 1927, after which it was rented by other Surrealist acquaintances, Robert Desnos and Georges Malkine.[31] The cultural milieu that flourished briefly at Masson's studio, which was adjacent to Joan Miró's apartment and in proximity to Dubuffet's home, cannot be underestimated in examining Dubuffet's career. It seems particularly relevant given that at these moments, in these locations, one could see and participate in automatic writing, drawing, and the making of exquisite corpses—activities in which participants poured untamed thoughts and images onto paper and created bizarre collective renderings. Such conglomerates, this book will argue, retained their power as guideposts for Dubuffet's portraits.

When Dubuffet turned to painting full-time in 1942 (he had abandoned it twice during the interwar years), he distanced himself from what he called the "cultural machine" of Surrealism, yet he cultivated a friendship with Breton, with whom the artist began associating in earnest during the 1940s. Recalling later that he "never liked Surrealism," Dubuffet added, "I was very interested in Breton" (meaning the Surrealist leader's literary, philosophical, and artistic ideas).[32] For Dubuffet, as for many artists, the Surrealist counter-culture—and key ideas, in particular the notion of primal interiority as the most valid creative motivation— spilled out from the interwar years into the postwar era, leaving a marked imprint on his art. Although this Surrealist impact has been taken as a given and has thus received scant scholarly attention with regard to Dubuffet's work, the following pages will consider it as paramount to his production and

will elaborate upon some of its subtle—and not so subtle—inflections in his portraits.

"Primitivism," Surrealist ethnography, and non-Western art

Even as Dubuffet celebrated "the common man" and the graffiti art of the streets, he resisted the notion of art as a cultural product, preferring instead to focus on authentic art as subversive (graffiti, for example, as a transgressive act motivated by inner creative impulses). Despite his anticultural rhetoric, Dubuffet's belief in a human impetus to create and his appreciation of art produced outside of formal academic conventions aligned with the ideas of famed cultural art historian Alois Riegl that were famously expanded upon and circulated by art historian and psychiatrist Hans Prinzhorn. In the 1922 book *Artistry of the Mentally Ill*, Prinzhorn elaborated upon the idea of an inner creative impetus that he and other psychiatrists believed they had observed in the art of institutionalized patients.[33] This book—and this idea—had a major impact on European artists, particularly Breton, who had become fascinated by relationships between creativity and psychological processes during his time served as a medic during World War I and who had drawn from Freudian psychology to begin formulating Surrealist theory in the 1924 "Manifesto of Surrealism."[34]

Although Dubuffet pushed figuration to new and more radical extremes in the aftermath of World War II, the impetus for his experimentation formed during the interwar years, when he began exploring Surrealism and the images in Prinzhorn's book. Like many of Dubuffet's friends and, indeed, many Modern artists who were inspired by Prinzhorn's account of the art of mental patients, Dubuffet read little German. But the message was clear just the same: art could be the product of an inner compulsion to create. "The pictures in Prinzhorn's book struck me very strongly when I was young," Dubuffet proclaimed in a 1976 interview, adding that "they showed me the way and were a liberating influence."[35] These interests in relationships between art, culture, and psyche—and in structures of consciousness and creativity—shaped Dubuffet's postwar art and inspired his investigations of Art Brut. As many scholars have pointed out, Dubuffet's paintings carry traces of the art discussed in Prinzhorn's book, including smears, scratches, and figural distortions, some of which will be examined in the following chapters.

Processes of discovery and new understandings about constructed identity and fragmented selves were key to the Surrealist enterprise—as evinced in the writings of Dubuffet's friends Breton, Lacan, and others in the Surrealist milieu—and account for the artist's continued incorporation of a web of alternative visual sources. Even as his postwar writings focused attention on the idea of autonomous and purely inner creativity, his art and, this book argues, his portraits, belied his appropriative strategy and reliance upon a morphed and updated collage aesthetic.

French Modernists of the earlier twentieth century were well-known for looking to artistic sources outside of art historical canons (to theater, music, etc.) as well as to so-called "primitive" art forms in their efforts to rejuvenate Western painting and culture. Dubuffet was no exception. Taking a collage aesthetic and Surrealism's love of the "primitive eye" and unsettling juxtapositions to new and more radical extremes, Dubuffet relied, I argue, upon what James Clifford has described, more generally, as a kind of "cultural collage"—a tactic of "ethnographic Surrealism" that uses multi-cultural pastiche as its model.[36]

As Clifford observes, the Cubist fragmentation of pictorial space and the canons of realism "had set the pace for a general assault on the normal [normative]," creating an interwar environment in which the boundaries between East and West, and between high and low culture, were blurred.[37] In addition to creating artistic interest in masks and metamorphoses, the interwar culture, characterized by a loss of faith in Western progress and a new openness to cultural relativity, instigated what Clifford describes as an ethnographic attitude—a "general cultural predisposition which cuts through modern anthropological science and which it shares with modern art and writing."[38] Aligning the values of this ethnographic attitude with Surrealism as a cultural phenomenon, Clifford notes, however, that the Surrealists reversed the ethnologists' charge; rather than seeking to make the strange more familiar, they instead sought to make the familiar strange—to appreciate the extraordinary in the ordinary. These attitudes and approaches held sway even after World War II and provided a creative and anti- [mainstream] cultural impetus for Dubuffet's art. In fact, the craze for "Primitivism" in the European avant-garde, the interplay between artistic and intellectual life in interwar and postwar France, and the cultural milieu of Surrealism cultivated an openness to investigating the art of the Other (be it from familiar or far away locales) and for incorporating (often under-acknowledged) non-Western visual sources, particularly the art of Africa and Oceania. Although Dubuffet did not travel to Central Africa, like his acquaintance Michel Leris, or to Asia and its environs, as did his friend Henri Michaux—the subject of several of Dubuffet's portraits discussed in Chapter 4—

the artist visited an uncle in South America (in 1924) and traveled, first with his parents (in the 1920s), and later on his own (between 1947 and 1949) to North Africa on several occasions.[39] Despite the artist's North African travels and interest in Bedouin culture, the art considered in this book bears the imprint of the Oceanic art that attracted the Surrealists and, in some cases, the Indonesian art that enthralled his friends and portrait subjects Michaux and Artaud. Indeed, as this sampling suggests, the overarching impact of ethnographic research as relevant to Dubuffet's and his sitters' interests imprinted his entire portrait series.

Like many aspects of the early twentieth-century avant-garde, "Primitivism" took new, yet still problematic forms after World War II as artists looked increasingly to the primal creative impulses thought to lie dormant in all human beings. An early provocateur in this regard, Dubuffet paved the way for the appreciation of the untamed qualities of Art Brut. His portraits bear the marks of this interest while suggesting his continued engagement with the art forms of the Pacific and Indian Ocean cultures that had piqued Surrealist curiosities.

Art Brut, creativity, and materiality

As this book will elaborate, Dubuffet brought a number of interwar precedents into the postwar era, when he began selecting and composing from a variety of alternative visual sources that included Art Brut. Famous for his interest in this untrained art, Dubuffet believed he had found a truly intuitive source of artistic inspiration—a naïve art that was uncorrupted by mainstream European culture and attuned to primal human impulses.

In 1945 Dubuffet began actively investigating Art Brut and in 1947 collaborated with Breton and a group of Surrealist affiliates—publisher Jean Paulhan, author Henri-Pierre Roché, artist Slavko Kopač, critic and gallerist Michel Tapié, and self-styled "primitivist" art dealer Charles Ratton—to found the Foyer de l'Art Brut. The following year, they founded the Compagnie de L'Art Brut, an organization dedicated to the study and collection of this art they thought resulted from internal, creative urges.[40] "It is only in 'Art Brut' that one finds, I believe, the natural and normal processes of the creation of art in their elementary and pure state," Dubuffet wrote, adding that "a work of art is interesting, in my opinion, only on the condition that it is a very immediate and direct projection of what happens in the depths of being."[41]

One of the primary ways Dubuffet began emulating Art Brut was by modifying his paint into a non-traditional material. When he first returned to a career in

painting during the war, he emulated the crudity and exuberance of folk art and children's drawings. His 1943 *Metro* series (Plate 1), for instance, shows the influence of these naïve art forms in tandem with Art Brut and Oceanic art; his puppetesque figures call to mind both the Art Brut sculptures of the famed Prisoner of Basel and the Iban masks of Borneo. In stark visual contrast, and in one of several stylistic transformations, Dubuffet's 1946 *Mirobolus, Macadam et Cie Hautes Pâtes* (Mirobolus, Macadam and Company, High Pastes) series—the immediate precursor to the portraits—marked a transition as he began highlighting the physicality of his paint and corporeality of his figures. He produced these *haute pâte* paintings, as he called them, with a thick paste concocted of oil paint and lowly materials such as dirt and detritus. Astounded (or confounded) by the blunt materiality of these works, critics discussed them in terms of mud and *merde*. The paintings' thick, material presence and references to bodily functions (and, perhaps, scarcity) seemed all too apt, and some critics considered the works to be wildly inappropriate amidst the wreckage of the war and occupation.[42]

In discussing Dubuffet's emphatic materiality, Rachel Perry has also expanded our understanding of his Art Brut influences, calling attention to both his methodical research and his description of "cobbling together" disparate images and texts for his planned *Almanach de l'Art Brut*, about which he claimed such bricolage was the "brut" form most fitting for the task.[43] The failed journal, it appears, revealed early on the collage approach Dubuffet applied to his artistic and, as Baptiste Brun observes, ethnographically-oriented endeavors.[44]

Dubuffet's prolific writings on Art Brut, and his ideas about what he took to be the internally-driven creativity of authentic art, have more than impacted interpretations of his work; they have, until recently, set the parameters of the discourse. Although twenty-first century scholars have begun to deconstruct these mythologized portrayals, Minturn and Maier have shown that art historical allies such Hubert Damisch, Max Loreau, and Peter Selz aided Dubuffet in writing the creation myth of his own art history, in which he ever so adeptly wriggled back and forth between avant-garde and Art Brut presentations of his work.[45] Rather than reinforce or reject the importance of Art Brut as foundational to Dubuffet's postwar praxis, this account seeks to enrich understanding of his work by situating it within a particular cultural milieu and examining the visual and historical evidence that his practice relied upon a variety of Art Brut and other visual sources found outside of European artistic canons. While many scholars have explored Dubuffet's work in relation to Art Brut, few accounts have delved into his paradoxical reliance upon processes of appropriation and assemblage.

Notable exceptions are Antonia Dapena-Tretter and Jean H. Duffy, who each begin to examine Dubuffet's artistic style in relation to the ostensibly untamed art he admired, be it produced at the margins or outside of European culture.[46]

Despite the many interpretations of Dubuffet's art in relation to Art Brut, few scholars have looked closely at his portraits compared to images produced by people considered to be mentally ill. This omission is, perhaps, understandable when one considers Dubuffet's intentional (though rather intermittent) distancing of his own work from the Art Brut he constantly promoted as the ultimate creative expression. Indeed, despite a history of researching and collecting Art Brut, and the fact that he produced numerous works with clear visual references to it, he maintained as late as his 1976 interview: "My work was never directly influenced by Art Brut."[47] The dearth of comparisons made between Dubuffet's work and the art of mental patients featured in Prinzhorn's book and the collection in Heidelberg is nevertheless surprising given the fact that Dubuffet had seen the book early in his career, acknowledged its impact on his art, and began touring mental institutions in the 1940s, visiting the Prinzhorn collection specifically in 1950. The half-hearted elision of Dubuffet's Art Brut influence is even more surprising when one considers that he amassed the definitive collection of it that is now exhibited at a dedicated museum in Lausanne, Switzerland.[48] "I must emphasize that Art Brut, which I aim at, is not at all the one that has become quite fashionable in the past few years in the cultural circles," Dubuffet wrote in his 1951 essay "In Honor of Savage Values."[49] Instead, he argued that Art Brut was "completely foreign to the ways of culture and classicism."[50] These statements are profoundly significant to interpreting Dubuffet's art; for with these proclamations he both celebrates the cultural aloofness of Art Brut and belies his position of distance from it as source material.

Leading the charge to locate and tap into primal creativity, Dubuffet set out to accomplish an impossible task: to create art that could simultaneously escape culture, resonate with the viewer, and produce individually and culturally transformative effects. Although Dubuffet sought to bypass culture altogether as a source of creativity by looking, paradoxically, for inspiration to art made by cultural outsiders, he (like many twentieth-century artists) reacted primarily against European cultural hegemony and turned to a variety of so-called "primitive" sources at the margins of Western culture for inspiration. This book seeks to complicate and re-situate Dubuffet's art in relation to Art Brut, revealing his larger, heretofore downplayed, practice of alternative source-hunting that also drew upon non-Western artifacts. Colliding and uncomfortably combining these disparate sources, he created his unruly portraits.

Archetypes, memories, and conceptual movements

Jean H. Duffy has conceived of Dubuffet's reliance upon abstracted "templates" to be a means by which the artist attempted to evoke common human experience.[51] Indeed, Dubuffet's many discussions of "the common man" and the notion of archetypal imagery bear this out.[52] In claiming to have rendered his portraits from memory, Dubuffet's use of the term "archetype" was consistent with Bachelard's philosophy, which drew, in turn, upon Carl Jung's notion of the latent poetic image that reverberates, however subtly, within the viewer to serve as a creative model. Bachelard's philosophy had great currency in France during the inter- and postwar eras and also appears to have inspired Dubuffet's belief that enculturated habits—an encumbrance to art and creative thought—should be negated.[53] Although Bretonian Surrealism has been more closely associated with the ideas of Freud than of Jung, Dubuffet's attunement to Jung's ideas about primal and universally resonant archetypes, filtered through the lens of Bachelard's poetic image, may mark one of the ways in which the artist chose his own course—a path that was instigated, but not entirely delineated, by Surrealism and instead drew upon an eclectic array of conceptual sources.

It is important to note that the idea of a latent poetic image and the distrust of habitude as a deterrent to creative thought also had a more direct precedent, for Dubuffet, in Breton's Surrealist theory. Although Breton became well known for proselytizing on these subjects—interiority as a creative model and art as a means to subvert the illusions of bourgeois conventions—he began in earnest in his 1924 "Manifesto of Surrealism." In this document (a text in which he cites the poetry of Dubuffet's mutual acquaintance Robert Desnos), the Surrealist leader outlined his initial definition of Surrealism as "psychic automatism in its pure state, by which one proposes to express—verbally, by means of the written word, or in any other manner—the actual functioning of thought."[54] With these words he expressed the Surrealist values of tapping into inner creativity and subverting cultural conventions, adding that such practice should be "exempt from any aesthetic or moral concern."[55] *Surreality*, according to Breton, is the heightened reality realized by the "resolution of these two states, dream and reality, which are seemingly so contradictory."[56]

Breton scholar and translator Mary Ann Caws has discussed the intersections between Breton's and Bachelard's writings, pointing out that both appreciated the dynamic interplay between logic and imagination and between lived and imagined experience, each of which produces echoes upon the other. In both philosophies, as Caws notes, dissonances are thought necessary to shatter the

ossifying myths of habitude in bourgeois society.[57] Indeed, for both men and, I argue, for Dubuffet, unorthodox juxtapositions of concepts and images were creative counters to the dull life of the norm. Such creative metamorphoses, these men believed, could transform not only art but life itself.

Suggesting simultaneously typical (or archetypal) and fantastical figures, Dubuffet's portraits demonstrate the resonance, for the artist and his milieu, of not only Breton's and Bachelard's ideas, but also of anonymously produced art that stirs the imagination and suggests a primal urge to make marks. In addition to Art Brut and non-Western art, such sources—for these men—ranged from modern street graffiti to the Paleolithic cave paintings discovered in 1940 at Lascaux. Cave paintings in particular had intrigued Dubuffet and his friends— rogue Surrealist Gorges Bataille, most famously—by pointing to the origins of creativity in the remote, prehistoric, and therefore seemingly primal (read unenculturated) past.[58] Cave painting and its descendant, graffiti, influenced Dubuffet's immediate postwar production, including, as he acknowledged, his *Mirobolus, Macadam et Cie Hautes Pâtes, Le Murs* (Walls, a series of lithographs), and the portraits. Indeed, both of these anonymous art forms inflected Dubuffet's portraits and are reiterated in their thick muddy paint, gritty wall-like surfaces, and crude, yet lively figuration.

Polarities, tensions, and double dealings

As Caws observes, Breton's paradigm of *Communicating Vessels*—in which artists play with the notion of a *double conceptual reality* combining elements of the poetic and the logical—also had affinities with Bachelard's thought, both of which, as this book elaborates, appear to have impacted Dubuffet's art. In *Communicating Vessels*, Breton discusses, among other ideas, the importance of affect—the experience of deeply felt physiological responses—and cognitive processes to the viewer reception of art.[59] As the following pages discuss, the concepts of the poetic image, dual affective and cognitive responses, and a double reality that vacillates between utilitarian logic and creatively stimulating imagination, remained integral to the artist's painting.

The pages in this book have begun to elaborate the play of dualities and tensions (general/specific, flat/three-dimensional, high art/outsider art, and more) that appear, in a number of significant ways, in the unusual expressions and mannerisms of Dubuffet's portraits. Perhaps the most glaring conceptual tension in Dubuffet's work lies between his writings on artistic originality—

achieved by mining the "internal fires of life" beneath the "dead crusts" of enculturation—and his actual art practice, which, as all art must, relied to some degree on cultural precedents.[60] Dubuffet's exploration of this wide variety of tensions in his postwar portraits accounts for their odd, often jarring pictorial qualities that ultimately emerge from the tension between the double reality of the routine and the imaginative—the creature of waking habit and the artist who can materialize the stuff of dreams. Following this line of inquiry takes into account the supreme tension, for Dubuffet, between his anticultural writings and his immersion in the culture that gave them their impetus.

Form, *l'informe*, and Art Informel

Traces of various interwar ideas—particularly Surrealist notions about layers of consciousness and creative transformation—infused the Art Informel movement that Dubuffet, however hesitantly, helped lead into the critical reviews. He and many other artists associated with this movement rejected the rationality of geometric abstraction and the individualistic psychology of interwar Expressionism and even of Surrealism. Above all, Dubuffet and the like-minded writers and artist-agitators he depicted in his portraits resisted another war-inspired return to order. The post World War I *rappel a l'ordre* had been artistically and politically damaging enough, and the writings of Dubuffet's sitters are filled with anti-cultural proclamations of both the inter- and postwar eras. With Dubuffet at the forefront, postwar artists subverted "cultured" traditions (practices and institutions they associated with the legacy of an outdated and failed model of humanism) by producing formless, messy, and enigmatic imagery using unconventional materials and techniques.

The shift to a more monochromatic palette in many of Dubuffet's *haute pâte* paintings also suggests that, rather than attempting to generate affect through the use of color, as had a variety of artists since the days of early Romanticism, Dubuffet sought to impact the viewer with the utter physicality of his painting. "It hardly matters whether you find few or many colors there or which colors they may be!" Dubuffet asserts; what matters, instead, is the material impact of the work.[61]

Dubuffet described his process as "lay[ing] it on thick" and "learning how to smear," which he accomplished with gestures, rhythms, and "circulatory movements" that are reproduced in the painting as though they are "living things."[62] He worked the canvas horizontally, placing it on a table or the floor and spreading it with his *haute pâte* mixture in a similar process to that of his friend

Jean Fautrier, the subject of one of Dubuffet's portraits, whose formless yet visceral paintings dealt with war-time trauma and the Nazi atrocities he witnessed as a member of the French Resistance while hiding in a mental institution near Paris.[63]

Photographs of Dubuffet working, his canvases spread out on the floor, remind us that his postwar painting, though figurative, was in dialogue with the art of Jackson Pollock and American Abstract Expressionism, another movement with roots in the Surrealism of the interwar era that highlighted gestural painting. Although Dubuffet made relatively few comments about art in America, his attention to international artistic developments is clear in light of his first exhibition at the prestigious New York Pierre Matisse Gallery in 1947, his 1951 visit to New York and Chicago—where he delivered his famous lecture "Anticultural Positions"—and the fact that his friend Taipé was in the midst of organizing exhibitions of Pollock's and other American Abstract Expressionist art in Paris and of Art Informel in New York.[64] Produced in 1946-1947, the portraits may not yet reflect Dubuffet's keen awareness of postwar abstraction as a transatlantic phenomenon, but they nevertheless point to his growing recognition of global artistic dialogues. And dialogues, particularly those pertaining to art and its relationship to culture, are precisely what animated his portraits.

As Leo Steinberg argued brilliantly in his 1972 "Reflections on the State of Criticism," "Dubuffet's paintings, even his figurative works [even, as I argue, his portraits], call to mind the horizontality of a workbench or table," the "flatbed picture plane," as Steinberg writes, "in which the painted surface is no longer the analogue of a visual experience of nature but of operational processes."[65] Steinberg places Dubuffet in dialogue with Robert Rauschenberg, posing Dubuffet's painting as a precursor to "the most radical shift in the subject matter of art, the shift from nature to culture." Indeed, the horizontality of perspective, the highlighting of artistic processes (seen by Dubuffet to be in tension with culture), and the relocation of art-making from the lofty easel to a messy workshop were all elements of postwar painting that Dubuffet embraced in his writings and *haute pâte* technique. Tipped back up to a vertical position, however, a portrait by Dubuffet takes on the characteristics of a wall, blurring the boundaries between the painting and its support while simultaneously proclaiming the painting's physicality. Dubuffet discussed painting in terms of spontaneity and inner creativity as well as the "accidents" and "adventures" of the artist's hand and materials.[66] Spreading layer upon layer of his thick paint concoctions with a spoon, kitchen utensil, and even his fingers, Dubuffet

worked with "any mud at hand."[67] His additive and subtractive techniques create another set of tensions and a unique interplay between his smeared-on and gouged-out paint. These echo the tensions between movement and stillness and between Dubuffet's volatile figures and the canvases that appear to ensnare them.

The traces of Dubuffet's processes are apparent in his painting, laid out, he asserts, like a road map for the viewer to follow. Here again, Dubuffet's strategies align with Bachelard's philosophy, in which the poetic image reverberates to produce a kind of doubling that compels the viewer to "relive" the objects depicted from the standpoint of an art work rather than its real-world referents.[68] For Bachelard, such a reverberation "become[s] a new being in our language," and in its grip we begin to imagine that we, too, are participating in some way in the creative act.[69] It is interesting to note that Lévi-Strauss also used such language in discussing the viewer reception of art in *The Savage Mind*, in which he asserts that by way of artistic transmutations, the viewer "is transformed into an active participant [recognizing other possible sources and transmutations] without even being aware of it."[70] Likewise, Dubuffet proclaims: "The painting will not be viewed passively; scanned as a whole by an instantaneous glance, but [instead] relived in the way it was worked out; remade by the mind and, if I may say *re-acted*" so that the viewer "feels all the painter's gestures reproduced within himself."[71] With enigmatic gestures and double-entendres at the ready, the portraits seem poised to communicate directly with their viewers, though the message is, as Dubuffet intends, disturbingly unclear. Once again, these ideas also echo Breton's *Communicating Vessels*, in which art and the imaginative world vivify quotidian experience. The portraits thus point, in their way, to the larger gesture that frames Dubuffet's practice—a desire to bypass utilitarian reason and cultured artistic habits in favor of a raw, creative encounter.

In writing that "the hand speaks," of "laying it on thick," and of "learning how to smear," Dubuffet indicates that gestural painting is as important as the gestures of the figures he depicts.[72] And this combination of blunt materiality and emphatic gesture is another approach that can be found in art of the mentally ill and other ostensibly cultural outsiders that inspired Dubuffet and the Surrealists before him. For Dubuffet, materiality and gesture formed a dual line of attack to the sensibilities. It is with cryptic gestures, after all, that many of his figures directly, if enigmatically, confront the viewer, their contorted limbs all the more suggestive of bodily experience. These enigmatic gestures and appendages that escape their usual bodily placement or double for other figural elements linked

these works to both Art Brut and the Art Informel movement that continued to explore Surrealist notions of doubling and dual realities. These unusual gestures also combined with a variety of uncanny facial expressions to suggest Dubuffet's referencing of Oceanic art in ways that I will discuss in the following chapters.

Dubuffet's friends Bataille and Tapié adopted the terms *l'informe* (unformed or formless) and *Informel* (informal or untrained) to refer, in different ways, to primal creativity that undoes cultural traditions and resists becoming merely the next new style. Tapié, whose prose is discussed in tandem with Dubuffet's portraits of the critic in Chapter 2, spearheaded the Art Informel movement, cultivated a transnational atelier, and, for a time, heavily promoted Dubuffet's painting. In keeping with these diverse approaches to unrefined creativity, Dubuffet wrote of "starting with the unformed" to produce his messy paintings.[73] The word "starting," however, is key and can help us surpass the by-now tired situation of Dubuffet's work in relation to Bataille's concept of *l'informe*—a correlation that is only somewhat tenable.

Yve-Alain Bois and Kent Minturn have already begun discussing the degree to which the artist's renderings were inflected by Bataille's concept of *l'informe*—a notion that resists the ordering classification of words (labels, definitions) and emphasizes (non-utilitarian) *function* over form.[74] Dubuffet's often-touted suspicion of classifying categories, of the written word, and of much European painting demonstrates his appreciation of *l'informe*, as does his celebration of base matter and the so-called "primitive" cultures that, according to Dubuffet, understand "the continuity of all things," producing art forms that "conjure things, not isolated, but linked to all that surrounds them."[75] Certainly, the rudimentary appearance of Dubuffet's paintings is also in keeping with this idea, resisting the fixity of conventional—or, for that matter, most avant-garde—pictorial surfaces. By the same token, the violent, subtractive aspects of Dubuffet's process—the scratches, gouges, and ruts with which he scores his figures—allude, in their way, to *l'informe*, which for Bataille accounts for the human urge to deface. The notion of *l'informe*, as Bois and Minturn note, almost certainly impacted Dubuffet's work, although ultimately his painting, even his play with materiality, expressed the artist's will to form.[76] The comingling of the antithetical concepts of form and the unformed in Dubuffet's practice contributed to the overarching sense of tension in his portraits. Seeking to provide a more nuanced view of these tensions, the following pages explore the artist's aporetic comingling of disparate materials and visual and conceptual sources, his radical reconfiguration, and his reconceptualization of art as a means to subvert culture.

Surrealism, ethnography, and a collage aesthetic after the war

Critical to this book's examination of Dubuffet's anticultural themes and tensions in his portraits will be the continued relevance to his work of the closely interconnected notions of the uncanny (*àla* Freud) and the marvelous (*àla* Breton), for which I rely to a degree upon Hal Foster's interpretations.[77] While these terms describe aspects of Surrealism that I will elaborate upon as relevant in the following chapters, each of these terms grapples with the destabilizing effects of encountering unusual combinations of the familiar and the strange that hint at something primal—repressed and yet strangely familiar— about oneself in relation to the world. Like many of the Surrealists, Dubuffet appreciated the Comte de Lautréamont's poetic image of "a Chance meeting on a dissecting table of a sewing machine and an umbrella" in the *Songs of Maldoror* (1868). Dubuffet cites this work specifically in his "Notes for the Well-Read," indicating that the image served as a conceptual if not a pictorial model for his painting.[78]

In texts such as "Anticultural Positions" and "In Honor of Savage Values," Dubuffet argued that art is only authentic to the extent that it reflects internally-driven creative impulses. Yet, in "In Honor of Savage Values," he concedes that an artist might subconsciously emulate external sources, which, as he wrote, "he has assimilated . . . believing entirely in good faith, that he pulled it [his work] out of his own reserves."[79] Indeed, he asserts: "The swindle in such a case is not always deliberate" or "often it is, but even so it is almost always (at least the majority of the time) unconscious and involuntary, and usually, the author [Dubuffet himself?] is in good faith."[80] Once again, Dubuffet's proclamations align with the effects Lévi-Strauss attributed to the bricolage of the "naïve" or untrained artist that triggers within the viewer subconscious recognition of correlations among various images and deeply embedded memories.[81] Yet, Dubuffet's inconsistency with regard to originality and appropriation speaks volumes. His conflicted writings on the accidental (or deliberate?) mimicry of extant art forms is a byproduct of both the phenomenon Krauss has described as the "Modernist myth" of originary production and the futility of the artist's efforts to produce art solely from the depths of inner creativity.[82] Perhaps a combination of deliberate and accidental emulation (or reverse mimicry, in which the European copies the marginalized Other, if one thinks of Bhabha's post-colonial theory) accounts for the resemblance of Dubuffet's art to Art Brut and, I will argue, to a variety of non-Western artistic sources upon which this book will elaborate. In the

following pages, however, I discuss the idea that some of those resemblances appear to have been systematically contrived.

As Dubuffet began collecting Art Brut, he also began questioning what has become known as a triad of avant-garde primitivisms that inappropriately grouped the art of non-Western cultures with the art of children and the mentally ill (in contrast to Prinzhorn's book, Dubuffet's Art Brut collection contains scant non-Western artifacts). Yet his art and his prose, some of which I have already begun to document, suggest that he perpetuated this very conflation.[83] Latching onto the now defunct banner of "primitivism" that had appealed to Modernists of the earlier twentieth century, Dubuffet continued to rely on some of its exploitative practices, combining the visual—and primarily affective— characteristics of Art Brut and the arts of the South Seas, neither of which were familiar to mainstream Western viewers. His celebration of the inventiveness of Art Brut in his prolific writings thus masked his reliance upon an array of cultural sources. These, as will be discussed, included not only Art Brut but also Oceanic artifacts that began appearing in Surrealist collections during the 1930s.

Although it has been fairly commonly acknowledged that Dubuffet looked to Oceanic art for inspiration, the art historical attention to this fact has been minimal. Addressing this oversight, the portraits considered in this book are examined in tandem with a variety of Oceanic artifacts that appealed to the Surrealists—and some that piqued their curiosity yet are featured less prominently than other Oceanic and African artifacts in their collections, publications, and artistic quotations. Perhaps Dubuffet's emulation of enigmatic and less publicized Oceanic art accounts, in part, for the dearth of discussion about the resemblances between these artifacts and his work, indicating his ambition to walk his own artistic path. Yet, in his reliance upon cultural collage and elements of performance he continued, in his own way, to explore the Surrealist-inspired themes of multi-faceted identity, multivalence, and performativity—the potential of representation to not only enact or reinforce social norms but also to subvert them.[84]

While some of Dubuffet's sources appear to fit the loosely constructed category of "Oceanic" art—the art of diverse South Pacific Island cultures—fairly well, other of these artifacts originated in islands of the Indian Ocean and might be viewed more in terms of their cultural associations with maritime Southeast Asia, particularly Indonesia.[85] Asian art had appealed to the French avant-garde since the late nineteenth century. Southeast Asian art, however, was less familiar. For this reason it intrigued Dubuffet's friends Antonin Artaud and Henri Michaux, whose portraits Dubuffet painted in ways which, as I argue in Chapters 3 and 4, reflected their cultural as well as anticultural interests. Notable

among these impactful cultural forms were Indonesian masks, costumes, and puppets, none of which have been sufficiently recognized as inspirational to Dubuffet or the artists of his milieu. Some of these Indonesian cultural forms were rather rare in France, known in Paris primarily through ethnographic collections, photographs, and a number of publications to which, as Dubuffet's renderings and historical evidence suggest, he looked for information and creative stimulation. Dubuffet asserted that "the culture of the Occident is a coat which does not fit him; which, in any case, doesn't fit him anymore," noting that this culture "drifts further and further from daily life," until it "no longer has real and living roots."[86] These comments have only begun to pique scholarly interest and, as a result, scholars have rarely discussed Dubuffet's possible engagement with Asian art.[87] Evidence suggests that he nevertheless turned to the East and to a vast array of Oceanic (both Papuan and Austronesian) cultural forms in his efforts to enliven Western art. In combining and at times conflating non-European art and the art he designated to be Art Brut, Dubuffet both expressed his position that Western culture had failed and also re-articulated the myths and mistakes of the early twentieth century. The following chapters interrogate Dubuffet's portraits in tandem with a more nuanced view of the Oceanic artifacts that informed his figuration, as suggested by visual and historical evidence.

Affect, imagination, and creative transformation

The Oceanic masks, costumes, and other artifacts to which, I argue, Dubuffet turned for artistic inspiration to paint his portraits were invested with great power in their original contexts; they were objects thought to possess both dissociative and transformative effects. And this is just what Dubuffet wanted in his art. He thus translated these sources to create his pictorial idiom—and an aesthetic of disturbance with which he hoped to shake up Western culture. This emphasis on artistic disturbance was nothing new to twentieth-century Modernists, whose production relied as much upon negating artistic tradition as exploring pictorial innovation. Dubuffet's adaptation of disruption as an artistic force echoes Bachelard's philosophical and intertwined discussions of the poetic image and creativity as a cultural disturbance with the power to "awaken," as it were, "the sleeping being lost in its automatisms."[88] Such a proclamation could as easily be attributed to Breton, who used comparable terms in *Mad Love* and *Communicating Vessels* or, of course, to Lévi-Strauss, whose pitting of the primitive bricoleur against the civilized engineer in *The Savage Mind* also participated in this anticultural discourse.

In alignment also with the notion of bricolage being formulated by Lévi-Strauss, Dubuffet argued that to resist the rigidity of enculturation, "the thinker [the artist, even the viewer] must turn," must move, must change perspectives.[89] Through this creative movement, he believed one might take in, as best as possible, the dynamic nature of art and life. Dubuffet asks if it might thus be possible "for the mind to adjust to a new fragmentary and discontinuous perspective, and for it to decide to radically change its old operating procedures by orienting them from now on in this [new] direction"—or, more properly, in new *directions*.[90] Dubuffet was unable to produce art that was truly raw in the sense of being uncorrupted by culture, yet he created remarkable, culturally resistant hybrids—composite figures not bound by any one set of cultural norms.[91] He wanted these figures to disorient the viewer and subvert enculturation in odd, somewhat humorous, and, ultimately, disturbing ways. Foregrounding yet another tension in his fixed medium of paint, the portraits proclaim Dubuffet's interest in both movement and materiality. This tension between dynamism and stasis produces a sense of extreme disjunction in the portraits.

Staging the portraits, a theatrical approach

The mask-like faces and emphatic gestures of many of Dubuffet's portraits suggest that he looked to theatrical as well as non-traditional plastic means to produce impactful images. In fact, as Dubuffet's biography and other contemporaneous documents reveal, he had a keen interest in theater, and during the 1930s he made carved wooden puppets and papier-mâché masks when he converted part of his studio in order to stage impromptu performances (Figures 1.3 and 1.4).[92] Carrying this sense of overt theatricality into his postwar painting, he created a cast of characters for his portrait oeuvre (*Tapié Grand Duc, Bertelé Savage Cat, Edith Boissonnas as a Tibetan Demon*, and *Michaux as a Japanese Actor*, to name a few). These gesticulating and ethnographically inflected figures point, in their way, to Dubuffet's theatrical bent and, I argue, to his play with the tension between overt theatricality and the quality Michael Fried would describe, more generally, as "facingness"—a work's ability to confront the viewer in a way that foregrounds the modern conditions of viewing, representation, and artistic authenticity to stage a salient interpretive encounter.[93] Since Fried's formalist brand of art theory diverges so radically from Dubuffet's artistic aims, it is helpful to again consult Damisch. In his 1962 essay "Jean Dubuffet and the Awakening of Images" Damisch situates Dubuffet's work

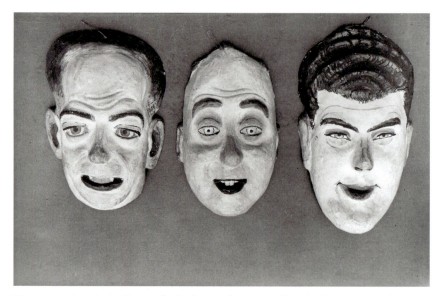

Figure 1.3 Jean Dubuffet, masks (Robert Polguère, André Claude, René Ponthier), 1935, papier-mâché (cardboard pulp) and paint. Fondation Dubuffet, Paris / © 2020 Artist Rights Society (ARS), New York—ADAGP, Paris. Hirshhorn Museum and Sculpture Garden, Smithsonian Institution, Washington, D.C. Photograph courtesy of the Fondation Dubuffet, Paris. Reproduced in *Catalogue des travaux de Jean Dubuffet, Fascicule I* (Paris: Fondation Dubuffet, 2003), 29, no. 53.

in relation to the Hegelian theme of the death of art, or rather, of art's innocence in the modern age.[94] Damisch asserts that "it mattered" to Dubuffet "that the viewer should have to decide on the work that is proposed to him," adding that "it mattered also that the viewer be given the illusion of having to constitute it as a work of art," and noting that for Dubuffet the viewer must therefore "define [the work of art] in his turn and for his own account, what he was to understand by these terms."[95] What was at stake for Dubuffet, then, was art's ability to cut through the falsity of its staging. It does so in his work by referencing its own performative, and thus transformative, power.

The ritual mask transformed by memory and imagination thus also served as one of Dubuffet's thematic models. Indeed, the very materiality of Dubuffet's *haute pâte* seems, as Pepe Karmel observes, to have been a logical progression from his papier-mâché masks of the 1930s.[96] As Minturn notes, moreover, these masks had the potential not only to fix the identities of the sitters, but also to allow their exchange during art- and performance-centered gatherings.[97] Dubuffet's *haute pâte* and interest in masks thus highlight his exploration of the

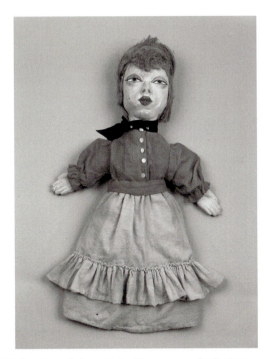

Figure 1.4 (and Color Plate 1) Jean Dubuffet, puppet of Lili, 1936, papier-mâché, wood, and paint, 60 cm. (23.6 in.) ht. Fondation Dubuffet, Paris. © 2020 Artist Rights Society (ARS), New York—ADAGP, Paris. Photograph courtesy of the Fondation Dubuffet, Paris. Reproduced in *Catalogue des travaux de Jean Dubuffet*, Fascicule I (Paris: Fondation Dubuffet, 2003), 33, no. 86.

relationships between materiality, mobility, and performance that this book explores in his portraits.

For Dubuffet, authentic art should, to the greatest extent possible, result from and represent interior creative drives, "works that exhibit the abilities of invention and of creation in a very direct fashion, without masks or constraints."[98] Yet as this book illuminates, the mask as a means of transformation remained a central theme in his oeuvre. Looking to both pre-Modern European and non-Western masks, he blended the familiar with the strange in his portraits. The following chapters examine this under-studied yet key aspect of these works—the often-paradoxical artistic and thematic strategies by which Dubuffet sought to impact the viewer, produce a vivifying viewing experience, and effect a radical reorientation of the viewer's perspective. These strategies included juxtaposing the ordinary with the extraordinary in his figures to amplify affect and, crucially, to promote active, imaginative viewing. Following Dubuffet's own lines of inquiry, this book considers the intersection between his postwar portraiture,

Art Brut, and ethnography, arguing that his portraits were in dialogue with the artistic activities (poetry, prose, performance, and visual art) of his Surrealist-inspired sitters. In creating portraits of artist-intellectuals who extolled alternative art forms as a means to revitalize art and culture, Dubuffet called attention to the symbiotic relationship between art, the artist, and culture—a relationship he hoped to alter. In foregrounding the physicality of his figures in relation to the painting's surface, Dubuffet also called attention to the very structure of the tableau, highlighting both the embodied and enculturated aspects of viewing.

Portraits and chapters

The chapters in this book explore Dubuffet's portraits of key visual and literary artists who contributed, in their own iconoclastic ways, to the reshaping of postwar culture: Michel Tapié (Chapter 2), Antonin Artaud (Chapter 3), and Henri Michaux (Chapter 4). Each chapter considers Dubuffet's artistic practice in relation to a tripartite set of thematic concerns that he shared with his sitters and that organize the discussion of the portraits: assemblage, translation, and Surrealist transformation (Chapter 2); dissociation, performance, and ethnography (Chapter 3); and dislocation, creativity, and performativity (Chapter 4). Because Dubuffet's portraits depict sitters who were fascinated by so-called "primitive" art and concerned with painting, writing, and the performative/transformative dimensions of their work, each chapter considers the intertextual relationships between word, image, and performance *vis-à-vis* an array of intra-, inter-, and ostensibly extra-cultural forms. These chapters examine these distinct yet intertwined themes in relation to the particular artworks considered, and they elaborate upon the many related tensions Dubuffet set up in his portraits: high art/Art Brut, abstract/figurative, flat/three-dimensional, static/dynamic, and affective/interpretive.

Chapter 2, "Art as Other: surrealism, Collage, and Oceanic Art in the Portraits of Michel Tapié, Jean Paulhan, and the Company of Art Brut," highlights Dubuffet's multiple renderings of the theatrical art critic, curator, and dealer who promoted the new postwar art and achieved notoriety for coining the terms *art informel* and *art autre* (art of another kind) to describe work such as Dubuffet's. Many of the painters Tapié promoted, including Dubuffet, had explored Cubism and Surrealism, adapting comparable paradigms and applying collage-inspired imagery to their painting and promotion of postwar visual art. As this chapter

elaborates, Dubuffet's art was informed by a collage aesthetic that combined the affective qualities of Art Brut and the Oceanic imagery that inspired the biomorphic abstractions of Masson and Miró, whose studios had served as a nexus of Surrealist activities available to Dubuffet in close proximity to his home during the interwar years. Produced in 1946, after the war and at the onset of Dubuffet's stint into portraiture, his renderings of Tapié, Paulhan, and others in the Compagnie de L'Art Brut are characterized by dramatic facial expressions, distinctly circular eyes, and, in some cases, emphatic gestures. To create these effects, Dubuffet selected Art Brut and Oceanic imagery that he could translate—and transform—into what became known as his own pictorial idiom. This chapter explores Dubuffet's source-hunting among the Oceanic artifacts that were collected by his Surrealist friends and featured in ethnographic museums and publications, demonstrating his embrace of a collage aesthetic in his portraits, well in advance of his mixed-media collage of the 1950s for which he adopted the term "assemblage."[99]

Chapter 3, "Painting and Its Double: Surrealist Performance and Balinese Theater in the Portraits of Antonin Artaud," explores Dubuffet's renderings of one of the most notorious rogue Surrealists. A well-known poet and dramaturge during the interwar era, Artaud was institutionalized for dissociative disorders from 1937 until 1946, when Dubuffet and a consortium of friends gained the author's transfer to a private hospital and facilitated his fleeting re-entry into the late avant-garde during the final years of his life. This chapter considers the ways in which the confrontational air, odd bodily contortions, and figural doubling in Dubuffet's portraits reveal his engagement with Artaud's ideas, particularly his advocacy for the affective qualities of Balinese theater in his 1938 book *The Theater and Its Double*, which Dubuffet read (or reread) in 1945.[100] Highlighting the ways in which Balinese masks, costumes, and puppets appear in Dubuffet's painting, this chapter argues for their centrality to his Artaudian portrayals and to many of his other portraits. In viewing this understudied aspect of Dubuffet's career—his interest in Artaudian affect and masked performance—as a corollary to his investigation of Art Brut, this chapter considers his efforts to intensify the affective potential of his art while exploring relationships between creativity, culture, and altered states of consciousness. In drawing attention to Dubuffet's dialogue with Artaudian affect *vis-à-vis* the Balinese theater, however, this chapter also highlights a major difference in their approach—the fact that Dubuffet deployed affect as a means to create a more meaningful artistic encounter.

Chapter 4 "A 'Barbarian' in the Gallery: Southeast Asian Art and Performance in the *Portrait of Henri Michaux*," considers this and several of Dubuffet's portraits

of this quasi-Surrealist writer and visual artist, arguing for the centrality of Michaux's writings on cross-cultural contact to Dubuffet's depictions. Michaux's dream/nightmare-conjuring prose mastered the Surrealist art of juxtaposing dreaming and waking realities and drew the attention of Dubuffet, who wrote of his appreciation for Michaux's work.[101] Michaux's visual art explored disjunctive pictorial elements (notably between figuration and abstraction) and pushed them to the limits of dynamism, often drawing upon Asian art and calligraphy for inspiration. A celebrated world traveler and outspoken cultural critic, Michaux's 1933 book *A Barbarian in Asia* captured the attention of the French avant-garde.[102] Its impact on Dubuffet's portraits—images in which one glimpses cultural forms from the very regions Michaux traversed on the Southeast Asian and Oceanic legs of his journey—is examined in this chapter. Noting an aesthetic of displacement in Dubuffet's painting, this chapter explores the portraits' attunement to inter- and postwar discourses on the decentering effects of encountering difference, considering Dubuffet's hybrid, albeit appropriative, figures to have begun probing an outlook Bhabha has described, more generally, in the late twentieth century as an "interstitial perspective"—the embrace of cultural dislocation, liminality, and multiple points of view.[103]

Chapter 5, the book's conclusion, titled "Animating the Material: Assemblage, Theatricality, and Performativity in Dubuffet's Self-Portraits," considers Dubuffet's late work to be the logical outcome of his immediate postwar experimentation. Through the lens of Dubuffet's late self-portraits in the *Hourloupe* style, this chapter examines his radical shift away from gritty materiality to the colorful and crisply outlined figures he began producing in the early 1960s—figures that suggest the stylized patterning and pieced-togetherness of many oceanic artifacts. This chapter traces an artistic trajectory for Dubuffet that became ever more characterized by collage practices, pastiche, and overt theatricality, exploring the ways in which his self-portraits attest to his career-long investigation into the relationships between painting and performance, between the physical and fictive materiality of painting, and between the painter, the viewer, and culture. Key to this investigation of Dubuffet's late self-portraits are the ways in which they engage in his efforts to create both dissonances and resonances in his *Hourloupe* series of paintings, drawings, and sculptures, which culminated in his 1971-1973 *Coucou Bazar (The Hourloupe Ball)*, a total production he called a "living tableaux." In "animating" his painting (a practice that was already hinted at in his portraits) he expanded it to include stagecraft replete with ethnographically inflected masks, costumes, and even mechanized puppets.[104] This look at the late self-portraits thus reveals Dubuffet's long-term

commitment to painting, pastiche, and performance, representing his continued efforts to dislodge the viewer from the ordinary world and to transport him or her instead to a world attuned to life's "polyphonic" resonances.[105] Ultimately, this book surveys Dubuffet's efforts to produce portraits that allude, in their way, to art's performative and culturally transformative power.

Notes

1 Jean Dubuffet, letter to Florence Gould August 9, 1946, Fondation Dubuffet Archives. Gould was an arts patron who hosted weekly lunches that Dubuffet began attending with his friend, publisher Jean Paulhan. As Dubuffet writes: "Dans quelle aventure vous m'avez jete! Rien n'etait plus loin de ma pensee que de faire de portraits! je n'avais pas la moindre idee de cela! Eh bien me voila maintenant embarque dans cette affaire, es tout a fait passionee" (What an adventure you have thrown me into! Nothing could have been further from my thoughts than making portraits! I hadn't the least idea of doing that. Now I have embarked on this endeavor altogether passionately).

2 Jean Dubuffet, Catalogue de l'exposition "Portraits" à la Galerie René Drouin de 7 au 31 octobre 1947. "Les Gens sont bien plus Beaux qu'ils Croient" (These gentlemen are more attractive than they think), the headline reads. The subheading proclaims: "PORTRAITS à ressemblance extraite, à ressemblance cuite et confite dans la mémoire, à ressemblance éclatée dans la memoire Mr Jean Dubuffet, Peintre" (Portraits with resemblance extracted, with resemblance cooked and preserved in memory, with resemblance exploded in the memory of Mr. Jean Dubuffet, Painter). The full text in the "Causette" (Little Chat) contained in the catalogue can be viewed in Jean Dubuffet and Max Loreau, *Catalogue des travaux de Jean Dubuffet*, Fascicule III, "Plus beaux qu-ill croient, Portraits" (Paris: Fondation Dubuffet, 2003; first published J.-J. Pauvert, 1966), 13–16; an English translation is available by Sara Ansari and Kent Minturn in "Jean Dubuffet, 'Little Chat,'" in *Jean Dubuffet: "Anticultural Positions,"* ed. Mark Rosenthall (New York: Aquavella Galleries, 2016), 63–70.

3 *La Gazette des Lettres*, October 18, 1947, in Dubuffet and Loreau, "Extraits de presse," *Catalogue des travaux de Jean Dubuffet*, Fascicule III, 121; *Combat*, October 7, 1947, in Fondation Dubuffet, Press Clipping Archives. The full quote taken from *La Gazette des Lettres* reads: "M. Jean Dubuffet n'est tout honnêtement qu'un peintre académique, le pompier de la peinture enfantine" (Mr. Dubuffet is really only an academic painter; the "pompier"—vulgar emulator—of childish painting).

4 *Le Figaro littéraire* October 18, 1947, in Dubuffet and Loreau, "Extraits de presse," *Catalogue des travaux de Jean Dubuffet*, Fascicule III, 121. According to the

article, Paul Léautaud was so furious about Dubuffet's *Paul Léautaud a la chaise cannée* (Paul Léautaud on a Caned Chair) he "a manifesté l'intention d'aller Place Vendôme se casser lui-même la figure à coups de canne! (has expressed the intention to go to the Place Vendôme and strike the portrait himself with a blow from his cane).

5	For more on Dubuffet's portrait exhibition see Susan J. Cooke, "Jean Dubuffet's Caricature Portraits," in *Jean Dubuffet 1943–1963: Paintings, Sculptures, Assemblages: an Exhibition*, eds. James Demetrion, Susan J. Cooke, Jean Planque, and Peter Schjeldahl (Washington, D.C.: Hirshhorn Museum and Sculpture Garden in association with the Smithsonian Institution Press, 1993), 21; and Andrea Nicole Maier, *Dubuffet's Decade*, Thesis (Ph.D.), University of California, Berkeley, 2009. Maier discusses the details of Dubuffet's feud with Léautaud, which was fueled by Dubuffet's several depictions of the author after promising not to include him in the portrait series.

6	Kent Minturn, "Dubuffet avec Damisch," *October* 154 (Fall, 2015): 69–86; Minturn, "Physiognomic Illegibility: Jean Dubuffet's Postwar Portraits," in *Jean Dubuffet: "Anticultural Positions"* (New York: Acquavella Galleries, 2016), 37–62; Cooke, "Jean Dubuffet's Caricature Portraits," 20–33; Maier, *Dubuffet's Decade* (full citation in note 5 above). I also address these issues in Stephanie Chadwick, *Disorienting Forms: Jean Dubuffet, Portraiture, Ethnography*, Thesis (Ph.D.), Rice University, 2015.

7	Cooke, "Jean Dubuffet's Caricature Portraits," 28.

8	Jean Dubuffet, "Anticultural Positions," a 22-page facsimile of the artist's manuscript notes [handwritten in English] for a lecture at the Arts Club of Chicago on December 20, 1951, in Richard L. Feigen, *Dubuffet and the Anticulture* (New York: R. L. Feigen & Co., 1969), insert; Dubuffet, "In Honor of Savage Values" (1951), trans. Kent Minturn, *Anthropology and Aesthetics*, no. 46 (Autumn, 2004); 259–268; Jean Dubuffet, "Notes for the Well-Read," in Mildred Glimcher, Marc Glimcher, and Jean Dubuffet, *Jean Dubuffet: Towards an Alternative Reality*, trans. Joachim Neugroschel (New York: Pace Publications, 1987), 67–86.

9	More about Dubuffet's friendship with Breton can be seen in their voluminous correspondence, much of which deals with the founding of Dubuffet's Company of Art Brut, that can be seen in the archives of the Fondation Dubuffet and the Bibliothèque Littéraire Jacques Doucet. Many of these are reprinted in Dubuffet, *Prospectus et tous écrits suivants* and Jean Dubuffet, et al., *Correspondance: 1944–1968* (Paris: Gallimard, 2003). A letter dated May 25, 1948 from Dubuffet to Breton (Bibliothèque Littéraire Jacques Doucet) lists Breton and each of the Company of Art Brut contributors and also appears in "A Word About the Company of Art Brut," in *Asphyxiating Culture and other Writings*, trans. Carol Volk (New York: Four Walls, 1986), 109. For more on Dubuffet's acquaintance with Lacan see Dubuffet, letter to photographer Daniel Wallard, December 20, 1944, in "Jean Dubuffet

Correspondence and Papers, 1944–1984," records of the Getty Research Institute. Dubuffet encourages Wallard (a French photographer who associated with members of the French avant-garde) about an upcoming trip to Paris, advising: "Il faut voir aussi mon ami le Dr. Jacques Lacan, psychiatrist, il a une consultation à Ste Anne" (You must also see my friend Dr. Jacques Lacan, a psychiatrist who has a post at St. Anne); this was a mental hospital that periodically exhibited the art of mental patients. For more on Dubuffet's acquaintance with Lévi-Strauss see this chapter's discussion and notes 10, 12–14 below.

10 Claude Lévi-Strauss, *The Savage Mind*, trans. George Weidenfeld and Nicolson Ltd. (Chicago: University of Chicago Press, 1962), 11. See also Anna Dezeuze, "Assemblage, Bricolage, and the Practice of Everyday Life," *Art Journal* 67 (Spring, 2008): 31–37. Dezeuze discusses the relationships between the ideas and practices of assemblage and bricolage that, as she elaborates, lead to process-based practices in contemporary art. The first line of her article cites a discussion of collage between Dubuffet and Museum of Modern Art curator William Seitz, in which Dubuffet acknowledges the cultural specificity of art historical terms.

11 Dubuffet, "The Common Man Carries the Day," in "Notes for the Well-Read," in Glimcher, 70. Dubuffet refers to his admiration for the creative workings of "the common man" and he reinforces this idea by using vernacular (or his own variations of it) in this and many of his writings about art.

12 Kent Minturn, "Dubuffet, Lévi-Strauss, and the Idea of Art Brut," *RES: Anthropology and Aesthetics*, no. 46 (Autumn, 2004): 247–258.

13 Lévi-Strauss, Letter to Jean Dubuffet of November 15, 1948, trans. Kent Minturn, in *RES: Anthropology and Aesthetics*, no. 46 (Autumn, 2004): 267.

14 Lévi-Strauss, *The Savage Mind*, 11; Dubuffet, "The Common Man Carries the Day," in "Notes for the Well-Read," in Glimcher, 70.

15 Jacques Derrida, "Structure, Sign, and Play in the Discourse of the Human Sciences," in *Writing and Difference*, trans. Alan Bass (Chicago: University of Chicago Press, 1978), 6; Nasrullah Mambrol, "Claude Lévi-Strauss's Concept of Bricolage," in *Literary Theory and Criticism* (March 21, 2016), https://literariness.org/2016/03/21/claude-levi-strauss-concept-of-bricolage/.

16 Lévi-Strauss, *The Savage Mind*, 13.

17 For more on Dubuffet's New Invention category of art see Jean Dubuffet, "Art Brut Chez Dubuffet," in *Prospectus et tous écrits suivants*, Vol. II (Paris: Gallimard, 1967), 47; Michel Thévoz and Jean Dubuffet, *Collection de l'art brut: Château de Beaulieu* (Lausanne: La Collection, 1976); Lucienne Peiry, *Art Brut: The Origins of Outsider Art* (Paris: Flammarion 2006); and "Neuve Invention," *Collection de l'art brut Lausanne*, https://www.artbrut.ch/en_GB/art-brut/neuve-invention (accessed November 24, 2019).

18 Lévi-Strauss, *The Savage Mind*, 14.

19 André Breton, *Communicating Vessels* (1932), trans. Mary Ann Caws and Geoffrey T. Harris (Lincoln, Nebraska: University of Nebraska Press, 1990), 4–5.

20 Rosalind Krauss, "The Originality of the Avant-Garde," in *The Originality of the Avant-Garde and Other Modernist Myths* (Cambridge, Mass: MIT Press, 1985), 151–170.

21 Maurice Merleau-Ponty, *Phenomenology of Perception* (1945), trans. Colin Smith (London: Routledge, 1962), 143, 153; Hubert Damisch and Sophie Berrebi, "Writings and Correspondence: 1961–1985: Hubert Damisch and Jean Dubuffet," trans. Nicholas Huckle and Molly Stevens, *October* 154 (Fall, 2015): 8–68; Mary Ann Caws, "The 'réalisme ouvert' of Bachelard and Breton," *The French Review* (January, 1964): 302–311 and Mary Ann Caws, ed., "Translator's Introduction," in André Breton, *Mad Love* (Lincoln, Nebraska: University of Nebraska Press, 1987); xi–xii. Kent Minturn, "Dubuffet avec Damisch," *October* 154 (Fall, 2015): 69–86. As Minturn notes, Dubuffet's writings about art also influenced Damisch's interpretation of the artist's work. For more on Dubuffet's interest in movement see Geneviève Bonnefoi, *Jean Dubuffet* (Caylus, France: Association mouvements, 2002). For more on Dubuffet and Phenomenology, see Jean H. Duffy, *Perceiving Dubuffet; Art, Embodiment, and the Viewer*, (Liverpool; Liverpool University Press, 2021), which I read while reviewing these page proofs.

22 For more on the concepts of the performative and performativity, see J. L Austin, *How to Do Things with Words* (Cambridge: Harvard University Press, 1962); Jacques Derrida, *Of Grammatology* (Baltimore: Johns Hopkins University Press, 1976); Judith Butler, *Gender Trouble: Feminism and the Subversion of Identity* (New York: Routledge, 1990); and Kira Hall, "Performativity," *Journal of Linguistic Anthropology* 9, no. 1–2 (2000): 184–187. Hall discusses the trajectory and wider applications of the concept of the performative in linguistic anthropology and literary studies, considering various approaches to the idea that representation shapes identity.

23 For more on these concepts of hybridity and "interstitial perspective," see Homi K. Bhabha, *The Location of Culture* (London: Routledge, 1994).

24 James Clifford, "On Ethnographic Surrealism," in *The Predicament of Culture* (Cambridge: Harvard University Press, 1988), 117–151. For comprehensive discussions of Parisian ethnographic institutions see also Daniel Sherman, *French Primitivism and the Ends of Empire, 1945–1975* (Chicago: University of Chicago Press, 2011).

25 Jean Dubuffet, *Biographie au pas de course*, 21–22. Special thanks to Cécile-Laure Kouassi for assistance with the in-depth translations from this book.

26 Dubuffet, *Biographie au pas de course*, 21–22, 36, 47. Dubuffet's friends hailing from his hometown of Le Havre included writers Georges Limbour, Raymond Queneau, and Armand Salacrou. In Paris, Dubuffet also befriended a number of avant-garde artist-intellectuals, including art dealer and critic Daniel-Henry Kahnweiler, the poet Max Jacob, artists Juan Gris, George Braque (later), and other artist-intellectuals

associated with Cubism and Surrealism. For more on Dubuffet and Braque see Daniel Abadie, *Dubuffet* (Paris: Centre Pompidou, 2001), 365; and Rachel Perry, "Painting in Danger," *RIHA Journal* 221 (August 30, 2019), 7. Perry discusses Dubuffet's contact with Braque while experimenting with diverse materials and processes, citing Dubuffet's Letter to Jean Paulhan of October 3, 1946.

27 André Breton, *Surrealism and Painting*, trans. Simon Watson Taylor (New York: Harper & Row, 1972), 102. Breton discusses this painting as representative of the surrealistic genius of Picasso.

28 Breton, *Surrealism and Painting*, 7.

29 Dubuffet, *Biographie au pas de course*, 21–22.

30 Dubuffet, *Biographie au pas de course*, 21–22; André Masson, *Les Aneeé Surréalistes: Correspondences 1916-1942* (Paris: La Manufacture, 1990), 28–29. Fondation Dubuffet, http://www.dubuffetfondation.com/bio_set_ang.htm (accessed November 30, 2014); Abadie, *Dubuffet*, 356. During the early 1930s Dubuffet lived in Saint-Mandé and ran a wine wholesale business in Bercy.

31 Jean Dubuffet to Jacques Berne, February 8, 1947, in Jean Dubuffet and Jacques Berne, *Lettres à J.B.: 1946-1985* (Paris: Hermann, 1991), 6–8; Dubuffet, *Biographie au pas de course*, 17–22; André Masson, in Kristy Bryce and Mary Ann Caws, *Surrealism and the Rue Blomet* (New York: Eklyn Maclean, 2013), 43; Masson, *Les Aneeé Surréalistes*, 28–29.

32 Dubuffet, "Art Brut Chez Dubuffet," in *Prospectus et tous écrits suivants*, 49.

33 Hans Prinzhorn, *Artistry of the Mentally Ill* (New York: Springer-Verlag, 1972). For more on Alois Riegl as an influence on Hans Prinzhorn see David Maclagan, *Outsider Art: From the Margins to the Marketplace* (London: Reaktion Books, 2009), 8; and Colin Rhodes, *Outsider Art: Spontaneous Alternatives* (New York: Thames & Hudson, 2000), 59–61.

34 André Breton, "Manifesto of Surrealism," in Charles Harrison and Paul Wood, *Art in Theory 1900-2000: An Anthology of Changing Ideas* (Malden, Mass: Blackwell Publishing, 2003), 451; see also Hal Foster, "Blinded Insights On the Modernist Reception of the Art of the Mentally Ill," *October* 97 (Summer, 2001): 3–30.

35 Dubuffet, "Art Brut Chez Dubuffet," in *Prospectus et tous écrits suivants*, 41–42. Dubuffet also states that "interest in the art of the insane, and the rejection of established culture, was 'in the air' when I was a student, in the 1920s."

36 Clifford, *The Predicament of Culture*, 118–119. These ideas are also discussed in my dissertation in note 6 (above). See also Jill Shaw, *A Coat that Doesn't Fit: Jean Dubuffet in Retrospect, 1944-1951* (Ph.D. diss., University of Chicago, 2013). Shaw acknowledges that viewing Dubuffet's work through the lens of Clifford's notion of ethnographic Surrealism is helpful but argues that since Dubuffet's and the Surrealists' motives and processes differed vastly the correlations should not be overstated. In contrast, I contend that the resonances of Surrealist interests in

processes of discovery, investigating non-European cultures, and making the familiar strange were too great to be denied as shaping forces of Dubuffet's art.

37 Clifford, *The Predicament of Culture*, 129–130.

38 Clifford, *The Predicament of Culture*, 121; see also Sherman, *French Primitivism and the Ends of Empire* cited in note 24 (above).

39 Dubuffet, *Biographie au pas de course*, 23–24; Abadie, *Dubuffet*, 365–366.

40 Jean Dubuffet, "A Word About the Company of Art Brut," in *Asphyxiating Culture,* 109. The group also benefitted from the patronage of American expatriate portrait instigator Florence Gould.

41 Dubuffet, "In Honor of Savage Values," 262.

42 Fondation Dubuffet, Cahiers 2 & 3, Press articles. Dubuffet filled these volumes with press clippings related to his art during the year 1945–1947. A selection of these articles is also available in Dubuffet and Loreau, "Extraits de presse," *Catalogue des travaux de Jean Dubuffet*, Fascicule III, 121–122. A number of these are celebratory, but many are derisive, proclaiming that Dubuffet's work signaled the degeneration of art. For more on Dubuffet, postwar conditions, and the concept of *L'Informe*, see Yve-Alain Bois, "To Introduce a User's Guide," *October* 78 (Fall, 1996): 25. For more on Dubuffet's materiality as relates to material conditions see also Petra ten-Doesschate Chu, "Scatology and the Realist Aesthetic," *Art Journal* 52, no. 3 (Autumn, 1993): 41–46.

43 Dubuffet, quoted in Rachel Perry, "*Paint Boldly!*: Dubuffet's DIY Manual," *October* 154 (Fall, 2015): 88–89. Perry's main focus is Dubuffet's materiality, but her discussion of his formation of the Compagnie de L'Art Brut and proposed *Almanach de l'Art Brut* provides insights into how these projects fit his overall artistic goals.

44 Baptiste Brun, "Réunir une documentation pour l'Art Brut: les prospections de Jean Dubuffet dans l'immédiat après-guerre au regard du modèle ethnographique," *Cahiers de l'École du Louvre, recherches en histoire de l'art, histoire des civilisations, archéologie, anthropologie et muséologie*, no. 4, (April, 2014): 56–66.

45 For foundational discussion of Dubuffet's artistic development, see Dubuffet, *Biographie au pas de course*; Dubuffet and Hubert Damisch, *Prospectus et tous écrits suivants* Vols. I–IV (Paris: Gallimard, 1967); Dubuffet and Max Loreau, *Catalogue des travaux de Jean Dubuffet* (Paris: Fondation Dubuffet, 2003); and Peter Selz, *The Work of Jean Dubuffet* (New York: Museum of Modern Art; Doubleday, 1962). For critical analysis of these narratives, in which Dubuffet positions his art in relation to the naïve creations of Art Brut, see Minturn, "Dubuffet avec Damisch," *October* 154 (Fall, 2015): 69–86; Maier, *Dubuffet's Decade* (full citation in note 5 above) and Maier "Jean Dubuffet and the Bodies of Ladies," *Art History* 34, no. 5 (2011): 1013–1041; see also Roja Najafi's "Figuration, Abstraction, and Materiality in the works of Jean Dubuffet (1901–1985)," Thesis (Ph.D.), University of Texas, 2017. Importantly, Minturn notes that in a 2002 interview Damisch acknowledged the impact Dubuffet's writings had on the art historian's own work (74).

46 Antonia Dapena-Tretter, "Jean Dubuffet & Art Brut: The Creation of an Avant-Garde Identity," *Platform*, Vol. 11, "Authenticity" (Autumn, 2017): 12–33; Jean H. Duffy, "Jean Dubuffet's Beautiful People," *Word & Image* 35, no. 2 (June, 2019): 191–209. Duffy in particular acknowledges some of the visual evidence suggesting that to produce his portraits Dubuffet borrowed from the art of children and non-Western cultures. In the latter discussion Duffy cites my 2015 dissertation, which details the foundational research of Dubuffet's engagement with non-Western art that made this book possible.

47 Dubuffet, "Art Brut Chez Dubuffet," in *Prospectus et tous écrits suivants*, 57–58. Interviewer John MacGragor compares Dubuffet's *Man with a Rose* to drawings by Anton Müller. Dubuffet denies any direct source hunting. The resemblance between these two images is, however, undeniable, and they are compared directly in Lucienne Peiry, *Art Brut: The Origins of Outsider Art* (Paris: Flammarion, 2006), 98.

48 For more on Dubuffet's donation of the collection to the Swiss government see Michel Thévoz and Dubuffet, *Collection de l'art brut: Château de Beaulieu* (Lausanne: La Collection, 1976); see also "History," in *Collection de l'art brut Lausanne*, https://www.artbrut.ch/en_GB/art-brut/history (accessed November 24, 2019). For more on Dubuffet's visit to the Prinzhorn Collection see Dubuffet, "Art Brut Chez Dubuffet," in *Prospectus et tous écrits suivants*, 46 and "Dubuffet's List," Prinzhorn Collection, University of Heidelberg website, https://prinzhorn.ukl-hd.de/index.php?id=152&L=1 (accessed December 4, 2019). Dubuffet recalls his visit to be in 1948 or 1949, but the Prinzhorn Collection records containing an unpublished list by Dubuffet of selected works indicate the visit took place in 1950. The Prinzhorn Collection organized an exhibition of these works, *Dubuffet's List*, from December 17, 2015 to April 10, 2016.

49 Dubuffet, "In Honor of Savage Values," 263.

50 Dubuffet, "In Honor of Savage Values," 263.

51 Duffy, "Jean Dubuffet's Beautiful People," 199.

52 Dubuffet, "The Common Man Carries the Day," in "Notes for the Well-Read," in Glimcher, 70.

53 Gaston Bachelard, *The Philosophy of No: A Philosophy of the New Scientific Mind*, trans. G. C. Waterson (New York: Orion, 1968), a translation of Bachelard, *La philosophie du non: essai d'une philosophie du nouvel esprit scientifique* (Paris: Presses universitaires de France, 1940); Bachelard, "Introduction," in *The Poetics of Space* (1957), trans. Maria Jolas (New York: Orion, 1964), xi–xii, xxix; Bachelard, *La Terre et les reveries de la volonté: Essai sur l'imagination de la matière* (Paris: José Corti, 1947); 105; Bachelard, *Le nouvel esprit scientifique* (Paris: Librairie Félix Alcan, 1934). See also Sarah Wilson, "Paris Post War: In Search of the Absolute," in *Paris Post War: Art and Existentialism 1944–55*, ed. Frances Morris (London: Tate Gallery, 1993), 34; and

Marianne Jakobi, "Nommer la forme et l'informe: La Titraison comme genèse dans l'oeuvre de Jean Dubuffet," *Item* February 19, 2008, http://www.item.ens.fr/index. php?id=187132 (accessed July 2, 2015). Wilson discusses the intertextuality between Dubuffet's painting and Bachelard's ideas on "the dynamic hand" and primordial matter. Jakobi discusses the postwar French interest in primal matter, noting the parallels between Dubuffet's essay "Réhabilitation de la boue" (Rehabilitation of Mud) and Bachelard's elaboration of a "valorisation de la boue" (valorization of mud) in his *La Terre et les reveries de la volonté*.

54 André Breton, "Manifesto of Surrealism," in Harrison and Wood, 452.

55 André Breton, "Manifesto of Surrealism," in Harrison and Wood, 452.

56 André Breton, "Manifesto of Surrealism," in Harrison and Wood, 450.

57 *Caws, "The 'réalisme ouvert' of Bachelard and Breton," 302–311.* See also Caws, "Translator's Introduction," in André Breton, Mad Love (Lincoln, Nebraska: University of Nebraska Press, 1987), xi–xii. Citations for texts by Bachelard are included in the following notes.

58 For more on the postwar fascination with Paleolithic cave paintings, see Georges Bataille, *Lascaux, or, The Birth of Art: Prehistoric Painting* (Lausanne: Skira, 1955); Suzanne Guerlac, "The Useless Image: Bataille, Bergson, Magritte," *Representations* 97 (Winter, 2007), 28.

59 Breton, *Communicating Vessels*, 4–5.

60 Dubuffet, "In Honor of Savage Values," 262.

61 Dubuffet, "Notes for the Well-Read," in Glimcher, 73, 77.

62 Dubuffet, "Notes for the Well-Read," in Glimcher, 77.

63 Dubuffet, *Biographie au pas de course* (Paris: Gallimard, 2001), 48; Fondation Dubuffet, "Studio Log 3 January 1947, *Antonin Artaud aux houppes*" (Antonin Artaud with Tufted Hair) reprinted in Dubuffet and Loreau, *Catalogue des travaux de Jean Dubuffet*, Fascicule III, 79; also reprinted in Andreas Franzke, *Dubuffet*, trans. Robert Wolf (New York: Harry N. Abrams, 1981), 47. Dubuffet met Jean Fautrier in 1943 after becoming acquainted with Jean Paulhan, and Fautrier's 1945 *Otage* series profoundly affected Dubuffet. The two artists also worked in a similar manner, spreading a thick paste onto horizontally placed canvases, and experimenting with adding real world elements such as ash, sand, and detritus to the mixture.

64 Dubuffet, "Anticultural Positions," in Feigen (full citation in note 8 above). Additional documents related to Dubuffet's Arts Club lecture are available in the Inventory of the Arts Club Records, Newberry Library, Roger and Julie Baskes Department of Special Collections, Chicago and in the Pierre Matisse Papers, Morgan Library, New York. Tapié organized many art exhibitions, including the *Mirobolus Macadam & Cie: hautes pâtes de J. Dubuffet* at the Galerie René Drouin in Paris (1946), the *Exhibition of Paintings by Jean Dubuffet* at the Pierre Matisse Gallery in New York (1951), *Signifiants de l'informel* (1951), and *Jackson Pollock* (1952), at the Galerie Paul

Facchetti, Paris. For more on international abstraction see the 2012 exhibition catalogue *Art of Another Kind: International Abstraction and the Guggenheim, 1949–1960*.

65 Leo Steinberg, "Reflections on the State of Criticism," in *Robert Rauschenberg* (Cambridge, Mass: MIT Press, 2002), 28.

66 Dubuffet, "Notes for the Well-Read," in Glimcher, 69, 72.

67 Dubuffet, "Notes for the Well-Read," in Glimcher, 77; see also Perry, "*Paint Boldly!*", 87–110. As Perry rightly observes, Dubuffet's meticulous recording of his processes and materials was at odds with his rhetoric about artistic spontaneity.

68 Dubuffet, "Notes for the Well-Read," in Glimcher, 72–73; Bachelard, *The Poetics of Space*, xxix.

69 Bachelard, *The Poetics of Space*, xix.

70 Lévi-Strauss, *The Savage Mind*, 16.

71 Dubuffet, "Notes for the Well-Read," in Glimcher, 72–73. See also Duffy, "Dubuffet's Beautiful People," 199. Duffy mentions Dubuffet's interest in what she calls "artwork-viewer dynamics," which I also discuss in detail in my 2015 dissertation cited in note 6 above.

72 Dubuffet, "Notes for the Well-Read," in Glimcher, 73, 77.

73 Dubuffet, "Notes for the Well-Read," in Glimcher, 67.

74 Yve-Alain Bois, "No to . . . the Informel," in *Formless: A User's Guide* (New York: Zone Books, 1997), 138–143; *Georges Bataille: Vision of Excess. Selected Writings, 1927–1939*, trans. Allan Stoekl, Carl R. Lovitt, and Donald M. Leslie Jr. (Minneapolis: University of Minnesota Press, 1985), 31.

75 Dubuffet, "Anticultural Positions," 5, 11, in Feigen insert. See also Sigmund Freud *Civilization and Its Discontents*, trans. Joan Riviere (London: Hogarth Press, and the Institute of Psycho-analysis, 1930); Romain Rolland, "To Sigmund Freud, 5 Dec. 1927," and "To Sigmund Freud, 17 July 1929" in *Selected Letters of Romain Rolland* (Delhi: Oxford University Press, 1990), 95; see also Rolland, *Prophets of the New India* (New York: Boni, 1930). We get a glimpse here of Freud's notion of the "oceanic feeling" conceived initially by French writer, historian, and mystic Romain Rolland. Having arrived at the idea through his study of Eastern philosophy, which he promoted heavily in France, Roll and described the oceanic feeling as a sense of limitlessness and attunement to all things.

76 Bois, 138–143; Kent Minturn, "Physiognomic Illegibility: Jean Dubuffet's Postwar Portraits," in *Jean Dubuffet: "Anticultural Positions,"* 37–62.

77 Hal Foster, *Compulsive Beauty*, Cambridge: MIT, 1993.

78 Dubuffet refers to the Comte de Lautréamont's *Songs of Maldoror* in "Notes for the Well-Read," in Glimcher, 81.

79 Dubuffet, "In Honor of Savage Values," 261.

80 Dubuffet, "In Honor of Savage Values," 261.

81 Lévi-Strauss, *The Savage Mind*, 16.

82 Krauss, *The Originality of the Avant-Garde*, 151–170. I use the term "mimicry" in this portion of the text in the traditional, rather than the postcolonial usage.

83 For more on this triad, see Charles Harrison and Paul Wood, *Art in Theory 1900–2000* (Malden, Mass: Blackwell Publishing, 2000), 121; David Maclagan, *Outsider Art: From the Margins to the Marketplace* (London: Reaktion Books, 2009), 8; and Colin Rhodes, *Outsider Art: Spontaneous Alternatives* (New York: Thames & Hudson, 2000), 59–61.

84 For more on performativity, see Austin and Derrida in note 22 above.

85 For more on Oceanic art, see Anthony J. P. Meyer, *Oceanic Art* (Köln: Könemann, 1995); Metropolitan Museum of Art, and Eric Kjellgren, *How to Read Oceanic Art* (New York: Metropolitan Museum of Art, 2014). For more on Papuan and Austronesian language groups see John Edward Terrell, Kevin M. Kelly, and Paul Rainbird, "Foregone Conclusions?: In Search of Papuans and Austronesians," *Current Anthropology* 42, no. 1 (2001): 97–124, doi:10.1086/318436. Some scholars include Southeast Asia in discussing Oceania, while others examine the art from these regions separately. Although the cultures of the regions we call "Oceania" can be placed roughly into two distinct linguistic families—Papuans and Austronesians—both are nevertheless intricately diverse and culturally intertwined. Thus, the appropriateness of categories and relationships, many of which were established in the early twentieth century, are still being investigated and are hotly contested.

86 Dubuffet, "Anticultural Positions," in Feigen insert (full citation in note 8 above).

87 For a notable exception see Jill Shaw, Chapter Two, "Electroshock," in *A Coat that Doesn't Fit: Jean Dubuffet in Retrospect, 1944–1951* (Ph.D. diss., University of Chicago, 2013), 52–104. Although in this chapter Shaw focuses on the works Dubuffet created on or about his trips to Algeria, she considers them in relation to the history of Orientalism.

88 Bachelard, *The Poetics of Space*, xxxi. For thorough discussions of disturbance and negation in avant-garde and Modernist practices, see Peter Bürger, *Theory of the Avant-Garde* (Minneapolis: University of Minnesota Press, 1984); for more on the idea of an aesthetic of disturbance in Modern art and theater see David Graver, *The Aesthetics of Disturbance: Anti-Art in Avant-Garde Drama* (Ann Arbor: University of Michigan Press, 1995).

89 Dubuffet, *Asphyxiating Culture*, 42.

90 Dubuffet, *Asphyxiating Culture*, 42; see also Bonnefoi in note 21 above. Although she does not develop these ideas in relation to Dubuffet's dialogue with the writings of his portrait sitters or the Oceanic and Indonesian cultural forms I consider here, Bonnefoi also discusses Dubuffet's work in terms of disorientation and a thematic of movement.

91 See also Duffy, "Jean Dubuffet's Beautiful People," 201; and notes 6, 21, 45, and 71 above. Comparing Dubuffet's work with children's and Oceanic art, Duffy also acknowledges the portraits as amalgams created from multiple sources outside of European traditions. In creating these amalgams, she argues, the artist "focused on the essentially human in his portrait subjects."

92 Dubuffet, *Biographie au pas de course*, 15–24, 32–37; Georges Limbour, *Tablea bon levain à vous de cuire la pate* (Paris: René Drouin, 1953), 91–92, translated in Kent Minturn, *Contre-Histoire: The Postwar Art and Writings of Jean Dubuffet* (Ph.D. diss., Columbia University, 2007), 110–111.

93 For more on Michael Fried's seminal discussion of "facingness" or "strikingness," see *Manet's Modernism* (Chicago: University of Chicago Press, 1998), 195, 233–235. See also Jean H. Duffy, "Dubuffet Plays Hide-and-Seek: Lineage, Reflexivity, and Perception in Coucou Bazar," *The Art Bulletin* XCVII, no. 2 (June, 2016): 237–260. Duffy's article provides an in-depth discussion of Dubuffet's exploration of performance and perception in his 1971–1973 and 1978 productions of *Coucou Bazar*, an animated tableau that combined painting, sculpture, and stagecraft.

94 Hubert Damisch and Sophie Berrebi, "Writings and Correspondence," 17.

95 Damisch and Berrebi, "Writings and Correspondence," 18–19.

96 Pepe Karmel, "Jean Dubuffet: The Would-be Barbarian," *Apollo* CLVI, no. 489 (October, 2002): 16.

97 Special thanks to Kent Minturn, who noted this use of the masks to exchange identities in a lecture given at Rice University on November 26, 2013. Special thanks also to Baptiste Brun, who, at the Université Rennes symposium *Dubuffet versus la culture* on April 6, 2017, raised important questions about Dubuffet's investigation of a variety of European folk masks.

98 Dubuffet, *Asphyxiating Culture*, 110; Dubuffet, "In Honor of Savage Values," 260.

99 Peter Selz, *The Work of Jean Dubuffet* (New York: Museum of Modern Art; Doubleday, 1962), 160–163. This book also includes Dubuffet's "Memoir of the Development of My Work From 1952," 73–138.

100 Dubuffet, Letter to Jean Paulhan, December 11, 1945, in *Correspondence: 1944–1968*, 269–270. Dubuffet writes: "Je lis *Le Théâtre et son double* d'Antonin Artaud et suis émerveillé d'y trouver justement les mêmes idées que les miennes" (I am reading *The Theater and Its Double* by Antonin Artaud and am amazed to find in it the same ideas as mine).

101 Dubuffet, *Lettres a J.B., 1945–1985* (Paris: Hermann, 1991), 5, 11 (letters of January 13, 1947 and May 29, 1947 cited also in Minturn, *Contre-Histoire*, 94); Dubuffet writes: "J'aime bien (surtout pour commencer, pour soutenir mes premiers pas dans cette enterprise de portraits) traiter de personages aussi merveilleux que possible (comme Michaux, Léautaud, Artad, Cingria) parce que ça m'en traîne, ça

m'excite." (I like (especially to begin, to support my first steps in this enterprise of portraits) to deal with people who are as marvelous as possible (like Michaux, Léautaud, Artad, Cingria) because that's what compels me, excites me) (5). Dubuffet also writes of being "entiché de Michaux" (infatuated by Michaux) in his letter of May 29, 1947 (11).

102 Henri Michaux, *Un barbare en Asie* (Paris: Gallimard, 1945); Michaux, *A Barbarian in Asia*, trans. Sylvia Beach (New York: New Directions, 1986). First edition published in 1933.

103 Homi K. Bhabha, *The Location of Culture*, 1.

104 Dubuffet, *Jean Dubuffet: Writings on Sculpture*, 98. See also the *Catalogue des travaux de Jean Dubuffet*, Fascicule XX, "L'Hourloupe I" and XXI", "L'Hourloupe II"; Jean Dubuffet, Sophie Duplaix, and Béatrice Salmon, *Coucou Bazaar* (Paris: Arts décoratifs, 2013); and the Fondation Dubuffet, http://www.dubuffetfondation.com/hourloupe_ang.htm, (accessed December 4, 2019).

105 Dubuffet, "Notes for the Well-Read," in Glimcher, 70.

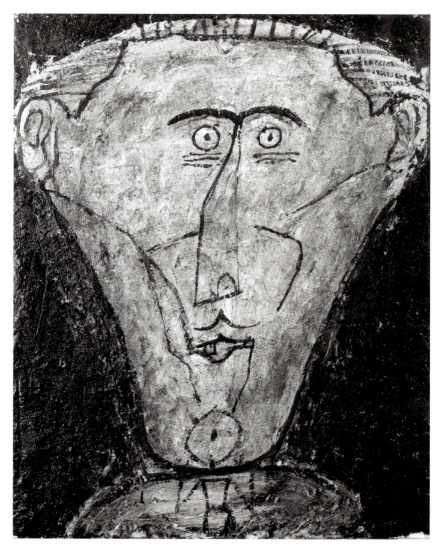

Figure 2.1 (and Color Plate 4) Jean Dubuffet, *Tapié Grand Duc* (Tapié Grand Duke), August, 1946, *haute pâte* (oil, bitumen, and plaster) on canvas, 83 × 67.5 cm. (32.7 × 26.6 in.). Fondation Dubuffet, Paris / © 2020 Artist Rights Society (ARS), New York—ADAGP, Paris. Städel Museum, Städelsches Kunstinstitut und Städtische Galerie, Frankfurt. Photograph: Städel Museum, Frankfurt. Reproduced in *Catalogue des travaux de Jean Dubuffet*, Fascicule III (Paris: Fondation Dubuffet, 2003), 30, no. 34.

Art as Other: Surrealism, Collage, and Oceanic Art in the Portraits of Michel Tapié, Jean Paulhan, and the Company of Art Brut

Part I. From Surrealism to Art Informel: The Intriguing and the Unformed in Dubuffet's Portraits

There is something strange about the looming face of *Tapié Grand Duc* (Figure 2.1 and color Plate 4). The portrait bears certain caricaturesque features, to be sure—its anatomical distortions, wide eyes, and quasi-comic facial expression. Yet viewing this painting in tandem with the writings of the artist and his sitter, and comparing it to the Art Brut and Oceanic sources to which, this chapter argues, Dubuffet looked for inspiration, suggests that this portrait exceeds the purview of caricature alone. Indeed, subverting the genre of caricature and even of portraiture, this and other of Dubuffet's portraits challenged all artistic conventions—a charge for modern art that gained new urgency in the postwar era, when the values of humanistic culture appeared to be bankrupt.

Promoting his program to avert all programs, Dubuffet conceived of his process as both radically experimental and a means of channeling the primal, though typically latent, creativity he believed every human being possessed. He thus touted the "common man's" ability to "carry the day" and counseled artists to produce "instinctive drawings."[1] Advocating art that "respect[s] the impulses, the ancestral spontaneity of the human hand when it draws its signs," Dubuffet also tapped into the postwar nostalgia for an imagined pre-modern culture that he, his portrait sitter Michel Tapié, and many of the artist-intellectuals depicted in the portrait series believed to have been more attuned to natural forms of creativity.[2] Tapié—who helped Dubuffet exhibit and promote his work and the Art Brut (untrained art of ostensible outsiders) that both men believed to exemplify this instinctive creativity—featured prominently among the artist's portraits.

A leading curator, critic, and promoter of postwar avant-garde art, Tapié had also tried his hand at modern painting and jazz, experimenting with new and vibrant forms of creative expression. These *synergistic* interests aligned with those of many postwar artists including Dubuffet, who for a time also benefitted from Tapié's skills as an art dealer. Tapié took a more overtly Nietzschean approach to his writings on art as a liberating force than did Dubuffet and certainly concurred with the artist's suspicion of culture. Tapié likewise shared Dubuffet's belief in an interior model of creativity, a sentiment the critic elaborated upon in hyperbolic essays and exhibition catalogues published during the 1940s and 1950s. The most notable of these, aside from his directly relevant *Mirobolus Macadam & Cie: hautes pâtes de J. Dubuffet* (1946), was *Un art autre* (1952), which is usually translated as "Art of Another Kind."[3] Despite Dubuffet's ambivalence with regard to Art Informel, the movement Tapié worked tirelessly to promote using Dubuffet as a figure head, each man conceived of authentic art as both internally driven and radically Other. This admixture of opposites aligned with ideas about the subconscious forces repressed by modern culture that had been explored in Surrealist art since the 1920s. Intriguingly, Dubuffet combined elements suggesting radical difference with familiar faces in his portraits, making the familiar strange in a way that was attuned to, yet markedly distinct from, the Surrealist art of the interwar era.

Like a bricoleur, this chapter argues, Dubuffet cobbled together this and other of his portraits using an eclectic array of visual sources that included both Art Brut and Oceanic art—a conflation he alluded to in his "Anticultural Positions" and "In Honor of Savage Values."[4] In embracing bricolage (albeit covertly) Dubuffet's process revealed both the marks of his interwar explorations of Cubism and Surrealism and his engagement with the structuralist philosophies that continued to gain currency in the postwar era. These artistic and philosophical trends in particular had begun to shed light on the methodology of bricolage at work in the cultural processes that both fascinated and repelled Dubuffet. In his seminal 1962 book *The Savage Mind*, the structural anthropologist Claude Lévi-Strauss would both elaborate upon this idea of bricolage and argue for its resonance with a wild mode of thinking that originated in remote human history.[5] In that same text, he conceived of the bricoleur as an adaptive tinkerer who, in contrast to the engineer (or, in our case, educated artist), creates using whatever material is at hand. In this chapter I too adopt the methodological approach of the bricoleur—taking stock of the various Oceanic sources available to Dubuffet and examining the visual as well as historical evidence for their impact in transforming his postwar figuration.

Archetypes and the anticulture

In proclaiming "I like to paint universal data" and "all I want my painting to do is evoke a human face," Dubuffet announced his intention for his portraits to resonate with basic human experience. Yet, these proclamations also revealed a contradictory endeavor—to depict individual sitters, such as Tapié, and to simultaneously suggest "archetypal" imagery.[6] In this way, as I argue in Chapter 1 (this book's introduction), Dubuffet's use of the term "archetype" was consistent with Gaston Bachelard's philosophy, which drew, in turn, upon Carl Jung's notion of the latent poetic image that reverberates inside the viewer, reaching into a remote, intuited, pre-industrial past and inspiring a culturally liberating future to serve as a creative model.[7] Bretonian Surrealism has been more closely associated with the ideas of Freud than of Jung. Even so, Jung's notion of a collective, yet pre-societal consciousness appears to have resonated with Dubuffet more than Surrealism's emphasis on biographical psychology.[8] Moreover, Jung's ideas about archetypes, via Bachelard's formulation of the archetype as a latent poetic image that inspires creativity, had great currency in France during the postwar era and appears to have enunciated a general longing for a return to a primal—read unenculturated—state of awareness.

Surrealist scholar Mary Ann Caws has demonstrated significant intersections between Bachelard's writings and Bretonian Surrealism, noting that both men formulated ideas about the latent poetic image and appreciated the dynamic interplay between lived and imagined experience.[9] In his 1924 "Manifesto of Surrealism," André Breton highlighted the interior model for Surrealism by defining the movement as "psychic automatism in its pure state, by which one proposes to express—verbally, by means of the written word, or in any other manner—the actual functioning of thought"—an idea that remained at the core of Dubuffet's art theory.[10] Claiming to have depicted his sitters from memory, the artist tapped into both the idea of resonating archetypes and the notion of automatic writing and drawing as the product of one's innermost creative forces.[11] These interests resulted in numerous portraits of sitters such as Tapié, who shared an enthusiasm for art that combined the seemingly primal with the radically new and pitted inner creativity against stultifying cultural habitude.

The uncanny juxtapositions of Surrealism thus resonated, transformed, after the war. Breton and Bachelard had both disseminated ideas about the ways that external stimuli could trigger hauntingly fragmented memories. Believing such moments to be vital to disrupting quotidian activities and authenticating experience, these men advocated art that suggested creative metamorphoses and

the conjoining of the lived and imagined worlds. "*Surreality*," according to Breton, is the heightened reality realized by the "resolution of these two states, dream and reality, which are seemingly so contradictory."[12] In like manner, after World War II Dubuffet asserted: "Art generally has to mix the habitual and familiar with the marvelous" to evoke "not just one thing at a time but various things at once, whole orders of things."[13] Staging uncanny encounters of their own, Dubuffet's portraits juxtapose the ordinary with the extraordinary.

In opposing Surrealism to cultural norms, Breton had asserted that "Surrealist practice should be "exempt from any aesthetic or moral concern."[14] In a similar vein, Bachelard argued in his 1940 book *The Philosophy of No: A Philosophy of the New Scientific Mind*, that encultured habits encumber creative activity and should thus be negated—an idea at the very heart of Dubuffet's anticultural position.[15] In attunement with these philosophies of negation being reformulated after the war, Dubuffet proclaimed that art should "force the mind out of its usual ruts" so that "the mechanisms of [encultured] habit no longer function" and the mind is freed to pursue new forms of meaning.[16] Tapié shared these beliefs about creative autonomy and the conviction that encultured habits encumber authentic art, so he sprinkled his art criticism with references to "a New Beyond."[17] He opposed art that promoted comfortable aesthetic absorption and instead called for art that "confronts us as the way of contemplation," offering "no accessory satisfaction whatsoever."[18] Art, Tapié argued, should confound rather than content the viewer.

Dubuffet used less esoteric language in his writing than did Tapié, whose prose, as art historians observe, is so hyperbolic as to be difficult to take seriously. In celebrating "the ancestral spontaneity of the human hand when it draws its signs," however, and bandying terms about such as "alchemy" and "transmuting," Dubuffet also used grandiose language to discuss art.[19] He tended to balance these terms, however, by brandishing them alongside his humorous quips and praise of basic humanity, whose "weakness and awkwardness" should appear, Dubuffet asserts, "in every detail of a painting."[20] Yet, in ceaselessly proclaiming his intention to produce anticultural art, Dubuffet's writings aligned with the critic's prose. Of course, neither man could escape the culture he eschewed. In fact, Dubuffet's portraits represented a veritable who's-who of postwar Paris.

In a cast of characters that includes many eccentrics, *Tapié Grand Duc* depicts one of the most unusual and least discussed of Dubuffet's acquaintances. As a self-styled promoter of the new postwar art seeking to subvert social realism and academicism of any kind, Tapié turned his attention to messy, "unformed," and seemingly untamed painting. The artists who interested Tapié, such as Dubuffet,

created art that resisted rote categorization while highlighting the artistic process, the process of viewing, and the relationship between the artist, the artwork, and the viewer. For work possessing these qualities, Tapié coined the terms *Art Informel* (untrained or unformed) and *Art Autre* (art Other, or art of another kind). He applied these terms to describe Dubuffet's work and, as previously noted, he organized several exhibitions of Dubuffet's and other experimental art.[21] The critic applauded radical artistic innovation and looked the world over for artistic inspiration, comingling disparate artistic practices in his Art Informel exhibitions of work by an international coalition of artists. For Tapié, as for Dubuffet, the most impactful art was improvisational—open to both exploration and chance. "Teaming up with chance," Dubuffet argued, was the way to create an intuitive artistic adventure that challenged the status quo.[22] It was this shared eagerness to transform art in the postwar context that inspired Dubuffet's several portraits of the critic. Expressing the enthusiasm the two men shared for Art Brut, these portraits also demonstrate a collage-inspired aesthetic that, as this chapter will elaborate, relied upon various forms of the Oceanic art that began circulating among the Surrealists between the wars.

One can see evidence of such bricolage in Dubuffet's painting. And this aesthetic of disjunctiveness corresponded to the Cubist collage of the interwar era, the art theory of Surrealism, and the philosophy of Lévi-Strauss, who, in "The Savage Mind," opposed the intuitive ingenuity of the untrained, pre-Modern, or non-Western bricoleur to the professional trained in European practices.[23] As Jacques Derrida has elaborated in his Poststructuralist philosophy, the processes of citation and grafting that characterize bricolage actually highlight those of representation generally, which necessitate selecting and composing from available signs, be they words, images, or objects.[24] Intriguingly, and in contradistinction to the purely inner creativity of Dubuffet's "anticultural position," he too acknowledged that an artist might, even subconsciously, emulate external sources, which "he has assimilated . . . believing entirely in good faith, that he pulled it [his work] out of his own reserves."[25] "The swindle in such a case," Dubuffet asserts, "is not always deliberate;" or "often it is," he adds, "but even so it is almost always (at least the majority of the time) unconscious and involuntary, and usually, the author is in good faith."[26] In this way, Dubuffet alluded to the matrix of language and the inevitable imprint of cultural sources upon the mind of the artist. Consciously or otherwise, artistic creation results from conceptual (or varying degrees of actual) bricolage. This chapter explores the idea that Dubuffet enhanced his painting by adding conscious bricolage to his practice. His portraits speak to this embrace of a collage aesthetic and what

he later called "a new fragmentary and discontinuous perspective" in his painting.[27] It is precisely the collision of disparate elements that produces quirky, quasi-comic, and decidedly disjunctive effects in portraits such as *Tapié Grand Duc*. Moreover, the adoption of a collage aesthetic in this and other of Dubuffet's paintings and drawings foreshadowed his mixed-media collage of the 1950s, which he distinguished from Picasso's and Braque's early twentieth-century experiments by adopting the term "assemblage."[28]

Dubuffet, Tapié, and Art Brut

In the wake of World War II, Dubuffet began collaborating with Tapié, Breton, publisher Jean Paulhan, non-Western art dealer Charles Ratton, and a few others to establish the Foyer de l'Art Brut. They did so in 1947 in the basement of the Galerie René Drouin, the very gallery where Dubuffet exhibited his portraits that year. The group then expanded its enterprise to form the Compagnie de l'Art Brut, the primary venue for Dubuffet's advocacy of outsider art in 1948. There, Tapié curated Art Brut exhibitions and helped manage the permanent collection then housed at the Editions Gallimard, a publisher of many books by the French avant-garde that would include Dubuffet's later writings.[29]

Dubuffet maintained throughout his career that Art Brut "never directly influenced" his art.[30] As noted in Chapter 1 (this book's introduction), however, his prolific writings on what he took to be Art Brut's internally driven creativity have, until recently, dominated the discourse surrounding his work. Ever since his art gained notoriety after World War II, concurrently with his exploration of the art of mental patients and other marginalized creators, there have been critics and scholars who tended to conflate Dubuffet's style with Art Brut, some taking it as a given—incorrectly—that he adopted that moniker for his own work.[31] As *the* definer of Art Brut, Dubuffet insisted that the term referred only to "art emanating from persons foreign to the specialized circles and elaborated by those shielded from any influence, in a completely spontaneous and immediate way."[32] His own work might have been produced in an unconventional manner outside of academic ateliers and sanctioned artistic circles, but it was not shielded from influence. Indeed, Art Brut was perhaps his greatest influence. I suggest that his work fit, albeit problematically, somewhere along a spectrum comparable to that he later conceived of for others and defined as "New Invention"—work that appeared fresh and unfettered by mainstream culture despite the artist's awareness of artistic precedents.[33] Although he aspired to achieve comparable

artistic effects, he never claimed to create Art Brut because by his own definition of it his own work did not, *could* not, qualify.

While some critics and scholars have conflated Dubuffet's work with the Art Brut he promoted, others have homed in on his proclamations about inner creativity to the point of omitting or glossing over the visual evidence for his direct use of Art Brut as source material. A notable and fairly early exception is John MacGragor, who, in a 1976 interview, questioned Dubuffet about the strong resemblance between his painting *Man with a Rose* and drawings by Anton Müller, an Art Brut creator featured in Hans Prinzhorn's 1922 book *Artistry of the Mentally Ill* whose work Dubuffet was also collecting.[34] Although twenty-first century scholars including Kent Minturn, Pepe Karmel, and a few others have begun to deconstruct Dubuffet's mythologized persona and situate his work within his cultural milieu, few have investigated the extent to which he might have relied upon visual sources in his paintings.[35] As mentioned in Chapter 1, notable recent exceptions to this trend are Antonia Dapena-Tretter and Jean H. Duffy, who each begin to examine Dubuffet's work in relation to the art produced outside or at the margins of European culture.[36]

This chapter looks closely at Dubuffet's portraits as evidence of a kind of painterly bricolage and elaborates upon the visual and historical evidence of his use of both Art Brut and Oceanic sources. It bears repeating that this conflation also occurs verbally in Dubuffet's "Anticultural Positions" and "In Honor of Savage Values," both of which discuss Art Brut in relation to so-called "primitive" art produced outside of traditional European practices.[37]

Cultural collage

Contrary to popular belief, Dubuffet's brand of postwar primitivism did not shift to Art Brut and ideas about internally motivated creativity alone. Indeed, this chapter explores the continued impact of the exploration of non-Western art that began in the interwar era on Dubuffet's art, which appears attuned to what James Clifford has described, more broadly, as an "ethnographic Surrealist" approach.[38] This is to say that Dubuffet's art demonstrates both a Cubist- and Surrealist-inspired interest in collage and an aesthetic of assemblage that fostered the inclusion of diverse artistic elements, unusual materials, and, I argue, an assortment of Oceanic motifs that he combined to form his unruly figures. In portraits such as *Tapié Grand Duc* Dubuffet thus also practiced a kind of "cultural collage"—the term Clifford uses to describe the interwar, multi-disciplinary

appropriation of diverse cultural artifacts and images—as an artistic model.[39] This impetus to both cobble together and, paradoxically, create something original is the aspect of Dubuffet's practice this chapter explores, considering the ways in which his paintings of Tapié, Paulhan, and others transformed the collage aesthetic and combined it with blunt materiality during the postwar period. Reconfiguring the human image in a way that might signal new beginnings while still resonating with the primal humanity Dubuffet envisioned to be lost in modern European culture, he drew, I argue, upon Oceanic artifacts as he sought to recreate the kind of transformative processes that had occupied the interwar Surrealists.

Consider *Tapié Grand Duc*'s similarity to an early self-portrait by Picasso (Figure 2.2). As a colossus among the European avant-garde and one of the first artists to draw inspiration from African artifacts, it would be difficult to deny his impact on Modern art. His disjunctive Cubist style and experiments with collage certainly impressed Breton, who in "Surrealism and Painting" asserted: "we claim him [Picasso] unhesitatingly as one of us."[40] It appears that Dubuffet has

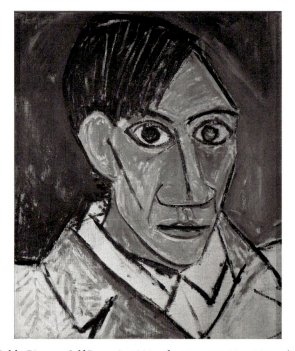

Figure 2.2 Pablo Picasso, *Self Portrait*, 1907, oil on canvas, 56 × 46 cm. (22 × 18 in.). © 2021 Estate of Pablo Picasso / Artists Rights Society (ARS), New York. National Gallery, Prague. Photograph © Erich Lessing / Art Resource, NY.

intensified Picasso's harsh angularity and discordant treatment of the figure's eyes, nose, and mouth to even more emphatically heighten the sense of tension between two- and three-dimensionality that Picasso had achieved, in part, by emulating African masks. Dubuffet was so successful in amplifying these effects that, as Pepe Karmel has noted, Picasso appears to have reciprocally quoted Dubuffet in a later self-portrait, as if each of the two men sought to outdo the unnerving effects of the other (Figure 2.3). Each of these portraits considered here stares straight ahead, as if dazed. Each features crude drawing and juxtaposes organic and geometric shapes to form a startling, mask-like visage. The touch of humor in Dubuffet's painting also recalls some of Picasso and Braque's work, as does the incorporation of everyday materials in Dubuffet's *haute pâte* (high paste) concoction and monochromatic palette. In Dubuffet's painting the everyday (non-academic) materials consisted not of collaged paper but of the dirt, ash, and detritus (sometimes including paper) that he mixed into his *haute pâte*. The gritty materiality and simple, yet jarring, expression of his figures has traditionally been attributed to postwar discussions of base materiality and the

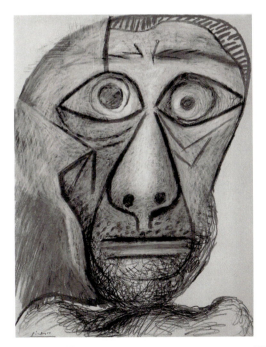

Figure 2.3 Pablo Picasso, *Self Portrait*, 1972, wax crayon on paper, 65.7 × 50.8 cm. (25.88 × 20 in.). © 2021 Estate of Pablo Picasso / Artists Rights Society (ARS), New York. Private collection, Tokyo. Photograph courtesy of Enrique Mallen, ed. Online Picasso Project. Sam Houston State University, 1997–2020.

artist's growing interest in the raw immediacy of Art Brut, many examples of which feature bizarre figures with exaggerated features and proportions.[41] His painting, however, also bears the marks of the avant-garde foray into exoticism to produce unnerving effects.

Part II. Assemblage as Paradigm: A Collage of Oceanic Sources

Although African masks had intrigued Picasso and the Surrealists who followed in his wake, Oceanic artifacts began to attract the Surrealists during the 1930s. As Elizabeth Cowling points out, this was due precisely to the seeming ability of Oceanic art to remain "savage" and to resist the aestheticization to which African art had, by then, been subjected in French culture.[42] Prizing the "savage" above all, Dubuffet took his art in an even more fiercely different direction. Analysis of his portraits suggests that he looked to the Oceanic artifacts that were still so inexplicable—so radically Other—in Western culture as to be uncontainable by its norms. The peculiar combination of force and apparent humor (at least by Western standards) in some Oceanic artifacts made them the perfect inspiration for Dubuffet, who aimed to produce jarring, amusing, and thought-provoking art that could subvert the European status quo. Lamenting the "layers" of cultural masking that "encrust" Eurocentric identities and "suffocate" creative expression, Dubuffet, it appears, turned to the masking practices of Oceania for renewed inspiration.[43] Indeed, one could say that the mask—and as seen in the portrait of Tapié, a mask that conveys the impact of mixed-media assemblage—became both a formal and thematic feature in Dubuffet's portraits, suggesting his fascination with creative transformations.

An intriguing Oceanic source for *Tapié Grand Duc*, which I consider based on striking visual similarities, is a mask featured in a 1946 Museum of Modern Art (MoMA) exhibition and catalogue titled *Art of the South Seas* (Figure 2.4).[44] Although it is uncertain whether Dubuffet would have seen this particular image that year (for example, whether the book would have already made it to the Bibliothèque Nationale de France or to Dubuffet's collector friends or whether the image would have appeared in the press), it is interesting to note that the publication of this photograph virtually concurred with Dubuffet's portrait. In both the photograph and the painting, large, angular faces fill the picture plane and stare straight ahead with small, disc-like eyes. Perhaps this gaze—and its association in a Western context with surprise or shock—appealed to Dubuffet,

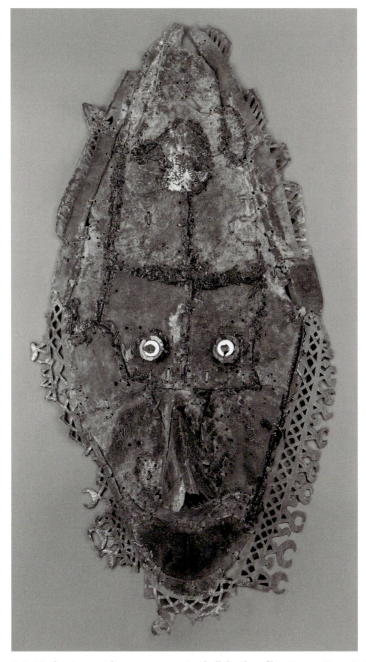

Figure 2.4 Mask, nineteenth century, tortoiseshell, leather, fiber, Papua New Guinea, Torres Straits, 114.3 × 60.96 × 17.78 cm. (45 × 24 × 7 in.). Peabody Essex Museum, Goodwin Collection, 1890, E2135. Photograph: Peabody Essex Museum. An earlier photograph of this mask was featured in Ralph Linton et al.; *Arts of the South Seas* (New York: Museum of Modern Art, 1946), 128.

as would the mask's apotropaic function among the headhunting Torres Straits peoples who produced it.[45] Perhaps Dubuffet looked to just such a mask to create one of his famous puns, this time to produce a *Tête* (portrait head) of Tapié.

Dubuffet did not gain fluency in English until his visit to the United States between 1951 and 1952, during which time he resided in New York and visited the Arts Club of Chicago, where he delivered, in English, his famous lecture "Anticultural Positions" (December, 1951).[46] Even before then, though, he kept abreast of artistic developments abroad. His friend Ratton, the famed African and Oceanic art dealer who helped found Dubuffet's Compagnie de l'Art Brut, had introduced him to Modern art dealer Pierre Matisse to facilitate New York sales in 1945, and it is likely that Dubuffet turned his attention to the New York art scene around that time.[47] In any case, according to its authors, the timeliness of the exhibition—which showcased the vast variety of art lumped under the term "Oceanic," including, as the book announced, the art of Polynesia, Micronesia, Melanesia, and Australia—was assured by the attention turned to the Pacific theater of operations during World War II.[48] The book had an international distribution and has long been in the collection of the Bibliothèque Nationale de France, where Dubuffet was known to conduct research. It is thus plausible that he encountered this book and artistically translated the mask in this very photograph for his painting. Either way, the resemblance between his portrait and the photographed mask is striking and suggests his familiarity with this or another such mask in a photograph or ethnographic collection.

The treatment of the hair in the portrait reveals another uncanny resemblance to this kind of mask—the ray-like lines of the hair mimic the remnants of a carved lattice trim that frames the mask in the photograph. At first glance the framing element of the mask appears to be suggested only in the upper portion of the portrait's head. Yet, close looking reveals traces of a beard-like rubbing circumscribing the painted face that faintly re-articulates the mask's latticework. These traces are striking along the nearly-strait edges of the portrait's cheeks and suggest the tension between angularity and curviness that give the mask its kite-like shape. Even more striking is that the highlighted area below the chin's U-shaped swoop in the painting contrasts with the opposing curve of the shoulders in a way that connotes a wispy beard while echoing this mask's lattice fragment. The painted lines of the shoulders in Dubuffet's portrait jut out from the face to create an angular protrusion—and another remarkable re-articulation of the chipped lattice at the bottom right of the mask. The negative space left by this fragment even suggests the slope of a shoulder in a way that Dubuffet appears to have seized upon for his painting.

Among other elements, the contiguous and slightly arched eyebrows in Dubuffet's portrait differ from the mask, which may have no brows at all. Yet the brows in the painting echo the roughly stitched shell abutments over the mask's eyes that to a Western viewer suggest the raised eyebrows of surprise or shock. The lips and pencil mustache in the painting also resemble the stitched mouth of the mask and the shadow cast over it by the long triangular nose. These stitched-together shell fragments, which contribute to the jarring, piecemeal effect of such a mask, would have especially appealed to Dubuffet, for they suggest a process he was beginning to explore in his art—the combining of disjunctive forms to create acutely arresting figures. Such rough stitching (or something very much like it) appears to have inspired Dubuffet, who has transformed it into the stitch-like lines with which he has pieced together his portrait face. It is also interesting to note that these disc-like eyes reappeared in the three-dimensional sculpted heads Dubuffet produced of unconventional materials in the 1950s.

Surrealist echoes and Oceanic art

Like many of the Surrealists, Dubuffet had frequented the Musée d'Ethnographie du Trocadero between the wars and appreciated the revamped collection when it was transferred to the Musée de l'Homme in 1937. According to the Musée du Quai Branly (where most of these artifacts are housed today), "Local learned societies were often the initiators and leaders of a network of regional museums" and "an extensive exchange of ethnographic objects took place between national and regional museums and the numerous ethnographic museums which were established throughout Europe and the rest of the world."[49] Oceanic art could also be seen at the Musée national des Arts d'Afrique et d'Océanie that was constructed on the site of the 1931 Paris Colonial Exposition. As Janine Mileaf has observed, the Galerie Ratton (the gallery of Dubuffet's friend Charles Ratton) had also housed the Surrealist counter-exposition that same year, exhibiting a collage-like array of diverse African and Oceanic artifacts that highlighted both the exploration of cultural difference and the issue of colonialist appropriation.[50] These issues and images resonated after the war; so much so that although Dubuffet had travelled to South America (in 1924) and made several trips to North Africa (first with his parents in the1920s and later on his own between 1947 and 1949), his portrait bears the marks of Surrealism's encounters with Oceania.[51]

Dubuffet also had ample opportunity to view Oceanic art within his casual interwar circles, and this was especially so at the adjacent studios of André Masson and Joan Miró, which together formed a nexus of Surrealist activities located in proximity to Dubuffet's Montparnasse home and that he wrote of visiting.[52] As Cowling and Philippe Peltier have demonstrated, Oceanic Maro (bark cloth) paintings more than inspired Surrealists such as Masson, Miró, and others working in biomorphic abstraction, and artifacts such as these could be seen in the company of Surrealist compatriots (Figure 2.5).[53] The impact of these bark cloths, particularly those featuring fish-like faces with angular features and large, disc-shaped eyes, can be seen in this and many of Dubuffet's portraits of Tapié, another of which will be discussed in the following pages. Considering that Tapié's own painting resembled the styles of the very Surrealists who had looked to bark cloth paintings as visual sources, it is reasonable to assume that he too, directly or indirectly, took inspiration from Oceanic art.

As already noted, Dubuffet's friends Breton and Ratton maintained sizable Oceanic collections. Ratton had been in Surrealist circles since the 1920s, and in 1930 he organized *L'Exposition d'art Africain et d'art Océanien* at the Galerie du Théâtre Pigalle as well as a public sale of many of Breton's and Paul Éluard's African and Oceanic artifacts. These two events, and the previously mentioned 1931 Surrealist Counter Exposition, put Oceanic art into the public eye and

Figure 2.5 Example of Maro (painted bark cloth) of Tobati collected by J. Viot. Bark fabric. Indonesia, Papua, Jayapura (kabupaten), Sentani (lake), early twentieth century, inner bark, beaten, paint, 64 × 138.7 × 27.9 cm. (25.19 × 54.60 × 11 in.), Inv. 71.1933.64.1. Photograph: Patrick Gries, Musee du Quai Branly—Jacques Chirac © Musée du Quai Branly—Jacques Chirac, Dist. RMN-Grand Palais / Art Resource, NY.

instigated even more collecting of Oceanic artifacts. It is interesting to note that during the postwar period, Ratton featured in Dubuffet's portraits including a humorous drawing that conflates his round-rimmed glasses with the large circular eyes of one of the most popular Oceanic artifacts in Paris—an anthropomorphic mask from Papua New Guinea at the Musée de l'Homme.[54]

During the postwar period, Dubuffet also communicated regularly with gallery owner Pierre Loeb, with whom the artist collaborated to assist the mentally ill, rogue Surrealist Antonin Artaud (discussed in Chapter 3). Like Ratton, Loeb had been influential to the Surrealists and, in fact, organized the first Surrealist exhibition at his Galerie Pierre in 1925. He was also instrumental in introducing Oceanic art, including a variety of bark cloth paintings, to Parisian viewers and collectors.[55] Photographs of European colonialist expeditions and expositions also circulated and a 1949 article lists numerous documentary and popular films that had presented Oceanic art to the French public since the beginning of the twentieth century.[56] Thus a collage-like array of Oceanic artifacts and motifs became available to French viewers—and to artists such as Dubuffet looking for creative stimulation.

Given these connections and the visual evidence I consider here, it is surprising that scholars have not, until my 2015 dissertation and Duffy's 2019 article, paid much attention to the ways in which these and other Oceanic artifacts, including masks, paintings, and sculptures, impacted Dubuffet's work.[57] Intriguingly, however, Oceanic motifs *less* likely to be glimpsed in Surrealist art appear in Dubuffet's painting, helping to define his idiosyncratic postwar style. This is particularly true of *Tapié Grand Duc*'s pieced together appearance, angular face, and stark circular eyes, which appear to have been adapted to the likenesses of this particular sitter (Figure 2.6).

Dubuffet's use of these and other common motifs in Oceanic art suggests his collecting not of Oceanic objects but of their visual imprints, which he transformed to create his striking, hybrid figures. His appropriation of the Oceanic motifs that had been only minimally deployed by the Surrealists indicates that strategic combinations of artistic hybridity and originality shaped his practice. Oceanic art thus piqued his curiosity, inspired his interest, and quite likely instigated some of the ethnographic research he was known to conduct in Parisian museums and libraries, providing him with ample source material to translate, perhaps filtered through memory, into his unique pictorial idiom. To my eye, he translated Oceanic art into his work in much the same manner as he appropriated aspects of Art Brut—with a humorous yet unsettling, and somewhat exploitative, twist.

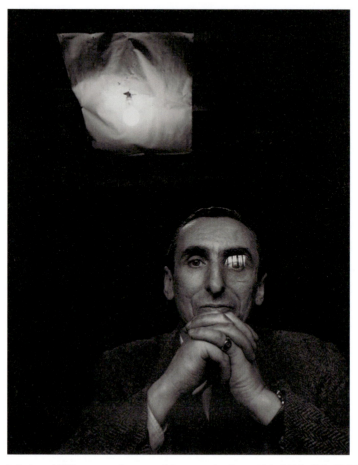

Figure 2.6 Arnold Newman, photographic portrait of art critic Michel Tapié, May 12, 1954 in Paris. Arnold Newman Collection. © Arnold Newman / Getty Images.

Other portraits, other Oceanic sources

Created the same month as *Tapié Grand Duc*, the drawing *Michel Tapié petit théâtre de rides* (Michel Tapié, Little Theater of Wrinkles) shares many comparable features (Figure 2.7). These include straight brows above disc-shaped eyes that also resemble those of Oceanic masks such as that featured in the MoMA catalogue. In the drawing the brows are shown closer to the starkly circular eyes, but the overall impact is comparable, as is the slight look of confusion or surprise (to Western eyes) caused by the combination of these features. As in *Tapié Grand Duc,* Dubuffet homes in on the head in this portrait, thus few figural elements detract from the impact of the face, from which the piercing eyes gaze ambivalently—and disturbingly—ahead.

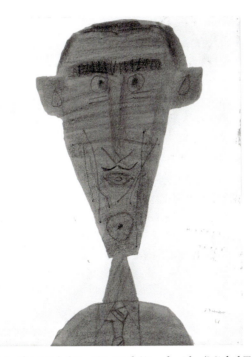

Figure 2.7 Jean Dubuffet, *Michel Tapié petit théâtre de rides* (Michel Tapié, Little Theater of Wrinkles / Lines), August, 1946, pencil drawing on paper, 41 × 33 cm. (16 × 13 in.). Fondation Dubuffet, Paris / © 2020 Artist Rights Society (ARS), New York—ADAGP, Paris. Private collection (formerly in the collection of Michel Tapié). Photograph courtesy of the Fondation Dubuffet, Paris. Reproduced in Jean Dubuffet, *Catalogue des travaux de Jean Dubuffet*, Fascicule III (Paris: Fondation Dubuffet, 2003), 24, no. 24.

As with other of Dubuffet's portraits, *Michel Tapié petit théâtre de rides* bears striking resemblances to a variety of Oceanic artifacts. In addition to the mask in the MoMA catalogue, this drawing is notably similar to the aforementioned anthropomorphically-rendered fish heads that appear on the bark cloth paintings collected by Loeb and other of the Surrealists (see Figure 2.5). Comparing these artworks suggests that Oceanic art impacted Dubuffet's work differently than that of his Surrealist friends who became interested in biomorphic abstraction. Hybrid figuration, on the other hand, attracted Dubuffet. Although the bark cloth painting I consider here depicts fish-like creatures (a common motif in some Oceanic cultures), I cannot help but notice the similarity between Dubuffet's portrait and the shape of these Oceanic heads, which are elongated as if stretched down from the top toward their acutely pointed chins. Likewise, both of Dubuffet's portraits of Tapié considered in this chapter and the Oceanic

bark cloth faces are bifurcated vertically down the center and again laterally by the lines that intersect with the emphatically linear noses. The faces of each of these figures feature both organic and geometric shapes, which are particularly prominent at the cheeks and chins. In Dubuffet's portraits the angular elements are echoed by the flattened, triangular necks. Although the warped geometry of the foreheads and widow's peaks in Dubuffet's portraits are more rectangular than the V-shapes below the Oceanic figures' ovular foreheads, each suggests a comparable tension between flatness and form. In both Dubuffet's portraits and the bark cloth paintings, the figures gaze blankly and disconcertingly, and it is unclear whether they regard or look just past the viewer. Comparing Dubuffet's portraits to the figure at the right of the bark cloth specifically, we see that each of these faces stares out with the same disc-like eyes with tiny dots for pupils—a common motif in both Oceanic art and Dubuffet's portraits.

One can also find the influence of the Oceanic sculptures collected by Loeb in Dubuffet's portraits of Tapié, helping to inform the odd-shaped heads and carved look of the faces as well as the strangely circular eyes. When considering the portraits next to a photograph taken by explorer Jacques Viot on an expedition for Loeb, who planned to increase his sales of Oceanic art among the Surrealists visiting his Parisian gallery (Figure 2.8), one notices the parallels between Dubuffet's depictions of Tapié and these sculptures produced by the Sentani people to mark the homes of their chiefs. Viot found over sixty of these sculptures submerged in Lake Sentani (a lake located near the geopolitical border separating the island of New Guinea into its western, Indonesian, and eastern, Melanesian halves). The photograph I consider was taken in 1929 to document Viot's discovery as he prepared the sculptures for shipping, exhibiting, and sales at Loeb's gallery and other venues frequented by the Surrealists.[58] Some of these carved figures sport enigmatic, V-shaped smiles, an abstraction of the human mouth that Surrealists were surprised to see in figures from a region they associated (incorrectly) with fierce headhunting tribes. The peoples of Lake Sentani were not, in fact, headhunters and the benign smiles and apparent lack of ferocity in these figures may have accounted for the relative lack of enthusiasm they received from the Surrealists visiting Loeb's gallery, who prized the most intimidating looking sculptures for their collections.[59] This was not the case, however, for Dubuffet.

Less zoomorphic than the bark cloth paintings that attracted Mason and Miró, these sculptures featured none of the patterning that had inspired biomorphic abstraction. But the odd insertion of humor caused by the Western interpretation of these smiles appears to have caught Dubuffet's eye, a find, it seems, that attuned to his brand of disquietingly humorous art. Indeed, the

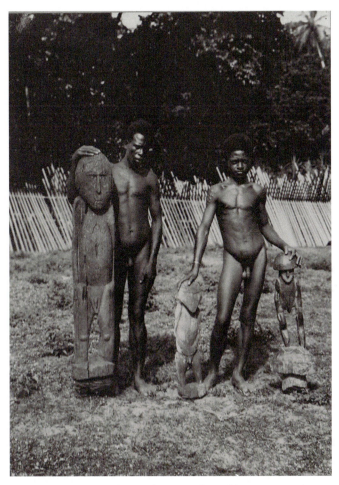

Figure 2.8 Photograph of wooden sculptures collected by Jacques Viot, 1929. Proof on baryta paper, 29.4 × 22.6 cm. (11b × 8.7 in.). PP0004189. © RMN-Grand Palais / Art Resource, NY. Musee du Quai Branly—Jacques Chirac, Paris.

effects produced by these strange, smiling sculptures were just what he wanted to achieve in his work, which he described in "The Art of the Joke" to be a combination of the droll and slightly disturbing.[60] Many of Dubuffet's other portraits quote the posture of these sculptures, whose arms cradle their torsos, hands groping toward the phallus in a pose that would be decidedly inappropriate for European gentlemen.[61] Combining signs of such raw immediacy with oddly disjunctive humor could stage the kind of inexplicable encounter that, Dubuffet writes, could "freeze you in your tracks."[62] He achieved this ideal—one that is not so different from Lautréamont's "chance encounter of a sewing machine and an umbrella on an operating table"—in his portrait.[63]

Paulhan, "primitivist" echoes, and disjunctiveness

Not all of Dubuffet's portraits were so droll. His portraits of Jean Paulhan, the author, *Nouvelle Revue Française* (*NRF*) publisher, and arts patron who introduced Dubuffet into the postwar artistic milieu, are some of the artist's most enigmatic works. These portraits allude to the mask, particularly the pieced-together Torres Strait variety, and in some cases combine the intense, disk-shaped eyes with emphatic gesture to create even more intensely unnerving effects.

With a history of avant-garde affiliation and an interest in ethnography, Paulhan was happy to promote Dubuffet's painting and Art Brut collecting. By introducing Dubuffet to the weekly gatherings at the home of arts patron Florence Gould, Paulhan helped pave the way for the artist's portrait series.[64] Paulhan may have also helped inspire Dubuffet's practices of appropriation and assemblage to achieve transformative effects. As Carol Murphy notes, "Metamorphosis was a key concept in Paulhan's life-long reflections on language and thought" (she lists several of his writings on art as examples) and he used the term "Metamorphosis" to title the collection he established at the *NRF* and the related volumes published with Gallimard that included, among other notable titles, Breton's 1937 *L'Amour fou* (Mad Love). Paulhan proposed this aptly titled collection to the Gallimard publishing house in order to publish books by Picasso, Caillois, Dubuffet, and several of the artist's friends who featured in the portrait series, including Antonin Artaud, Henri Michaux, and other artist-intellectuals with Surrealist and ethnographic interests.[65]

Paulhan was attracted to non-Western art and had dabbled in ethnography since even before World War I and the interwar coalescence of ethnographic and Surrealist practices. He even studied with sociologist Émile Durkheim and philosopher *cum* armchair anthropologist Lucien Lévy-Bruhl in Paris before embarking upon a project to translate indigenous poems during a 1908–1910 teaching position in Madagascar.[66] Traces of Durkheim's and Lévy-Bruhl's thoughts on the cultural dimensions of epistemology and culturally diverse modes of thinking informed Paulhan's ethnographic pursuits. These ideas also inflected Dubuffet's "Anticultural Positions" which repeatedly preferences so-called "primitive" over occidental thinking.[67] The artist would surely have discussed these ideas with his friend Paulhan and one can glean references to these issues in the two men's voluminous correspondence.[68]

Co-founding Dubuffet's Foyer de l'Art Brut and Compagnie de l'Art Brut along with Tapié, Ratton, and their small band of Art Brut enthusiasts, Paulhan

was thus also a compatriot in the pursuit of the art the friends believed to result from primal creative impulses and he accompanied Dubuffet to tour Swiss cities in 1945 to search for Art Brut.[69] The trip demonstrated Dubuffet's methodical and, as Baptiste Brun rightly observes, ethnographically-informed endeavors.[70] As Rachel Perry notes, Dubuffet also applied these methods to research for his planned *Almanach de l'Art Brut*, about which he wrote of "cobbling together" disparate texts and images.[71] The failed journal, it appears, revealed early on the artist's combining of bricolage and ethnography in his Art Brut collecting. Although Dubuffet denied any direct copying of Art Brut, we have seen both the resemblances and his concession that an artist might indirectly or subconsciously emulate existing imagery that "he has assimilated" and that he believes "in good faith, that he [has] pulled out of his own reserves."[72] Based on the visual evidence I examine here, Dubuffet appears to have both assimilated and systematically appropriated Art Brut and Oceanic motifs, which he conflated to create his hybrid figures.

Consider Dubuffet's *Portrait of Jean Paulhan* (Figure 2.9) in comparison to some examples of Art Brut. Gesturing emphatically to the viewer, the figure's right arm (at the left of the painting) is held up; its left arm (at the painting's right) is held out, the fingers of the crudely rendered hand brushing the canvas edge. The pose of this left arm is more than awkward; it is disturbing. Appearing to burst forth from what appears to be the pentimento of a previously rendered appendage, this arm bends at the elbow as if broken. A ghost arm remains, however, its hand resting between the figure's legs as if to grab or protect the phallus. The organ is not seen in this usual, anatomically correct location, however, and appears to have been ripped from its proper place and transported upward to double as quasi-comic, yet disquieting, neckwear. This transposition suggests the doubling, bodily fragmentation, and castration anxiety believed by Dubuffet's friend Jacques Lacan to reveal the ego-identity as incomplete and only fictitiously unified.[73] In Surrealism, Foster observes, the conflation of everyday materials and objects with imagery suggestive of male or female anatomy signaled the movement's fascination with strange admixtures of the animate and inanimate, dream and reality, and cultural and natural processes.[74] Genital displacement that connotes biological sex, emasculation, and perhaps also gender ambiguity appears as a strategy in several of Dubuffet's portraits.[75] In the painting of Paulhan, small circles suggesting buttons below the phallic necktie also call to mind abject droplets of urine or semen arcing over the pentimento (or perhaps formless, faux pentimento) hand, foregrounding the artist's engagement with Georges Bataille's concept of *l'informe* and positioning

Figure 2.9 Jean Dubuffet, *Portrait of Jean Paulhan*, February, 1947, *haute pâte* on canvas, dimensions unknown. Fondation Dubuffet, Paris / © 2020 Artist Rights Society (ARS), New York—ADAGP, Paris. Location unknown. Photograph courtesy of the Fondation Dubuffet, Paris. Reproduced in Jean Dubuffet, *Catalogue des travaux de Jean Dubuffet*, Fascicule III (Paris: Fondation Dubuffet, 2003), 86, no. 124.

the body as a savage element that ultimately cannot be tamed by Western culture.[76]

As discussed in Chapter 1 (this book's introduction), one of the ways Dubuffet emulated Art Brut and aligned his art with the rage for *l'informe* (the unformed), was to modify his paint to create his lumpy, amalgamous *haute pâte*, which he has smeared and gouged to produce the *Portrait of Jean Paulhan*. In this portrait blunt materiality works in tandem with the brute force of the figure's gaze, expression, and gesture, which are as aggressive as they are confounding. The emphatic materiality is not the portrait's only reference to Art Brut, however. The unnerving genital displacement also recalls the sculptures of mental patient Karl Genzel (pseudonym Brendel) that appear in Prinzhorn's *Artistry of the Mentally Ill* and feature genitals that dangle from their chins (Figure 2.10).[77]

Hal Foster has noted the striking similarity between Dubuffet's figures and the work of another mental patient, Hermann Behle (Beil), whose art Hans Prinzhorn also featured in his collection and discussed in his book (Figure 2.11).[78] These resemblances are especially apparent in the *Portrait of Jean Paulhan*. Both

Figure 2.10 Johann Karl Genzel (pseudonym Brendel), *Die Frau mit dem Storch* (Woman with the Stork) [sometimes also called Tadpole figure], wood sculpture, inventory no. 122, c. 1925, 18.5 × 12.5 cm. (7.3 × 4.9 in.). © Prinzhorn Collection, University Hospital Heidelberg. Prinzhorn Collection, Heidelberg. Photograph courtesy of the Prinzhorn Collection.

Figure 2.11 Hermann Heinrich Friedrich Behle (pseudonym Beil), untitled drawing, inventory no. 76/4. c. 1929, pencil and crayon on paper, 17.5 × 11.9 cm. (7 × 4 3/4 in.). © Prinzhorn Collection, University Hospital Heidelberg. Prinzhorn Collection, Heidelberg. Photograph courtesy of the Prinzhorn Collection.

Dubuffet's and Behle's figures fill the picture plane and are posed frontally as though splayed out against its surface. Both feature headgear-like hair and feet that are cut off by the bottom of the frame. As with the semen-like buttons in the portrait of Paulhan, the shirt buttons of Behle's figure also suggest bodily functions gone awry; in Behle's figure they combine with harsh downward lines to form a channel between the neck and the dangling genitals. Rendered flatly and frontally, the genitals of Behle's figure also appear to be flayed and even to drip blood. Although placed in the anatomically correct position between the

legs, the sex organs in Behle's figure appear barely connected to the body and are thus also disturbingly displaced. Foster points out that these jarring elements that evoke trauma also exist in the art of the mental patients that attracted Dubuffet. As Foster observes, resemblances between Dubuffet's figures and the art of mental patients suggests that although he glorified Art Brut for appearing to be the product of a purely internal creative operation, he appears nevertheless to have looked to such art as both an artistic paradigm and a visual source.[79] This certainly appears to be the case in the *Portrait of Jean Paulhan*.

The figure of Paulhan looks as though it has been pressed back into, or perhaps flattened forward against, the picture plane as well, and this creates an acute sense of tension that amplifies the figure's other disturbing qualities. These include the traumatized face, split arm, and castrated genitals, each of which appears to simultaneously disconnect and interpenetrate. These elements combine to evoke what Foster describes, more generally, as Dubuffet's "schizophrenic sense of literal self-dislocation."[80] It is my claim that this pictorial slippage in Dubuffet's painting was intentional—that he not only idealized the primal purity of Art Brut (a fact discussed by Foster) but also embraced its disturbance, seeking to deploy it for maximum pictorial impact.

Dubuffet's interest in the psychological processes that inspired Art Brut and his previously cited acquaintance with Lacan would have most certainly informed his approach. Lacan's concept of mimicry—the adaptation of environmental characteristics as a protective mechanism in the animal kingdom or, in psychology, the identification with and perceived threat of the dissolution of the self into the imagery of its surrounding environment—had likewise been adapted from the ideas of Roger Caillois, another Surrealist whose writing surely caught Dubuffet's attention. Mimicry, for Lacan, would be central to his well-known theory of the Mirror Formation of identity, in which self-awareness and a sense of cohesive identity are gained only tentatively through the gaze with the recognition, ultimately, that one's mirror reflection represents only an *image* of the self and thus represents both the self and the Other.[81] It is precisely this comingling of the hauntingly familiar and the startlingly strange that appear in Dubuffet's portrait, which gazes unnervingly from its mask-like visage.

As with the portraits of Tapié, the painting of Paulhan also bears striking resemblances to Oceanic masks and figures and thus provides clues to Dubuffet's processes of appropriation. In addition to the previously discussed Torres Strait mask (see Figure 2.4), Dubuffet's *Portrait of Jean Paulhan* also bears remarkable resemblances to a sculpture produced by the Iatmul (Yat-mül) peoples of Papua New Guinea, examples of which can be seen today in the Musée du Quai Branly

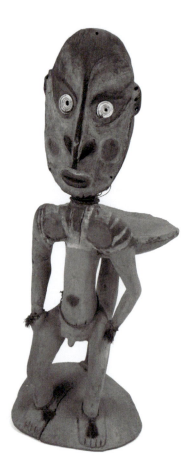

Figure 2.12 Pulpit of the Orator "Têgêt",
Papua New Guinea, Eastern Sepik, Wosera-
Gaui, village of Aibom, between 1900 and
1965. Artist: Tuupa (twentieth century),
wood, shell, black and white pigments, 101 ×
41.5 × 39.5 cm. (39.8 × 16.34 × 15.55 in.).
Collected by Jean Guiart in 1965. Previously
in the Musée national des arts d'Afrique et
d'Océanie Inv. 72.1965.14.210. Photograph ©
Musée du Quai Branly—Jacques Chirac,
Dist. RMN-Grand Palais / Art Resource, NY.
Musee du Quai Branly—Jacques Chirac,
Paris.

and the ethnographic museum of Marseille, which houses an Oceanic collection
that includes artifacts donated by Dr. Henri Gastaut, who acquired many of the
artifacts from Dubuffet's friend Ratton and other Surrealist dealers in non-
Western art (Figure 2.12).[82] This figure too glares menacingly at the viewer, its
fierceness accentuated by its disc-shaped eyes and facial patterning. The
downward swoop of the figure's brow differs from the painting, yet such pattering
and exaggerated widow's peaks also appear in the portrait. Indeed, the painting
appears to mimic the linear harshness of such rendering—in this example, the
painted and sculpted figure on an orator stool—while inverting the V-shaped
mouth and adding ferocious teeth, other motifs common to much Oceanic art
that in the painting signal direct communication. Such features appear to have
been adapted to Paulhan's likeness, in the painting, in which the expression may
seem enigmatic and even maniacal to the Western viewer. At the same time,
however, the experience of this jarring expression and these unnerving eyes in

the portrait calls to mind the "shell shock," with which Dubuffet sought to revitalize the viewing encounter.[83]

Because Dubuffet attributed to such sculptures, which he had also recently seen at Swiss ethnographic museums, the kinds of disjunctive qualities he ascribed to Art Brut, he asserted in his essay "In Honor of Savage Values": "We find ourselves here in the presence of extraordinarily delirious productions."[84] "Any alienist [psychiatrist] to whom we would show [these artifacts] without mentioning their origin," he added, "would diagnose at once that they carry all the marks of the most unbound schizophrenic."[85] He was not alone in making this untoward conflation; Prinzhorn had set the precedent by including photographs of Oceanic art in his book *Artistry of the Mentally Ill.*[86] For Dubuffet, such delirium, which he and his sitters explored as altered states of awareness, was a prerequisite to creating and even interpreting authentic art. Having been "shocked by the trauma" of such art, Dubuffet asserts, "the mind is aroused."[87]

As previously noted, Dubuffet began questioning the interwar "Primitivism" that inappropriately conflated the art of non-Western cultures with the art of children and the mentally ill and, as a result, his Art Brut collection contained scant non-Western art.[88] Yet his art and some of his previously cited writing attest to this very conflation. Having transformed the now-defunct moniker that had appealed to Modernists of the earlier twentieth century, Dubuffet continued to rely on some of its exploitative practices, combining the visual, and primarily affective—deeply felt physiological and emotional effects—that characterize Art Brut and some Oceanic art, both of which were unfamiliar to mainstream Western viewers. While celebrating art in its most primal and ostensibly unenculturated form, Dubuffet nevertheless produced hybrid, culturally inflected figures—"sphinxes," as he wrote of his amalgams, that might resonate while resisting categorization (the act of being named or owned) within any existing tradition.[89] Although his commitment to an internal model of creativity and modern European myths of originality inhibited his ability and willingness to openly discuss the impact of outside visual sources to his work, his exploration of diverse forms of creative expression suggest an interest in cultural difference and a form of artistic hybridization. Considering the degree to which Dubuffet internally (or otherwise) acknowledged his processes of appropriation, however, he would likely have considered them to attune Surrealist notions of mimicry and transfiguration resulting from contact with the kinds of outside stimuli he took to resonate with primal creativity.

With such ideas in mind, I am struck by the correlation of motifs between Dubuffet's portraits of Jean Paulhan (and seen time and again in Dubuffet's

portrait series) and Oceanic artifacts. In a 2018 article, I discussed in detail the arresting parallels between the *Portrait of Jean Paulhan* and a ceremonial mask and costume produced by the Iatmul peoples that includes the patterned, pieced-together face; aggressive gaze; bodily anomalies (replete with phallic neckwear); and gesture.[90] Here, however, I restrict my discussion to artifacts confirmed to have been featured in French and other European collections and publications or for which it is probable that reproductions existed in libraries accessible to Dubuffet. With that in mind, I turn my attention to another of Dubuffet's portraits, *Paulhan Etat II* (Figure 2.13), for this portrait combines the oddly-shaped head

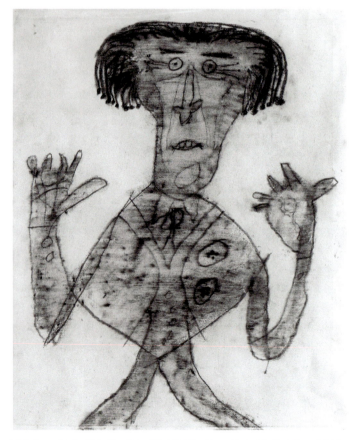

Figure 2.13 Jean Dubuffet: *Paulhan Etat II* (Paulhan State 2), October, 1946, pencil drawing on paper, 36 x 30 cm. (14 x 11.8 in.). Fondation Dubuffet, Paris / 2020 Artist Rights Society (ARS), New York—ADAGP, Paris. Location unknown. Photograph courtesy of the Fondation Dubuffet, Paris. Reproduced in Jean Dubuffet, *Catalogue des travaux de Jean Dubuffet*, Fascicule III (Paris: Fondation Dubuffet, 2003), 49, no. 64.

and shockingly rounded eyes with the emphatic gesture of upraised arms—another motif common to Oceanic art.

It is interesting to note that when Dubuffet and Paulhan toured Swiss cities in search of Art Brut, they also visited ethnographic museums containing Oceanic art. Visiting the Musée d'Ethnographie de Genève, they were able to see its Oceanic collection and meet its illustrious director Eugène Pittard, who had invited them to view the Swiss carnival masks that piqued the interest of the Surrealists. Publications of the museum's holdings at the time of Dubuffet's visit feature photographs of artifacts that are comparable to some of those discussed in this chapter.[91] Dubuffet and his traveling companion also visited Basel, about which Dubuffet announced, "I recently saw in the Ethnographic Museum of Basel a group of decorated and painted wooden sculptures coming from the former German colony of New Mecklenburg, now called New Ireland [a territory of Papua New Guinea], which have just been offered to this museum and are presently on display."[92] These Oceanic artifacts, he asserted, confronted the viewer with untamed creativity.

In addition to the contemporaneous resources I have already discussed—including the collections of Breton, Ratton, Loeb, and popular French museums including the Musée de l'Homme, which even published postcards highlighting the collection's Oceanic artifacts—still other collections included Oceanic art. One prominent source was the collection of Dr. Stephen Chauvet.[93] Some of Chauvet's artifacts featured in Surrealist-inspired exhibitions of Oceanic art in Paris, and in 1929 he donated an extensive collection of these artifacts to the Musée d'ethnographie du Trocadéro, making them available to the general public and to artists such as Dubuffet who were known to visit the ethnographic museum. Given Dubuffet's well-known propensity for research, he was likely also familiar with museum catalogues and other Oceanic publications, including Chauvet's 1930 book *Les arts indigènes en Nouvelle-Guinée,* which both featured in the Bibliothèque Nationale de France and celebrated Oceanic artifacts, including those Chauvet donated to the Trocadéro (Figure 2.14).[94] Considering also Dubuffet's friendship with Breton, Ratton, and others (including members of the Musée de l'Homme staff) acquainted with ethnographic activities in Paris over the years, it is also likely that the artist would have discussed the form and iconography of Oceanic artifacts with experts in his company, perhaps pursuing the question of culturally-situated meaning in publications available through the Surrealists or Parisian museums and libraries. It is *Paulhan Etat II*'s very enigmaticness that raises questions about how meaning is produced and interpreted and what role art plays in these processes.

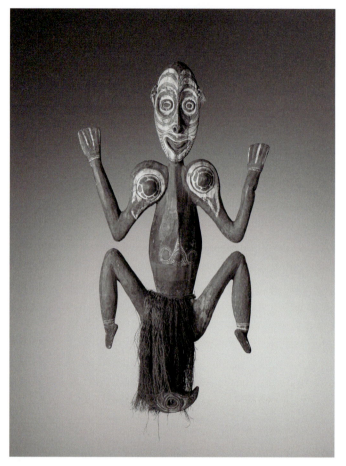

Figure 2.14 Hook, Papua New Guinea Sepik River early twentieth century, wood, plant fibers, pigments, 118 × 64.5 cm. (46.47 × 25.39 in.). Inv. 71.1914.1.7. Musee du Quai Branly—Jacques Chirac, Paris. Photograph: Patrick Gries / Bruno Descoings © Musée du Quai Branly—Jacques Chirac, Dist. RMN-Grand Palais / Art Resource, NY. Photographed object initially in the collections of the Trocadéro and the Musée de l'Homme and featured in Stéphen Chauvet, *Les arts indigènes en Nouvelle-Guinée* (Paris: Société d'éditions géographiques, maritimes et coloniales, 1930).

Flatness, mixed-media, and transfiguration

The motifs of circular eyes and upraised arms seen in *Paulhan Etat II* could signal a variety of meanings in Oceanic artifacts, including ferocity, protection, and the placation of revered ancestor spirits. Figures with these eyes and this pose could also be found in Breton's collection.[95] Of course, these motifs are

interpreted differently in a Western context, for example in Dubuffet's portrait, and many of the work's viewers might have agreed with a later critic's observation that Dubuffet's figures "appear to have been flattened out by a steamroller."[96] Once again, for Dubuffet's avant-garde viewers, the figure might appear to be pressed down into the canvas or flattened forward against the picture plane. Indeed, the ambivalence between forward and backward thrust in this and other of Dubuffet's portraits heightens the sense of tension between blunt materiality and pictorial space—between two- and three-dimensionality—first foregrounded by Cubism. In Dubuffet's figures this creates a jarring pun on Modernism's reverence of flatness.

Consider also Dubuffet's *Paul Léautaud on a Caned Chair*, a portrait of the writer and critic who reportedly threatened to damage the unflattering likeness with his cane (Figure 2.15).[97] This figure likewise appears to be flattened across the painting's surface, an effect that is enhanced by the figure's circular eyes and emphatically upraised arms. These and a large, rounded, yet strangely polygonal head are its dominant features. These are common motifs in Oceanic artifacts that include the carved and painted suspension hooks used traditionally to store food and valuables and—by some Oceanic cultures—to collect the heads of revered ancestors or conquered enemies (Figure 2.16).[98] Dubuffet's bobble-headed figure sits, arms and legs akimbo, in a pose characteristic of these hooks, now anchored to a caned chair in France. Although the legs in the portrait fold limply to the side, the portrait's stick-thinness and upraised arms mimic the amalgamous figures used to form many such hooks. The pose of Dubuffet's figure also echoes the criss-cross forms of the sculpture's outstretched appendages. Even the etched lines tattooing the sculpture's face and body find their way into Dubuffet's portrait, suggested by scrapes in the thick paint. Though displaced, the most direct appropriation of such patterning in the portrait appears on the seat of the chair, its caning indicated by crude crosshatched lines that resemble the sculpted figure's markings. Such criss-cross patterning appears in many Oceanic artifacts that include the bark cloth paintings Loeb collected and circulated among the Surrealists and the mixed-media costumes and artifacts Chauvet collected, published, and donated to French museums.

This odd combination of jarring and humorous effects in Dubuffet's painting is attuned, in a way, to those intended by some Oceanic sculptors, who relied upon multivalence to communicate simultaneously on multiple cultural registers.[99] As Dubuffet asserted, effective art must evoke "not just one thing at a time but various things at once, whole orders of things."[100] The apparent stylistic

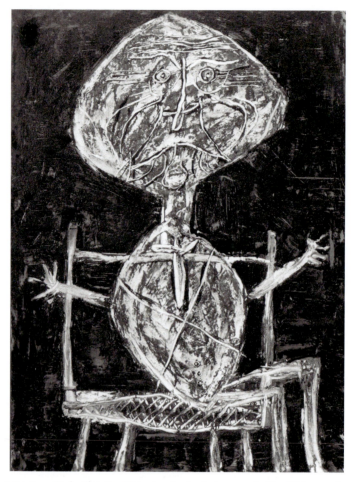

Figure 2.15 Jean Dubuffet, *Paul Léautaud a la chaise cannée* (Paul Léautaud on a Caned Chair), November, 1946, *haute pâte* (oil and other materials) on canvas, 129.5 × 96.5 cm. (51 × 38 in.). Fondation Dubuffet, Paris / © 2020 Artist Rights Society (ARS), New York—ADAGP, Paris. New Orleans Museum of Art (Bequest of Victor K. Kiam). Photograph courtesy of the Fondation Dubuffet, Paris. Reproduced in Jean Dubuffet, *Catalogue des travaux de Jean Dubuffet*, Fascicule III (Paris: Fondation Dubuffet, 2003), 65, no. 90.

mimicry in Dubuffet's portrait reflects both his fascination with the unsettling impact of Oceanic art and his eagerness to translate it into his own brand of quasi-humorous and artistically subversive figuration.

Patterning reminiscent of Oceanic art also appears in Dubuffet's *Bertelé bouquet fleuri portrait de parade* (Ceremonial Portrait of Bertelé as a Blossoming Bouquet), which refrains from blatant referencing of Oceanic art while retaining

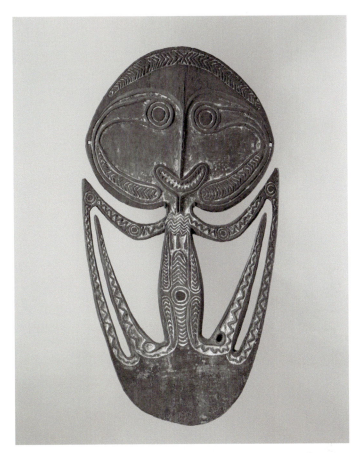

Figure 2.16 Kerewa skull hook (*agiba*), Papua New Guinea, twentieth century, wood, paint, ht, 141.9 cm. (55 7/8 in). The Metropolitan Museum of Art Image copyright. The Michael C. Rockefeller Memorial Collection, Gift of Nelson A. Rockefeller, 1969 (1978.412.796). Photograph © The Metropolitan Museum of Art. Image source: Art Resource, NY.

its visual thrust (Figure 2.17). Many of the painting's characteristics echo the rendering of Paulhan, including the intensity of the figure's gaze (made possible by its staring, circular eyes), ambiguous appendages (outstretched arms that suggest the legs seen in the Oceanic suspension hooks), and double-entendre attire (crudely rendered apparel that includes an explicitly penile necktie). This portrait confronts us with a decidedly skull-shaped visage that is accentuated by the stitch-like lines representing teeth. In addition to recalling the apotropaic mask discussed in the opening of this chapter, these elements call to mind some of the most glaringly affective Oceanic art to be found—the ceremonial skulls created by the Iatmul and some other traditional cultures of Papua New Guinea.

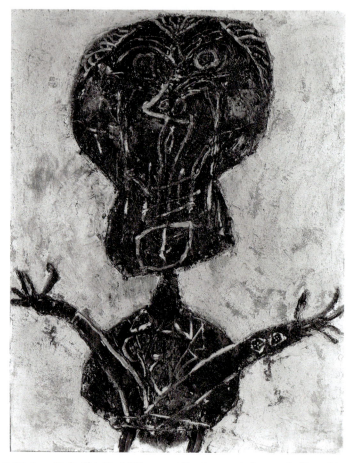

Figure 2.17 Jean Dubuffet, *Bertelé bouquet fleuri portrait de parade* (Bertelé as a Blossoming Bouquet, Sideshow Portrait), July–August, 1947, oil (*haute pâte*) on canvas, 116.8 × 88.9 cm. (46 × 35 in). © Fondation Dubuffet, Paris / © 2020 Artist Rights Society (ARS), New York—ADAGP, Paris. The National Gallery of Art, Washington (Gift of the Stephen Hahn Family Collection). Photograph courtesy of the Fondation Dubuffet, Paris. Reproduced in Jean Dubuffet, *Catalogue des travaux de Jean Dubuffet*, Fascicule III (Paris: Fondation Dubuffet, 2003), 107, no. 162.

In these works that originally functioned within headhunting practices outlawed under colonialism, human skulls were overlaid with clay, shell, and hair to produce the trophy heads of defeated enemies or revered ancestors.[101] In some examples one finds modeled mouths; in others the actual teeth of the deceased. Examples of these skulls could be seen in Breton's collection and are now on view at the Centre Pompidou and the website Association Atelier André Breton.[102] In Dubuffet's portrait, the teeth also take on the stitch-like appearance

of many of the Oceanic figures that appear in panel paintings and masks. Adding painterly gesture to his depiction of this gesturing figure, Dubuffet dragged a brush or other instrument (perhaps one of his trowels, spatulas, or fingers) through the muddy surface of the painting's *haute pâte*, creating both painterly and sculptural effects that also evoke the rawness of Art Brut.

The materiality of Dubuffet's *haute pâte* seems, as Pepe Karmel observes, to be a logical progression from the papier-mâché masks he produced during the interwar era (see Figures 1.3 and 1.4).[103] In fact, it is interesting to note that Dubuffet created his masks by making clay and plaster casts of his friends' faces and layering them with papier-mâché, which he then painted.[104] Perhaps this layering process guided his portraiture as he looked to the clay-coated skulls of Oceania for inspiration. For Dubuffet, authentic art should, to the greatest extent possible, result from creative inner drives and "exhibit the abilities of invention and creation in a very direct fashion, without masks or constraints."[105] Yet, the mask that could both hide his methods and reveal his fascination with alternative artistic sources remained an important aspect of his paradoxical creative process. Representing many things in many cultures, transformation is the mask's *raison d'être*. And transformation was the crucial component of Dubuffet's collage-inspired practice, his appropriation games, and, importantly, his quest to remake art in postwar Europe.

Although Dubuffet's experiments with collage are generally said, according to his own narrative, to have begun with his butterfly works (compilations of actual butterfly wings) in 1953, a lone collage appears in the volume of the *catalogue raisonné* dedicated to his portraits.[106] Listed also in Dubuffet's exhibition announcement as # 71 of the portraits shown in 1947, *Bertelé Buvard taché d encre a stylo* (Bertelé Blotting Paper Stained with Ink From a Pen) is a collage of ink drawings (Figure 2.18). This cut-and-paste figure must have seemed a remarkable anomaly within a body of portraits produced in loose scrawls or layered and rutted paint. Yet this flattened figure too recalls Oceanic masks—particularly its skeletal head, circular eyes, and teeth that look like stitched lines. Formally and thematically a collage, the figure gazes out toward the viewer to create another glaring encounter. This figure stands at a crossroads of Dubuffet's artistic development. Blurring the boundaries between painting, drawing, and collage, it provides insights into a praxis that approaches art itself as a form of assemblage—combining "the familiar and the marvelous," as Dubuffet wrote, to trouble all preconceived notions about art and culture.[107] It is just such a troubling of viewer expectations that the remaining portraits considered in this book instigated, as Dubuffet turned his attention to performance as well as masking.

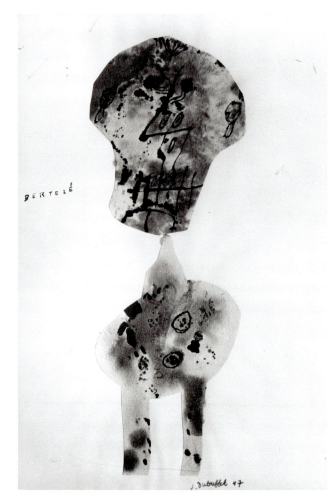

Figure 2.18 Jean Dubuffet, *Bertelé Buvard taché d encre a stylo* (Bertelé Blotting Paper Stained with Ink From a Pen), July–August, 1947, collage of ink washes, dimensions unknown. Fondation Dubuffet, Paris / © 2020 Artist Rights Society (ARS), New York—ADAGP, Paris. Location unknown. Photograph courtesy of the Fondation Dubuffet, Paris. Reproduced in Jean Dubuffet, *Catalogue des travaux de Jean Dubuffet*, Fascicule III (Paris: Fondation Dubuffet, 2003), 93, no. 138.

Notes

1 Jean Dubuffet, "Notes for the Well-Read," in Mildred Glimcher, et al., *Jean Dubuffet: Towards an Alternative Reality*, trans. Joachim Neugroschel (New York: Pace Publications, 1987), 85.

2 Dubuffet, "Notes for the Well-Read," in Glimcher, 73.

3 Michel Tapié, *Mirobolus Macadam & Cie: hautes pâtes de J. Dubuffet* (Paris: Drouin, 1946); Tapié, *Un art autre: où il s'agit de nouveaux dévidages du réel* (Paris: Gabriel-Giraud, 1952).

4 Jean Dubuffet, "Anticultural Positions," a 22-page facsimile of the artist's notes [handwritten in English] for a lecture at the Arts Club of Chicago on December 20, 1951, in Richard L. Feigen, *Dubuffet and the Anticulture* (New York: R. L. Feigen & Co., 1969); Jean Dubuffet, "In Honor of Savage Values" (1951), trans. Kent Minturn, *Anthropology and Aesthetics*, no. 46 (Autumn, 2004). Additional documents related to Dubuffet's Arts Club lecture "Anticultural Positions" are available in the Inventory of the Arts Club Records, the Newberry Library, Roger and Julie Baskes Department of Special Collections. See also "L'Art brut préféré aux arts culturels," in Dubuffet, *Prospectus et tous écrits suivants*, Vol. I (Paris: Gallimard, 1967), 198–202, translated as "Art Brut Preferred to the Popular Arts," in Glimcher, 101–104.

5 Claude Lévi-Strauss, *The Savage Mind*, trans. George Weidenfeld and Nicolson Ltd. (Chicago: University of Chicago Press, 1962), 1; see also Anna Dezeuze, "Assemblage, Bricolage, and the Practice of Everyday Life," *Art Journal* 67 (Spring, 2008): 31–37. As noted in Chatper 1, Dezeuze considers the relationships between the ideas and practices of assemblage and bricolage, which she discusses as instigators of process-based practices in contemporary art. The first line of her article cites a discussion of collage between Dubuffet and Museum of Modern Art curator William Seitz, in which Dubuffet acknowledges the cultural specificity of such art historical terms.

6 Dubuffet, "Notes for the Well-Read," in Glimcher, 78. See also Jean H. Duffy, "Jean Dubuffet's Beautiful People," *Word & Image* 35, no. 2 (June 2019): 191–209. Citing my 2015 dissertation for some of her references, Duffy acknowledges the portraits as amalgams created from multiple sources outside of European traditions, in which she argues the artist "focused on the essentially human in his portrait subjects" (201). See note 35 for my dissertation and article citations.

7 Gaston Bachelard, *The Philosophy of No: A Philosophy of the New Scientific Mind*, trans. G. C. Waterson (New York: Orion, 1968), a translation of Bachelard, *La philosophie du non: essai d'une philosophie du nouvel esprit scientifique* (Paris: Presses universitaires de France, 1940); Gaston Bachelard, *La Terre et les reveries de la volonté: Essai sur l'imagination de la matière* (Paris: José Corti, 1947), 105; Gaston Bachelard, *The Poetics of Space* (1957), trans. Maria Jolas (New York: Orion, 1964), xi–xii, xxix. See also Sarah Wilson, "Paris Post War: In Search of the Absolute," in *Paris Post War: Art and Existentialism 1944–55*, ed. Frances Morris, (London: Tate Gallery, 1993), 34; and Marianne Jakobi, "Nommer la forme et l'informe: La Titraison comme genèse dans l'oeuvre de Jean Dubuffet," *Item* February 19, 2008, http://www.item.ens.fr/index.php?id=187132 (accessed July 2, 2015). Wilson discusses the intertextuality between Dubuffet's painting and Bachelard's ideas on primordial

matter and dynamism. Jakobi discusses the postwar French interest in primal matter and notes the parallels between Dubuffet's essay "Réhabilitation de la boue" (Rehabilitation of Mud) and Bachelard's elaboration of a "valorisation de la boue" (valorization of mud) in his *La Terre et les reveries de la volonté*.

8 C. G. Jung, *The Archetypes and the Collective Unconscious* (Princeton, NJ: Princeton University Press, 1968). Originally published in 1934, Jung's book conceived of "a deeper layer" of the subconscious, which does not derive from personal experience and is not a personal acquisition, but is instead universal and contains "contents and modes of behavior that are more or less the same everywhere and in all individuals" (3). Although Dubuffet's writings show little interest in specific archetypes, such as the Anima (male) or Animus (female) personas conceived by Jung, the artist's writings on archetypes and common experience suggest affinity with Jungian psychology.

9 Mary Ann Caws, "The 'réalisme ouvert' of Bachelard and Breton," in *The French Review* (January, 1964): 302–311. See also Mary Ann Caws, ed., "Translator's Introduction," in André Breton, *Mad Love* (1937) (Lincoln, Nebraska: University of Nebraska Press, 1987), xi–xii.

10 André Breton, "First Manifesto of Surrealism," in Charles Harrison and Paul Wood, eds., *Art in Theory 1900–2000* (Malden, Mass: Blackwell Publishing, 2000), 452.

11 The full text in the "Causette" (Little Chat) contained in Dubuffet's exhibition catalogue can be viewed in Jean Dubuffet and Max Loreau, *Catalogue des travaux de Jean Dubuffet*, Fascicule III," Plus beaux qu-ill croient, Portraits" (Paris: Fondation Dubuffet, 2003), 13–16; it can also be read in Dubuffet, "Causette," in Dubuffet, *Prospectus et tous écrits suivants*, Vol. II, 67–73; an English translation is available by Sara Ansari and Kent Minturn in Jean Dubuffet, "Little Chat," in *Jean Dubuffet: "Anticultural Positions,"* ed. Mark Rosenthall (New York: Aquavella Galleries, 2016), 63–70.

12 Breton, "First Manifesto of Surrealism," in Harrison and Wood, 450.

13 Dubuffet, "Notes for the Well-Read," in Glimcher, 76.

14 Breton, "First Manifesto of Surrealism," in Harrison and Wood 452.

15 Bachelard, *The Philosophy of No* (see the full citation and additional resources in note 7 above).

16 Dubuffet, "Notes for the Well-Read," in Glimcher, 81.

17 Michel Tapié, "A New Beyond," in Herschel B. Chipp, *Theories of Art* (Berkeley: University of California Press, 1968), 603.

18 Tapié, "A New Beyond", in Chipp, *Theories of Art*, 603.

19 Dubuffet, "Notes for the Well-Read," in Glimcher, 73, 76, 84.

20 Dubuffet, "Notes for the Well-Read," in Glimcher, 73.

21 In addition to the exhibitions of Art Informel and Dubuffet's work previously cited in note 3 above, Tapié also curated *Henri Michaux* (Paris: René Drouin, 1948); *Matta*

(Paris, René Drouin, 1949); *Véhémences confrontées* (Paris: Galerie Nina Dausset, 1951), *Exhibition of Paintings by Jean Dubuffet* (New York, Pierre Matisse Gallery, 1951); and *Jackson Pollock* (Paris: P. Facchetti, 1952). For lively art historical analyses of postwar abstraction, see Paul Schimmel, et. al., *Destroy the Picture: Painting the Void, 1949–1962* (New York: Skira, 2012).

22 Dubuffet, "Notes for the Well-Read," in Glimcher, 69.

23 Claude Lévi-Strauss, *The Savage Mind*, trans. George Weidenfeld and Nicolson Ltd. (Chicago: University of Chicago Press, 1962), 11.

24 Jacques Derrida, *Of Grammatology* (Baltimore: Johns Hopkins University Press, 1976); Derrida, "Structure, Sign, and Play in the Discourse of the Human Sciences," in *Writing and Difference*, trans Alan Bass (Chicago: University of Chicago Press, 1978), 6.

25 Dubuffet, "In Honor of Savage Values," 261.

26 Dubuffet, "In Honor of Savage Values," 261.

27 Dubuffet, *Asphyxiating Culture and other Writings*, trans. Carol Volk (New York: Four Walls, 1986), 42.

28 Peter Selz, *The Work of Jean Dubuffet* (New York: Museum of Modern Art, Doubleday, 1962), 160–163. This book also includes Dubuffet's "Memoir of the Development of My Work From 1952," 73–138. The section features Dubuffet's "Le Torrent, Les Papillons" (The Mountain Torrent, The Butterflies) and "Assemblages D'Empreintes" (Imprint Assemblages) on pages 83–85 and 103–106.

29 Dubuffet, "A Word About the Company of Art Brut," in *Asphyxiating Culture*, 109. There is also much correspondence between Dubuffet and his co-founders regarding the Company of Art Brut that can be seen in the archives of the Fondation Dubuffet and the Bibliothèque Littéraire Jacques Doucet. Many of these are reprinted in Dubuffet, *Prospectus et tous écrits suivants*; and Dubuffet, et al., *Correspondance: 1944–1968* (Paris: Gallimard, 2003). A letter dated May 25, 1948 from Dubuffet to Breton (Bibliothèque Littéraire Jacques Doucet) is also particularly helpful as it lists each of the contributors and the sum of funds they had thus far pledged to the endeavor.

30 Dubuffet, "Art Brut Chez Dubuffet," in *Prospectus et tous écrits suivants*, Vol. III, 57–58.

31 Conflations of Dubuffet's work with Art Brut can be found in Georges Limbour, *Tableau bon levain à vous de cuire la pate: l'art brut de Jean Dubuffet* (Paris: R. Drouin, 1953) and countless critical reviews and exhibition catalogues. For foundational discussion of Dubuffet's artistic development in relation to Art Brut, see Glimcher, et al., *Jean Dubuffet: Towards an Alternative Reality*; Selz, *The Work of Jean Dubuffet*; Hubert Damisch, "Introduction," in *Prospectus et tous écrits suivants* Vol. I; Max Loreau, "Introduction" and comments, in *Catalogue des travaux de Jean Dubuffet*; and Jean Dubuffet, *Biographie au pas de course* (Paris, Gallimard, 2001)

among others. Special thanks to Cécile-Laure Kouassi for assistance with the in-depth translations of Dubuffet's biography.

32 Dubuffet, "In Honor of Savage Values," 264. On this same page, Dubuffet cites as inspirational both Oceanic art in ethnographic museums and accounts of Asian dance.

33 For more on Dubuffet's New Invention category of art, see Jean Dubuffet, "Art Brut Chez Dubuffet," in *Prospectus et tous écrits suivants*, Vol. II (Paris: Gallimard, 1967), 47; Michel Thévoz and Jean Dubuffet, *Collection de l'art brut: Château de Beaulieu* (Lausanne: La Collection, 1976); Lucienne Peiry, *Art Brut: The Origins of Outsider Art* (Paris: Flammarion 2006); "Neuve Invention," *Collection de l'art brut, Lausanne*, https://www.artbrut.ch/en_GB/art-brut/neuve-invention (accessed November 24, 2019).

34 Hans Prinzhorn, *Artistry of the Mentally Ill*, trans. Eric von Brockdorff (New York: Springer-Verlag, 1972), a translation of Prinzhorn, *Bildnerei der Geisteskranken* (Berlin: Springer, 1922); Dubuffet and MacGragor, "Art Brut Chez Dubuffet," in *Prospectus et tous écrits suivants*, Vol. III. 57–58. MacGragor asked Dubuffet pointedly about the resemblance between *Man with a Rose* to drawings by Anton Müller, but Dubuffet denied any direct use of Müller's work as a visual source. The resemblance between these two images is, however, undeniable, and they are also compared directly in Lucienne Peiry, *Art Brut: The Origins of Outsider Art*, 98.

35 For nuanced twenty-first-century discussions of Dubuffet in context, see Kent Minturn, "Dubuffet avec Damisch," *October*, 154 (Fall, 2015): 69–86; Pepe Karmel, "Jean Dubuffet: The Would-be Barbarian," *Apollo* CLVI, no. 489 (October, 2002): 12–20; Antonia Dapena-Tretter, "Jean Dubuffet & Art Brut: The Creation of an Avant-Garde Identity," *Platform*, Vol. 11, "Authenticity" (Autumn, 2017): 12–33; Andrea Nicole Maier, *Dubuffet's Decade*, Thesis (Ph.D.), University of California, Berkeley, 2009; and Maier "Jean Dubuffet and the Bodies of Ladies," *Art History* 34, no. 5 (2011): 1013–1041, see also Stephanie Chadwick, *Disorienting Forms: Jean Dubuffet, Portraiture, Ethnography*, Thesis (Ph.D.), Rice University, 2015; and Chadwick, "Radical Reconfiguration: Appropriation, Assemblage, and Hybridity in Jean Dubuffet's Portrait of Jean Paulhan," *Art Inquiries* xvii, no. 3 (Fall, 2018), 47–66.

36 Dapena-Tretter, "Jean Dubuffet & Art Brut," 12–33; Duffy, "Jean Dubuffet's Beautiful People," 191–209. Duffy in particular acknowledges some of the visual evidence that suggests that to produce his portraits, Dubuffet borrowed from the art of children and non-Western cultures, arguing that the artist drew from multiple sources outside of European traditions to suggest common human experience. For some of her discussion she cites my 2015 dissertation (full citation in note 35 above), in which I elaborate the detailed research of Dubuffet's engagement with non-Western art that made this book possible.

37 See note 4 above for full citations of Dubuffet's "Anticultural Positions" and "In Honor of Savage Values." Throughout these texts Dubuffet aligns non-Western art with the so-called "primitivism" of Art Brut by pitting both against Western cultural institutions and artistic training. In his "In Honor of Savage Values" (264) Dubuffet writes: "I recently saw in the Ethnographic Museum of Basel a group of decorated and painted wooden sculptures coming from the former German colony of New Mecklenburg, now called New Ireland [a territory of Papua New Guinea]," claiming that "any alienist [psychiatrist] to whom we would show [these artifacts] without mentioning their origin would diagnose at once that they carry all the marks of the most unbound schizophrenic."

38 James Clifford, "On Ethnographic Surrealism," in *The Predicament of Culture* (Cambridge: Harvard University Press, 1988), 118–119.

39 Clifford, 118–119.

40 André Breton, "Surrealism and Painting" (1928), in *Surrealism and Painting*, trans. Simon Watson Taylor (Boston: Museum of Fine Arts Publications, 2002), 7. This book was originally published in 1965 by Editions Gallimard, Paris.

41 Although there are many discussions of Dubuffet's interest in Art Brut and materiality—including Foster, "Blinded Insights," 16; Yve-Alain Bois, "No to . . . the Informel," in Bois and Rosalind Krauss, *Formless: A User's Guide* (New York: Zone Books, 1997); and Petra ten-Doesschate Chu, "Scatology and the Realist Aesthetic," *Art Journal* 52, no. 3 (Autumn, 1993): 41–46—the past few years have witnessed a new enthusiasm for the topic that has resulted in several more theoretically updated examinations, notable of which is Rachel Perry, "*Paint Boldly!*: Dubuffet's DIY Manual," *October* 154 (Fall, 2015): 88–89.

42 Elizabeth Cowling, "L'Oeil Sauvage: Oceanic Art and the Surrealists," in *Art of Northwest New Guinea*, ed. Suzanne Greub (New York: Rizzoli, 1992), 181. The aestheticism Dubuffet resisted can also be seen in Man Ray's 1936 photograph of one of Ratton's African sculptures that was used to promote the 2013 exhibition *Charles Ratton: L'Invention des arts "primitifes"* at the Musée du Quai Branly and on the cover of the catalogue, Philippe Dagen and Maureen Murphy, *Charles Ratton, L'invention des arts "primitifs"* (Paris: Skira Flammarion, 2013).

43 Dubuffet, "In Honor of Savage Values," 264. As previously noted, on this page, Dubuffet also cites as inspirational both accounts of Asian dance and Oceanic art in ethnographic museums.

44 Ralph Linton, Paul S. Wingert, and René D'Harnoncourt, *Arts of the South Seas* (New York: Museum of Modern Art, 1946); MoMA Archives, *Arts of the South Seas* [MoMA Exh. #306, January 29–May 19, 1946], https://www.moma.org/calendar/ exhibitions/3188 (accessed January 15, 2015).

45 Linton, et. al, 124. Produced by a headhunting tribe in the Torres Straits, New Guinea, the plaque-like mask served as a sign of aggression that could both ward off evil spirits and distinguish kinship, especially during funeral rites.

46 For more on Dubuffet's "Anticultural Positions" and the Arts Club Records in the Newberry Library, Roger and Julie Baskes Department of Special Collections, see note 4 above.

47 Dubuffet, *Biographie au pas de course*, 52; Pierre Matisse Papers, Morgan Library Archives, New York; Glimcher, 303. Matisse began purchasing Dubuffet's paintings and working to arrange Dubuffet's first American exhibition at the Pierre Matisse Gallery, where Dubuffet would exhibit from 1947 to 1959.

48 Linton, et. al., 7.

49 Musée du Quai Branly, "History of the Collections," http://www.quaibranly.fr/en/collections/all-collections/history-of-the-collections/ (accessed January 5, 2018). For comprehensive discussions of Parisian ethnographic institutions, see Clifford 118–119 and Daniel Sherman, *French Primitivism and the Ends of Empire, 1945–1975* (Chicago: University of Chicago Press, 2011), 23–36. The Musée de l'Homme was formed in part by the efforts of Dubuffet's acquaintance and College de Sociologie affiliate Paul Rivet from a reworking of the collection of Le Musée d'Ethnographie du Trocadero in 1937. The Musée National des Arts d'Afrique et d'Océanie formed a permanent collection at the site of the 1931 Paris Colonial Exposition at Vincennes, near Paris. These ethnographic holdings have now been combined at the Musée du Quai Branly.

50 Janine Mileaf, "Body to Politics: Surrealist Exhibition of the Tribal and the Modern at the Anti-Imperialist Exhibition and the Galerie Charles Ratton," *RES: Anthropology and Aesthetics*, no. 40 (Autumn, 2001): 239–255. For more on Surrealist arts and ethnographic intersections see Clifford, 122–135; Cowling, 181; Philippe Peltier, "Jacques Viot, the Maro of Tobati, and Modern Painting: Paris–New Guinea 1925–1935," in *Art of Northwest New Guinea*, 159, 162–163.

51 Dubuffet, *Biographie au pas de course*, 23–24; Daniel Abadie, *Dubuffet* (Paris: Centre Pompidou, 2001), 365–366. See also Jill Shaw, Chapter Two, "Electroshock," in *A Coat that Doesn't Fit: Jean Dubuffet in Retrospect, 1944–1951* (Ph.D. diss., University of Chicago, 2013), 52–104. Shaw discusses the works Dubuffet created during or as a result of his trips to Algeria, arguing that they represented instances in which Dubuffet sought creative breaks from Paris environs but stopped short of engaging in full-fledged Orientalism.

52 Dubuffet, *Biographie au pas de course*, 21–22; Jean Dubuffet to Jacques Berne, February 8, 1947, in Jean Dubuffet and Jacques Berne, *Lettres à J.B.: 1946–1985* (Paris: Hermann, 1991), 6–8; André Masson, *Les Aneeé Surréalistes: Correspondences 1916–1942* (Paris: La Manufacture, 1990), 28–29; André Masson, in Kristy Bryce and Mary Ann Caws, *Surrealism and the Rue Blomet* (New York: Eklyn Maclean, 2013), 43.

53 Cowling, 181; Peltier, 159, 162–163.

54 For more on Ratton's extensive collecting and to see a comparison between Dubuffet's portrait and a photograph of the collector, see Dagen and Murphy, 118.

For more on Oceanic art exhibited at La Galerie du Théâtre Pigalle, see Carl Einstein, "Art exotique, 1930," *Gradhiva* 14 (2011), 194–197, https://journals.openedition.org/gradhiva/2204 (accessed August 26, 2017). For more on Breton's collection see André Breton and F. H. Lem, *Océanie* (Paris: A. Olive, 1948), and André Breton and Paul Éluard, *Collection André Breton et Paul Éluard. Sculptures d'Afrique, d'Amérique, d'Océanie* (Paris: n.p., 1931); for a look at Breton's collection, see the extensive photographs in "L'atelier de la rue Fontaine," Association Atelier André Breton, http://www.andrebreton.fr/desktop (accessed November 21, 2017).

55 For more on Loeb's collecting, see Cowling, 181; Peltier, 159, 162–163; and Simon Kooijman and Jac Hoogerbrugge, "Art of Wakde-Yamna and Area and Humboldt Bay," in *Art of Northwest New Guinea: From Geelvink Bay, Humboldt Bay, and Lake Sentani*, ed. Suzanne Greub (New York: Rizzoli, 1992), 95–100.

56 Patrick O'Reilly, "Le 'documentaire' ethnographique en Océanie: Étude, suivie d'un Répertoire analytique et critique de vingt-cinq films," *Journal de la Société des Océanistes* 5, 1949, 117–144, doi: 10.3406/jso.1949.1630, https://www.persee.fr/doc/jso_0300-953x_1949_num_5_5_1630?q=Le+%E2%80%9Cdocumentaire%E2%80%9D+ethnographique+en+Oc%C3%A9anie:+%C3%89tude (accessed November 22, 2017).

57 Duffy, "Jean Dubuffet's Beautiful People," esp. 191, 199–203; and comments in note 6 above.

58 Peltier, 159, 162–164 (fig. 9, 5–17); Kooijman and Hoogerbrugge, 95–100. Kooijman and Hoogerbrugge also discuss the fact that in a note written to collector Jean de Menil of November 1, 1963 on the back of one of the photographs of these sculptures, Viot indicated that the artifact had been owned at one point by the sculptor Jacob Epstein and that after his death Charles Ratton sold it to one of the Rockefellers. Such (albeit anecdotal) provenance demonstrates the international collecting of these artifacts, many of which later entered permanent museum collections in Europe, England, and the United States. Pierre Matisse, who would become Dubuffet's New York representative, also served as a likely conduit for Oceanic art between Europe and the United States; he began exhibiting artifacts amassed through his European connections as early as 1938 in an exhibition titled *America, Oceania, Africa*, April 20–May 9, 1938, Pierre Matisse Gallery, Madison Avenue and 57th St., New York.

59 Peltier, 159, 162–164. Peltier discusses the Surrealists' lack of enthusiasm for these particular Oceanic sculptures, noting their preference for ferocious imagery from the region.

60 Dubuffet, "Notes for the Well-Read," in Glimcher, 81.

61 The portraits that re-articulate the posture of these Oceanic sculptures, most notably the *Portrait of Pierre Benoit*, can be seen in Jean Dubuffet, *Catalogue des travaux de Jean Dubuffet*, Fascicule III (Paris: J.-J. Pauvert, 1966).

62 Dubuffet, "Notes for the Well-Read," in Glimcher, 81.

63 Comte de Lautréamont, *Les Chants de Maldoror* (1869) (Brussels: Editions "La Boetie," 1948). See also Gaston Bachelard, *Lautréamont* (Paris: Corti, 1939); and Bachelard, *The Savage Mind*, 14, in which he likens artistic bricolage to the Surrealist notion of objective chance. Dubuffet also references Lautréamont's *The Songs of Maldoror* in "Notes for the Well-Read," in Glimcher, 81.

64 Jean Dubuffet, "Letter to Florence Gould, 9 Aug. 1946," Fondation Dubuffet Archives. Paulhan introduced Dubuffet to the weekly luncheons held by American expatriate Florence Gould, an arts patron. Dubuffet writes to Gould, "Dans quelle aventure vous m'avez jete! Rien n'etait plus loin de ma pensee que de faire de portraits! Je n'avais pas la moindre idee de cela! Eh bien me voila maintenant embarque dans cette affaire, es tout a fait passionee." (What an adventure you have thrown me into! Nothing could have been further from my thoughts than making portraits! I hadn't the least idea of doing that. Now I have embarked on this endeavor altogether passionately.) For more discussion on the impact Paulhan had on Dubuffet's painting, see also Kent Minturn, "Physiognomic Illegibility: Jean Dubuffet's Postwar Portraits," in *Jean Dubuffet: "Anticultural Positions"* (New York: Acquavella Galleries, 2016), 37–62; and Maier, *Dubuffet's Decade* (full citation in note 35 above).

65 Carol J. Murphy, "Re-presenting the Real: Jean Paulhan and Jean Fautrier," in *The Power of Rhetoric, the Rhetoric of Power: Jean Paulhan's Fiction, Criticism, and Editorial Activity,* ed. Michael Syrotinski (New Haven, Conn: Yale University Press, 2004), 71. For a complete list of the Metamorphosis series, see the Gallimard website. http://www.gallimard.fr/Catalogue/GALLIMARD/Metamorphoses (accessed December 7, 2017).

66 Jean Paulhan, *Jean Paulhan et Madagascar, 1908–1910* (Paris: Gallimard, 1982); John Culbert, "Slow Progress: John Paulhan and Madagascar," *October* 83 (Winter, 1998): 71–95; Denis Hollier and R. Howard Bloch, *A New History of French Literature* (Cambridge, Mass: Harvard University Press, 1989), 903–904.

67 Dubuffet, "Anticultural Positions," 1–22. The artist pits so-called "primitive" art and attitudes against Occidental culture throughout this text.

68 Dubuffet, et al., *Correspondance: 1944–1968*. For more on the similarities, and also the well-publicized differences, between the ideas circulated by these two cultural thinkers, see Dominique Merllié, "Durkheim, Lévy-Bruhl and 'Primitive Thinking': What Disagreement?" *P.U.F. L'Année sociologique* 62, no. 2 (2012): 429–446.

69 Dubuffet, *Asphyxiating Culture*, 109; Dubuffet, *Biographie au pas de course*, 53; Jean Paulhan, *Guide d'un petit voyage en Suisse* (Paris: Gallimard, 1947); Archives du Musée d'Ethnographie de Genève, "Compte rendu de l'Administration municipale de 1945, Genève," 1946, p. 3; see also Lucienne Peiry, "Le rôle d'Eugène Pittard dans l'aventure de l'Art Brut," in *TOTEM* 65 (October 2013–March 2014): 10–11, http://www.ville-ge.ch/meg/totem/totem65.pdf (accessed September 15, 2017).

70 Baptiste Brun, "Réunir une documentation pour l'Art Brut: les prospections de Jean Dubuffet dans l'immédiat après-guerre au regard du modèle ethnographique," *Cahiers de l'École du Louvre, recherches en histoire de l'art, histoire des civilisations, archéologie, anthropologie et muséologie,* no. 4 (April, 2014): 56–66.

71 Dubuffet, quoted in Rachel Perry, "*Paint Boldly!*: Dubuffet's DIY Manual," *October* 154 (Fall, 2015): 88–89. Perry's main focus is Dubuffet's materiality, but her discussion of his formation of the Compagnie de L'Art Brut and proposed *Almanach de l'Art Brut* provides insights into how these projects fit his overall artistic goals.

72 Dubuffet, "In Honor of Savage Values," 261.

73 Dubuffet, letter to Daniel Wallard, December 20, 1944, "Jean Dubuffet Correspondence and Papers, 1944–1984," Getty Research Institute. Dubuffet encourages Wallard, a photographer, to visit Lacan, whom Dubuffet calls a friend. For more on Lacan's ideas on castration and ego-identity see also Jacques Lacan, "The Mirror Stage as Formative of the Function of the I," in *Ecrits: the first complete edition in English*, trans. Héloïse and Bruce Fink (New York: W.W. Norton & Co, 2006), 75–81. Lacan had been studying fragmented identity since his dissertation but over time synthesized these ideas into his famous theory of the Mirror Formation of Identity, which he initially discussed in a 1936 lecture, iterated in subsequent variations, and also published in the *Revue Francais de Psychanalyse* 13, no. 4 (1936): 449–455.

74 Hal Foster, *Compulsive Beauty* (Cambridge: MIT Press, 1993).

75 Creating comical though unsettling allusions to castration in his male sitters, he used this tactic even in depicting his few female subjects. His portraits of the poet Edith Boissonnas are cases in point, as they depict her in a smart suit with plunging lapels and a ruffled neck scarf that double as vulva. The portrait *Edit Boissonnas à l'écharpe* (Edith Boissonnas with a Scarf), for example, appears in the *Catalogue des travaux de Jean Dubuffet*, Fascicule III, 85.

76 Georges Bataille, *Vision of Excess: Selected Writings, 1927–1939,* trans. Allan Stoekl, Carl R. Lovitt and Donald M. Leslie Jr. (Minneapolis: University of Minnesota Press, 1985), 31.

77 Prinzhorn, *Artistry of the Mentally Ill,* 146. This comparison is also in my 2015 dissertation and subsequent article in note 35 above.

78 Prinzhorn, *Artistry of the Mentally Ill,* 240–248.

79 Foster, "Blinded Insights," 16.

80 Foster, "Blinded Insights," 16.

81 Jacques Lacan, "The Line and Light," in *The Four Fundamental Concepts of Psycho-Analysis,* trans. Alan Sheridan (New York: Norton, 1978), 91–104; Lacan, "The Mirror Stage as Formative of the Function of the I," in *Ecrits,* 75–81 (cited in note 73 above); Roger Caillois, "Mimicry and Legendary Psychasthenia," trans. John Shepley, *October* 31 (1984): 17–32, doi: 10.2307/778354 (originally published in *Minatoure 7,* 1935); Caillois, "The Praying Mantis: from Biology to Psychoanalysis" and "Mimicry and Legendary Psychasthenia" in *The Edge of Surrealism: A Roger Caillois Reader,* ed. Claudine Frank

(Durham: Duke University Press, 2003), 69–102. For more on the impact of Caillois's theories to Dubuffet's collage, see Sarah K. Rich, "Jean Dubuffet: The Butterfly Man," *October*, 119 (Winter, 2007), 46–74; for a post-Colonialist interpretation of mimicry, see also Homi K. Bhabha, "Of Mimicry and Man: The Ambivalence of Colonialist Discourse," in *The Location of Culture* (London: Routledge, 1994), 85–92. Bhabha cites Lacan in discussing mimicry as both the subject's sense of disintegration into (or of being under attack by) a hostile environment—as in the camouflage of warfare—and, alternately, efforts to adapt to the imbalances caused by colonialist practices.

82 For a photograph of this sculpture and more on the Oceanic collection at the Musée des Arts Africains, Océaniens et Amérindiens à la Vieille Charité de Marseille, see *Collections Permanetes* at the museum's website: http://culture.marseille.fr/les-musees-de-marseille/musee-d-arts-africains-oceaniens-amerindiens-maaoa; for more on Dr. Gastaut, who donated his private collection to this museum in 1988, see the site for MuseoArtPremier-Collection-Gastaut-MAAOA: http://www.museoartpremier.com/Gastaut-MAAOA-M.html (accessed December 3, 2017).

83 Dubuffet, "Notes for the Well-Read," in Glimcher, 81.

84 Dubuffet, "In Honor of Savage Values," 264.

85 Dubuffet, "In Honor of Savage Values," 264.

86 Prinzhorn, *Artistry of the Mentally Ill,* 249–252. From a problematic and Eurocentric nineteenth-century point of view, Prinzhorn discusses visual correlations between the art of mental patients and so called "primitive" societies. Prinzhorn includes comparative photographs of a number of African and Oceanic artifacts without considering the possibility that some of the resemblances he observed between them and the creative output of some of the mental patients he studied might have resulted from those patients emulating such artifacts seen previously in ethnographic publications and colonial expositions. Conversely, in collecting Art Brut Dubuffet weeded out the art of any mental patients influenced by Western artistic conventions and celebrated and collected only those creations that resonated with his appreciation of what he took to be untamed rawness.

87 Dubuffet, "Notes for the Well-Read," in Glimcher, 81.

88 For more on this triad, see note 86 above; see also David Maclagan, *Outsider Art: From the Margins to the Marketplace* (London: Reaktion Books, 2009), 8; and Colin Rhodes, *Outsider Art: Spontaneous Alternatives* (New York: Thames & Hudson, 2000), 59–61.

89 Dubuffet, "Landscaped Tables, Landscapes of the Mind, Stones of Philosophy," in Selz, *The Work of Jean Dubuffet*, 63. Using language that conjures images of exotic lands to discuss the materiality of his works that combine images and genres, and the verticality and horizontality that create tension between two- and three-dimensionality, Dubuffet describes them as "half revealed" as if by "some sphinx's tongue, very different from our articulated languages," adding that "one expects such a tongue from a being as different from ourselves as gum-varnish."

90 Chadwick, "Radical Reconfiguration," 300–302 (full citation in note 35 above). The
 costume I discuss in this article—"Dance Costume: Late 19th-Early 20th Century,
 Iatmul"—can be viewed online at the Metropolitan Museum of Art, https://www.
 metmuseum.org/art/collection/search/311649. I have omitted it here because this
 particular costume was more recently acquired; it is in the Metropolitan Museum of
 Art in New York, and I have not yet located concrete proof that such a costume was
 acquired by European collectors of the mid-twentieth century. The formal
 similarities and the many expeditions to the Iatmul cultures of Oceania prior to
 World War II, however, suggest that such a comparison is as valid as it is intriguing.
 See also Duffy, "Dubuffet's Beautiful People," 200. Duffy notes the resemblances
 between several of the characteristics of this portrait and a figure painted on an
 Oceanic shield in the collection of the Musée du Quai Branly.

91 Dubuffet, *Biographie au pas de course*, 53; Archives du Musée d'Ethnographie de
 Genève, "Compte rendu de l'Administration municipale de 1945, Genève," 1946, p. 3;
 Musée d'Ethnographie de la Ville de Genève, "Eugène Pittard: Le Visage multiplié du
 monde (1937)," in *Le Visage multiplié du monde: quatre siècles d'ethnographie à
 Genève* (Geneva: Musée d'Ethnographie), 1985, 123–130; see also Peiry, "Le rôle
 d'Eugène Pittard dans l'aventure de l'Art Brut," 10–11.

92 Dubuffet, "In Honor of Savage Values," 264.

93 For more on the publication of postcards and other Musée de l'Homme highlights,
 see Musée du Quai Branly, "Océanie – Nelle Guinée Piquet surmonté d'une face
 humaine," No. de gestion: PP0152717, http://collections.quaibranly.fr/#0b2620ef-
 d35c-459d-9ffc-1ba404ef45c7 (accessed November 21, 2017). In this example, a
 wooden stake topped with the image of a human face is listed as "Appartient à une
 série de cartes postales éditées par le Musée d'Ethnographie du Trocadéro
 reproduisant des objets des collections" (appearing in a series of postcards edited by
 the museum reproducing the objects of the collections).

94 Stéphen Chauvet, *Les arts indigènes en Nouvelle-Guinée* (Paris: Société d'Éditions
 Géographiques, Maritimes et Coloniales, 1930); see also Patrick O'Reilly, "Stephen
 Chauvet, 1885–1950," *Journal de la Société des Océanistes* 7 (1951): 219–222, http://www.
 persee.fr/doc/jso_0300-953x_1951_num_7_7_1703 (accessed November 21, 2017).

95 Eric Kjellgren, *How to Read Oceanic Art* (New York: Metropolitan Museum of Art,
 2014), 13, 16–17. For more on multivalence in Oceanic art see also Anthony J. P.
 Meyer, *Oceanic Art* (Köln: Könemann, 1995). For more on Breton's collection, see
 "L'atelier de la rue Fontaine," on Association Atelier Andre Breton website: http://
 www.andrebreton.fr/desktop (accessed November 21, 2017).

96 Henry McBride, "Four Transoceanic Reputations," *Art News* xxxxix, no. 9 (January,
 1951), 28–29.

97 "Le Figaro Littéraire 18 Oct. 1947," in Dubuffet, *Catalogue des travaux de Jean
 Dubuffet*, Fascicule III, 121. According to the article, Paul Léautaud was so furious

about Dubuffet's *Paul Léautaud a la chaise cannée* (Paul Léautaud on a Caned Chair), he "a manifesté l'intention d'aller Place Vendôme se casser lui-même la figure à coups de canne" (has expressed the intention to go to the Place Vendôme and strike the portrait himself with a blow from his cane).

98 For more on the creation and use of suspension hooks in Oceanic cultures, see Chauvet, *Les arts indigènes en Nouvelle-Guinée*; Linton, *Arts of the South Seas*; Kjellgren, *Oceania: Art of the Pacific Islands in the Metropolitan Museum of Art*; and Natasha McKinney, "Ancestral Remains from Oceania: Histories and Relationships in the Collection of the British Museum," in *Regarding the Dead: Human Remains in the British Museum*, ed. Alexandra Fletcher, Daniel Antoine, and J. D. Hill (London: British Museum, 2014), 35–36. McKinney discusses the trophy heads collected by Middle-Sepik River peoples, including the clay-covered skulls of the Iatmul. She also discusses the patterned skull hooks of the Kerewa people. Although I use an easily accessible image from the Metropolitan Museum of art for comparison, such hooks (in which one sees many variations of the characteristics discussed here) were on view in the Parisian and Swiss ethnographic collections Dubuffet visited. See also Duffy, "Dubuffet's Beautiful People," 208 (note 103). Duffy notes the resemblance between the arms in the *Portrait of Jean Paulhan* and an Oceanic suspension hook in the collection of the Musée du Quai Branly (ascension no. 71.1914.1.7), which is also shown here (2.14) from a page in Stephen Chauvet's book documenting objects he collected and donated to the Trocadéro. Finally, see my note 58 above, in which I cite reports that Ratton likely also sold Oceanic artifacts amassed by Viot to the Rockefellers and other collectors who eventually donated some of these artifacts to major museums.

99 Anthony J. P. Meyer, *Oceanic Art* (Köln: Könemann, 1995). For more resources on multivalence in Oceanic art see also note 95 above.

100 Dubuffet, "Notes for the Well-Read," in Glimcher, 76.

101 For more on headhunting in Oceanic art, see Linton, 95, 124; and Kjellgren, *How to Read Oceanic Art,* 13, 19–20.

102 "L'atelier de la rue Fontaine," Association Atelier Andre Breton: http://www.andrebreton.fr/desktop (accessed November 21, 2017).

103 Karmel, 16.

104 Limbour, *Tableau bon levain à vous de cuire la pate*, 16–17.

105 Dubuffet, "In Honor of Savage Values," 260.

106 *Bertelé Buvard taché d encre a stylo* is reproduced in Jean Dubuffet, *Catalogue des travaux de Jean Dubuffet*, Fascicule III, 93, figure no. 138. For a full discussion of Dubuffet's butterfly collages, see Rich, 46–74. For Dubuffet on his early collage practices, see Dubuffet, "Le Torrent, Les Papillons" (The Mountain Torrent, the Butterflies) and "Assemblages D'Empreintes" (Imprint Assemblages) in Selz, *The Work of Jean Dubuffet*, 83–84 and 84–85, respectively.

107 Dubuffet, "Notes for the Well-Read," in Glimcher, 76.

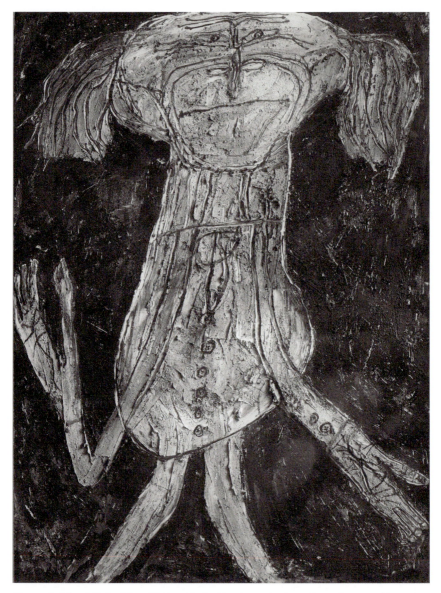

Figure 3.1 (and Color Plate 5) Jean Dubuffet, *Antonin Artaud aux houppes* (Antonin Artaud with Tufts of Hair), January, 1947, oil on canvas, 130 × 97 cm. (51.18 × 38.18 in.). Fondation Dubuffet, Paris / © 2020 Artist Rights Society (ARS), New York— ADAGP, Paris. Morton G. Neumann Family Collection, U.S. Photograph courtesy of the Fondation Dubuffet, Paris. Reproduced in Jean Dubuffet, *Catalogue des travaux de Jean Dubuffet*, Fascicule III (Paris: Fondation Dubuffet, 2003), 78, no. 111.

3

Painting and Its Double: Surrealist Performance and Balinese Theater in the Portraits of Antonin Artaud

Part I. Dissociation: Artaudian Art Brut in Dubuffet's Painting

The figure confronting us in Jean Dubuffet's *Antonin Artaud aux houppes* (Antonin Artaud with Tufts of Hair) seems an alien being (Figure 3.1 and color Plate 5). Its wide, heart-shaped head, shocks of hair, and gangly limbs command our immediate attention. With a sweeping gesture, the figure's left arm (at the painting's right) bows outward, appearing to arc closer in space toward the viewer and into the painting's border. Raised as if signaling the viewer directly, the figure's acutely-angled right arm (at left) bisects the torso, appearing to plunge down into the body before jutting awkwardly back up to gesture with a claw-like hand. This hand, too, brushes the painting's edge, enhancing the sense of tension between the depicted figure and its ensnaring canvas. What is this being that does not so much resemble a man as it does a strange creature characterized by odd bodily contortions and a massive head sprouting fluffy tufts of hair (or fur, or feathers)?

This painting of the notorious rogue Surrealist, poet, and playwright-cum-visual artist Antonin Artaud is rife with pictorial oddities, and there are many reasons to single it out from the portraits Dubuffet produced of his artistic and literary friends. Although Dubuffet's letters credit art patron Florence Gould's weekly salon-style luncheons for his foray into portraiture between the summers of 1946 and 1947, it might as easily have been inspired by this particular acquaintance, who made disconcerting portraits of his own while institutionalized for dissociative disorders.[1] Dubuffet's letters reveal his interest in Artaud's drawings and, as the story goes, the two men made portraits of each other, though Artaud's depiction of Dubuffet has been missing since its exhibition by gallerist Pierre Loeb in 1947.[2] A portrait of Dubuffet's wife Lili remains, however,

a testament to Artaud's forceful, some say disturbed, artistic style (Figure 3.2).
Indeed, his inclusion of marks resembling blood, insects, and punctures (in
some works, literally punctures of the paper) threaten to disturb the integrity of
the rendering, the depicted figure, and perhaps even the psyche of the viewer.
Conceiving of art as a "magical agent," Artaud believed it could dissociate and,
importantly, transform the viewer to revive him or her from a culturally-induced
malaise.[3] Like many artists on the fringes of Surrealism, Artaud's anticultural
writings reveal a belief that art could serve as an antidote to the creative atrophy
experienced within modern culture. Art could transform life.

"If theater doubles life," Artaud wrote in a letter to his friend, the author and
publisher Jean Paulhan, then "life doubles true theater," meaning that it produces
new forms of lived experience—new ways of viewing the world.[4] "By this double,"
Artaud proclaimed, "I mean the great magical agent of which the theater, through
its forms, is only the figuration on its way to becoming the transfiguration."[5]

Proclaiming in a comparable manner that "the effect of a work of art is to
force the mind out of its usual ruts" so that "the blinders of habit fly off" and
"everything seems fraught with new meaning, aswarm with echoes, resonances,
[and] overtones," Dubuffet also looked to art as a medium of transformation.[6]

Figure 3.2 Antonin Artaud, *Portrait of Lili (Lily)*, Dubuffet, 1947, chalk and colored
pencil on paper, 67 × 49 cm. (26.37 × 19.29 in.) framed. © 2020 Artist Rights Society
(ARS), New York—ADAGP, Paris. Private collection, France. Photograph courtesy
of Cabinet Gallery, London.

Having been "shell-shocked by the trauma" of experiencing authentic—and thus truly creative—art, Dubuffet asserts that "all the faculties of the mind are aroused, all its bells start clanging."[7] His quest to arouse the viewer's entire being through the senses had much in common with Artaudian affect—deep-seated, physiologically experienced emotions that Artaud wanted theater (and art in general) to produce. Indeed, just as Artaud intended his theatrical productions to give the viewer a "jolt," Dubuffet wanted his art to simulate the trauma of "Shell-Shock" in order to not only stun but also overturn the viewer's preconceived notions and values.[8] Of course, he did not mean to produce the negative trauma we now understand to be the Post Traumatic Stress Disorder that results from experiencing harrowing events. But the fact that Dubuffet used this World War I term to describe his ambition for his art to negate passive, culturally enmeshed viewing habits signals his continued affinities with Surrealist ideas, particularly if we consider the movement's rise on the heels of Andre Breton's battlefield trauma service and interest in psychological processes.[9] Artaud, too, emphasized trauma as a catalyst for his literary, theatrical, and visual art. However, whereas Artaud has become a symbol of affect theory, which holds the somatic to be the primary form of experience, Dubuffet prized creative (which is not to say academically intellectual) *thinking* above all. "Art should short-circuit" enculturated meanings and "addresses itself to the mind," Dubuffet asserted, and painting, in his view, "is a language charged with meaning."[10]

Comingling elements of Bretonian Surrealism (particularly the fascination with juxtaposed opposites and the duality of lived and imagined experience) with Artaud's notion of authentic art as radically transformative, Dubuffet transformed postwar figuration in his portraits.[11] In adopting a philosophy of dialectical movement that attuned to the cultural negation elaborated by Gaston Bachelard as a "philosophy of no," Dubuffet aimed for his art to trigger something approximating an epistemological break.[12] Indeed, his proclamations indicate that by creating such fissures in ordinary habits of viewing and of understanding, his art might reset and broaden the viewer's conception of the horizon of creative possibilities. In this way, the viewer, and by extension the culture Dubuffet saw as an entropic force, might re-engage with life's "polyphonic [and polymorphic] resonances."[13]

Painting and its double

This chapter explores Dubuffet's dialogue with Artaud, affect, and performance *vis-à-vis* Artaud's writings on the Balinese theater in his 1938 book *The Theater*

and Its Double.[14] Dubuffet read (or reread) this book in 1945—the very year he instigated his Art Brut research in earnest and began visiting the institutionalized author. At the core of this book, which is a compilation of Artaud's writings on theater produced prior to his being institutionalized for mental illness, was his essay "On Balinese Theater"—a performance that makes an appearance in Dubuffet's portrait.[15] This chapter thus considers Dubuffet's painting in relation to both Artaud's writing and the very theatrical forms that inspired it, particularly Balinese costumes and puppets. These, I argue, became the impetus for both the portraitist and his sitter to dissociate the viewer from ordinary enculturated habits and to radically transform the viewing encounter. Crucial to this transfiguration was a Surrealist conception of doubling, which this chapter also considers in relation to the tensions and contortions Dubuffet has created in his painting.

Notice the ways in which figural elements are replicated and conflated in Dubuffet's painting to serve dual functions. The sinews in Artaud's unnaturally thick neck, for example, delineate a second, much thinner neck, propped on top of which we see a shrunken face-within-a-face, as the innermost contour becomes a second head. The flaring nostrils are thus transformed to double as a new set of eyes in which barely perceptible pupils appear to look upward and back as if to see the larger figure from which this miniature head has emerged. This interplay of gazes between these dual faces creates a troubling sense of confrontation, calling attention to the process of viewing as our eyes move back and forth between them. These gazes also heighten the sense of tension in the painting, suggesting both the symbiosis of these forms and their imminent split.

Notice too how the wide neck and embryonic torso merge, both cultivating and confounding our expectations for the definition we associate with the human form. At the same time, the lines defining the thin inner neck suggest small, squared-off shoulders that project outward toward us in the process of flailing the arms. These telescoping shoulders also foreground a necktie that doubles for the penis of the implied second man, transforming the flailing arms into legs. Once we see this tie as a penis, the buttons, in their turn, flip into abject droplets of urine or semen (seen also in the *Portrait of Jean Paulhan* discussed in Chapter 2, Figure 2.9), reproducing, yet again, the doubling that characterizes this portrait of Artaud. The odd attachment of these arms/this second set of legs conveys a sense of outward movement as well, as if the flattened figure could somehow tip forward, emerge from the canvas, and walk on all fours. In the upper register, this tension is echoed as the figure's head presses against the top boundary. Thrust upward by the long, thick neck, the figure strains as though

ready to spring from the frame like a jack-in-the-box. Even the tufts of the figure's hair approach the edges of the painting, as if barely restrained by its borders. The effect of these tensions between movement and stillness is one of barely contained, or perhaps uncontainable, force—a force with which Dubuffet aims to disturb and, one could say, dissociate the viewer.

The status of the second (submerged or emerging) figure in this portrait is equally perplexing. Despite the organic feel of the fleshy *haute pâte*, one senses that this smaller figure could be operating the gangly, oversized arms as though by some mechanical apparatus (like a puppeteer manipulating a large puppet). The phallic necktie likewise strikes an unnerving if also slightly humorous chord, suggesting both castration and bizarre re-attachment as the organ dangles improbably at the neck. In encountering this dislocation we do well to recall that for Dubuffet's friend Jacques Lacan, symbolic castration represented the dual—and disconcerting—psychological and somatic experiences of being thrust into socio-symbolic (read cultural) life. This insertion into culture instigates the mechanisms of self-reflection and sentient human experience yet, according to Lacan, instills a sense of the loss of life's raw intensity.[16] This dual problematization was a key concern for both Dubuffet and his portrait sitter. As artists grappling with modern Western experience and processes of negation that underpinned Modernist and other avant-garde discourses, the fact that both men saw art in opposition to culture made Artaud an ideal subject for Dubuffet's painting.

The two men held similar anticultural beliefs, which they had developed within the interwar Surrealist milieu. Accordingly, in an essay titled "The Theater and Culture," the preface to *The Theater and Its Double*, Artaud proclaimed:

> At a time when life itself is in decline, there has never been so much talk about civilization and culture. And there is a strange correlation between this universal collapse of life at the root of our present-day demoralization, and our concern for a culture that has never tallied with life but is made to tyrannize life.[17]

Dubuffet picked up this torch in the aftermath of the war when he announced in a letter to Paulhan: "I am reading *The Theater and its Double* by Antonin Artaud and am amazed to find there the same ideas as mine."[18] Describing European culture as "a dead language, without anything in common with the language spoken in the street," Dubuffet believed his art could serve as an antidote to the effects of a culture that "no longer has real and living roots."[19] Both men believed true art should subvert classically informed and modern European academicism to engage the viewer in as raw and direct a manner as possible. "We must insist

upon the idea of culture-in-action," Artaud asserted, adding that "if our life lacks brimstone, i.e. a constant magic, it is because we choose to observe our acts and lose ourselves in consideration of their imagined forms instead of being impelled by their force."[20]

Just as Artaud set the stage for Dubuffet's anticultural rhetoric, the dramaturge's proclamation that "theater conventions have had their day" and that "we can no longer subscribe to theater which repeats itself every night according to the same, ever the same, old rituals" prefigures Dubuffet's pitting of art against culture.[21] Whereas Dubuffet railed against cultural practices, however, Artaud had lived his life according to his edicts—and thus against the cultural grain. Plagued by mental illness and drug addiction, Artaud had been an outrageous agitator since he first affiliated with the Surrealists in the early 1920s. He became one of the most controversial—and earliest exiled—of the group and was thus a cultural outsider even among his counter-cultural acquaintances.[22] Yet, as Susan Sontag notes, Artaud remained a fellow traveler to the movement and shared Surrealist interests that included a love of "the Orient," a fascination with madness as a challenge to cultural norms, and a desire to provoke interruptions of Otherness that disturb the status quo.[23]

As an artist who, in a sense, doubled his persona, moving (albeit inadvertently) from unruly avant-garde literary to quasi-Art Brut visual artist, Artaud's artistic theories resonated with Dubuffet and provided a unique model for his painting. The painted gesture in Dubuffet's portrait suggests that he was also fascinated by Artaud's dynamic, gestural expressions (or dramatic outbursts), which continued off stage during treatment and which Artaud's psychiatrist Gaston Ferdière assessed to mean that the author's "personality is double."[24] Schizophrenia and multiple personality disorders were little understood during the first half of the twentieth century, and the former, particularly, retained its status as a catch-all (usually mis-) diagnosis for a variety of psychologically- and physiologically-induced mental illnesses. As a sign of the cultural fascination with schizophrenia, it featured prominently as a topic in Lacan's dissertation.[25] Artaud might well have endorsed Ferdière's diagnoses, moreover, since the author's ideas about theater—and authentic art—relied upon the notion of radical splitting from mainstream European culture (itself conceived of as the cause of a profoundly disturbing mind–body schism) to instigate creative dissemination.

Although Artaud's views were extreme (in the "Theater and the Plague" he conceived of theater as *pharmakon*—poison or infection given as a curative—that could inflict the audience to cure European atrophy of the senses), he was not alone in his conceptualization of the schizophrenic effects of Western

culture.[26] Many in the avant-garde adopted the idea of schizophrenic dislocation to conceptualize the double trauma of Modernity, an idea perhaps most famously elaborated upon in the cultural criticism of Georg Simmel.[27] This Modern trauma was instigated, on the one hand, by agitation, a faster-paced life, and industrialization, and, on the other hand, by an imagined loss of richness as a result of blasé, habitual (near-mechanical) performances of societal roles and the endless repetitions of conventional artistic representations. The symptoms of this Modern crisis included desensitization to the stimuli of everyday life and a sense of nostalgia for primal forms. Thus, Artaud asserted that "we can no longer subscribe to theater which repeats itself every night according to the same, ever the same, old rituals."[28] Noting the parallel between stale, formulaic art and a sense of the "generalized collapse of life" Artaud thus also proclaimed that "we must believe in a sense of life renewed by theater."[29] Art must *double* or re-create life.

Many early-twentieth-century artists, writers, and intellectuals examined dualities in their work and some, particularly the Surrealists, looked to the double figure as an image suggestive of both fragmentary experience and the notion that identity is dynamic and performed. This idea was also elaborated upon by Lacan, who conceived of the ego as a protective construct masking multifaceted, and thus unstable, identity.[30] Images of creative doubling and performed identity could be found in a variety of double self-portrait photographs and paintings, and these images and their associated ideas resurfaced in the postwar era. We can see the exploration of duality in Dubuffet's pre- and postwar art, examples of which include his 1936 *Double autoportrait au chapeau melon* (Double Self-Portrait with a Bowler Hat) (see Figure 1.2) and his 1944 *Deux brigands* (Two Brigands) (Plate 3), which I discuss in greater detail in this book's conclusion.

Having a debated status, yet an unmistakable resemblance as a self-portrait, *Two Brigands* later featured in *College de Pataphysique*—a journal dedicated to Artaud's idol and eponymous inspiration for his Alfred Jarry Theater of the 1920s, each of which lampooned cultured institutions and practices. In fact, in the 1960s Dubuffet participated in the College de Pataphysique, a group dedicated to highlighting cultural absurdities and promoting anticultural principles.[31] Dubuffet's affinities with this group, his dual paintings, and his proclaimed affinity with the artistic ideas expressed in *The Theater and Its Double* suggest that the concept of doubling and its imagery attracted him. It is thus no surprise that he explored these ideas—and the theme of doubling—in his portrait of Artaud.

Shocking theatrics and surrealist encounters

The theater Artaud had in mind resembled nothing before seen in mainstream performance. Modeled, in part, after his Alfred Jarry Theater, this new theater would be composed of "dynamic expressions in space" to produce "dissociative and vibratory actions upon the sensibility."[32] Artaud believed his Alfred Jarry Theater, which deployed high theatrics including the use of large puppets, bizarre stagecraft, and hyperbolic gesture during the 1920s "expressed what life has forgotten," namely, its richness, resonances, and emotional intensity.[33] Moreover, Artaud asserted at that time that "the Jarry Theater does not cheat, does not ape life, does not represent it" but instead "aims to extend it, to be a sort of magical operation, open to any development."[34] In short, this theater was meant to (re) produce or *stimulate* life, answering "a mental need" which, according to Artaud, "audiences feel is hidden deep down within themselves."[35] He thus proclaimed that "the endlessly renewed fatigue of the organs [in Modern culture] requires intense and sudden shocks to revive our understanding"—shocks he aimed to produce with his theater.[36]

Both Dubuffet's and Artaud's creative outputs indicate that they sought to tap into a primal, pre-conscious, pre-linguistic, mode of human experience—making affective disturbance a central part of their creative work. As Dubuffet depicted the author, this chapter argues, he investigated Artaud's claims for extreme affect, experimenting with the kinds of intensely affective responses that painting might produce in the viewer. Intrigued though he was by Artaud's claims, however, Dubuffet never reframed the act of painting from "representation" to sheer "production," the crucial move that, as Todd Cronan argues, separates affect theorists from those who still believe in the agency of the author to intentionally produce, and the viewer to interpret, art; for Artaud, as Cronan notes, affect replaced agency and meaning, becoming the primary function of art.[37] For Dubuffet, affect was deployed as a means to create a more meaningful artistic encounter. Dubuffet aimed, in a sense, to *move* the viewer, not remove agency from the equation, hence his assertion that art must instigate "a whole inner mechanism" that must "start working inside the viewer."[38]

Like Artaud, Dubuffet had cultivated a contentious relationship with artistic tradition and really with any existing artistic program, including that dictated by Surrealist counter-culture under the direction of Breton. Although Dubuffet recalled with enthusiasm the extent to which Dada was "in the air" during his youth, he was more ambivalent with regard to Surrealism, calling it a "cultural machine."[39] As discussed in the preceding chapters, however, Dubuffet

acknowledged his interest in Breton (and thus, presumably, Breton's art theory), and the two men collaborated during the late 1940s to found both the Compagnie de L'Art Brut (discussed in Chapter 1) and the Société des Amis d'Antonin Artaud (Friends of Artaud) that made possible the author's postwar transfer from an impoverished French mental institution to a private hospital near Paris.[40] Both Dubuffet and Artaud had participated in the Surrealist milieu that pervaded French culture between the wars, moreover, and Surrealist occupations continued to resonate (albeit transformed), for these and other artists in the postwar years; this could be seen in the two men's continued appreciation of strange forms, unusual juxtapositions, and the untamed creativity of the works of the mentally ill and other non-professional artists.[41]

Unlike Artaud, who briefly participated in Breton's sanctioned atelier, Dubuffet was never an official Surrealist. He disapproved of Breton's insistence upon cliquish conformance to his dictates rather than the promotion of genuine creative freedom.[42] Dubuffet and Breton became long-term (if at times contentious) friends, however, at about the time Dubuffet produced his portraits. The two men shared both the Dada and Surrealist senses of irony with regard to culture and each rejected stabilizing norms (society portraiture, for instance) as absurd, hypocritical, and creatively stifling.[43] Dubuffet also retained a Surrealist interest in processes of discovery that resonate with desires to both subvert modern Western culture and reconnect with sensations of seemingly repressed aspects of human experience. Thus, he wrote of creating "instinctive drawings" and "teaming up with chance" to produce his art.[44] But his notion of tapping into the "impulses of ancestral spontaneity" placed an even greater emphasis on primal creativity and placed him in dialogue with the likes of Artaud, who was well known for his anticultural diatribes and proselytizing for art he associated with raw creative expression.[45]

The art of dissociating

Consider the doubling in Dubuffet's portrait: its dual, mask-like face; arms that double as legs; and penis that serves as a necktie. Consider, too, the ambiguous spatial relationship suggested by the interpenetration of body parts and the sense that the figure could emerge from the canvas. This imagery suggests that Dubuffet used his portrait of Artaud to explore the ideas about doubling that were at the root of *The Theater and Its Double* and, indeed, at the core of Surrealism.

The aforementioned dualities of modern consciousness, particularly between thinking and feeling and between lived and imagined experience, and the related desires to reunite ordinary life and vital creativity made the concept of doubling important, in different ways, to the Surrealists. This was so much so that both the Bretonian and dissident factions had their own distinct, yet intertwined, interpretations. As previously discussed, Breton's Surrealism hinged on the appreciation of disorienting dualities between conscious experience and subconscious processes he conceived of using the metaphor of "Communicating Vessels."[46] This duality was central to Breton's notion of the marvelous, which, as I concur with Hal Foster and other scholars, aligned with Sigmund Freud's notion of the uncanny—the unsettling sensation instigated by strange, yet strangely familiar, combinations of images or objects that problematize categories of experience and suggest repressed desires and anxieties. Freud's essay "The Uncanny" is riddled with discussions of doubles in one form or another and, Foster observes, the double is "an avatar of the uncanny," which for Freud signaled the activation of otherwise repressed infantile or primordial stages.[47] Discussing Dubuffet's interest in the "accidental face," which may appear, as though by magic, as our eyes and minds organize the visual stimuli in natural or manmade objects into recognizable patterns, Minturn also points to Dubuffet's fascination with the Bretonian brand of doubling found in evocative, hybrid imagery.[48] For the idea of an emerging face is a generative model, a sign or surprising form taken to be in some way meaningful by the viewer, as if emerging and thus becoming available for discovery from a world characterized by fascinating symbols that mirror those representing repressed desire in dreams.[49] This concept of doubling—and a face that does just that—is an important component of Dubuffet's portrait.

Yve-Alain Bois also alludes to generative doubling in Dubuffet's work, indicating that despite the artist's acquaintance with Georges Bataille and the concept of *l'informe* (formless)—and in contradistinction to Dubuffet's embrace of base materiality as an alternative to overly-refined art—his painting and, indeed, his writing demonstrates an overarching will to form.[50] "Beginning with the unformed," is the way to create good art, according to Dubuffet; but "beginning" is the operative word.[51] For Dubuffet the concept of the unformed framed the artistic act as both in a sense an originary ground zero, as Hubert Damisch indicates about Dubuffet's postwar art, and also a process of discovery through experimentation with materials that connote natural forms.[52] Art-making entailed a double operation— "transmuting" to create work that is "born from the materials."[53]

Hal Foster notes that despite Dubuffet's focus on Art Brut as the result of what he conceived of as a liberating and purely internal artistic operation, his painting

alludes, in various ways, to the trauma glimpsed in the art of the mental patients that so intrigued him.[54] In Chapter 2, I argued that this allusion to trauma in Dubuffet's painting was intentional and functioned as one aspect of his attempt to break with and subvert what he called "cultured" art. Here I add that the allusion to trauma in Dubuffet's art articulated the dissociative aspect of Surrealism's dual and ambivalent view of doubling explored most avidly by Artaud and other of the rogue Surrealists.

In the dominant, Bretonian stream of Surrealism, the notion of doubling relies upon conceptual hybridization as ordinary forms and materials are taken by the viewer to suggest human anatomy, repressed desire, and primal states or stages of being that society tries consistently to suppress.[55] In the distinct yet related dissociative view that characterizes Artaud's writing, doubling and ambiguous, hybrid imagery can suggest trauma seen as necessary to instill internal (or internalized) transformation resulting from contact with outside stimuli, which Artaud sought to achieve in theater. For Surrealists like Artaud, such stimuli in the form of art should instigate a kind of trauma in order to trigger liberating creative forces. In this complementary stream of Surrealist thought the concept of mimicry refers to a sense of the effacement of the self (or, in art, the breakdown of form and figure) as it splinters into its environment or takes on the characteristics of its surroundings (a major problem when experienced within culture—a radical transformation when instigated by the artistic encounter).

French philosopher Roger Caillois most famously theorized this form of mimicry (adopted to the human psyche from the camouflage of animals and insects such as the praying mantis) as a sense of "depersonalization through assimilation into space" and an "instinct of abandon."[56] No doubt such depersonalization afflicted some of the Art Brut artists suffering from schizophrenia or dissociative disorders that intrigued Dubuffet. Yet, in the minds of artists such as Dubuffet—and his portrait subject, Artaud—the detachment from enculturated identities and norms could serve dual functions, dissociating the viewer from socially constructed reality and attuning him or her instead to life's visceral and emotive resonances. Dubuffet's embrace of the ambivalence between the generative and dissociative views of doubling would thus have had precedents in both the radical ideas of Artaud and the general Surrealist outlook that explored the intertwined dualities that comprise, and complicate, the human psyche.

The disjunctive relationships between Dubuffet's figure and its ground, the arm that penetrates the body, and the castrated and re-attached genitals, suggest this type of dissociative doubling. So too, the fragmented face-within-a-face

suggests schizophrenic dislocation—a dissociation artists had long attributed to experiencing those aspects of modernity (rigid art and cultural institutions, efforts to expand social control, and ever more cacophonous urban spaces) thought to inhibit free, creative expression. For Dubuffet—as for his subject, Artaud—art should dissociate the viewer from such ordinary viewing and thinking habits. Dubuffet explored these ideas, combining both dissociative and regenerative images of doubling (two sides of the same coin) in his portrait. The painting thus demonstrates both his continued engagement with Surrealist ideas and his defiance of either-or categories, evoking both the will to form and the *informe,* traumatic displacement and creative doubling. Indeed, it is precisely this ambivalence, this push-and-pull tension, that provides the matrix for the ultimately (re)generative themes Dubuffet wished to convey.

Although Dubuffet's writings about art downplayed his interest in the psyche of an artist (and, indeed, of a portrait subject), his references to the personalities behind Art Brut in a 1976 interview belie this position.[57] Even in texts such as "In Honor of Savage Values," however, one can find references to the "emotional movements of the author."[58] Recalling his years of researching Art Brut, Dubuffet acknowledged being fascinated by the personalities behind it, stating, "I am always greatly curious; I want to link the work with a mind."[59] This admission, and even Dubuffet's interest in Breton's persona, suggests some preoccupation with the personality of a sitter such as Artaud, whose madness, isolation, and confrontational nonconformity to social norms placed his work somewhere in between avant-garde art and Art Brut production.

Dubuffet proclaimed his enthusiasm for Artaud's work in 1945—the same year the artist began researching Art Brut and visiting the institutionalized author.[60] Indeed, records show that Dubuffet was the first visitor allowed to see Artaud since he had been moved to Rodez in 1943 at the mutual behest of Artaud's mother and Surrealist poet Robert Desnos, a friend not only to Dubuffet but also to Artaud and his doctor, Ferdière.[61] Dubuffet and his sitter had likely encountered each other during the height of Surrealism, however, and some accounts place their meeting in the early 1920s at Masson's Montparnasse studio. Given Dubuffet's interest in Dada and Artaud's idol Alfred Jarry, it is also likely that during the 1920s Dubuffet investigated Artaud's Alfred Jarry Theater. Dubuffet would surely have known of Artaud prior to their postwar visitations, which were likely sparked by the painter's exploration of exceptional art made by culturally isolated mental patients.[62] It is clear, in any case, that Artaud piqued Dubuffet's interest at the moment he began touring mental facilities searching for examples of Art Brut—so much so that Dubuffet produced three portraits of the author in this series.

Artaud's doctor, Ferdière, also played a role in the meeting. A Surrealist poet as well as a prominent psychiatrist, he aided Artaud's transfer from the impoverished state mental institution near occupied Paris to the one Ferdière himself administered south of the occupied zone in Rodez. Ferdière both encouraged Artaud's drawing at Rodez and made the art of the patients there available to Dubuffet after the war (the men's correspondence indicates that Ferdière was less cooperative about releasing Artaud's drawings, hoping instead to profit from exhibiting them with collections of the art of the mentally ill). Despite the animosity that arose between Dubuffet and the psychiatrist as a result of competing to acquire Artaud's art, they corresponded regularly about his wellbeing and cooperated in 1946 to obtain for him the other transfer to a private hospital near Paris and, briefly, to a renewed presence among the Parisian avant-garde before his untimely death in 1948.[63]

Dubuffet supported Artaud's artistic efforts and encouraged him to draw the portraits exhibited from July 4 to July 20 at Loeb's Galerie Pierre under the title "Portraits and Drawings by Antonin Artaud"—just a month before Dubuffet's own portrait exhibition at the Galerie René Drouin.[64] In fact, each man proclaimed to have produced his portraiture from memory in a similar way.[65] By this time, Artaud's history of mental problems, institutionalization, and electroshock therapy had prematurely aged him, causing the deeply fissured lines of his gaunt face (Figure 3.3). Electroshock-etched lines in Dubuffet's portrait, suggested by deep fissures in the paint, produce the double figure of Artaud.

Antonin Artaud aux houppes also bears strong resemblances to the art of mental patients featured in Hans Prinzhorn's book *Artistry of the Mentally Ill*, which intrigued Dubuffet and which I discuss in Chapter 2 in relation to the *Portrait of Jean Paulhan*.[66] A notable resemblance exists, for example, between Dubuffet's portrait of Artaud and the sculptures created by mental patient Karl Genzel (pseudonym Brendel), which are characterized by their large heads atop bow-legged lower limbs that double as arms (see Figure 2.11). Moreover, these sculptures' genitals hang directly from their chins—an intriguing placement that reappears in Dubuffet's painting. Given that Dubuffet would have seen these sculptures in Prinzhorn's book, he clearly replicates the distorted limbs and misplaced genitals in his portrait, giving his sitter arms that are also legs and a quasi-comic, yet ultimately disturbing, penis/necktie.

As I also discuss in Chapter 2, Hal Foster has noted that some of Dubuffet's art resembles the Art Brut of Herman Beehle (pseudonym Beil) (see Figure 2.12).[67] I believe such resemblances are particularly compelling in Dubuffet's portrait of Artaud. Both Dubuffet's and Beehle's figures appear to be crudely and

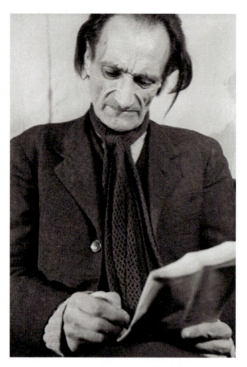

Figure 3.3 Denise Colomb, photograph of Antonin Artaud, 1947. © Denise Colomb, Médiathèque de l'Architecture et du Patrimone, Charenton-le-Pont, France © Ministère de la Culture / Médiathèque du Patrimone, Dist. RMN-Grand Palais / Art Resource, NY.

somewhat schematically rendered. Importantly, each contains features that double to produce a second, emerging face. Although Beehle's drawing lacks the "face-within-a-face" seen in Dubuffet's painting, the figure's nipples combine with its navel and what appear to be buttons to instead form a face within the torso (an instance of doubling that can also be seen in Dubuffet's famous painting *Will to Power*). In addition to this "double face," the heart-shaped torso in Beehle's rendering prefigures the heart-shaped head in Dubuffet's portrait. Beehle's figure, too, is posed frontally, its feet are cut off at the bottom of the picture plane, and fluffy head gear (or tufts of hair) project from the sides of the head as if threatening to escape the rendering's borders. These pictorial elements recur in Dubuffet's portrait. Whereas Foster believes that Dubuffet's figures only inadvertently alluded to the trauma glimpsed in the art of mental patients such as Beehle, I see both the resemblances and their allusions to trauma in Dubuffet's painting as intentional, fitting for his depiction of Artaud, and attuned to the playwright's ideas about the dissociative yet vivifying effects of authentic art.[68]

Produced January 3, 1947, the portrait of Artaud heralded not only the two men's portrait exhibitions to be held that summer, but also the July–August 1947 International Surrealist Exposition. The imminence of the Surrealist exposition perhaps also fed Dubuffet's interest in Artaud, who as a "rogue" Surrealist nearing the end of his life (and still sporadically quarreling with Breton) declined to participate. Within days of Dubuffet's portrait, Breton and many members of the artistic avant-garde would nevertheless witness (and fund) Artaud's January 13, 1947 solo performance or *Tête-à-tête*, as he called it. Unfortunately, the widely supported event that took place at the Théâtre Vieux-Colombier highlighted Artaud's unstable—and unmanageable—personality. Indeed, it was a performance so jarringly disjunctive, and at times overtly aggressive, that it was unclear to what degree it was artistically agitational or the incensed ravings of the mentally ill playwright. Dubuffet's correspondence with the author and members of the Friends of Artaud reveal that the artist's infatuation with the playwright was wearing thin—the result of Artaud's drug-induced rampages and demands for more of the funds needed for his care, for which Dubuffet served as the treasurer.[69] In Artaud's book *The Theater and Its Double*, however, Dubuffet found a paradigm for the radical transformation of art that resonated during the postwar period.

Part II. From Behind the Scenes: Balinese Theater Makes an Appearance in the Portraits

The Theater and Its Double, which Artaud published with the help of Paulhan in 1938, advocates for art that can dissociate the viewer from quotidian experience. In addition to celebrating art that could interrupt the ordinary with a sense of the extraordinary, the book called for European performance to emulate the theaters of the Orient, particularly the Balinese theater, which Artaud touted for its ability to generate a multiplicity of sensory experiences. "In the Oriental theater of metaphysical tendency, contrasted with the Occidental theater of psychological tendency," Artaud writes, "forms assume and extend their sense and their signification on all possible levels," adding that these forms "set up vibrations on every level of the mind at once."[70]

Like Artaud, Dubuffet also lamented the stale state of Western art and culture, proclaiming that "the culture of the Occident is a coat which does not fit him; which, in any case, doesn't fit him anymore" and instead "drifts further and further from daily life."[71] Although these comments suggest that Dubuffet had

the art of "the Orient" on his mind, they have only begun to pique scholarly interest. As a result, scholars have rarely discussed Dubuffet's possible engagement with art produced east of Europe or specifically Asian art.[72] The dearth of research into Dubuffet's exploration of Southeast Asian cultural forms is especially odd given that he extolled *The Theater and Its Double*, the book that cohered around Artaud's essay "On Balinese Theater" and that Dubuffet held to resemble his own art theory. And while some work exists on Dubuffet's connections with Artaud, no one, to my knowledge, has speculated on Dubuffet's active engagement with Artaud's primary inspiration—the Balinese theater.[73] Yet, as this analysis suggests, Balinese performance appears in Dubuffet's portrait.

Archetypes, puppets, and costumes

Looking to Balinese theater as a model, Artaud's book advocated the use of puppet-like costumes, even puppetesque actors, to provoke autonomic viewer responses and unleash untamed psychic forces. His language is more hyperbolic than descriptive, but his discussion of Balinese actors as automaton-like beings completely engrossed in their performance attuned to the Surrealist interest in the automatic channeling of subconscious forces—an interest Dubuffet had also explored since the 1920s. In Balinese theater, Artaud asserted, archetypal costumes radically transformed the performers appearances to evoke images, sensations, and states of being that existed prior to language and independently of linguistically translatable registers of consciousness.[74] Whereas Artaud wrote of "depersonalizing" his actors using fantastical costumes, Dubuffet described his portraiture as depicting only a "very general level of the elementary human form."[75] For both men, this emphasis on depersonalization meant decreased awareness of culturally-shaped personality and increased attunement to raw, creative experience.

Not surprisingly, Artaud shared Dubuffet's fascination with archetypes—symbolic patterns, figures, or personifications of various modes of experience that resonate with notions of primeval life, serve as models for subsequent renderings, and symbolize the creative impetus itself. For artists such as Dubuffet and his sitter, archetypes represented the primal creative forces repressed by Western culture. These forces, they believed, could best be represented by images the Western viewer sees as strange (Other) but that nevertheless resonate with him or her as strangely familiar. In this way, the idea of the archetype attunes to

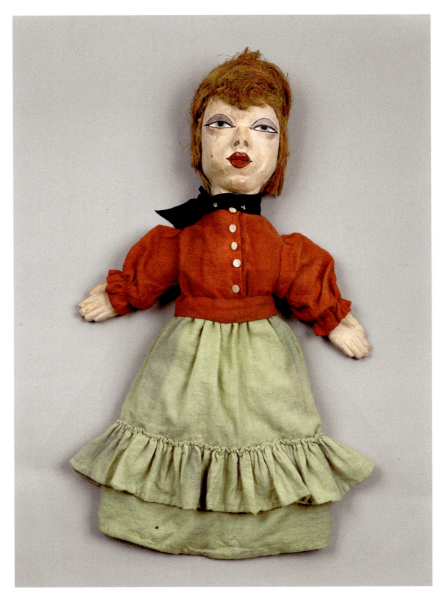

Plate 1 Jean Dubuffet, puppet of Lili, 1936, papier-mâché, wood, and paint, 60 cm. (23.6 in.) ht. Fondation Dubuffet, Paris. Fondation Dubuffet, Paris / © 2020 Artist Rights Society (ARS), New York—ADAGP, Paris. Photograph courtesy of the Fondation Dubuffet, Paris. Reproduced in *Catalogue des travaux de Jean Dubuffet*, Fascicule I (Paris: Fondation Dubuffet, 2003), 33, no. 86.

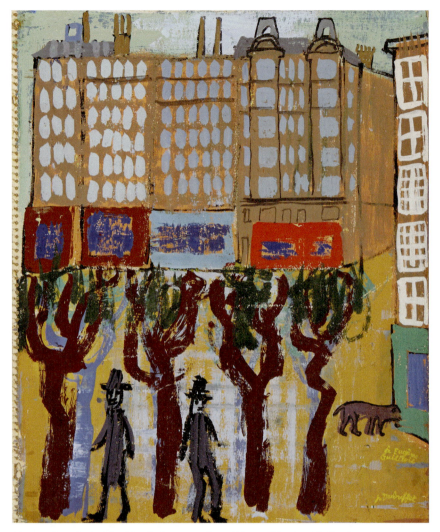

Plate 2 Jean Dubuffet, *Vue de Paris au chein* (View of Paris with Dog), 1943, gouache on paper, 37 × 30 cm. (14.6 × 11.8 in.). Fondation Dubuffet, Paris / © 2020 Artist Rights Society (ARS), New York—ADAGP, Paris. Private collection, France. Photograph courtesy of the Fondation Dubuffet, Paris. Reproduced in *Catalogue des travaux de Jean Dubuffet*, Fascicule I (Paris: Fondation Dubuffet, 2003), 63, no. 47.

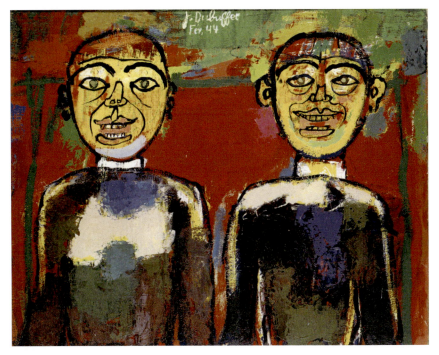

Plate 3 Jean Dubuffet, *Deux brigands* (Two Brigands), February, 1944, oil on canvas, 66 × 81 cm. (26 × 31.9 in.). Fondation Dubuffet, Paris / © 2020 Artist Rights Society (ARS), New York—ADAGP, Paris. Private collection, U.S. Photograph courtesy of the Fondation Dubuffet, Paris. Reproduced in Jean Dubuffet, *Catalogue des travaux de Jean Dubuffet*, Fascicule I (Paris: Fondation Dubuffet, 2003), 157, no. 229.

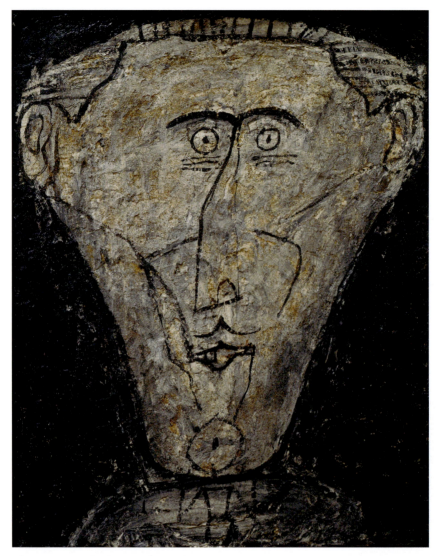

Plate 4 Jean Dubuffet, *Tapié Grand Duc* (Tapié Grand Duke), August, 1946, *haute pâte* (oil, bitumen, and plaster) on canvas, 83 × 67.5 cm. (32.7 × 26.6 in.). Fondation Dubuffet, Paris / © 2020 Artist Rights Society (ARS), New York—ADAGP, Paris. Städel Museum, Städelsches Kunstinstitut und Städtische Galerie, Frankfurt. Photograph: Städel Museum, Frankfurt. A black and white photograph of this artwork appears in *Catalogue des travaux de Jean Dubuffet*, Fascicule I (Paris: Fondation Dubuffet, 2003), 30, no. 34.

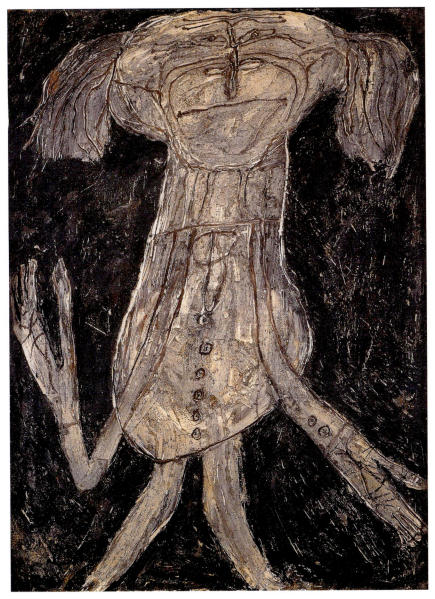

Plate 5 Jean Dubuffet, *Antonin Artaud aux houppes* (Antonin Artaud with Tufts of Hair), oil on canvas, January, 1947, 130 × 97 cm. (51.18 × 38.18 in.). Fondation Dubuffet, Paris / © 2020 Artist Rights Society (ARS), New York—ADAGP, Paris. Morton G. Neumann Family Collection, U.S. Photograph courtesy of the Fondation Dubuffet, Paris. Reproduced in Jean Dubuffet, *Catalogue des travaux de Jean Dubuffet*, Fascicule III (Paris: Fondation Dubuffet, 2003), 78, no. 111.

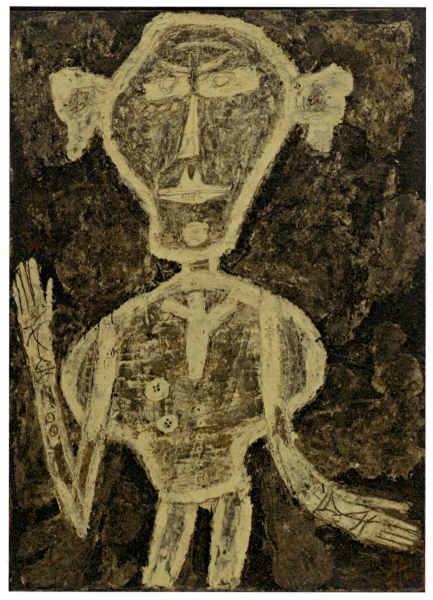

Plate 6 Jean Dubuffet, *Portrait of Henri Michaux*, "gros cernes crème" (Portrait of Henri Michaux thick rings of cream January, 1947, oil on canvas, 130.7 × 97.3 cm. (51.18 × 38.38 in.). Fondation Dubuffet, Paris / © 2020 Artist Rights Society (ARS), New York—ADAGP, Paris. The Sidney and Harriet Janis Collection, Museum of Modern Art, New York. Photograph: © The Museum of Modern Art/Licensed by SCALA / Art Resource, NY. A black and white photograph of this artwork appears in Jean Dubuffet, *Catalogue des travaux de Jean Dubuffet*, Fascicule III (Paris: Fondation Dubuffet, 2003), 79, no. 112.

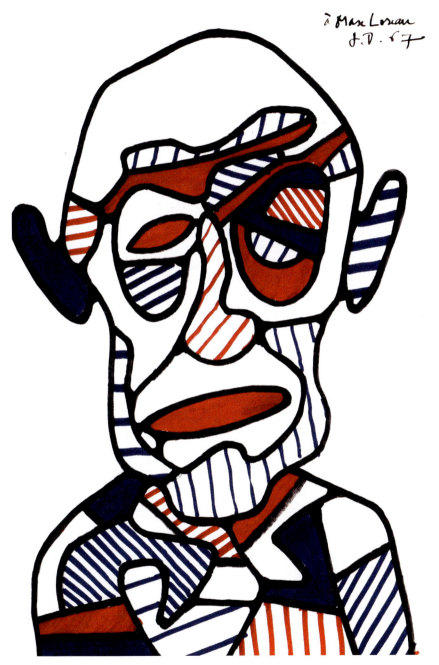

Plate 7 Jean Dubuffet, *Autoportrait VI,* December, 1966, marker on paper, 25 × 17.5 cm. (9.8 × 6.9 in.). Fondation Dubuffet, Paris / © 2020 Artist Rights Society (ARS), New York—ADAGP, Paris. Private collection, Canada. Photograph courtesy of the Fondation Dubuffet, Paris. Reproduced in Jean Dubuffet, *Catalogue des travaux de Jean Dubuffet*, Fascicule XXII (Paris: Fondation Dubuffet, 2003), 71, no. 209.

Plate 8 Jean Dubuffet, *Coucou Bazar*, performed in Turin, 1978. Photograph: Kurt Wyss © 2021 Fondation Dubuffet, Paris / ARS, New York—ADAGP, Paris. Fondation Dubuffet, Paris.

Freud's notion of the uncanny as a sense of the recurrence of primal states of being and to Breton's concept of the marvelous, which celebrates such encounters through processes of discovery. Both Dubuffet and Artaud evoked the idea of mythic archetypes in their art. Thus, Artaud proclaimed that the "theater must be considered as the Double not of direct, everyday reality of which it is gradually being reduced to an inert replica," but rather of "another archetypal and dangerous reality"—a raw, vibrant experience.[76] For Artaud, this double reality was not merely one that juxtaposed lived and imagined experiences, but one that slammed the two forcefully together to produce vivifying effects. Paradoxically, Dubuffet brought this *brut* and abstract depersonalization to his portraits, creating figures that both resemble his friends and evoke the crude figuration of ancient graffiti.

Artaud's efforts to depersonalize the actors in his ideal theater and his envisioning of the audience as a vibrant collective body were ideas that aligned more with a radicalized version of Jung's concurrently developed notion of a collective (yet precultural) conscious than with Surrealism's emphasis on biographical psychology.[77] Likewise, Dubuffet appears to have used the term "archetype" in a manner that was more attuned to the ideas of Bachelard, which drew, in turn, upon Jungian philosophy in which the archetype—an originary poetic image—is thought to "lie dormant," within a person (or within people generally) so that the artistic act—an expression of the primal will to create—resonates with the viewer, suggesting a creative pattern or matrix.[78] Although in the preceding chapters I have discussed the many correlations between Breton's and Bachelard's ideas, this interest in a primal collective consciousness over individually (yet culturally bracketed) psychology marks one of the key differences—and it is a difference found also in Artaud's and Dubuffet's writings.

Although Dubuffet expressed disinterest in capturing the psyche or the "accidental peculiarities" of his subject's appearances, he represented his sitter's most striking characteristics.[79] In *Antonin Artaud aux houppes*, these were the deep fissures of Artaud's once-handsome face, the glaring slits of his eyes, and his unkempt hair. Comparing the portrait to photographs of Artaud taken the same year, one sees his long hair escaping its pomade to form arcs on the sides of his head (see Figure 3.3). Dubuffet stylized these shocks of dog-eared hair into literal dog ears to create a hybrid, taxonomically ambiguous figure. As the following pages elaborate, these and other distortions in Dubuffet's portrait point, in their way, to the artist's dialogue with Artaud and his writings on Balinese performance.

Balinese performance

For Artaud, the Balinese theater, which is characterized by elaborate costumes, gestures, and gyrations, epitomized the physical and intensely gestural performance that he believed could shock and potentially revive Western audiences. He wanted to (re)produce this theater that "upsets all our preconceptions, inspiring us with fiery magnetism" to function like "a spiritual therapeutic."[80] His advocacy of recreating this "perpetual play of mirrors, in which human limbs seem resonant with echoes" surely attracted Dubuffet, who wanted his art to create "echoes, resonances, and overtones."[81] It is easy to see why Dubuffet found inspiration in Artaud's book and in the Balinese theater that inspired Artaud's writing.

Balinese performance so fascinated Artaud when he saw it at the 1931 Paris Colonial Exposition that he immediately penned his famous essay, "On Balinese Theater," which he first published that year in the popular *Nouvelle revue Française*.[82] For Artaud, the Balinese theater epitomized the kind of mythic performance he had attempted to produce in his Jarry Theater using large puppets, emphatic gestures, shocking hyperbole, and odd juxtapositions of violence and humor. In his view, the bold stagecraft of Balinese performance highlighted the theater's physicality and attuned viewers to their own corporeality (a carnality suppressed in sublimating models of traditional European art), providing a means to reach the viewer's entire being.

For Artaud, the fantastical masks, costumes, and puppets that were animated by jerky choreography and angular poses functioned as though they were "moving hieroglyphs"—living ideographs able to produce the "primal sense of power which nature has of suddenly hurling everything into chaos."[83] So-called picture writing and interpretive gestures fascinated Artaud, Dubuffet, and other artists who had been impacted by Surrealism. As Minturn has discussed, Dubuffet's interwar studies of pictographs, ideographs, hieroglyphics, and calligraphy aligned with his concurrent interests in Artaud and the physicality of the sign.[84] This fixation with bodily signs and enigmatic gesture also characterizes Dubuffet's postwar portrait.

Like Artaud, Dubuffet had almost certainly attended the extremely popular 1931 Paris Colonial Exposition, which was held at the Vincennes park near his home at the eastern outskirts of Paris.[85] It is likewise reasonable, then, to assume that he visited the Dutch Pavilion, a highly publicized and elaborate compound featuring an array of artifacts and performances by which the Dutch colonial powers hoped to expand tourism in their Indonesian colony (colonial hegemony

that began being challenged as the world watched in 1946–1947, the very years of Dubuffet's portraits). Although a Surrealist boycott of the 1931 exposition and concurrent counter-exposition highlighted the exploitative colonialism of the main event, these activities did little to deter most viewers, perhaps the most notable of whom, thanks to his essay, was Artaud.[86] Whether Dubuffet attended the performance or viewed photographs and films available in the popular press and ethnographic publications, the performance was so impactful that he appears to have revisited its forms in his 1947 portrait of the author.[87]

As a result of ethnographic expeditions, colonial exhibitions, and the Dutch marketing of its colonies to promote tourism, Western curiosity about Indonesian culture bloomed during the early twentieth century. Indeed, the "Bali craze" swept both Europe and the Americas during the 1930s, attracting visual artists as diverse as Walter Spies (from Germany) and Miguel and Rose Covarrubias (from Mexico and the United States), each of whom moved to Bali and disseminated awareness of its cultural forms through their artworks and ethnographic texts. Spies founded an artist colony in Bali that served as a hub of collaboration between artists, photographers, popular filmmakers, and ethnographers. Included among these interdisciplinary cohorts were members of Les Archives internationales de la Danse (AID), a Paris-centered group whose organizers included the likes of Former avant-garde Ballets Suedois director Rolf de Maré and Dubuffet's old friend Fernand Léger. The AID recorded performances and preserved costumes and other artifacts related to Balinese and multi-cultural dance, all of which they made available to the French public.[88]

This enthusiasm to learn more about Balinese culture also attracted the famous anthropologists Margaret Mead and Carleton Gajdusek (from the United States) and Gregory Bateson (from England), who together published *Balinese Character: a Photographic Analysis* in 1942, a book that features texts and photos of Balinese performance and discusses the role of gestures in everyday life.[89] Covarrubias' experiences as an illustrator for *Vanity Fair*, the *New Yorker, Theater Arts Monthly*, and other fashionable magazines had cultivated his attunement to popular trends that included exoticism. His time in Bali, made possible by a Guggenheim Fellowship, expanded his anthropological interests and resulted in his publishing his own study of Bali, first in an article and then in his book *Island of Bali*, both of which consist of his observations and illustrations accompanied by his wife Rose's photographs of Balinese culture and performance.[90] His renderings of Balinese customs and costumes mimicked the angular style of the indigenous artworks in his book and appealed to the Modernist sensibilities of his readers, some of whom could access his publications

at the Bibliothèque Nationale de France in Paris (Figure 3.4). The angularities of his renderings also mimicked the poses found in Balinese dance—poses that can be glimpsed in Dubuffet's portrait of Artaud.

Balinese imagery also made its way into a number of documentary films, including those produced by the AID, and even featured in popular movies. The Hollywood movie *Honeymoon in Bali* exemplified the popularization of Balinese culture, and a poster accompanying the movie's French release, *Lune de miel à Bali,* featured illustrated Balinese dancers in emphatically angular poses.[91] Although scant scholarship exists on Balinese or other Indonesian art forms circulating in France during the postwar era, it seems logical enough that Dubuffet engaged with them, given his interest in Artaud and in theater, masks, and puppets, which, as noted in the previous chapters, he produced and performed in his studio during the 1930s (see Figures 1.3 and 1.4). In Chapter 2, I discuss the mask as a thematic element in Dubuffet's art. In the remaining pages of this chapter, I consider the apparent impact of Balinese masks and

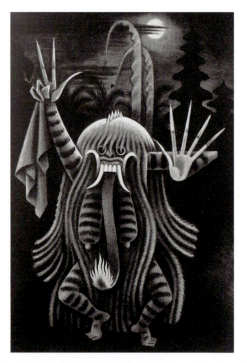

Figure 3.4 José Miguel Covarrubias, *Rangda*, in *Theater Arts Monthly, The Theater in Bali* xx, no. 8 (August 1936); also featured in José Miguel Covarrubias, *Island of Bali* (London: KPI, 1986) 334. First published in 1937 with editions in 1946 and 1947. Artwork and photograph © 2021 estate of Miguel Covarrubias.

costumed performance in his portrait of Artaud, for whom these art forms also provided exhilarating inspiration.

Masks, costumes, and movement

A regional form of traditional Indonesian performance, Balinese theater evolved from puppetry and relies heavily on dance composed of jerky, angular poses (Figure 3.5). The performance centers on Balinese Hinduism's value of balance in a dualistic world—between life-giving and life-threatening forces, masculine

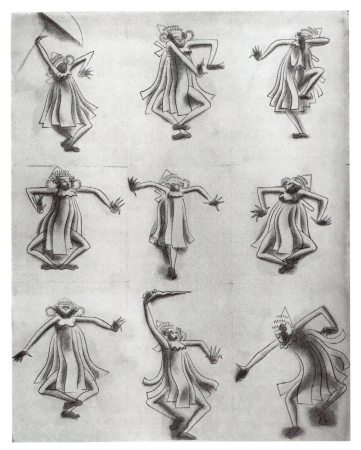

Figure 3.5 José Miguel Covarrubias, *Movements of the Baris*, in *Theater Arts Monthly, The Theater in Bali* xx, no. 8 (August, 1936); also featured in José Miguel Covarrubias, *Island of Bali* (1937) (London: KPI, 1986), 226. First published in 1937 with editions in 1946 and 1947. Artwork and Photograph © 2021 estate of Miguel Covarrubias.

and feminine characteristics, and locomotive and static states—dualities that intrigued the Surrealists. The choreography emphasizes contrasts between coarse and refined movements and is composed of *tangkis* (transitions between static poses and emphatic gestures in which the arms and hands are held out and bent at odd angles). These moves are meant to communicate the idea that balance can only momentarily be achieved by continually (re)engaging processes of renewal.[92] The poses are thus, by design, difficult to maintain and express transitory states of being—qualities that fascinated Artaud and, likewise, Dubuffet, who would rail against cultural stasis and argue that "the thinker [artist, viewer] must turn," must move, must change perspectives.[93]

Artaud appreciated the ways that Balinese performers used their emphatic gestures to communicate boldly and directly with the audience, effacing the boundary between the actors and the viewers. Taking the Balinese theater as his model, he hoped to transform European theater into a space where the plastic forms of its production—costumes, gestures, sound, lighting, stage effects, and so on—prompted primal affective responses.[94] He wanted to mimic Balinese stagecraft to create a double structure able to both strike and grip the viewer's sensibilities, producing "an inexhaustible mental ratiocination, like a mind ceaselessly taking its bearings in the maze of its [own] subconscious."[95] This sensorial barrage, Artaud believed, could repair the split between the mind and the body, and between art and life, that he perceived in Western theater and culture, reviving the viewer from a state of culturally-induced somnambulism to generate a renewed sense of vitality.[96]

The Balinese performers Artaud (and likely Dubuffet) saw at the Paris Colonial Exposition wore dramatic makeup, carved wooden masks, and elaborate costumes, some of which were layered to portray otherworldly figures. Although part of a long Balinese tradition, this imagery was startlingly new to Artaud and most contemporary French viewers. And it was precisely this combination—old (seemingly primal) and shockingly novel (to Western eyes)— that interested the dramaturge. He especially favored the puppet-like costumes, which he thought gave "each actor a double body and a double set of limbs" so that "the dancer, bundled into his costume seems to be nothing more than his own effigy."[97] His description could serve equally well for Dubuffet's portrait. Indeed, the painting is unsettling as a result of the puzzling relationship between its dual and symbiotic figure/s, the tense spatial relationships between the figure and the painting's borders, and the ambiguous, yet highly theatrical, relationship between the figure and the viewer. These effects are heightened by the sense that the figure could project outward from the canvas, breaking the boundary

between the artwork and the viewer in a manner akin to the Balinese theater Artaud wanted to emulate.

In Balinese theater, the immobility of the mask counters the jerky choreography of the dancers and parallels their punctuating pauses. Although some of the masks feature moving, puppet-like mechanisms, they effect an uncanny sense of stillness that contrasts, unsettlingly, with our expectations for facial dynamism (a contrast that for Artaud might epitomize a Surrealist juxtaposition).[98] Dubuffet's portrait achieves a similar effect, producing a sense of tension between the mask-like rigidity of his portrait's face—fixed forever in his *haute pâte* medium—and the movement implied by the tightly packed and doubling figure. I argue that a sense of "movement" also occurs as our vision moves back and forth between the two figures in the painting. The arms in the painting appear to "move" between being arms and legs, the necktie between clothing and penis, and so on. As Damisch observes, such a sense of perceptual and conceptual movement was paramount in Dubuffet's art.[99] This "movement" contrasts with the initial impact of the static quality of the painting and, in part, accounts for its effectiveness, allowing Dubuffet to do in paint what Artaud hoped to achieve with his Balinese-inspired theater—to dissociate and redirect the viewer's perspective. Although Dubuffet worked in a static medium, he thus intended his painting to affect "the most intimate and profound internal movements."[100] Concentrating on the affective play between movement and stasis, Dubuffet's portrait demonstrates the painter's ideal, shared and theorized by Artaud, of an art that both agitates and stimulates the viewer.

Barong and *Rangda*

Although dissimilar in many respects, Dubuffet's portrait of Artaud shares salient characteristics with the spectacular *Barong* and *Rangda* costumes that appeared at the 1931 Paris Colonial Exposition and that featured in Artaud's *The Theater and Its Double* (Figures 3.6 and 3.7).[101] The strangely canine qualities of the portrait's wide, heart-shaped head and dog-eared shocks of hair are particularly reminiscent of the *Barong Ket* costume created from an elaborate array of fabrics, feathers, fur, carved wood, paint, and metal leaf to portray a spectacular, dragon-like form whose flowing masses of fur confound our expectations even for a fantastical dragon (Figure 3.6). The wild tufts of fur are especially pronounced at the sides of its large floppy head and appear, transformed, in Dubuffet's abstracted, yet corporeal, portrait.

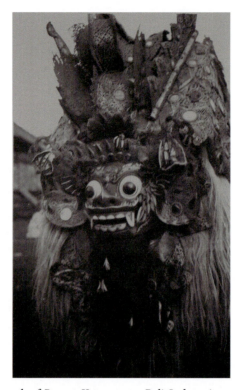

Figure 3.6 Photograph of *Barong Ket* costume, Bali, Indonesia, wood, fibers, feathers, paint, and gold leaf, early twentieth century. Tropenmuseum, Amsterdam. Collection Nationaal Museum van Wereldculturen. Call. no. TM-60053623. Public Domain. A comparable photograph was taken by Walter Spies, 1938. New York Public Library, Claire Holt archives (copy of a photograph at the Bibliothèque Nationale de France, Musée de l'Opéra, Paris produced from a negative Holt took to New York City during World War II).

The *Barong Ket* portrays an archetypal character in Balinese culture, and traditional belief holds that the costume embodies a protective spirit that encompasses the grandeur of a lion and the playfulness of a puppy—a fitting description for Dubuffet's furry figure of Artaud. In addition to the tufts of the *Barong*'s mane, Dubuffet's portrait all but replicates the wide slash-of-a-mouth that we see when the mask's mechanical jaw closes. Moreover, the sinews in the portrait's unnaturally thick neck that delineate the second, much thinner neck—propped on top of which we see the shrunken face-within-a-face—also echo the costume, in which a relatively small mask hangs below a wide, heart-shaped headdress that hides the performer. At the same time, Artaud's rectangular neck (and decidedly phallic necktie) re-articulate the *Barong*'s long beard, a symbol of

his phallic power.[102] All of these formal convergences point to Dubuffet's direct referencing of the Balinese theater in his portrait.

Because the *Barong* character walks on all fours, its costume is operated by not one, but two men. The front man manipulates the elaborate headdress, moving tufts of the costume's mane as though flapping large ears and snapping the jaws of the mask. The other man brings up the rear, flouncing the character's floppy tail. Thus, the costume is like the portrait of Artaud, literally doubled. In fact, the name of the costume, *Barong*, likely stems from the Sanskrit "*bharwang*," meaning "two spaces"—an apt name for this two-person costume—and a fitting model for the doubling in Dubuffet's portrait, which is characterized by its theatrical pose, dual, heart shaped faces, and unruly tufts of hair.[103]

That the arms in Dubuffet's painting could double as legs also mimics the two-person *Barong* costume, in which the legs of the front performer double as the arms or front legs of the character. The conflation of a penis and a necktie likewise suggests the idea of a man (or men) inside, the actor/s animating the costume like a puppet. This proximity of head, neck, and sex organs in the portrait also has a theatrical precedent; the *Barong* mask rests at about the level of the performer's mid-torso throughout much of the performance, and during part of the performance the actors animating the costume sit down, at which time the mask rests even closer to the front man's genitals. Dubuffet's portrait of Artaud appears a kindred spirit to the *Barong* costume—a fantastic amalgam of hybrid forms.

News photographs of the 1931 Paris Colonial Exposition suggest that Dubuffet also looked to the *Rangda* costume in painting the portrait of Artaud, who referenced this very costume when he mentioned the Balinese theater's "devil" in his book (see Figure 3.7).[104] The *Rangda* costume actually portrays (and belief likewise holds that it embodies) a female demon or witch that appears in the *Barong* dance and other Balinese performances enacting the duality of good and evil. The exposition photograph considered here shows the costume sprouting long "tufts" of hair or fur, which we also see in Dubuffet's portrait.[105] Minus the long teeth of the demon costume, the portrait's mouth again echoes the straight upper lip in the costume's mask. Although the portrait does not feature the long, fiery tongue that hangs from the mask's mouth, Artaud's rectangular neck and penis-necktie echo the shape of the costume's tongue, which symbolizes power—in this case, phallic power held by a female deity and performed, traditionally, by a male actor who serves also as a shaman. The portrait's penile necktie may be somewhat humorous, but if so, it is analogous to the kind of "joke" Dubuffet describes as so powerfully unsettling it can "stop you in your tracks."[106] Such humor features prominently in the Balinese theater, which often combines it with

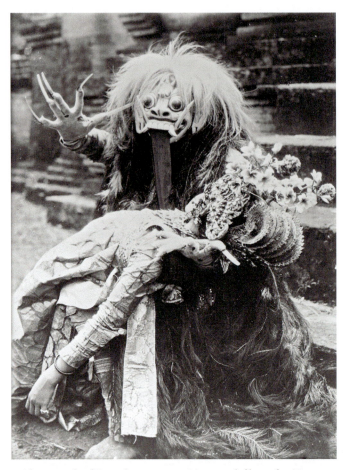

Figure 3.7 Photograph of *Rangda* costume, 1931, wood, fibers, fur. Tropenmuseum, Amsterdam. Collection Nationaal Museum van Wereldculturen. Call. no. TM-10004741. This photograph also appears in "A la Exposition Coloniale La Pavillon des Indes Neerlandaises," *Le Miroir du Mond* 68, June 20, 1931. Associated Press.

the ideas of sacred creativity, engagement with danger, and other ultimately life-affirming activities in the same performance. The displaced penis/necktie in Dubuffet's painting suggests vulnerability and dissociation *à la* Artaud. But like the *Rangda*'s tongue and the *Barong*'s beard, this displaced phallus may also signify the power of altered states of being and creative transformations. For Dubuffet, as for Artaud, even humorous art is more than merely a joke; it is a trigger with which to unleash a strike against the viewer's sensibilities.

The similarity of the *Rangda* costume to Dubuffet's portrait parallels the relationship between the character and the performer in Balinese theater. Although the *Rangda* is gendered female, a male actor performs the role based

on tradition and sacred, apotropaic ritual. Because the costume is believed to be capable of invoking evil spirits and possession by black magicians, it is animated by *anak ṣakti,* men in touch with sacred feminine forces conceived of as the creative matrix. Although the sanctioned performers are men, *ṣakti* is the female principle in Hinduism, which Indian travelers spread to Indonesia in antiquity. Balinese theater also expresses this dualism as tension between order and chaos, movement and stasis, and so on.[107] The photograph from the early twentieth-century performance in Paris shows the *Rangda* figure poised dramatically, one arm raised in a manner Dubuffet appears to have seized upon for his portrait (see also a comparably posted performer in Figure 3.8). Dubuffet, whose

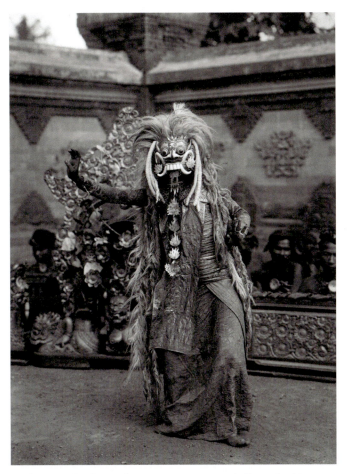

Figure 3.8 Photograph of *Rangda* costume, 1929, wood, fibers, fur. Tropenmuseum, Amsterdam. Collection Nationaal Museum van Wereldculturen. Call. no. TM-60042916. Photograph: S. Satake, Tosari Studio. Public Domain.

portraits demonstrate a fondness for comingling opposites, may well have played with this notion of dual gender in rendering Artaud, whose own drawings sometimes featured hermaphrodites.[108] As a sign of opposing cosmic forces, sacred performance, and invigorating enthrallment, this costume would surely have appealed to Dubuffet as much as Artaud's writings on its effects, providing Dubuffet with inspiration for his portrait.

As with the *Barong* costume, Dubuffet could have easily encountered this and other photographs of the *Rangda* costume in the popular press coverage of the Colonial Exposition, possibly reviewing articles after the war in the very libraries where they were archived and where he conducted research of ethnographic materials. It bears repeating that the AID's Paris headquarters housed an archive of texts and photographs related to Indonesian dance and periodically exhibited artifacts and screened films they had taken of performances in Bali. Books by Mead, Covarrubias, and Spies also feature the costume; a photograph in Spies' 1938 *Dances and Drama in Bali* even shows the *Rangda* as literally doubled— enacted by *multiple* costumed actors in a single performance staged to produce discomfiting effects (Figure 3.9).[109] Given Dubuffet's background in Surrealism, his penchant for ethnographic research, and his chosen subject of Artaud, it is

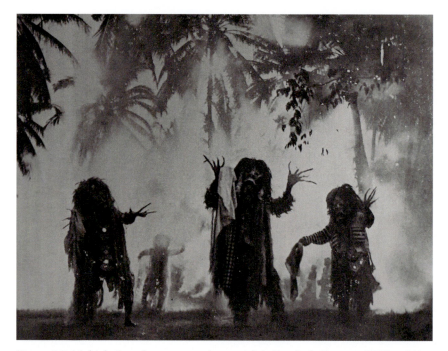

Figure 3.9 Multiple *Rangda* costumes, photograph in Beryle de Zoete and Walter Spies *Dance and Drama in Bali*, (1938.) Kuala Lumpur; Oxford University Press, 2002).

unlikely that this creative doubling in the costume would have escaped the artist's attention.

The *Rangda* costume disquiets, thrills, and frightens. As a means to entrance other characters and even the viewers, the dancing actor vibrates the costume's long, claw-like fingers.[110] This "rippling of joints, a musical angle made by the arm with the forearm ... and fingers that seem to be coming loose from the hand" captured Artaud's imagination, surpassing anything he had experienced in Western performance and producing the effects he likened to "a play of mirrors, in which human limbs seem resonant with echoes."[111]

Dubuffet's portrait re-articulates the claw-like hands and theatrical gestures in the exposition photograph considered here (see Figure 3.7). Raising its right arm, elbow bent at an odd angle, Dubuffet's figure doubles the pose of the costumed actor. The figure's arcing left arm also echoes the costumed performer, who, with that arm, balances an actress feigning entrancement. This picture might have particularly appealed to Dubuffet given the fact that he, Artaud, and even Bachelard likened cultural habitude to a form of sleepwalking that is diametrically opposed to creative vitality. Dubuffet's painting of Artaud is as disturbing as, yet less threatening than, the demon depicted in the photograph, suggesting instead an amalgam of Balinese theatrical forms—a conglomeration of archetypal traits enacted and visually merged by the *Barong* and *Rangda* during part of the dance when their two faces touch.[112]

Just as Dubuffet would have been aware of Artaud's dual personalities reported by Ferdière, the artist would also have known of Artaud's belief that he was persecuted by demons, a condition both Artaud and Ferdière discussed.[113] Dubuffet must have understood Artaud's reputation for wildly theatrical gesture, not only during his performances but also in conversation, during the course of his treatments, and in talking to the demons that he believed tormented him. The portrait comingles the features and gestures of the two demons that most impressed the author about Balinese theater.

With its gangly limbs akimbo, Dubuffet's portrait also calls to mind the Indonesian puppetry from which the Balinese theater is said to have emerged (Figure 3.10). As with dolls and mannequins, puppets resonated for the Surrealists due to the abilities of these forms to conjure feelings associated with lively playfulness, on the one hand, and, on the other hand, deathly stillness that resonated with childhood fears and fascinations. This combination of opposing associations resulted precisely from the juxtaposition of movement (in the figures' mimicry of human, animal, or hybrid forms) and the stasis of these inanimate objects that confound our expectations for living dynamism. In the

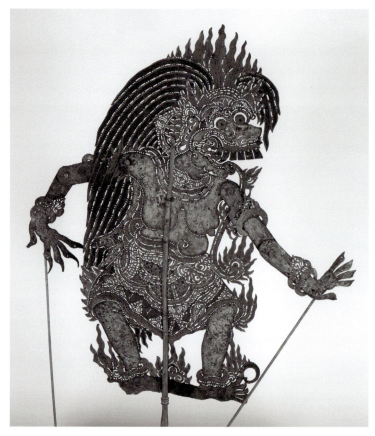

Figure 3.10 *Wajang kulit* puppet, *Rangda*. Tropenmuseum, Amsterdam. Collection Nationaal Museum van Wereldculturen. Call. no. RV-Liefkes-281. Photograph: Nationaal Museum van Wereldculturen.

case of an Indonesian puppet, an artist provides its form but a *Dalang*—a puppeteer conceived of as a shamanistic channeler of vital energies—provides its dynamism. This combination would have intrigued Dubuffet, who both produced puppets (see Figure 1.4) and wrote of "uncork[ing] passages through which the internal voices of savage man can express themselves."[114] This combination surely fit the image of Artaud, who looked to fantastical puppets and mythic figures to create a new and more vibrant reality.

Several aspects of Dubuffet's portrait allude to this fascination with puppetry and, I argue, to its specifically Indonesian forms. Two oddities of the portrait in particular—the strangely attached arms and crooked, unstable legs—suggest *wayang golek* (three-dimensional wood), *wayang Krucil* (low relief wood), and *wayang kulit* (carved leather) puppets, each of which the puppeteer holds upright

and which feature angular, jointed arms that the puppeteer moves by manipulating sticks attached to the wrists. The visual connection between portrait and puppet is perhaps most striking in the bizarre pose and odd angles of the figure's arms, its right arm suggesting jointed elements controlled mechanically, its left arm arced in a rounded, seemingly cutout shape. Moreover, the figure's spindly, impossibly-posed legs reinforce the idea that they are not functional supports. Along with the inverted funnel-shaped negative space between them, they suggest a figure held up on a stick or, alternately, a hollow Lyonnais sock puppet such as Dubuffet himself produced. The wide head in the portrait also mimics these puppets and its upward thrust calls to mind the way in which these particular puppets enter a stage (in this case the picture plane) from below. Such features indicate that Balinese theater appealed to both Dubuffet the painter and Dubuffet the puppeteer. The flatness, angularity, and subdued brownish hues of his two smaller portraits of Artaud also resemble the cut out forms of Indonesian shadow puppets, though these smaller portraits lack the gesturing limbs of the larger painting and their overall impact is of jarring stillness (Figure 3.11).

Although it is reasonable to assume that the wide array of Balinese artifacts shown at the Dutch Pavilion at the 1931 Colonial Exposition included the puppets that feature so prominently in Balinese culture, a photograph in *Vu Magasine* confirms that the exhibition featured strikingly similar Javanese counterparts.[115] In addition to the likelihood that Dubuffet saw the Dutch Pavilion and its artifacts in 1931, he could have seen this or a comparable photograph in the extensive press coverage of the exposition or in any number of ethnographic publications or archives during the period leading up to creating his portrait. He might also have seen examples if he traveled with his *Guignol* teacher to Lyon, a center of puppetry and puppet collecting (that is now home to a world puppet museum) when he began producing puppets and masks during the 1930s.[116] Dubuffet could certainly have seen Indonesian puppets during his trip to Holland (Indonesia's colonial occupier) in 1932.[117] The Swiss ethnographic museums he visited with Paulhan in 1945 also housed substantial Indonesian collections and the artist might have seen such artifacts in other Swiss or French venues. He surely read about such puppets in Artaud's book and in the writings of friend Henri Michaux, which I discuss in relation to the portraits of that author/artist in Chapter 4.

The quasi-sculptural qualities of Dubuffet's *haute pâte* may have had more in common with low relief wood and carved leather shadow puppets than with their more three-dimensional counterparts. And these low relief puppets, situated somewhere between two- and three-dimensionality, would have surely

Figure 3.11 Jean Dubuffet, *Portrait d'Antonin Artaud cheveux épanouis* (Antonin Artaud with Blooming Hair), August 1946, pencil and gouache on paper, 41.5 × 33 cm. (16.3 × 12.9 in.). © Fondation Dubuffet, Paris / 2020 Artist Rights Society (ARS), New York—ADAGP, Paris. Private collection, Germany. Photograph courtesy of the Fondation Dubuffet, Paris. Reproduced in Jean Dubuffet, *Catalogue des travaux de Jean Dubuffet*, Fascicule III (Paris: Fondation Dubuffet, 2003), 31, no. 29.

appealed to Dubuffet the painter and mixed-media sculptor. The monochromatic planar forms of the portrait, so different in this respect from colorful Balinese costumes, mimic the two-dimensionality and coloration of some shadow puppets—and all shadow performance seen from the audience opposite the illuminated screen. To the extent that Dubuffet worked within the modern problematic of painting as both an object and a two-dimensional representation, low relief shadow puppets (some of which had impacted French visual culture since the inception of the famous Chat Noir theater) are logical visual sources.

The portrait's color scheme of flesh-colored pigment over a dark, earthy background both suggests and inverts the hues of shadow puppetry, which casts dark silhouettes on a pale screen. Intriguingly, and, I believe, of interest to Dubuffet, in Balinese shadow puppetry, some viewers watch the performance while sitting with the puppeteer behind the screen and thus see the performance directly—in its true colors—rather than in shadow.[118] Such an interplay between seemingly-direct versus mediated representation must have appealed to Dubuffet, who believed that authentic art resulted from channeling inner creative forces—vital energies that resonate with all that surrounds them.[119] Impacted by what James Clifford describes as an ethnographically Surrealist interwar milieu in which juxtapositions were made between making the strange familiar in ethnography and making the familiar strange in Surrealism, Dubuffet would have also appreciated the fact that, like the Balinese theater it spawned, Balinese shadow puppetry was (and still is) performed for both entertainment and sacred ritual and is likewise thought capable of transporting the viewer to altered and vivifying states of awareness.[120]

Just as Balinese audiences see the *Dalang* in Balinese puppetry as a conduit to authentic experience, so too did Dubuffet envision the artist as a visionary. His artistic aims were thus strikingly similar to Artaud's claims that the Balinese theater was a magical agent whose elaborate forms and enthralling dances (Balinese theater features a variety of electrifying "trance dances") could awaken the viewer from a culturally induced automatism.[121]

Both men wanted to create a kind of inverse trance dance in order to create an enlivening artistic encounter. Delivering Artaud's awakening jolt, Dubuffet hoped also to "short circuit" and re-situate meaning. In contrast to "cultured" art, which relies upon enthralling notions of beauty, symmetry, and gracefulness, Dubuffet meant to shock, transfix, and transform the viewer with disorienting asymmetry, distortion, and hybrid, alien-seeming forms. His aims in this regard aligned with Artaudian theater but for one crucial difference—Dubuffet's "short circuiting" of meaning presupposes the possibility of art's (albeit opaque) intelligibility and the interpretive agency of both the artist and the viewer. In other words, for Dubuffet, affect worked in tandem with intellect, never negating the capacity of the viewer to "re-act" (imaginatively re-enact) the artistic movements that foster creative experience.[122]

"Art is a language," Dubuffet attested, an "instrument of knowledge, [an] instrument of expression"—or, one might say, art combines thinking and feeling to inspire the thrill of interpretation.[123] Adding that "painting has a double advantage" over verbal language, Dubuffet asserted its power to "conjure objects with greater

strength" and "open to the inner dance of the painter's mind a larger door to the outside."[124] Notions of primal (pre-linguistic) forces that "move" the viewer to feel and act in certain ways (as laid out in *The Theater and Its Double* and certain forms of affect theory) resonated with some of Dubuffet's writings on art and, perhaps, his notion of Art Brut as the product of a primal creative impetus. Yet, the overarching themes of his painting and writing indicate that he wanted (and believed in) more for his art and, importantly, from his viewer, in whom "a whole inner mechanism" must "start working."[125] Adding that art "has always been considered in this way by [so called] primitive peoples," Dubuffet's art was not meant to suggest a mere return or re-attunement to a state of primal affective response (mere physiology) but rather a "turn," a movement toward embracing the *dual* nature of thinking-and-feeling human experience. Affect, the viewer's deep, physiologically experienced emotive reaction, was one of two responses Dubuffet hoped to instigate; the other was interpretive. The exploration of Artaudian affect thus marked a unique moment in Dubuffet's career—a moment in which he probed the relationships between inner creativity, the physicality of his art, and the embodied (and ultimately enculturated) experiences of the viewer.

Notes

1 Jean Dubuffet, letter to Florence Gould August 9, 1946, Fondation Dubuffet. Gould was an American expatriate and arts patron married to art collector Frank J. Gould. Dubuffet visited and corresponded with Mrs. Gould regularly and in this particular letter he proclaims: "Dans quelle aventure vous m'avez jete! Rien n'etait plus loin de ma pensee que de faire de portraits! je n'avais pas la moindre idee de cela! Eh bien me voila maintenant embarque dans cette affaire, es tout a fait passionee." (What an adventure you have thrown me into! Nothing could have been further from my thoughts than making portraits! I hadn't the least idea of doing that. Now I have embarked in this endeavor altogether passionately.) See also Jean Dubuffet, *Biographie au pas de course* (Paris: Gallimard, 2001), 53–55.

2 Jean Dubuffet to Jean Paulhan, January 15, 1946, in *Correspondance: 1944–1968* (Paris: Gallimard, 2003), 274; Jacques Derrida and Paule Thévenin, *The Secret Art of Antonin Artaud*, trans. Mary Ann Caws (Cambridge, Mass: MIT Press, 1998), 32, 52–53 and notes 79–81. According to Derrida and Thévenin, "One of the first portraits [done by Artaud] in Paris is that of Jean Dubuffet, on the afternoon of August 27, 1946. And it is not without importance that it should be the portrait of a painter." They add that during the course of a rendezvous between Artaud and poet

Jacques Prevel, "Jean Dubuffet, who, in the days before, had done from memory two portraits of Antonin Artaud, shows them to him." According to Derrida and Thévenin, Artaud's portrait of Dubuffet was never returned after Artaud's exhibition at the Galerie Pierre.

3 For more on Artaud's drawings, how he conceived of them, and their public reception, see Margit Rowell, ed., *Artaud: Works on Paper* (New York: Museum of Modern Art, 1996), which can be viewed in its entirety on the Museum of Modern Art website, https://www.moma.org/documents/moma_catalogue_292_300001756.pdf (accessed January 12, 2018); for Artaud's interwar writings on art and magic, I refer primarily to Antonin Artaud, *The Theater and Its Double*, trans. Mary Caroline Richards (New York: Grove Press, 1958); writings by Artaud in *Artaud on Theatre*, eds. Claude Schumacher and Brian Singleton (Chicago: Ivan R. Dee, 2001); and Evelyne Grossman, ed., *Antonin Artaud: 50 Drawings to Murder Magic*, trans. Donald Nicholson-Smith (New York: Seagull, 2008).

4 Antonin Artaud to Jean Paulhan, January 25, 1936, in *Correspondance: 1944–1968*, 269–270; Artaud, "The Theatre and Its Double," in Schumacher and Singleton, 97, See also Artaud, *Œuvres complètes*, V (Paris: Gallimard, 1956), 196–7.

5 Artaud, "The Theatre and Its Double," in Schumacher and Singleton, 97.

6 Jean Dubuffet, "Notes for the Well-Read," in Mildred Glimcher, et al., *Jean Dubuffet: Towards an Alternative Reality*, trans. Joachim Neugroschel (New York: Pace Publications, 1987), 8.

7 Dubuffet, "Notes for the Well-Read," in Glimcher, 81; see also Geneviève Bonnefoi, *Jean Dubuffet* (Caylus: Association mouvements, 2002). Bonnefoi also discusses Dubuffet's work in terms of disorientation and a thematic of movement, though she does not develop these ideas in relation to Dubuffet's portrait, to the writings of his sitters, or to the Indonesian cultural forms I consider in this chapter.

8 Dubuffet, "Notes for the Well-Read," in Glimcher, 81; Dubuffet, *Asphyxiating Culture and other Writings*, trans. Carol Volk (New York: Four Walls, 1986), 101; Artaud, "The Tragedy 'The Cenci' at the Folies-Wagram," in Schumacher and Singleton, 165.

9 André Breton, "First Manifesto of Surrealism," in *Art in Theory 1900–2000*, ed. Charles Harrison and Paul Wood (Malden, Mass: Blackwell Publishing, 2000), 451; see also Hal Foster, "Blinded Insights: On the Modernist Reception of the Art of the Mentally Ill," *October* 97 (Summer, 2001): 3–30.

10 Jean Dubuffet, "Anticultural Positions," a 22-page facsimile of the artist's manuscript notes [handwritten in English] for a lecture at the Arts Club of Chicago on December 20, 1951, in *Dubuffet and the Anticulture* (New York: R. L. Feigen & Co., 1969), 18–19; Dubuffet, *Asphyxiating Culture and other Writings*, 101.

11 For more on duality in Surrealist theory, see André Breton, *Communicating Vessels* (1932), trans. Mary Ann Caws and Geoffrey T. Harris (Lincoln, Nebraska: University of Nebraska Press, 1990) among other texts.

12 Gaston Bachelard, *The Philosophy of No: A Philosophy of the New Scientific Mind*, trans. G. C. Waterson (New York: Orion, 1968), a translation of Bachelard, *La philosophie du non: essai d'une philosophie du nouvel esprit scientifique* (Paris: Presses universitaires de France, 1940); Gaston Bachelard, "Introduction," in *The Poetics of Space*, trans. Maria Jolas (New York: Orion, 1964), xi–xii, xiv–xv; see also Stephanie Chadwick, *Disorienting Forms: Jean Dubuffet, Portraiture, Ethnography*, Thesis (Ph.D.), Rice University, 2015; Jill Shaw, *A Coat that Doesn't Fit: Jean Dubuffet in Retrospect, 1944–1951* (Ph.D. diss., University of Chicago, 2013). Shaw's dissertation also explores Dubuffet's work in terms of conceptual "breaks," considering his utilization of creative breaks from the routine of working in Paris in order to revitalize his oeuvre with fresh bodies of work.

13 Dubuffet, "Notes for the Well-Read," in Glimcher, 81.

14 The full citation for Artaud's *The Theater and Its Double* appears in note 3 above.

15 Artaud, *The Theater and Its Double*, 53–67.

16 Dubuffet, letter to photographer Daniel Wallard, December 20, 1944, in "Jean Dubuffet Correspondence and Papers, 1944–1984," records of the Getty Research Institute. Dubuffet encourages Wallard (a French photographer who associated with members of the French avant-garde) about an upcoming trip to Paris, advising: "Il faut voir aussi mon ami le Dr. Jacques Lacan, psychiatrist, il a une consultation à Ste Anne" (You must also see my friend Dr. Jacques Lacan, a psychiatrist who has a post at St. Anne); this was a mental hospital that collaborated with Dr. Gaston Ferdière (Artaud's psychiatrist) to exhibit the art of mental patients. For more on Jacques Lacan's conceptualization of symbolic castration and the fragmented self, see his *Ecrits: the first complete edition in English*, trans. Heéloïse and Bruce Fink (New York: W.W. Norton & Co., 2006); and the *Stanford Encyclopedia of Philosophy*, "Jacques Lacan," http://plato.stanford.edu/entries/lacan/ (accessed July 28, 2015).

17 Artaud, *The Theater and Its Double*, 7.

18 Jean Dubuffet to Jean Paulhan, December 11, 1945, in *Correspondance: 1944–1968*, 269–270. Dubuffet writes: "Je lis Le Théâtre et son double d'Antonin Artaud et suis émerveillé d'y trouver justement les mêmes idées que les miennes" (I am reading *The Theater and its Double* by Antonin Artaud and am amazed to find there the same ideas as mine).

19 Dubuffet, "Anticultural Positions," 3.

20 Artaud, *The Theater and Its Double*, 8.

21 Artaud, "The Alfred Jarry Theater (1926–7)," in Schumacher and Singleton, 31.

22 Malcolm Haslam, *The Real World of the Surrealists* (New York: Rizzoli, 1978), 12–130; Stephen Barber, *Blows and Bombs* (New York: Creation, 2003), 6.

23 Susan Sontag, ed., *Antonin Artaud: Selected Writings* (New York: Farrar, Strauss, and Giroux, 1973), xxvii. For more on the dissident or ethnographic Surrealists as fellow travelers who broke with Breton while retaining many core Surrealist interests, see

James Clifford, "On Ethnographic Surrealism," in *The Predicament of Culture* (Cambridge: Harvard University Press, 1988), 542.

24 Gaston Ferdière, *Nouveau écrits de Rodez*, ed. Evelyne Grossman, *Œuvres* (Paris: Gallimard, 2004), 54; Barber, *Blows and Bombs*, 141. Related information can also be found in a letter from Gaston Ferdière to Jean Paulhan, January 18, 1946, File Antonin Artaud, Fondation Dubuffet Archives, which discusses Artaud's condition.

25 Jacques Lacan, "La Famille" in *Encyclopédie française* (Paris: A. de Monzie,1938); Jacques Lacan, *The Seminar of Jacques Lacan: Family Complexes in the Formation of the Individual*, trans. Cormac Gallagher (Dublin: Cormac Gallagher School of Psychotherapy St. Vincent's Hospital, 2003); Lacan, "The Mirror Stage as Formative of the Function of the I," in *Ecrits: the first complete edition in English*, trans. Héloïse and Bruce Fink (New York: W.W. Norton & Co., 2006), 75–81. Lacan had been studying fragmented identity since his dissertation, but over time he synthesized these ideas into his famous theory of the Mirror Formation of Identity, which he initially discussed in a 1936 lecture, iterated in subsequent variations, and also published in the *Revue Francais de Psychanalyse* 13, no. 4 (1936): 449–455.

26 Artaud, *The Theater and Its Double*, 22.

27 Georg Simmel, "The Metropolis and Modern Life" (1903), in German History in Documents and Images (GHDI), http://germanhistorydocs.ghi-dc.org/about.cfm (accessed January 10, 2020).

28 Artaud, "The Alfred Jarry Theater (1926–7)," in Schumacher and Singleton, 31.

29 Artaud, *The Theater and Its Double*, 11, 13; Artaud, "The Theatre and Its Double," in Schumacher and Singleton, 97.

30 For more on Lacan and the ego, see sources provided in notes 16 and 25 (above).

31 Jean Dubuffet and Philip Kaplan, *Quelques introductions au cosmorama de Jean Dubuffet, satrape* (Paris: Collège de Pataphysique, 1961), 21; information on Dubuffet's involvement with this group can also be found in the letters from Limbour to Dubuffet in the Bibliothèque Armand Salcrou archives, Le Havre, Collège de Pataphysique file, 1958. See also Kent Minturn, "Greenberg Misreading Dubuffet," 130.

32 Artaud, *The Theater and Its Double*, 38, 89, 92–93.

33 Artaud, "The Alfred Jarry Theater (1928)," in Schumacher and Singleton, 38.

34 Artaud, "The Alfred Jarry Theater (1928)," in Schumacher and Singleton, 38.

35 Artaud, *The Theater and Its Double*, 92–94.

36 Artaud, *The Theater and Its Double*, 86.

37 Todd Cronan, *Against Affective Formalism: Matisse, Bergson, Modernism* (Minneapolis: University of Minnesota Press, 2013), 32, 64. For more on affect see also Ruth Leys, "The Turn to Affect: A Critique," *Critical Inquiry* 37, no. 2 (Spring, 2011): 434–472; for more on art historical and philosophical understandings of affect and cognition working in tandem as dual faculties see Robert B. Pippin, *After*

the Beautiful: Hegel and the Philosophy of Pictorial Modernism* (Chicago: University of Chicago Press, 2014). *Affect* is a contested term referring to the triggering of physiological, pre-emotive responses, which some scholars argue supersede meaning. As Leys persuasively argues, the primacy that affect theorists attribute to physiology relegates cognition to a secondary function and, effectively, underestimates the active agency of the artist and viewer.

38 Dubuffet, "Notes for the Well-Read," in Glimcher, 78.

39 Dubuffet, "Art Brut Chez Dubuffet," in *Prospectus et tous écrits suivants*, Vol. IV (Paris: Gallimard, 1967), 41–42, 49.

40 Jean Dubuffet to André Breton, May 25, 1948; Jean Dubuffet to André Breton, July 3, 1948, archives of the Fondation Dubuffet and the Bibliotheque Doucet; Dubuffet, "A Word About the Company of Art Brut," in *Asphyxiating Culture*, 109. Dubuffet's and Breton's correspondence regarding Art Brut and other matters is available in the above archives and some of them are published in Dubuffet's *Prospectus et tous écrits suivants* (full citation in note 39 above). For more information on Dubuffet, Breton and *L'Amis d'Artaud*, see Rowel, 162.

41 Sontag, *Antonin Artaud,* xxiv, xxv, 11. For more on Dubuffet's many Surrealist acquaintances, see also my discussion in Chapter 1 and Dubuffet, *Biographie au pas de course*, 21–22; Jean Dubuffet to Jacques Berne, February 8, 1947, in *Lettres à J.B.: 1946–1985* (Paris: Hermann, 1991), 6–8; André Masson, *Les Année Surréalistes: Correspondences 1916–1942* (Paris: La Manufacture, 1990), 28–29; André Masson, in Kristy Bryce and Mary Ann Caws, *Surrealism and the Rue Blomet* (New York: Eklyn Maclean, 2013), 43; Derrida and Thévenin, *The Secret Art of Antonin Artaud*, 9. Derrida and Thévenin write: "So Antonin Artaud almost completely stops drawing toward 1924. At that time he frequents the rue Blomet where André Masson had set up his studio with Miró, Dubuffet, and Malkine as neighbors." Masson's writings also recall Dubuffet's and Limbour's visits to the Surrealist circles of the studios on the Rue Blomet in the early 1920s. When Masson vacated his studio, it was rented by Surrealist poet Robert Desnos, who continued Surrealist activities at that location.

42 Dubuffet, "Art Brut Chez Dubuffet," in *Prospectus et tous écrits suivants*, 49.

43 Dubuffet, "Art Brut Chez Dubuffet," 41; see also John Maizels, *Raw Creation: Outsider Art and Beyond* (London: Phaidon Press Limited, 1996), 31–32.

44 Dubuffet, "Notes for the Well-Read," in Glimcher, 69.

45 Dubuffet, "Notes for the Well-Read," in Glimcher, 69, 70, 73.

46 André Breton, *Communicating Vessels* (full citation in note 11 above).

47 Sigmund Freud, "The Uncanny," in *The Standard Edition of the Complete Psychological Works of Sigmund Freud*, vol. XVII, ed. and trans. James Strachey (London: Hogarth Press, 1974), 219–253; Hal Foster, *Compulsive Beauty* (Cambridge: MIT Press, 1993), 8; see also Pieter Borghart and Christophe Madelein, "The Return of the Key: The Uncanny in the Fantastic," *Image and Narrative: Online Magazine of*

the Visual Narrative, ISSN 1780–678X, http://www.imageandnarrative.be/inarchive/uncanny/borghartmadelein.htm (accessed August 19, 2019).

48 Kent Minturn, *Contre-Histoire: The Postwar Art and Writings of Jean Dubuffet* (Ph.D. diss., Columbia University, 2007), 84. See also a discussion of Dubuffet's portraits in Kent Minturn, "Physiognomic Illegibility: Jean Dubuffet's Postwar Portraits," in *Jean Dubuffet: "Anticultural Positions"* (New York: Acquavella Galleries, 2016), 37–62.

49 André Breton, *Nadja* (New York: Grove Press, 1960), 19–20. For more on Breton's thoughts on the marvelous world of signs see also *Mad Love* (*L'amour Fou*) (Lincoln: University of Nebraska Press, 1987) and *Les pensées d'André Breton: guide alphabétique*, ed. Henri Béhar (Lausanne: L'Age d'Homme), 1988.

50 Yve-Alain Bois and Rosalind E. Krauss, *Formless: A User's Guide* (New York: Zone Books, 1997), 138–143.

51 Dubuffet, "Notes for the Well-Read," in Glimcher, 67.

52 For more on Dubuffet's creative approach see the interview with Hubert Damisch in Yve-Alain Bois, Dennis Hollier, and Rosalind Krauss, "A Conversation with Hubert Damisch," *October* 85 (Summer, 1998), 5.

53 Dubuffet, "Notes for the Well-Read," in Glimcher, 67, 69, 84.

54 Foster, "Blinded Insights," 16.

55 See also Foster, *Compulsive Beauty*, 7–9, 20–23. Foster discusses the image of the double in Freud's writing about the concept of the uncanny and considers the ways in which the Freudian uncanny and the Surrealist notion of the Marvelous are intertwined.

56 Roger Caillois, "The Praying Mantis: from Biology to Psychoanalysis" and "Mimicry and Legendary Psychasthenia" in *The Edge of Surrealism: A Roger Caillois Reader*, ed. Claudine Frank (Durham: Duke University Press, 2003), 69–102; see also Sarah K. Rich, "Jean Dubuffet: The Butterfly Man," *October* 119 (Winter, 2007): 46–74. Rich discusses Dubuffet's butterfly collages in relation to theories of mimicry including Caillois's.

57 Dubuffet, "Art Brut Chez Dubuffet," in *Prospectus et tous écrits suivants*, 41–42.

58 Dubuffet, "In Honor of Savage Values," 259.

59 Dubuffet, "Art Brut Chez Dubuffet," in *Prospectus et tous écrits suivants*, 45. Discussing his initial interest in researching Art Brut (in this case, of the artist Anton Müller), Dubuffet acknowledges that he wants to know "Who this artist was!" adding: "Of course it isn't so important to establish a connection with the biography. The pictures can stand alone. But I am always greatly curious. I want to link the work with a mind." Since Dubuffet acknowledges his interest in the personalities of the Art Brut producers he researched, it is not so surprising to find hints of his sitter's personality in his rendering.

60 Jean Dubuffet to Jean Paulhan, December 11, 1945, in *Correspondance: 1944–1968*, 269–270.

61 Pierre Chaleix, "Presentation," in *Nouveau écrits de Rodez* by Gaston Ferdière (Paris: Gallimard, 1977); Artaud and Evelyne Grossman, *Œuvres* (Paris: Gallimard, 2004), 1757–1759, 1762–1763; Barber, *Blows and Bombs*, 139–140; Guillaume Fau and Jean-Noël Jeanneney, *Antonin Artaud* (Paris: Bibliothèque Nationale de France, 2006), 45; Rowell, *Artaud: Works on Paper*, 11, 161–162; Valérie Da Costa and Fabrice Hergott, *Jean Dubuffet: Works, Writings, and Interviews*, trans. Ann King (New York: Distributed Art Publishers, 2006), 12–13; Dubuffet, *Biographie*, 55. At the outbreak of World War II, Artaud suffered horrible conditions, including starvation, in the Ville-Evrard institution before the intervention that transferred him to Rodez. Rowell documents Dubuffet's pivotal role in gaining Artaud's subsequent release from Rodez to the private Ivry-sur-Seine clinic run by Dr. Achille Delmas. Dubuffet and members of the by-then-historical avant-garde founded a committee to provide for Artaud's care. They also raised funds by performing Artaud's work and by auctioning paintings donated by a range of artists, including Georges Braque and Pablo Picasso. Artaud had always dabbled in drawing and painting, and he intensified his efforts under Ferdière's care. Artaud's portraits, however, were made mostly after his transfer to Ivry.

62 Barber, *Blows not Bombs*, 26, 139–140; Dubuffet, *Biographie*, 20–22; Da costa and Hergott, 12–13; Dubuffet and Daniel Abadie, *Dubuffet* (Paris: Centre Pompidou, 2001), 354, 469–70. Barber places Dubuffet's and Artaud's meeting in 1923. As indicated in note 31 above, information on Dubuffet's interest in playwright Alfred Jarry and in Artaud's Jarry Theater can also be found in the letters from Limbour to Dubuffet in the Bibliothèque Armand Salcrou archives, Le Havre, Collège de Pataphysique file, 1958.

63 Jean Dubuffet to Jean Paulhan, January 22, 1946, in *Correspondance: 1944–1968*, 277. Dubuffet writes to Paulhan that "Ferdière ne se content pas d'intercepter les dessins, il intercepte aussi les lettres" (Ferdière is not content to intercept the [Artaud's] drawings, he also intercepts the letters). See also notes 16 and 61 (above).

64 Jean Dubuffet to Jean Paulhan, Augsust 16, 1947, in *Correspondance(s)*, 450. In this letter Dubuffet discusses Artaud's portrait exhibition.

65 Dubuffet, "How to Make a Portrait," in "Notes for the Well-Read," in Glimcher, 78; "Art Brut Chez Dubuffet," in *Prospectus et tous écrits suivants*, 42; Artaud and Grossman, 1763; Jacques Derrida and Paule Thévenin, 52–53. Dubuffet's allusion to memory may at first seem inconsistent with his Modernist appeal to spontaneity, and to a degree it is. But it is consistent with Modern privileging of the sketch conceived of as closer to the creative impulses of the artist. Moreover, Dubuffet likened his "extraction" to a kind of excavation of buried creative forces, aiming to release this creativity rather than recreate a surface likeness (or psychological study) of his sitter.

66 Hans Prinzhorn, *Artistry of the Mentally Ill* (New York: Springer-Verlag, 1972), 146. Prinzhorn used pseudonyms to protect patients' identities.

67 Hal Foster, "Blinded Insights," 16. Also in Foster, *Prosthetic Gods* (Cambridge, Mass: MIT Press, 2004), 205; for a foundational discussion of Beil/Beehle's artwork see Prinzhorn, *Artistry of the Mentally Ill*, 240–248.

68 Hal Foster, "Blinded Insights," 16.

69 Jean Dubuffet to Jean Paulhan, January 8–9, 1947; Barber, *Blows and Bombs*, 183–184. Artaud and Breton had fallen out in 1926 after a quarrel about Artaud's hyperbolic and overly aggressive staging of the Alfred Jarry Theater, and they had only tentatively reconciled. Despite the fact that Artaud and Breton had a tense relationship, however, the Surrealist leader participated in *L'Amis d'Artaud*, helping to raise money for Artaud's care and for his performance. Dubuffet discusses this in his letter to Paulhan but does not, to my knowledge, discuss the performance afterward.

70 Artaud, *The Theater and Its Double*, 72.

71 Dubuffet, "Anticultural Positions," 3. In this same passage Dubuffet uses the term "Mandarin" in a derogatory fashion adopted by Europeans of his time to refer to officials and bureaucrats; rather than reflecting a disdain on Dubuffet's part for Chinese (or any Asian) culture, however, this remark indicates rather his distaste for cultural apparatuses.

72 For a notable exception see Shaw, Chapter Two, "Electroshock," in *A Coat that Doesn't Fit*, 52–104 (full citation in note 12 above). Although Shaw focuses on the works Dubuffet created during or as a result of his trips to Algeria, she considers them in relation to the broader history of Orientalism, arguing that they represent a more complex set of artistic goals that included efforts to invigorate his processes with the "cultural electroshock" instigated by his North African trips.

73 Significant discussions of Dubuffet and Artaud include Minturn, *Contre-Histoire*; Minturn, "Physiognomic Illegibility" in expanded note 48 above; Jean H. Duffy, "Dubuffet Plays Hide-and-Seek: Lineage, Reflexivity, and Perception in Coucou Bazar," *The Art Bulletin* XCVII, no. 2 (June, 2016): 237–260; Duffy, "Jean Dubuffet's Beautiful People," *Word & Image* 35, no. 2 (June, 2019): 191–209; and Scott B. Hamilton, *Dubuffet and Ubu Roi: The Influence of Antonin Artaud on Jean Dubuffet* (M.F.A. Thesis, Ohio University, August, 1996), 10–11, 27, 42–43, 50–51. Minturn emphasizes the (anti-narrative) incommunicability of Dubuffet's *Antonin Artaud aux houppes*. Duffy's "Jean Dubuffet's Beautiful People" mentions a few of Dubuffet's titles referencing forms of Asian theater in his portrait series and her "Dubuffet Plays Hide-and-Seek" discusses Dubuffet's exploring of performance and perception in his 1971–1973 and 1978 productions of *Coucou Bazar*, theatrical works she sees as influenced by Artaud's Alfred Jarry Theater. Hamilton considers the portrait series in relation to Artaud's Alfred Jarry Theater. But he handles the question of "influence" more biographically than formally, focusing on times and places the artist and writer may have had contact during the 1920s (10–11) and arguing that since Dubuffet was

only crystalizing his art theory during the 1940s, his contact with Artaud during that period was formative (27). See also my own 2015 dissertation cited in note 12 above.

74 Artaud, *The Theater and Its Double*, 62, also see 58, 60, 93–94, 123; and Artaud, "The Theater of Cruelty," in Schumacher and Singleton, 114. In the latter text Artaud, proclaims: "In this archetypal theater language will be formed around staging not simply viewed as one degree of refraction of the script, but as the starting point for theatrical creation."

75 Artaud, *The Theater and Its Double*, 58; Dubuffet, "Notes Du Peinture: Portaits," in Georges Limbour, *Tablea bon levain à vous de cuire la pate* (Paris: René Drouin, 1953), 91–92, quoted and translated in Minturn, *Contre-Histoire*, 110–111. See also Duffy, "Jean Dubuffet's Beautiful People," esp. 191, 199, 201. Duffy discusses Dubuffet's depersonalization of his portrait subjects as a way to suggest fundamental human likenesses and experiences.

76 Artaud, *The Theater and Its Double*, 48.

77 C. G. Jung, *The Archetypes and the Collective Unconscious* (Princeton, NJ: Princeton University Press, 1968). Originally published in 1934, Jung's book conceived of "a deeper layer" of the subconscious, "which does not derive from personal experience and is not a personal acquisition" but is instead universal and contains "contents and modes of behavior that are more or less the same everywhere and in all individuals" (3). Although, as noted in Chapter 2, Dubuffet's writings show little interest in specific archetypes, such as the Anima (male) or Animus (female) personas conceived by Jung, the artist's writings on archetypes and common experience suggest affinity with Jungian psychology.

78 Gaston Bachelard, *The Poetics of Space*, xi–xii. See also Duffy, "Jean Dubuffet's Beautiful People," 196, 199. Duffy conceives of Dubuffet's portraits as depending upon depersonalized and abstracted "templates," with which he suggested common human experience.

79 Dubuffet, "Notes for the Well-Read," in Glimcher, 78. Dubuffet writes: "In the subjects I paint I like to avoid anything fortuitous, I like to paint universal data," adding that "if I paint the likeness of a man, all I want my painting to do is evoke a human face, but without accidental peculiarities, which are really so insignificant."

80 Artaud, *The Theater and Its Double*, 85.

81 Artaud, *The Theater and Its Double*, 56, 85, and Artaud, "Theater and Cruelty," in Schumacher and Singleton, 122. See also Barber, *Blows and Bombs*, 26, 57; Dubuffet, "In Honor of Savage Values," 265; and Dubuffet, "Notes for the Well-Read," in Glimcher, 81.

82 Antonin Artaud, "Le Théâtre balinais, à l'Exposition Coloniale," *La Nouvelle Revue Française*, no. 217 (October, 1931).

83 Artaud, *The Theater and Its Double*, 57. Artaud adds that "these three-dimensional hieroglyphs are in turn brocaded with a certain number of gestures—mysterious

signs which correspond to some unknown, fabulous, and obscure reality which we here in the Occident have completely repressed." He discusses these ideas throughout the book; some other instances can be found on pages 26–27, 31, 54–55, 61.

84 Minturn, *Contre-Histoire*, 110; Minturn, "Physiognomic Illegibility," 37–62.

85 Abadie, 356; Fondation Dubuffet, http://www.dubuffetfondation.com/bio_set_ang. htm (accessed November 30, 2014). During the early 1930s, Dubuffet lived in Saint-Mandé and ran a wine wholesale business in Bercy.

86 For more on the joint Surrealist and French Communist Party counter exposition, see Jody Blake, "The Truth about the Colonies, 1931: Art Indigene in Service of the Revolution," *Oxford Art Journal* 25:1 (2002): 35–58; see also Janine Mileaf, "Body to Politics: Surrealist Exhibition of the Tribal and the Modern at the Anti-Imperialist Exhibition and the Galerie Charles Ratton," *RES: Anthropology and Aesthetics*, no. 40 (Autumn, 2001): 239–255.

87 Two of many press articles dealing with the 1931 Paris Colonial Exposition are *L'Illistration*, no. 616, August 22, 1931; and *Le Mirroir du monde*, no. 68, June 20, 1931. The exposition ran from May to November, and around 33 million people are reported to have attended. In July the Dutch Pavilion caught on fire and suffered major damages, including the loss of the Balinese stage, forcing performers to work on the ground, as in traditional Balinese theater. For comprehensive discussions of Parisian ethnographic institutions see Clifford, *The Predicament of Culture* (full citation in note 23 above); and Daniel Sherman, *French Primitivism and the Ends of Empire, 1945–1975* (Chicago: University of Chicago Press, 2011), 23–36. The Musée de l'Homme was formed in part by the efforts of Dubuffet's acquaintance and College de sociologie affiliate Paul Rivet from a reworking of the collection of Le Musée d'Ethnographie du Trocadero after the 1937 Colonial Exposition. Le Musée Nationales des Arts d'Africains et Océaniens formed as a permanent collection at the site of the previous Colonial Exposition in 1931 and remained on the original site at Vincennes until it was merged with the Parisian ethnographic collections now housed at the Musée du Quai Branly. For more on films about Bali, see Michelle Chin, "Bali in Film: From the Documentary Films of Sanghyang and Kekak Dance (1923) to Bali Hai in Hollywood's *South Pacific* (1958)," http://michellechin.net/writings/04.html (accessed January 21, 2018).

88 Beryl De Zoete and Walter Spies, *Dance & Drama in Bali* (1938) (Hong Kong: Periplus Editions, 2002), 95–97; for more on the AID see Inge Baxmann, *Les archives internationales de la danse: 1931–1952* (Pantin: Centre National de la Danse, 2006). This group conducted extensive field work in Indonesia and researched and collected Balinese, Javanese, and Sumatran costumes, puppets, and other performance-related artifacts they made publicly available at their Paris headquarters, where they featured a permanent collection, held special exhibitions

that attracted the French avant-garde, and maintained a library of photographs, films, audio recordings, and other ethnographic documentation. The AID closed during World War II, at which time member Clair Holt brought many photographs, negatives, and films to New York, which are now archived at the New York Public Library Dance Division. Others remain at the Bibliothèque Nationale de France, Musée de l'Opéra.

89	Gregory Bateson, Margaret Mead, and D. Carleton Gajdusek, *Balinese Character; a Photographic Analysis* (New York: New York Academy of Sciences, 1942).

90	Miguel Covarrubias, *Island of Bali* (1937) (London: KPI, 1986), 334 [Knopf edition, 1946]; see also page xxiii, in which Covarrubias recalls: "On the way back [to New York] we stopped in Paris, where the Colonial Exposition was going on. There we found friends from Bali—the Tjokordes of Ubud, feudal lords of Spies's village, the leaders of the troupe of dancers and musicians that were the sensation of the exposition." Much of the information in Covarrubias's book was published previously in Covarrubias, *Theater Arts Monthly: The Theater in Bali*, xx, no. 8 (August, 1936).

91	A copy of the poster for the French release titled *Lune de miel à Bali* can be viewed at the Notre Cinema Website, https://www.notrecinema.com/images/cache/lune-de-miel-a-bali-affiche_395642_26310.jpg (accessed January 27, 2018).

92	Bateson, Mead, and Gajdusek, *Balinese Character*, 164–167; Spies and De Zoete, *Dance & Drama in Bali*, 95–97; I. W. Dibia and Rucina Ballinger, *Balinese Dance, Drama and Music: A Guide to the Performing Arts of Bali* (Singapore: Periplus, 2004), 8–13, 18; Judy Slattum, *Balinese Masks: Spirits of an Ancient Drama* (Hong Kong: Periplus, 2003), 9, 18–19, 99; Mark Hobart, *Music and Ritual*, ed. Keith Howard (The Hague: Semar Publishers, 2006), 9, 99, 190. For additional discussion of Balinese culture and beliefs see also Angela Hobart, *Dancing Shadows of Bali: Theatre and Myth* (London: KPI, 1987).

93	Dubuffet, *Asphyxiating Culture*, 42.

94	Artaud, *The Theater and Its Double*, 61. Artaud writes: "Of this idea of pure theater, which is merely theoretical in the Occident and to which noone has ever attempted to give the least reality, the Balinese offer us a stupefying realization, suppressing all possibility of recourse to words for the elucidation of the most abstract themes—inventing a language of gesture to be developed in space, a language without meaning except in the circumstances of the stage." See also the quote in note 83 above.

95	Artaud, *The Theater and Its Double*, 63. Moreover, according to Artaud (57): "This spectacle is more than we can assimilate, assailing us with a superabundance of impressions, each richer than the next, but in a language to which we no longer hold the key a language in which an overwhelming stage experience seems to be communicated."

96 Artaud, *The Theater and Its Double*, 86. "One does not separate the mind from the body nor the senses from intelligence," Artaud asserted, as he believed such misconceived separation to lie at the root of European cultural atrophy. See also Susan Sontag, *Antonin Artaud*, xxiv, xxv, 11. Sontag notes that the Surrealists equated creativity with the vitality they believed to be stifled in Western culture, the lack of which led to a crisis of consciousness and an artificial sense of separation from one's own carnality.

97 Artaud, *The Theater and Its Double*, 58; see also Nicola Savarese, "Antonin Artaud Sees Balinese Theater at the Paris Colonial Exposition," *TDR* 45, no. 4 (Autumn, 2001): 51–77. In Balinese culture, theatrical costumes are considered sacred, produced by following strictly prescribed formulas to facilitate the easy recognition of archetypal characters. For resources on Balinese dance see citations in note 92 above.

98 Dibia and Ballinger, *Balinese Dance*, 8, 18, 54.

99 Hubert Damisch and Sophie Berrebi, "Writings and Correspondence: 1961–1985: Hubert Damisch and Jean Dubuffet," trans. Nicholas Huckle and Molly Stevens, *October* 154 (Fall, 2015): 18–20.

100 Dubuffet, "In Honor of Savage Values," 259.

101 Artaud, *The Theater and Its Double*, 44, 56.

102 For more on this costume and its symbolic meaning see Bateson, Mead, and Gajdusek, *Balinese Character*, 164–167; Spies and De Zoete, *Dance & Drama in Bali*, 95–97; Dibia and Ballinger, *Balinese Dance*, 70–72; Slattum, *Balinese Masks*, 99. See also Mark Hobart, *Music and Ritual*, 99, 108.

103 Bateson, Mead, and Gajdusek, *Balinese Character*, 164–167; Spies and De Zoete, *Dance & Drama in Bali*, 95–97; Dibia and Ballinger, *Balinese Dance*, 70–72; Slattum, *Balinese Masks*, 99. The *Barong* definition appears in Dibia and Ballinger, 71.

104 Artaud, *The Theater and Its Double*, 56.

105 *Le Miroir du Monde*, no. 68, 721–724, June 20, 1931; for a Modernist rendering of the costume, see Covarrubias, "Illustration of Queen Rangda," *Island of Bali* (1937) (London: KPI, 1986), 334 [Knopf edition, 1946]; and Covarrubias, "Illustration of Queen Rangda," *Theater Arts Monthly, The Theater in Bali*, xx, no. 8 (August, 1936).

106 Dubuffet, "Art and the Joke," in "Notes for the Well-Read," in Glimcher, 81. "These two categories have common blood. The unforeseen, the unusual is their shared domain. Don't misunderstand me, I am thinking about the acmes of art. Poe's tales, [Lautréamont's] *The Songs of Maldoror*, the statues on Easter Island. Not those innocent little jokes that divert your attention for a few moments, but the strong ones that instantly turn you to ice, change you to stone, because they're so good and so surprising."

107 Slattum, *Balinese Masks*, 85, 99. For more on Balinese culture and beliefs, see Angela Hobart, *Dancing Shadows of Bali* (full citation in note 92 above).

108 For more on Artaud's drawings, see Rowell, *Artaud: Works on Paper* (full citation in note 3 above); and also Sontag, *Antonin Artaud*, xxvii.

109 Spies and De Zoete, *Dance & Drama in Bali*, plate 35, see also figures 27–31. Spies also produced a popular 1929 movie about Bali, *Island of Demons.*

110 Bateson, Mead, and Gajdusek, *Balinese Character,* 164–167; Spies and De Zoete, *Dance & Drama in Bali*, 95–97; Dibia and Ballinger, *Balinese Dance*, 70–72; Slattum, *Balinese Masks*, 99.

111 Artaud, *The Theater and Its Double*, 56, 85; "Theater and Cruelty," in Schumacher and Singleton, 122. See also Barber, *Blows and Bombs*, 26, 57.

112 For more on this dance and to see this particular image, see Slattum, *Balinese Masks*, 99.

113 Rowell, *Artaud: Works on Paper*, 11, 161; see expanded footnotes 23, 56, and 59 for more on Ferdière's assessments of Artaud; see also Artaud's 1947 letter to Breton, quoted in Aurtaud and Grossman, x. In Bali, the word "demon" does not have the negative connotations it does in the West but instead describes powerful deities. Nevertheless, the parallels between the "demons" that appear in Artaud's biography and his writing about theater art based upon Balinese performance are worth noting.

114 Dubuffet, "Notes for the Well-Read," in Glimcher, 70.

115 "Javanese Puppets at the Dutch Pavilion, Paris Colonial Exposition," *Vu Magasine*, no. 171, 930–931, June 24, 1931.

116 For more on Dubuffet, puppetry, and theater see Dubuffet, *Biographie,* 36; and Frédéric Jaeger, "L'Hourloupe in Closeup (1962–1974)," in *Jean Dubuffet, Traces of an Adventure* (New York: Prestel, 2003), 42–44.

117 Dubuffet, *Biographie,* 30; Fondation Dubuffet, http://www.dubuffetfondation.com /bio_set_ang.htm (accessed March 25, 2011).

118 Mark Hobart, *Music and Ritual*, 190.

119 Dubuffet, "Anticultural Positions," 5–10.

120 Mark Hobart, *Music and Ritual*, 190. The *Dalang,* or puppeteer, is as much a spiritual mediator as a performer. See also Shaw, *A Coat that Doesn't Fit*, 75–84. Shaw discusses Dubuffet's tentative friendship with Breton and acknowledges that viewing Dubuffet's work through the lens of Clifford's notion of ethnographic Surrealism is helpful, arguing, however, that the connection should not be overly relied upon since Dubuffet's and Breton's motives and processes vastly differed. In contrast, I contend that the resonance among Surrealist interests in processes of discovery, investigating non-European cultures, and making the familiar strange was too great to be denied in shaping Dubuffet's art.

121 For more on these trance dances, see Mary Sabina Zurbuchen, *The Language of Balinese Shadow Theater* (Princeton, NJ: Princeton University Press, 1987), 158–159.

122 Dubuffet, "Notes for the Well-Read," in Glimcher, 72–73. Dubuffet proclaims: "The painting will not be viewed passively, scanned as a whole by an instantaneous glance, but [instead] relived in the way it was worked out; remade by the mind, and, if I may say *re-acted*" so that the viewer "feels all the painter's gestures reproduced within himself."

123 Dubuffet, "Anticultural Positions," 18–19.

124 Dubuffet, "Anticultural Positions," 21.

125 Dubuffet, "Notes for the Well-Read," in Glimcher, 78.

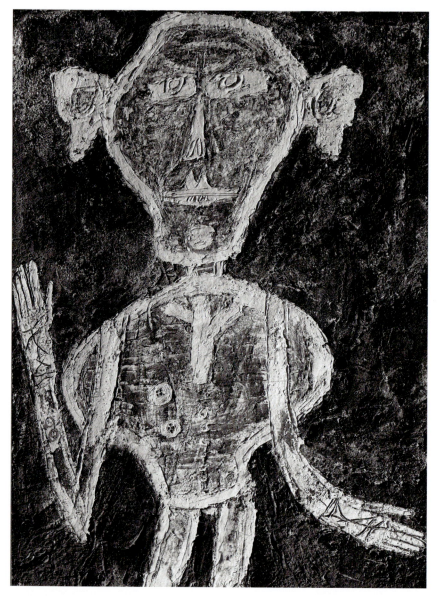

Figure 4.1 (and Color Plate 6) Jean Dubuffet, *Portrait d'Henri Michaux*, "gros cernes crème" (Portrait of Henr, Michaux thick rings of cream January, 1947, oil on canvas, 130 × 97 cm. (51.18 × 38 in.). Fondation Dubuffet / © 2020 Artist Rights Society (ARS), New York ADAGP, Paris. The Sidney and Harriet Janis Collection, Museum of Modern Art, New York. Black and white photograph courtesy of the Fondation Dubuffet, Paris. Reproduced in Jean Dubuffet, *Catalogue des travaux de Jean Dubuffet*, Fascicule III (Paris: Fondation Dubuffet, 2003), 79, no. 112. Color photograph in Plate 6 © The Museum of Modern Art/Licensed by SCALA / Art Resource, NY.

A "Barbarian" in the Gallery: Southeast Asian Art and Performance in the *Portrait of Henri Michaux*

Part I. Dislocation: Dubuffet, Michaux, and a Thematic of Movement

The *Portrait of Henri Michaux* is another of Dubuffet's disquieting figures (Figure 4.1 and color plate 6). It's mask-like visage, its large, bulging eyes, and its protruding ears create a fitting addition to Dubuffet's quasi-humorous, yet unnerving body of portraits. These features form a striking, if stylized, resemblance to Michaux, creating a likeness of the quasi-Surrealist Belgian writer and visual artist that is caricaturesque but exceeds the purview of ordinary satire. Hints of this categorical slippage appear in the embryonic, egg-shaped head and upper torso, which suggest rudimentary and enigmatically evocative symbols. The uneasy resemblance these features create between the portrait and its subject can be seen in a 1939 photograph, which shows Michaux's receding hairline, thin face, and high cheekbones (Figure 4.2). In Dubuffet's painting, the large, bulbous head rests atop a body whose frailty (gleaned also in the photograph) is accentuated by the top-heavy torso that lends the figure a sense of imbalance. This air of instability was precisely what Dubuffet wished to convey.

Dubuffet painted this likeness (one of several of Michaux) on January 4–5, 1947 in the very days after completing *Antonin Artaud aux houppes* on January 3 (see Figure 3.1). Like its immediate predecessor, the *Portrait of Henri Michaux* was rapidly executed; the gestures that produced it adapted from one figure to the next in quick succession. Given that it also bears strikingly similar gesticulations to the painting of Artaud, the two portraits appear to be in a dialogue. This chapter is thus in a kind of dialogue with ideas presented in Chapter 3, which discussed *Antonin Artaud aux houppes* in relation to Surrealist notions of doubling and dissociation as artistic objectives Artaud hoped to achieve by

Figure 4.2 Gisèle Freund, photograph of Henri Michaux, Paris, 1939, chromogenic print, 26 × 11 cm. (10.25 × 4.33 in.), AM1992–183. Copy photograph: Georges Meguerditchian © Copyright Gisèle Freund-RMN. Musee National d'Art Moderne, Centre Georges Pompidou, Paris © CNAC/MNAM/Dist. RMN-Grand Palais / Art Resource, NY.

emulating Balinese stagecraft. Taking up my conclusion, in that chapter, that Dubuffet amplified Artaudian affect as only one of a dual set of artistic aims, this chapter considers the other—his aim to stimulate the viewer's mind. Indeed, the artistic strategies adopted by both Dubuffet and Michaux were designed to do more than merely shock; they were also meant to prompt critical reflection. This was particularly so with regard to the symbiotic relationship between art, identity, and culture. Thus, Dubuffet asserted that "art addresses itself to the mind," and that painting "is a language charged with meaning."[1]

Given Michaux's mind-bending artistic and literary output, it should be no surprise that Dubuffet found him interesting, a fact which led Dubuffet to produce this portrait, which I envision here as a kind of pendant companion to *Antonin Artaud aux houppes*. Conceiving of the *Portrait of Henri Michaux* in this way helps illuminate Dubuffet's dual and conflicting sets of goals, not least of which was his effort to simultaneously subvert reasoned thought while

stimulating mental faculties. Making much of his "anti-intellectual" stance, Dubuffet's writings nonetheless offered a kind of vernacular art and cultural theory that echoed and yet transformed early twentieth-century notions of cultural negation, artistic innovation, and exoticism after the war. Dubuffet's art aligned in significant ways with Michaux's conceptual methods, which are explored in this chapter as a complement to Dubuffet's interest in Artaud's more emphatically visceral approach.

Proclaiming in his "In Honor of Savage Values" that authentic art exceeds the purview of utilitarian reason, Dubuffet added that what passes for knowledge (the encyclopedic drive of Western humanism) works not to vitalize intelligence but rather to "atrophy" it.[2] He thus celebrated the raw, aggressive qualities of Art Brut, asserting that "art has nothing in common with the plan of the head or with reason" and that "art that proceeds from the head and from reason is a very weak art."[3] Although he disdained "people who confuse art with the things of the reasoning head," calling them "people who do not ask much of art" or who "probably have no idea of what real art, when it shows itself in all its force, can bring," Dubuffet nevertheless wanted art to "restore the exact, the total truth of things" that, he argued, could be achieved by taking "a path of both clairvoyance [intuition] and [learned, reasonably deduced] knowledge."[4] These statements both proclaim and qualify Dubuffet's anti-intellectual position, revealing his view of art as *both* a thinking and feeling endeavor.

With this duality in mind, the nearly identical poses of the *Portrait of Henri Michaux* and *Antonin Artaud aux houppes* are worth considering. Each figure's right arm (at the left of the painting) bends in an overly acute angle, while his left arm (at the right of the painting) arcs in a curve. Neither of these gestures is possible in a human arm, and this accentuates the sense that what we see here is a depiction of the radically Other. In fact, it was Otherness, in one form or another, that appealed to both Dubuffet and his portrait subject, each of whom wanted to subvert, yet seemed fascinated by, processes of enculturation. As with the portrait of Artaud, the painting of Michaux holds its hands out, palms open, the right hand held up and the left hand lowered as if in a sweeping motion, signifying something unknown while conveying the ideas of movement and the impetus to communicate. This figure, too, suggests tensions between movement and stasis, and between two- and three-dimensionality, and the top-heaviness of the figure emphasizes these tensions, teetering as if to topple forward from the canvas. As in *Antonin Artaud aux houppes*, Michaux's head and hands also brush the paintings' edges, pushing into the canvas' borders as if to trying to escape them.

In many ways, the painting of Michaux echoes the portrait of Artaud, and in each painting, the mask-like faces strike a somewhat humorous, yet ultimately unnerving chord. Many of their features are *inverted*, however, producing a number of important differences. Perhaps the most striking differences are the shapes of the faces and heads. Both faces appear slightly heart-shaped, but in Michaux's case, the face and smooth, bulbous head are so elongated as to be nearly the opposite of Artaud's wide, fluffy, *Barongesque* features.[5] Whereas Artaud's portrait has large tufts of hair that sprout from the head and cover the ears, Michaux's elephantine ears spread markedly from the sides of his head, creating another hybrid figure and an oblique reference to what I see as its companion portrait.

The handling of the paint in the portrait of Michaux also stands as an inversion of *Antonin Artaud aux houppes*. Both of the portraits are roughly outlined with thick streaks of paint, yet the contours in Michaux's portrait are especially broad (a feature that is highlighted by the expanded title: *Portrait of Henri Michaux "thick rings of crème"*). The rendering of Michaux seems simpler, and this more schematic quality is disconcerting because it is strangely at odds with the crudeness of the rendering and gritty *haute pâte*, both of which enhance the work's ostensibly "primitive" appearance.

Both paintings feature neutral colors and a dark, earthy background, but the figure of Michaux is less fleshy-looking. While the pale contours delineate the figure and ground in Michaux's portrait, that effect is limited by the treatment of the areas inside the lines. The paint in this *inner space* (a frequent literary and pictorial theme for Michaux and the origin of creativity for both Dubuffet and his sitter) is swirled, crosshatched, and rutted with scratches and gouges that echo the shallow, earthy background. Without Dubuffet's thick contours of paint, the figure in the portrait would all but disappear into the background. With them, however, the figure seems to emerge from it, pushing forward from the canvas toward the viewer. This back and forth movement and complication of the figure–ground relationship calls to mind Roger Caillois's concept of mimicry, which he translated from insect biology to human psychology in "The Praying Mantis: from Biology to Psychoanalysis" and in "Mimicry and Legendary Psychasthenia."[6] We recall that Caillois's theory conceives of such mimicry as a sense of egoic dissolution, in which the subject experiences a sensation of merging with the surrounding environment. This blending of figure and ground and of inner and outer worlds also reminds us that for Dubuffet, painting expressed the "inner voices" of our humanity much more effectively than words.[7] For Dubuffet, these nonverbal voices represented

the primal impetus to make marks and, ultimately, set the stage for the interpretive encounter.

Once again, the rudimentary signs of modern Western clothing in the portrait seem out of place on a crude, alien, and ostensibly "primal" figure. As with *Antonin Artaud aux houppes*, this portrait of Michaux wears a bizarre, penis-shaped necktie that hangs above urine- or semen-drop buttons, all of which appear both humorous and disquieting. Tracing the line of these buttons in the figure of Michaux, one finds that the area between the figure's stick legs contains a strange, angular glob of paint (perhaps one of the chance occurrences Dubuffet cultivated in his work); and this glob suggests the dangling flesh that might remain where the phallus has been ripped from its proper place. This is a disturbingly violent, yet burlesque displacement on Dubuffet's part that may both poke fun at, and participate in, postwar debates about the relevance of figuration or—alternatively—disfiguration, a trend toward experiential, symbolic, and transformative deformation in art and literature that is found in much of Michaux's work and that resurfaced in postwar art. In the portrait, this glob might also suggest a twist on Lacanian castration, a symbol of both the frailty of the fiction of one's stable identity and the imagined loss of primal vitality upon entry into the linguistic/cultural order.[8] Of course, the theories of Breton and Bachelard, which are discussed in the previous chapters, also elaborate upon this idea of repression of vitality by culture, and it appears as the overarching theme of Dubuffet's writings.

The pendulous splotch of paint and displaced genitals so suggestive of castration in this portrait mirror Michaux's idiosyncratic and darkly humorous literary approach to unstable identity and the fragmented, incomplete self. As Virginia La Charité, David Ball, and others point out, Michaux treats the theme of identity in terms of not only a poetics of movement but also of fragmentation and even bodily dismemberment.[9] This is perhaps most evident, as La Charité notes, in Michaux's first poem, his 1923 *Les Reves et la jambe* (Dreams and the Leg), which conveys the disorienting sensation of awakening to find a detached leg, which his poetic persona discovers to be his own and which triggers a radical rethinking of his disjointed subjectivity. This shocking encounter, a confrontation also with Freud's uncanny and, as La Charité observes, with Michaux's own intellectual detachment, creates an acute awareness that the idea of the complete and stable self is a fiction.[10] As a consequence, Ball argues, the poem stages an eerie encounter with the self in all its multi-faceted mobility.[11] "Reading Michaux makes one uncomfortable," scholar Richard Ellmann notes, adding that "the world of Michaux's poems bears some relation to that of the

everyday, but it is hard to determine what."[12] Yet, as Elman also observes, we are unable "to reassure ourselves by calling it fantasy."[13]

Michaux's use of humor and odd deformations characterizes his overall challenge to the "form of order," La Charité adds, shaping a body of work in which it is *force* more than form that matters.[14] This sentiment resonated with the Art Informel movement and Dubuffet's postwar practice. Attunement to Michaux's brand of twisted humor, resistance to European formal conventions, and metaphorical bodily dislocation are evident in Dubuffet's portrait, producing an image that discombobulates the viewer in much the same way as Michaux's writing. The suggestion of the figure's instability and the tension between movement and stillness likewise allude to the two men's shared interests.

Intellectual currents

In letters to friend Jacques Berne, Dubuffet acknowledged his admiration of Michaux—and thus presumably also the author's writing, which is characterized above all by the thematics of movement and displacement.[15] Hubert Damisch has famously observed a sense of movement as well as tactility in Dubuffet's painting, which the art historian and philosopher has contemplated in dialogue with Maurice Merleau-Ponty's phenomenology. The acknowledgment of the significance of embodiment to human perceptions and interpretations in Merleau-Ponty's 1945 *Phenomenology of Perception* surely impacted Dubuffet's practice.[16] It is likely, however, that the portrait of Michaux also hinted at the subject's literary production, which was well known for exploring both the conditions and ungainly contradictions of embodied cognition. According to Minturn, one critic of the immediate postwar era even compared Dubuffet's and Michaux's work and proclaimed that Dubuffet was to painting what Michaux was to writing.[17] Both men had engaged in surrealism as a cultural phenomenon.

A celebrated writer, painter, and world traveler, Michaux was also an outspoken cultural critic who was as famous for his 1933 *A Barbarian in Asia*—a book that was reprinted in 1945—as he was for his enigmatic prose, poetry, and painting.[18] The following pages examine the impact of Michaux's visual art and writing, and particularly his travel account (a stream of consciousness spin on an Orientalist genre), to Dubuffet's portraits. This particular portrait of Michaux points to both the artistic processes with which these men experimented and the disorienting responses each of them wanted to produce in the viewer/reader, processes and responses that relied upon conceptual as well as gestural

movements. Since Dubuffet acknowledged his interest in "the emotional movements" of those who make thought-provoking art, it is easy to see how he would be fascinated with this theme in Michaux's work.[19]

Because Dubuffet painted this *Portrait of Henri Michaux* just after completing his painting of Artaud, and given the fact that both of these sitters expressed interest in Indonesian art, this chapter also explores the portrait in tandem with Michaux's writing on Asia and specifically Indonesia. Michaux spent time in Bali and discussed Balinese performances in his book, but he discussed much more than theater, choosing instead to examine the totality of cultural production he encountered during his Southeast Asian travels, and, as an unmoored European, commenting on his personal experiences of them.

In considering this portrait in tandem with the theme of dislocation that emerges in Michaux's book, this chapter takes into account the phenomenon of "culture shock"—a term coined by anthropologist Kalervo Oberg to describe the immediate and long-term reactions to cultural displacement and encountering difference. These include emotional and physiological (affective) responses that are often uncomfortable but that ultimately initiate growth and enrich the ways in which one views the world. Although Oberg elaborated upon it in 1960, the idea of inter-cultural contact creating disorienting and eye-opening experiences was already being explored *avant la lettre* by modern artists, particularly the Surrealists of the interwar, war-time, and immediate postwar eras.[20] Indeed, the issues ascribed to culture shock had begun being addressed as early as the nineteenth century as Europeans considered the effects of modernization, colonialization, and expanding ethnographic and anthropological pursuits. These issues returned to the forefront of the intellectual scene after the horrors of World War II and the onset of decolonialization, when artists such as Dubuffet and Michaux revisited the idea of promoting the decentering effects of encountering difference with renewed urgency. As we have already seen, moreover, the ideas of dissociation and shock were key components in Dubuffet's painting. The idea of dislocation is central to both men's work and inflects Dubuffet's depiction of the author. The concept of culture shock can thus be a useful tool for thinking about Dubuffet's and Michaux's approaches to their own cultural production, which relied upon the ideas of unmooring from European culture, reconnecting with primal humanity, and adopting unorthodox creative strategies. Such creative thought—*not* the encyclopedic acquisition of knowledge that accompanied colonialism—was what these men hoped, however paradoxically, to stimulate with their art.

As with *Antonin Artaud aux houppes* and other of Dubuffet's portraits considered in this book, the portrait of Michaux suggests that Dubuffet combined

various cultural sources to produce an enigmatic figure. The following pages analyze this hybrid in tandem with Michaux's book and photographs of some of the Indonesian dance costumes, masks, and puppets he would have seen on the Southeastern leg of his Asian journey. Considering the theme of movement and aesthetic of displacement that informs both the book and the painting, these pages ultimately explore the ways in which these artists sought to disrupt the identity of habitude to stimulate the mind.[21]

Ethnographic Surrealism—the tendency, described by James Clifford, of artists and social scientists to investigate non-European cultures during the interwar period that has informed the pages of this book—created a cultural milieu as intrigued by ethnographic discovery as it was by odd cultural juxtapositions. The following pages thus also consider the *Portrait of Henri Michaux*'s attunement to inter- and postwar discourses on the decentering effects of encountering difference.[22] These are ideas, moreover, that this particular sitter helped to circulate.

As with Breton's Surrealist theory, which conceived of the "Communicating Vessels" of inner and outer worlds, and Bachelard's "Philosophy of No," which asserted the need for epistemological breaks in order to bypass encultured habits of thinking and of viewing the world, creativity in Michaux's art was conceived of as the result of circumventing habitual thinking.[23] The themes of epistemological dislocation resonate in Dubuffet's portrait and emphasize a thematic of creative motion. Indeed, the portrait reflects Dubuffet's aims for his art to produce "the most profound internal movements."[24]

Dubuffet and his friend Michaux each produced both writings and visual art and conceived of their works as instigators of cultural decentering; Michaux wrote of painting to "decondition himself," and Dubuffet proclaimed that it is the function of art to engage the viewer in such a way that "the mechanisms of habit no longer function."[25] Here again, Dubuffet's art theory and practice show affinities with the philosophies of Breton and Bachelard—and with his portrait subject—that contrast imaginative movement with stagnant habitude.

Breton had pitted Surrealism against the cultural grain and argued that Surrealist practice should be "exempt from any aesthetic or moral concern."[26] In a similar vein, Bachelard argued in *The Philosophy of No* that encultured habits encumber creative activity and should thus be negated—an idea at the very heart of Dubuffet's anticultural position.[27] Drawing upon a comparable philosophy of dialectical movement, Dubuffet believed art could create fissures in ordinary habits of understanding that could reset and broaden the viewer's conceptual repertoire.[28] "The first step toward deconditioning will consist in distancing oneself

from all that is traditionally expected," Dubuffet wrote in his 1968 *Asphyxiating Culture*.[29] He had already begun following this path in his portrait of Michaux.

In following Dubuffet's efforts to unmoor the viewer, this chapter sees in his *Portrait of Henri Michaux* the rudimentary steps toward exploring a desirable sense of cultural dislocation. Avant-garde artists and thinkers had been subverting hegemonic culture since the nineteenth century. Their efforts, however, were all too often bound up with colonialist exploits. Dubuffet's work was only somewhat different in this regard. But as Jill Shaw observes (and despite Dubuffet's ingrained nationalism and Eurocentrism), the artist appears to have been motivated to explore and learn from alternative practices that were as disengaged as possible from the European "cultural machine."[30] Indeed, as Jean H. Duffy points out, Dubuffet's writings reflect a desire to make art that resonates with common humanity.[31]

The element of cultural appropriation that characterized early-twentieth-century art remained active in Dubuffet's postwar production. And this was true even of the work he produced in the image of Art Brut—the very art he believed to be untainted by culture. Exploring the contradictions in Dubuffet's practice, Antonia Dapena-Tretter notes the element of subtle exploitation that crept into his Art Brut collecting, which was itself a revamped form of Primitivism.[32] These conceptual contradictions and artistic processes which, against the grain of Dubuffet's own art theory, incorporated aspects of bricolage, likely enhanced the sense of imbalance in his ungainly figures. Despite the many contradictions that resulted from a more ingrained Eurocentrism than either Dubuffet or his portrait subject realized, they nevertheless shared a desire to change cultural directions. They moved, if by fits and starts, toward an approach described in quite a different late-twentieth-century context by postcolonial theorist Homi K. Bhabha as an "interstitial perspective"—an outlook valuing the richness of multifaceted identities.[33] This shared and contradictory set of goals drew Dubuffet to Michaux's art and writing and provided an impetus for his portrait.

The Surrealists had also begun exploring such a perspective, and this could be seen in their quests to make art attuned to the marvelous in everyday life. As Clifford demonstrates, they thrived on investigating ethnography (albeit in ways that continued, despite their stated wishes to the contrary, to rely upon colonial hegemony and the opening of remote, and thus exotic, locales to European consumption).[34] Their embrace of the idea of cultural difference as an antidote to hegemonic culture retained the taint of colonialism yet demonstrated some of the group's early steps toward a more diversified intellectual field. Dubuffet's friend Breton also elaborated upon early theoretical ideas about constructed

identity and cultural relativism, which pitted the artist against dominant culture and used disjunctive imagery and creative translation to create a framework for artistic transformation. That auspicious soil—the period following World War II and the collapsed myth of a European moral high ground—was uniquely seeded for artists to explore the creatively- and intellectually-liberating potential of reconceiving notions of identity. The imagery, ideas, and feelings Michaux expressed about what he interpreted to be the multicultural mélange he encountered during his interwar Asian travels, of which I focus on Southeast Asia, appear to have provided a conceptual model for Dubuffet and his hybrid portrait of the author. It is a portrait that, as we shall see, suggests both the artist's challenge to "categorical thinking" and his thinking about dislocation, difference, and hybrid identities.[35] The latter, it appears, impacted his portrait as much as the resonance of the Southeast Asian masks, costumes, and puppets Michaux would have seen on his journey.

Minturn has noted Dubuffet's fascination with evolving ideas about the formation of languages, and Dubuffet's writing is filled with statements about the power of art as a language with transformative effects.[36] Dubuffet's appropriative art practices, which in this book I have situated in relation to Claude Lévi-Strauss's concept of bricolage—a creative mode of operations within a set of culturally available precedents—can also be considered as a process Jacques Derrida later conceived of in his linguistic theory as citation and grafting.[37] Like many artists and intellectuals during the postwar years, Dubuffet was influenced by such cut-and-paste practices in the form of Cubist collage; however, as did the Surrealists with which he loosely associated, he focused a great deal of attention on the topics of interiority and artistic presence that would be rejected by later thinkers. Believing (in the very approach Derrida would later challenge) that "the cry" (or spoken word) is more meaningful than the language of writing, Dubuffet nevertheless also discussed art as signification, asserting that "painting is a language" that is "charged with meaning."[38] Although very different from poststructuralism in their emphasis on pitting inner creativity against exterior cultural forces, Dubuffet's intellectual precedents, and his own artistic approach, fueled postwar debates about the relationships between language, culture, and creativity and perhaps contributed to early formulations of the concept Derrida and other notable critical theorists would describe as *performativity*—the notion that speech-acts (iterations that perform particular social functions, really signification itself) profoundly shape experience.[39] All of these ideas are relevant to Dubuffet's portrait, which suggests his acute awareness of art-making as performative communication that could set the mind "wandering."[40] This idea

can be seen in the portrait's direct address of the viewer, communicative (if enigmatic) gestures, and the sense of movement and instability they produce. This value of imbalance and the ability to let the mind roam had a precedent in Michaux's *A Barbarian in Asia* and other writings.

Surrealism, picture writing, and gesture

As with the creative output of other of Dubuffet's portrait subjects discussed in this book, Michaux's writing and visual art retained affinities with Surrealism, and he, too, had participated in the Surrealist milieu of interwar Paris. Although the two men did not meet officially or become friends until 1944, when they were introduced by Paulhan, they could easily have encountered one another when they each frequented the experimental atelier of André Masson's Montparnasse studio or any number of Surrealist strongholds between the wars.[41] Surrealist explorations resonated in both Dubuffet's and Michaux's work and included a penchant for ethnographic enquiry and a fascination with producing bizarre, culturally disjunctive figures. Both men remained on the fringes of Surrealism, however, each preferring to go his own way rather than conform to the values of a group. Michaux particularly critiqued what he took to be Surrealism's superficialities, including its lauding, in the early days, of automatism at the expense of artistic agency.[42] In contrast, Michaux, and for that matter Dubuffet, embraced art-making as a dual procedure that activates cognitive faculties as well as deeper, preconscious forces.

Despite Michaux's reticence with regard to the Surrealist label, his writing is characterized by a comingling of dreaming and waking states, ambiguous yet life-changing situations, and ambivalent contact between self, circumstances, and the Other—themes that aligned with Surrealist ideas. These themes trouble his readers, as do the disjunctive tensions between his apparent disinterestedness as a writer and the heightened states of awareness his imagery evokes.[43] Curator Kazuo Nakabayashi notes that these very qualities also distinguish Michaux's painted figures, which appear as dynamic, morphing forms.[44] One could say that Michaux considered it his job as an artist to *move* the viewer in disorienting ways; he even compared his role as a writer to that of a train conductor alternating exploratory channels.[45] His work sets the viewer off-course, so to speak, and this holds true for his poetry, prose, and painting.

Michaux's concern for poetic imagery and interest in word–image relations have generated considerable scholarly attention; he makes use of hybrid forms

and often accompanies his texts with his own enigmatic renderings. As Minturn notes, both Michaux's and Artaud's interest in writing and language intrigued Dubuffet, and all of these artists investigated various forms of pictographic writing, including Mayan and Egyptian hieroglyphics and Chinese calligraphy.[46] These preoccupations with pictographs and with bodily signs appear throughout Michaux's visual production, becoming especially evident in his 1950–51 series *Mouvements*, in which abstracted forms suggest the human body, dynamism, and artistic communication in ways that pique the viewer's curiosity (Figure 4.3). It is also interesting to note Michaux's intention during his Asian travels, to

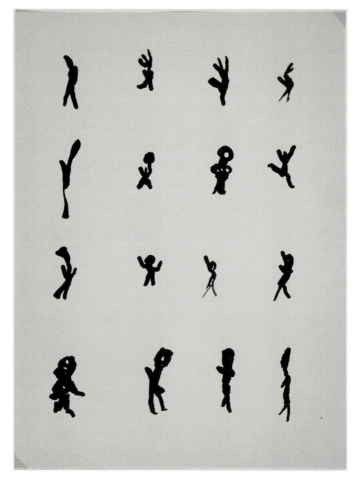

Figure 4.3 Henri Michaux, Untitled, *Mouvement* series, 1950–1951, Indian ink on paper, 32 × 24 cm. (12.59 × 9.45 in.). © 2021 Artists Rights Society (ARS), New York / ADAGP, Paris. Museo Nacional Centro de Arte Reina Sofía, Madrid. Photograph courtesy of Museo Nacional Centro de Arte Reina Sofía, Madrid.

communicate with his own form of gestural language, however unsuccessful, which he hoped would be universally understood.[47]

While differing greatly from Dubuffet's artistic style, Michaux's artworks share some important traits with Dubuffet's figures, revealing some key affinities between the two men's art. As with most of Dubuffet's portraits, many of Michaux's figures are disturbing. In some cases this troubling quality results from their ambiguously hybrid forms that blend human and inhuman characteristics. One such image is an untitled watercolor of 1946 (Figure 4.4.) in which the figure's elongated, snout-like visage, beady eyes, and oddly-shaped head strike an

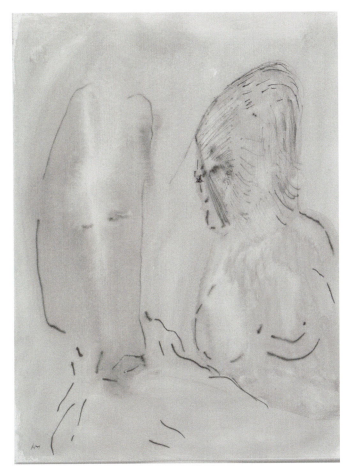

Figure 4.4 Henri Michaux, Untitled watercolor and ink on paper, 31.8 × 24.1 cm. (12.5 × 9.5 in.). © 2021 Artists Rights Society (ARS), New York / ADAGP, Paris. The Museum of Modern Art, New York. Acquired through the generosity of Jo Carole and Ronald S. Lauder, U.S.A. Photograph © 2021 The Museum of Modern Art/Licensed by SCALA / Art Resource, NY.

unnerving chord because they seem to only remotely suggest a human figure. Likewise, the suggestion of violence and mystery caused by the unusual vertical striations in the paint are unsettling, appearing to both mar the figure and evoke a shadowy, dreamlike world. Interestingly, though I have found little historical evidence that Michaux looked to the Indonesian figures he saw during his travels for artistic inspiration, the formal similarities between this and several other of his paintings and photographs of a wooden *Kayan Dyak* (Pig Mask) (Figure 4.5) of Borneo, another Southeast Asian (and partly Indonesian) island to which Michaux refers in *A Barbarian in Asia*, are compelling. These resemblances

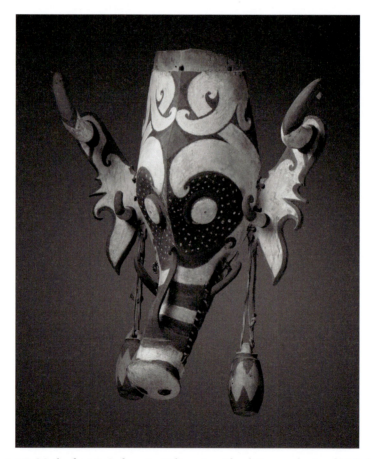

Figure 4.5 Mask of spirit. Indonesia, Kalimantan Island, Borneo, basin of Mahakam, Kenya people, 1978, wood, leather, 58 × 53 × 31.5 cm. (22.83 × 20.867 × 12.4 in.). Inv. 70.2001.27.234. Photograph: Patrick Gries / Bruno Descoings, Musee du Quai Branly—Jacques Chirac, Paris © Musée du Quai Branly—Jacques Chirac, Dist. RMN-Grand Palais / Art Resource, NY.

suggest that to produce his otherworldly figures, Michaux, too, may have looked to or recalled the cultural forms of Indonesia.[48]

Since the *Kayan Dyak* mask is used to drive threatening swine spirits away from newly planted crops, it is designed to be frightening, appearing as an alien form as a result of its zoomorphic appearance. The figure in Michaux's painting (one of several that resembles this form) is likewise unnervingly alien, producing the very effects Dubuffet appreciated in artistic production. It is interesting to note that both Michaux's art and writing deal with questions about mental impressions, processes, and instabilities, and that, as with Dubuffet, some of Michaux's art also suggests his engagement with the images in Hans Prinzhorn's *Artistry of the Mentally Ill*, which Michaux owned in an original 1922 edition.[49]

Despite the differences in their pictorial styles (Michaux's paint and ink is thinner, more *tachist*, and Dubuffet's *haute pâte* is more expressly material), each of these artists depicted strange figures that seem to waiver between one form and another, between stasis and movement, between two- and three-dimensionality, and, perhaps, even between one existential dimension and another, vacillating between appearing oddly comic and vaguely horrific. These fluctuations are emblematic of the artists' emphasis on creative *movements* and artistic transformations—ways of conceiving creativity that, as Susan Sontag notes, emerged from Surrealist discourses.[50] As this chapter has suggested, such creativity could only be conceived of by Dubuffet and Michaux as hybrid—a creative interplay by which the artists hoped to impact the viewer. Such encounters between self and other and between outer/lived and inner/imagined worlds, these artists thought, could transform the viewer and perhaps, by extension, revitalize culture.

"Through the act of painting," according to Nakabayashi, Michaux enacted a "return to the primordial point from which the human image was gradually extracted."[51] This quest for primal forms (images that might both signify and trigger the release of otherwise latent creative forces) drove Dubuffet's creative process as well, and it is no surprise that he expressed his appreciation of Michaux's work and featured him in several portraits.[52] Both men saw creativity as channeling the creative impetus they believed to be increasingly unavailable even to the European avant-garde and its postwar remnants. Wanting to convey a sense of this primal release to viewers who would seek to interpret the work in new and ever-changing contexts, they alluded to these forces through creative play and the gestural physicality of their production. This ambiguous blend of sensations, the artists believed, might set viewers off of the usual, culturally-prescribed course, moving and stimulating their creative imaginations and instigating personal, and ultimately cultural, transformations.

A "barbarian" in Southeast Asia

Although *A Barbarian in Asia* was unaccompanied by the illustrations Michaux featured in some of his other books, it describes his travels throughout various parts of Asia and can be counted among the popular 1930s depictions of Indonesia. In it, Michaux elaborates upon his fascination with the diversity of cultures and the differences between the many value systems he encountered there and his own European enculturation. He described Balinese culture as "wholesome and noble" and yet, in his opinion, overly concerned with cultural conventions—precisely what his European avant-garde sensibilities wanted to escape.[53] He saw the Balinese people as particularly "anxious to be proper"—a cultural disposition that was far from the Modernist dream of artistic freedom born of untamed creativity.[54] Yet it was this paradox, this recognition of both the impossibility of attaining a state of unenculturated nature and the nostalgia for its imagined loss, that characterized Michaux's book. Dubuffet does a similar dance in his portrait.

As Peter Broome observes, the theme of displacement features prominently in Michaux's writing.[55] Michaux traveled the world in order to disengage from his European mindset and experience cultural difference, and these efforts characterize *A Barbarian in Asia*.[56] On one level, the book outlines and provides acerbic commentary about the author's Asian travels between 1930 and 1931. But Michaux's vacillation between intrigued, acerbic, and tongue-in-cheek commentary is as important conceptually as his movement from destination to destination. This is not to say that the casual, yet blatant, eruptions of Eurocentrism are not off-putting to twenty-first-century readers. As with Dubuffet's portrait, however, Michaux's book warrants a closer look, for it, too, operates on multiple intellectual and emotive registers, highlighting a range of responses to the experiences of difference and revealing, it seems, even to the author himself, that despite his efforts to the contrary, his enculturation accompanies him everywhere.

Michaux's book highlights a conundrum—the fact that he can neither fully detach from his own European culture nor completely connect with the Asian, South Asian, and Southeast Asian cultures he visits. Expressing both his fascination and frustrations, his periodically derogatory comments about the local customs reveal Michaux's own biases, vacillating during the course of the account between interpreted observations and a self-reflexive exposé of European cultural assumptions. These he dances around with characteristically sardonic humor that produces unnerving effects. To Michaux's dismay, his

observations on indigenous customs highlight the futility of his task, revealing also that processes of enculturation in one form or another exist everywhere. The fact that this book highlights his status as a cultural outsider and complicates his efforts to distance himself from processes of enculturation, however, would have nevertheless appealed to Dubuffet, who both lauded Michaux's character and held cultural dislocation to be a liberating artistic ideal.[57] This interplay in *A Barbarian in Asia* between experience, representation, and interpretation—and the highlighting of dynamic relationships between art and culture and between affect and cognition—surely captivated Dubuffet.

Elaborating upon a variety of his reactions to encountering cultural difference—from euphoria to rejection to subtle hostility in the form of parody—the net effect of Michaux's book is to lay bare the processes he undergoes in a sometimes instantaneous, sometimes incremental, occasionally inspiring, and frequently unsettling re-orientation of perspective/s. And this is just what Dubuffet wanted to achieve with his art. Although Michaux's deadpan writing style lends an air of the mundane to the incredible, the effect is a Surrealist twist on making the familiar strange. In his book the exotic is revealed as someone's quotidian, and this assumption-challenging insight creates the uncanny sense that the author—and through his eyes, the reader—participates in a greater unmooring than expected. With its flailing arms and topsy-turvy stance, one could say the same of Dubuffet's portrait.

Although Michaux's blasé prose tempers the sense of wonderment and quirky humor in his account, culture shock nevertheless abounds in his chapter on Indonesia:

> Malays, Javanese of Sumatra, Balinese, Malay Soudanese of Borneo, of Flores, mixed with, married to a hundred insular races, to the Bataka, to the Dyaks, to the Chinese, to the Arabs, and even to the Papuas, converted in turn to the religion of India (Hinduism and Buddhism), then to Mohammedanism—here is enough to trip up anyone who attempts to generalize at every step. It is annoying.[58]

The impact of this "great multiform" of peoples that Michaux described as a "living challenge" to "our terrible Western monotony" resonated, in different ways, long after his trip.[59] Over time, upon reflection (as he indicated in his preface to the 1949 edition), he began to more fully appreciate the valuable transformative effects of his experiences.[60] As in many other of Michaux's writings (and, indeed, in much of his visual art), the disquieting encounters between self and other in *A Barbarian in Asia* foreground geographic and

conceptualized space, communicative contact, and interpretive distortions as co-shapers of identity. The book problematizes the very idea of stable identity and opens instead onto a world of experiential possibilities born of fragmentation, disorientation, and hybridity.

Michaux's experiences of cultural difference and hybridity (the intermingling of diverse cultural values, representations, and notions of identity) in Southeast Asia changed him profoundly while highlighting the very notion of identity as constitutive, a configuration of performed roles situated on culturally constructed stages.[61] His brief and satirically generalized discussion of Indonesia thus provides insights into both his efforts to explore cultural dislocation and his approach to identity as performance.

In dialogue with Michaux's book, and emerging from Dubuffet's "prehistory" of ethnographically inflected Surrealism, the mask-like face, stiff hands, and odd gesture in Dubuffet's portrait echo some of the very masks, costumes, and puppets of Bali and its island neighbors that Michaux visited during his trip. In these locales such artifacts were created to communicate through performance between two coexisting worlds distinguished by only porous boundaries—the land of lived experience and the imagined spirit realm.[62] The accoutrements of these performances also appeared in the ethnographic museums in Paris and Geneva that Dubuffet visited and in venues such as the 1931 Paris Colonial Exposition, where they were first glimpsed by Artaud and many Europeans. The disjunctive qualities of these artifacts and their use in ritual dances would be particularly relevant, appealing to the thematic of movement and transformation that propelled both Michaux's and Dubuffet's work. In imaginatively manipulating such imagery, this chapter argues, the mimicry in Dubuffet's portrait of Michaux served both formal and thematic ends, pointing to both his and his sitter's aims to dislocate the Western viewer from ordinary enculturated experience and to promote alternative modes of artistic engagement.[63]

Part II. Movements: Indonesian Dance and the *Portrait of Henri Michaux*

Consider again Dubuffet's emphasis on gesture in his portrait. The figure stands, though we cannot see its feet, which have been cut off by the canvas edge. Facing frontally, as if in direct address, the figure holds one hand up and seems to gesture with the other in an apparently sweeping motion, as if to communicate with the viewer. The stiff, incised hands, which lack the elongated fingers seen in

the painting of Artaud, are less expressive in and of themselves, yet they lead the awkward gestural performance to create a sense of burgeoning mobility and active engagement with the viewer.

Such gesture is a key component in Indonesian performance and, indeed, in many traditional Indonesian practices. It has a long history as a matter of course in Bali, one of the primary Southeast Asian locales Michaux discusses in his book. There, according to anthropologists Gregory Bateson, Margaret Mead, and Carleton Gajdusek in their 1942 book *Balinese Character*, gesture communicates not so much specific meanings as a *fundamental approach* to life, culture, and spirituality.[64] Thus, it is the *act* of gesturing itself that is significant—an idea that would appeal to postwar artists such as Michaux and Dubuffet who embraced both physical and conceptual gesture in their practice. This sacred signification in Bali was not restricted to ritual performances, nor was it relegated to art institutional, religious, or theatrical settings. This integration of meaningful art, ritual, and daily life also fascinated Western artists, anthropologists, armchair ethnographers, and tourists such as Michaux.[65] An aspiration to acknowledge a comparable mode of performance materializes in the portrait.

Intriguingly, while discussing the integration of angular gestures within traditional Balinese culture, anthropologists Bateson and Mead observed a thematic of fragmentation in which the body was conceived of not as a unity but rather as an amalgam of interrelated parts. This ideology, they argued, was symbolized as both an "integration and disintegration of the body" and found expression not only in habitual and highly exaggerated gestures, but also in "the whole puppet complex" that includes the various forms of Balinese puppetry, a range of ritual dances, and many aspects of daily life.[66] Indeed, according to Bateson and Mead, in traditional Balinese culture, the body was conceived to be "like a puppet" that is "pinned together at the joints."[67] Thus, in Bali, according to the authors, "folk beliefs are filled with personified limbs, legs and arms, and heads, each animated by a mischievous will of its own," adding that "in the hands, more intensely than any other part of the body, this dissociation, this independence of each small unit is seen."[68] Although Michaux did not elaborate upon this notion in his book, this model of the body in culture (and in relation to the cultural body) would surely have captured his attention, given its parallels with his own imagery of bodily dismemberment in poems such as "Dreams and the Leg" and his allusions to fragmentary and overlapping states of cognitive and cultural dissonance in his literary and visual production.[69] It is also an outlook that would appeal to Dubuffet, who infused his painting with a tension between fragmentation and integration *à la* Cubist collage and who had a history

of Surrealist contact, a fascination with puppet making, and an interest in performance.

Michaux's use of poetic and pictorial gestures in his art and writing were not meant to instill cultural cohesion as they are in Balinese culture. Rather, as an artistic strategy, gesture for Michaux had a double purpose—to dislodge habituated experience and to establish a basic human connection—to dis- and re-orient the viewer's perspective. As with Michaux's work, Dubuffet's portrait presents a double play that vacillates between the familiar and the foreign, between the corporeal and the interpretive. Its ability to intrigue is its power to subvert Western conventions and hierarchies while resonating, enigmatically, to suggest fundamental states of consciousness.

Although Dubuffet did not visit Bali or the artist collective established there that I discuss in Chapter 3 (limiting his early travel to Argentina and North Africa, to which he returned in the 1940s), the activities of the artists who flocked to the island were in full swing during Michaux's 1931 trip, and word of the collaborative tropical community that celebrated visual art, Balinese gesture, and dance spread throughout Europe.[70] Contemporaneous renderings indicate, moreover, that European artists found the interplay between angularity and fluidity, and between dynamism and stasis in Balinese art, to be artistically invigorating and particularly appealing to Modernist sensibilities (see Figures 3.6 and 3.7). Dubuffet also appears to have been intrigued and to have emulated such forms in his portrait, in which Michaux addresses the viewer using exaggerated, angular gestures.

Dubuffet's rendering of Michaux demonstrates the artist's continued interest in non-Western art and specifically the masks, costumes, and puppets that also captivated his portrait sitter. If Dubuffet painted his portrait from memory, as he claimed in the announcement for his portrait exhibition, then recollections of the ethnographic resources available to him in Parisian collections, publications, and photographs also surely informed it, configuring the image through the distorting lens of memory in a process consistent with the surrealist themes of metamorphosis and creative transformation.

Dance, movement, metamorphosis

Dubuffet's proclamation that painting is "much more immediate and much more direct than [a] language of words, much closer to the cry, or to the dance" suggests that he shared an interest in movement as a theme to explore in his art.[71] Indeed,

each of these men pursued the ideas of cultural dislocation and creative movement (disengaging from ordinary routine to experience and intentionally act upon deeply felt artistic impulses) in their work. Likewise, gesture and eclectic imagery played major roles in the art and writing of both men and resulted in uncanny, hybrid, and enigmatically communicative figuration. Michaux's pictographs—images that combine the inspirations of dance and Chinese calligraphy (conceived of by that generation of Europeans as pictographic writing)—emphasize dynamic visual communication and have even been performed on stage by professional dance teams (see Figure 4.3).[72] In a comparable approach, Dubuffet characterized his artistic process as "the inner dance of the painter's mind."[73]

Whereas "culture never ceases to cry fixation," Dubuffet argued in his 1968 book *Asphyxiating Culture*, "the mind tends toward mobility and propulsion."[74] Believing that "culture and [creative] thought are inverse movements," Dubuffet proclaimed that the thinker (the artist, the viewer) must "turn," must create a change of perspective that subverts Western enculturation and incites authentic creativity.[75]

As Parish notes, Michaux embraced movement as a theme in order to depict "the dynamism of the inner self."[76] Laurie Edson goes as far as to describe Michaux's aesthetic theory as an "ideology of perpetual movement"—a movement in which the experience of the self occurs only at given points in its creative evolution.[77] Michaux expanded upon this idea of the self in motion in his 1952 book *Mouvements,* inspired by his heretofore mentioned paintings grouped under that name (see Figure 4.3). Although he produced these renderings during his famous mescaline experiments (his radical attempts to merge consciousness with the primal creativity one might experience during altered states of awareness), these works bear consideration here. Dubuffet's portrait alludes to this fascination with locomotive states, which the author had already begun expressing before the two men became friends after the war.[78] Interestingly, Michaux believed that transforming his consciousness allowed him to become "a complete other"—an Other even to himself.[79] His remarks provide insights into not only the thematics of movement and dislocation, but also the idea of self-Othering that characterizes Michaux's creative transformations.

As Broome and Edson observe, the experience of self occurs in Michaux's writing only as an awareness of the transformative moments that occur within a creative continuum.[80] It is a moment such as this that Dubuffet's painting, as if in stop-motion, alludes to. In revealing the "countless changing positions of the self," as Broome notes, Michaux's writings highlight not only these inner

movements and transitions, but also, and above all, "delicate points of balance."[81] In this sense, Michaux's writing takes the very form/s of Balinese dance, in which gestures waver between movement and pose, signifying momentary points of balance within the dynamic flux of living forces. Such an interplay was a key feature of both Michaux's work and the Indonesian performances he encountered during his travels. Dubuffet portrays this tension between movement and moment (captured in the static and seemingly timeless medium of paint) in his portrait.

Motion and stasis in Balinese performance

Contrast between movement and stasis is particularly foregrounded in Indonesian shadow puppetry, about which Michaux notices that the puppeteers "move the arms [of the puppets] rather than the body" and in which the arms that are moved by sticks attached to the puppets' wrists appear "limp and dangling" when at rest but can be made to move "fast and excitedly" against a flickering, oil-lit screen.[82] Functioning, on the one hand, as dramatic ritual and, on the other hand, as entertaining performance, Balinese theater in general, which tradition holds emerged from sacred puppetry, creates an interplay of dissonances and resonances.

The *Jero Luh* is a hybrid, puppet-like costume that provides a fascinating example of this interplay of oppositions between movement and stasis while emphasizing communicative gesture (Figure 4.6). This sacred figure's features— its ovoid head, body of sticks and fabric, and long arms (one swaying, one bent)— may seem perplexing to Western viewers. Its enigmatic features are echoed in Dubuffet's portrait of Michaux, and this is particularly noticeable in the upper portion of the figure, which nearly re-articulates the mask's arched eyebrows that swoop upward and that, along with the creases of the forehead, form an elliptical shape suggesting an odd protrusion. The mask's squared, jutting jaw also appears in the portrait, in which a ring of paint on Michaux's chin hints, theatrically, at three-dimensionality. In any case, photos of the author, Dubuffet's portrait, and an example of this mask make for an intriguing comparison.

The *Jero Luh* costume, which consists of a mask mounted to a stick that is fitted with carved wooden hands attached to its garment sleeves, is decidedly puppetesque (Figure 4.7). It moves rhythmically, yet jerkily when it is carried in Balinese processionals or when worn by raucous street performers who enact humorous, sometimes lewd, yet sacred and ultimately life-affirming spectacles.

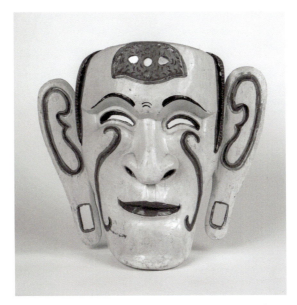

Figure 4.6 *Landung Jero Luh* mask, wood and paint, Bali, twentieth century. Tropenmuseum, Amsterdam. Collection Nationaal Museum van Wereldculturen. Call. no. 7082-S-495-4. Photograph: Nationaal Museum van Wereldculturen.

In these *Barong Landung* performances, the *Jero Luh* and her oafish husband *Jero Gede* enact a circular dance accompanied by the lighthearted, sing-song banter of the performers.[83] The odd, jerky movements in these performances can generate both mirth and disquietude—and this is just the kind of sensation that appealed to Dubuffet and to his portrait sitter. It also appears in the painting.

As described by Beryl De Zoete and Walter Spies, the *Jero Luh*'s slow, jerky movements are discomfiting.[84] So are the carved wooden hands with which the figure is fitted. These foreground the tensions between the effigy's static and moving components, particularly the left hand, which is typically pinned to the puppet's torso so that the bent arm forms a stiff, triangular pose. Despite its fixity, this pose is considered to be an archetypal dance posture that symbolizes movement and, indeed, Balinese choreography is based on the interplay of movement, transition, and stasis. Only the right arm moves freely, arcing loosely, yet listlessly from front to back as the figure is carried—a sweeping motion that is implied by the arced arm in Dubuffet's portrait. By De Zoete's and Spies' account, the odd disjunct between motion and rest effected by the disparately functioning arms of the *Jero Luh* is particularly unsettling.[85] A comparable effect is achieved in Dubuffet's portrait, in which the positioning of the figure's arms is reversed, its right arm (at the left of the painting) held in a stiff, angular pose and

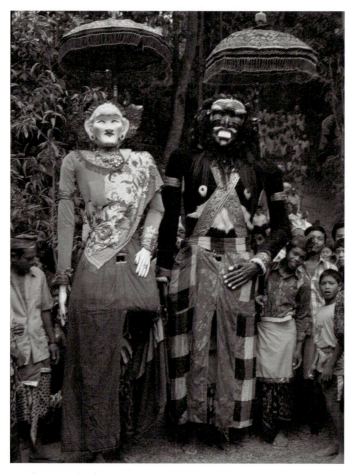

Figure 4.7 Photograph of *Barong Landung* performance featuring *Jero Luh* (left) and *Jero Gede* (right), Bali, Indonesia, 1982. Werner Forman Archive/. Location: 13. Photograph: HIP / Art Resource, NY. A photograph showing the *Jero Luh* figure in a similar pose appears in Beryl de Zoete and Walter Spies, *Dance and Drama in Bali* (1938) (Kuala Lumpur: Oxford University Press, 2002).

the left arm (at right) arced as if to suggest a swaying motion. The variance between this swaying arm in the puppet/costume (motion that is implied in the case of Dubuffet's painting) and the stasis of the figure's other, more angularly posed arm, rigid mask, and stiff wooden hands create an emphatically uncanny encounter that would resonate for artists attuned to Surrealism.

The stop-motion effects of Balinese choreography provide a model for thinking about Dubuffet's and Michaux's work. As previously noted, Edson considers Michaux's works to coalesce in an "ideology of perpetual movement"

punctuated only by "delicate points of balance" (see Figures 3.7 and 4.3).[86] Michaux himself conceived of his work—and identity—in this way, asserting: "There is not one self. There are not ten selves. Self does not exist. Self is merely a point of equilibrium."[87]

Dubuffet's portrait—in which the figure of Michaux teeters in a quasi-comic dance that wavers between conjoining with the canvas and toppling forward from its support—appears to echo the suggestion of tension between movement and stasis in Balinese choreography: short movements choppily punctuated by emphatically angular poses that represent the interactive relationship between balance and motion. Poised as if in mid-tumble, the figure of Michaux suggests just such a momentary—and inevitably untenable—point of rest. Its pose, likewise, points to performance—and to an ideal of life both naturally and consciously transitional, rather than artificially staged and static.

The phallic displacement in Dubuffet's rendering also conjoins intriguingly with Michaux's writing and with the Balinese *Jero Luh*. In addition to the idea of bodily dismemberment (in this case, castration), this gender-ambivalence may allude to the fact that in some of Michaux's first person poetry, he used feminine grammatical choices.[88] As with the portrait of Artaud (who was known for his own gender conflation), the Balinese effigy that the *Portrait of Michaux* resembles is also gendered female yet portrayed by a male performer.[89] To perform the *Jero Luh*, a male actor conceals himself, half-heartedly, beneath the figure's dress, animating the female character while remaining comically visible to the spectators. Once again, Dubuffet's portrait appears to bear remarkable parallels to the Balinese stagecraft that fascinated his sitter and suggests that these artists explored the idea that identity is constructed.

Although the *Jero Luh* was rare in Parisian ethnographic collections, Dubuffet may nevertheless have seen such a mask in the many ethnographic collections at his disposal in France and elsewhere.[90] He may also have seen such a mask in ethnographic photographs such as those featured in books by Bateson and Mead and De Zoete and Spies (both of the 1940s) as well as Claire Holt's 1939 *Théâtre & danses aux Indes néerlandaises,* a catalogue of objects collected, photographed, and filmed for the Archives internationales de la danse (AID).[91] As discussed in Chapter 3, this Parisian organization with strong ties to the early twentieth-century artistic avant-garde (and whose founder, Rolf de Maré, was also famous for forming the avant-garde Ballets Suédois) promoted world dance in publications and a variety of Parisian events supported by prominent artists, one of whom was Dubuffet's old friend Léger, who served on the organization's board and helped facilitate exhibitions on painting and dance. AID exhibitions of

Indonesian dance costumes in the 1930s featured an example of the *Jero Luh* held in their permanent collection that included a publicly accessible research library. The AID and its library remained open to the public until World War II and during a brief postwar period of attempted reorganization; afterwards many of the photo archives were donated to the Bibliothèque Nationale de France Opera Division in Paris, where they can still be viewed.[92] Perhaps even Michaux acquired photographs of such artifacts and performances during his Indonesian sojourn.[93]Given Dubuffet's interest in theater and Surrealist ethnography as an interwar phenomenon as described by Clifford, and considering the artist's reputation for conducting research at Parisian institutions and libraries, the AID was a likely source for him to encounter and study the kinds of Indonesian cultural forms that Michaux saw during his travels.[94]

The *Portrait of Michaux* and Sumatran effigies

Some key differences between Dubuffet's portrait and the *Jero Luh* puppet are worth noting. Yet they, too, echo the accoutrements of Indonesian performance—in this case, the ritual masks and puppets of Sumatra. The coloration and treatment of the eyes in Dubuffet's portrait differ most from the *Jero Luh*. They combine with the bulbous head to create remarkable resemblances to Sumatran *Hoda Hoda* masks that are carved from wood and treated with brown dyes (the earthy hues of which are comparable to those in the painting) and are worn along with carved wooden hands that the wearer moves in a puppet-like manner (Figure 4.8). Traces of the *sigale-gale,* a life-sized wooden puppet, also appear in the portrait (Figure 4.9). Although some formal similarities exist between these Sumatran artifacts and the Balinese *Jero Luh* due to cultural hybridity and the regional proximity of these neighboring island cultures, the Sumatran figures function very differently. As with the previously discussed costumes and puppets, these Sumatran artifacts have traditionally served to communicate between the lived and imagined worlds. But these masks and puppets were used in funerary rituals and, in the case of the *sigale-gale,* could even represent mourners who had never been born.[95]

By the time Michaux visited Indonesia, these once-guarded cultural forms were becoming outmoded, and their production and performances had already begun shifting to the realm of tourism and collecting. Yet these objects, which were believed to appease the spirits of the recently deceased and used to escort them from the land of the living to the overlapping spirit realm, continued to

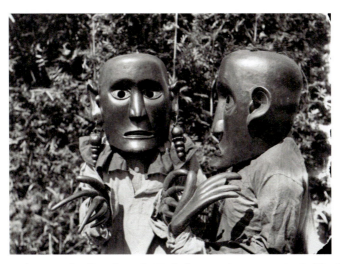

Figure 4.8 Photograph of Batak *Hoda-Hoda* dancers, Sumatra, 1930. Public domain. Tropenmuseum, Amsterdam. Collection Nationaal Museum van Wereldculturen. Call no. TM-10004608.

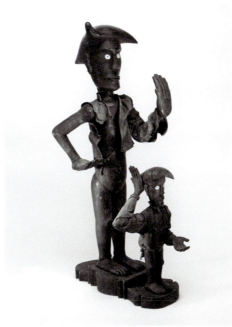

Figure 4.9 Two female figures with movable arms, Karo peoples, Sumatra. c. 1910, wood. Tropenmuseum, Amsterdam. Collection Nationaal Museum van Wereldculturen. Call no. TM-137-626. Photograph: Nationaal Museum van Wereldculturen. The function of this figure is uncertain, but the apparent dance attitude suggests that it might have some relation to the *sigale-gale* puppet.

resonate with local cultures and fascinate curious travelers. These ritual costumes varied by regional clan, and it is unclear to what degree the performances were impacted by tourism. Furthermore, Claire Holt's observations in her 1938 Indonesian field study indicate that at least one *Batak* group, the *Karo*, could perform these rituals "just for fun."[96]

Batak masks can have more or less rounded or hollowed out eyes, and some of them share key features with the *Jero Luh* that include large ears, a protruding forehead, and an elongated chin. Consider a 1930s photograph of *Batak* masks in the collection of the Tropenmuseum of Amsterdam (a city Dubuffet visited in 1931 to tour museums) that is reproduced in Paris collections (Figure. 4.10).[97] In the photograph, three masked figures appear, their large, bulky heads barely supportable by the dancers' bodies. Although the snapshot captures the dancers in mid-motion, the masks are clearly static, and their enlarged eyes appear to stare blankly into space. Looking closely, one sees that two of the masks have small tufts of hair, and one has a prominent mustache, but the smooth, bulky heads, oversized eyes, and protruding ears are the dominant features—features which compete with gesture for dominance in Dubuffet's painting.

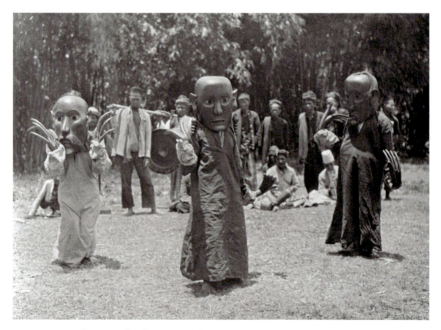

Figure 4.10 Photograph of *Batak Hoda-Hoda* dancers, Sumatra, 1930. Public domain. Tropenmuseum, Amsterdam. Collection Nationaal Museum van Wereldculturen. Call no. TM-60045323.

Each of the figures in this photograph bears a resemblance to Dubuffet's portrait of Michaux, but the bald figure in the center most notably so. Although the head is generally ovoid, many of its surfaces are carved in a more angular manner, giving the forehead and cheekbones an incongruously blocky appearance. The outlines of these surfaces, produced by a play of light and shadow on the wood's patina, create a tension between two- and three-dimensionality in the photograph. This is especially evident in the central figure, as it is in Dubuffet's portrait. In both cases, this play between bulkiness and flatness, between curviness and angularity, creates an odd facial structure, tapering down from a protruding brow and wide cheekbones to a narrower, yet apparently distended chin, which is accentuated in the portrait by the thick ring of paint below the mouth. The protruding ears, ovular eyes, triangular nose, and wide mouth of this photographed dancer are virtually identical to Dubuffet's portrait. The dancer's pose, too, bears consideration; his left arm (at right in the photo) appears at an odd angle, as if broken, which results from the way he holds the carved wooden hand by a rod that is concealed under the sleeves of his garment. The angle is less acute in the photograph than in the painting, but both arms form a V shape and support stiff, inhuman hands. It is difficult to see the right arm of the photographed figure (at left in the snapshot), but it appears to be held up and slightly outward in a manner echoed by Dubuffet's painting. Perhaps Dubuffet saw this or another such a photo. Perhaps Michaux even shared one from his trip.

The figure at the right of the photograph also warrants attention, since its pose, too, appears, as if re-articulated, in Dubuffet's portrait. First, the gown of this figure creases between the legs in such a way as to suggest the stick legs in Dubuffet's painting, producing a similar bulbous form for the torso. Second, the hands and arms are placed ambiguously in relation to the body. Once again, the figure's left arm (at right in the photograph) appears at an odd angle as a result of the way the dancer holds the carved wooden hand—another impossible-seeming V-shaped angle. Third, the stiffness of this wooden hand is also mimicked by the right hand of Dubuffet's figure. Although the left hand of the photographed figure and a detail of the center figure's hands in another photograph (see Figure 4.8) do not as closely resemble Dubuffet's portrait, the curves of these carved fingers prefigure the inhumanly curved left arm (at right) in the painting (see also Figures 4.11–4.12). For a painter such as Dubuffet, who was interested in puppetry, gesture, and conglomerate figures, the wooden hands of the *Batak* would activate the mask, transforming the performer, simultaneously, into both puppet and puppeteer.

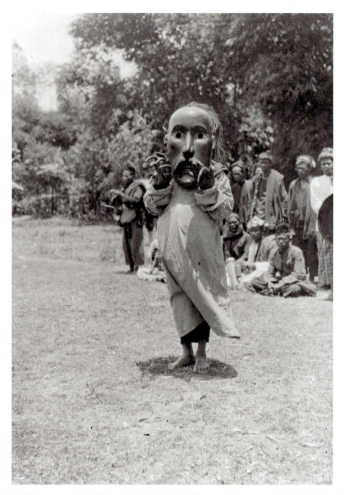

Figure 4.11 Photograph of *Batak Hoda-Hoda* dancer, Sumatra, 1930. Public domain. Tropenmuseum, Amsterdam. Collection Nationaal Museum van Wereldculturen. Call no. TM-10004609.

Although Sumatran forms were relatively rare in Paris during the first half of the twentieth century, the 1931 Paris Colonial Exposition provided one venue where they could be seen. Indeed, the reconstructed Sumatran dwellings, such as those Michaux described in his book, were said to be one of the exposition's main attractions.[98] In addition to other French and Swiss collections that might have housed such artifacts, the AID publications and archives show that the group owned examples of these masks, in addition to photographs and films of these artifacts used during ritual performances.[99] In any case, the combination of bulky mask, stiff hands, and suggestion of jerky movement appear in Dubuffet's portrait.

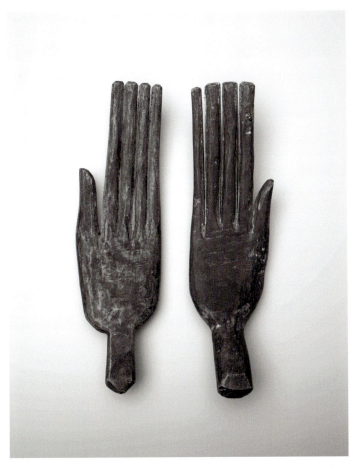

Figure 4.12 Wooden hands carried by *Batak* dancers, c. 1939, 27 × 8 cm. (10 5/8 × 3 1/8in.). Tropenmuseum, Amsterdam. Collection Nationaal Museum van Wereldculturen. Call no. TM-1318-1b. Photograph: Nationaal Museum van Wereldculturen. A comparable photograph of wooden hands carried by masked *Toba Batak* dancers was taken by Walter Spies, in the Claire Holt Papers, 1938, New York Public Library (copies of A.I.D archives, BNF Opera, Paris).

Puppets and portraits

The similarity between Dubuffet's *Portrait of Henri Michaux* to Sumatran *Hoda Hoda* masks is astounding. But these features are shared with an even more intriguing Sumatran effigy—the nearly life-sized *sigale-gale* puppet (see Figure 4.9). It is said that within traditional *Batak* cultures this figure served as a double that could stand in (with the aid of a puppeteer) to perform the funerary rites for childless clan members. These carved wooden puppets thus signified the

unfulfilled seeds of creative production. As legend has it, the puppets could also symbolize and, in a sense, re-animate the spirits of the deceased, bridging the gap between two worlds and calling attention to the need for vitality. Although these wooden doubles typically replaced imaginary originals (representing children who had never actually been born), they nevertheless represented the living spirit of the village mobilized to segregate the realms of the living and the dead.[100] Such use of art to usher out the old guard and clear space for living practices would have appealed to Dubuffet, a modern artist seeking to overturn artistic conventions with vibrant, yet primally resonant creative energy.

The puppet's uncanny appearance and jarringly disjunctive movements would have also resonated with the artist. Created to effect mobility, the *sigale-gale*'s movements are nevertheless stiff and jerky, a fact that accounts for its unnerving effects. Mounted on a large, sometimes rolling pedestal, the puppet stands straight and tall, its jointed wooden arms manipulated to gesture by a puppeteer using a complex system of ropes. The wooden face remains immobile, however, and this contrast between the rigidity of the mask and the jerky, rhythmic, movements of the arms troubles our expectations for living dynamism. Striking a remarkably unnerving chord, the seemingly magical, yet decidedly disturbing animation of the *sigale-gale* would surely have appealed to Dubuffet, the erstwhile puppeteer. What a fitting model to portray Michaux—a fellow traveler who combined the familiar and the strange to discombobulate his readers.

To an artist such as Dubuffet, who began his early artistic experimentation during the height of Surrealism, the *sigale-gale* might have seemed an uncanny precursor to the Surrealist mannequin, alluding to both life and death or a strange inbetween state. Such a near-hypnotic state, Dubuffet and Michaux's work suggest, is where most Westerners remain, ritualistically repeating culturally prescribed routines. The *sigale-gale* would surely resonate for Dubuffet, who equated the art of Western cultural institutions with atrophy and attributed true artistic production to creative movement.

Mixing "the habitual and familiar with the marvelous" was Dubuffet's artistic method. Through these means, the *Portrait of Henri Michaux* triggers an uncanny response. Its odd forms and displacements activate processes of inquiry in addition to affective gut reactions. It was not a purely reasoning mind that Dubuffet hoped to activate with this picture; far from it. Nor did he wish to engage in Surrealist excavation of the individual psyche, *à la* Breton, or in sync with collective culture, *à la* Jung. Addressing a core and ostensibly primal mode of making and encountering art, Dubuffet instead sought to expand our interpretations of what creativity means. His portrait was designed with unmooring in mind.

Poised as if to amble, even tumble toward us, the portrait of Michaux suggests not merely a momentary point of balance, but a desired sense of imbalance, expressing the value of dislocation and creative locomotion. Dubuffet achieves this in his portrait with puppet hands, disconcerting theatrical gesture, and mask-like facial features. These call to us, asking us to engage with this art, with this creative movement, and, ultimately, with this performance of (anti)cultural identity.

Notes

1 Jean Dubuffet, "Anticultural Positions," a 22-page facsimile of the artist's manuscript notes [handwritten in English] for a lecture at the Arts Club of Chicago on December 20, 1951, in Richard L. Feigen, *Dubuffet and the Anticulture* (New York: R. L. Feigen & Co, 1969), 18–19; Dubuffet, *Asphyxiating Culture and other Writings*, 101.

2 Jean Dubuffet, "In Honor of Savage Values," trans. Kent Minturn, *RES: Anthropology and Aesthetics*, no. 46 (Autumn, 2004): 260.

3 Dubuffet, "In Honor of Savage Values," 265.

4 Dubuffet, "In Honor of Savage Values," 265.

5 Chapter 3 of this book argues and provides support for the resemblance between Dubuffet's painting of Artaud and the *Barong, Rangda*, and other elements of the Balinese theater that inspired the author.

6 For more on Roger Caillois's theories on mimicry, see Roger Caillois, "The Praying Mantis: from Biology to Psychoanalysis" and "Mimicry and Legendary Psychasthenia" in *The Edge of Surrealism: A Roger Caillois Reader*, ed. Claudine Frank (Durham: Duke University Press, 2003), 69–102.

7 See note 6.

8 For more on Jacques Lacan's conceptualization of symbolic castration, see his *Ecrits: the first complete edition in English*, trans. Héloïse and Bruce Fink (New York: W.W. Norton & Co., 2006).

9 Virginia A. La Charité, *Henri Michaux* (Boston: Twayne Publishers, 1977), 21; David Ball, "Introduction," in *Darkness Moves An Henri Michaux Anthology, 1927–1984* (Berkeley, Calif: University of California Press, 1997), xii. See also Laurie Edson, *Henri Michaux and the Poetics of Movement* (Saratoga, Calif: ANMA, 1985), 46–48. All three scholars discuss Michaux's treatment of the thematic of the fragmented self. La Charité addresses bodily fragmentation specifically, citing Michaux's poem *Les Reves et la jambe* (Dreams and the Leg), 1923, while Ball discusses the thematic more generally in Michaux's work. Edson considers Michaux's work as dealing with identity formed through movement and momentary points of rest. As discussed in Chapter 3, Lacan also dealt with fragmentary identity in Jacques Lacan, "The Mirror Stage as Formative of the Function of the I," in *Ecrits: the first complete edition in*

English, trans. Héloïse and Bruce Fink (New York: W.W. Norton & Co., 2006), 75–81. Lacan had been studying fragmented identity since his dissertation but over time synthesized these ideas into his famous theory of the Mirror Formation of Identity, which he initially discussed in a 1936 lecture, iterated in subsequent variations, and also published in the *Revue Francais de Psychanalyse* 13, no. 4: 449–455.

10 La Charité, *Henri Michaux*, 21–27. See also Sigmund Freud, "The Uncanny," in *The Standard Edition of the Complete Psychological Works of Sigmund Freud*, vol. XVII, ed. and trans. James Strachey (London: Hogarth Press, 1974), 219–253.

11 Ball, *Darkness Moves*, xii, xiv–xv.

12 Richard Ellmann, "Introduction," in *Selected Writings: Henri Michaux,* VII (New York: New Directions, 1968).

13 Ellmann, *Selected Writings*, VII.

14 La Charité, *Henri Michaux*, 27.

15 Dubuffet, *Lettres à J.B., 1946–1985* (Paris: Hermann, 1991), 5, 11. These letters of January 13, 1947 and May 29, 1947 are also cited in Kent Minturn, *Contre-Histoire: The Postwar Art and Writings of Jean Dubuffet* (Ph.D. diss., Columbia University, 2007), 94. Dubuffet writes: "J'aime bien (surtout pour commencer, pour soutenir mes premiers pas dans cette enterprise de portraits) traiter de personages aussi merveilleux que possible (comme Michaux, Léautaud, Artad, Cingria) parce que ça m'en traîne, ça m'excite" (I like (especially to begin, to support my first steps in this enterprise of portraits) to deal with people who are as marvelous as possible (like Michaux, Léautaud, Artad, Cingria) because that's what compels me, excites me) (5): Dubuffet also writes of being "entiché de Michaux" (infatuated by Michaux) in his letter of May 29, 1947 (11). For more on Michaux's thematic of movement, see sources in note 10 above.

16 Maurice Merleau-Ponty, *Phenomenology of Perception* (1945), trans. Colin Smith (London: Routledge, 1962), 143, 153; Hubert Damisch and Sophie Berrebi, "Writings and Correspondence: 1961–1985: Hubert Damisch and Jean Dubuffet," trans. Nicholas Huckle and Molly Stevens, *October* 154 (Fall, 2015): 8–68; Kent Minturn, "Dubuffet avec Damisch," *October* 154 (Fall, 2015): 69–86; see also Jean H. Duffy, *Perceiving Dubuffet Art, Embodiment, and the Viewer* (Liverpool: Liverpool University Press, 2021), which I read while reviewing the page proofs of this book.

17 Minturn, *Contre-Histoire*, 94. Minturn references L.D. "Points sèches," in *La Marseillaise* (December 14, 1944); see also Baptiste Brun and Isabelle Marquette, "Portrait de Jean Dubuffet en anthropographe," in *Jean Dubuffet, un barbare en Europe* (Marseille: Musée des civilisations de l'Europe et de la Méditerranée, 2019), 9–20. The catalogue essay written by the curators of a 2019–2021 traveling exhibition *Jean Dubuffet, un barbare en Europe* also makes this connection and highlights the timeliness of considering the insights the artist might have gleaned from his friend that I discusses in relation to the *Portrait of Henri Michaux*.

18 Henri Michaux, *Un barbare en Asie* (Paris: Gallimard, 1933); reprinted *Un barbare en Asie* (Paris: Gallimard, 1945); I use *A Barbarian in Asia*, trans. Sylvia Beach (New York: New Directions, 1986).

19 Dubuffet, "In Honor of Savage Values," 259. See also Geneviève Bonnefoi, *Jean Dubuffet* (Caylus: Association mouvements, 2002). As mentioned in the previous chapters, although she takes a different approach to her study and does not develop these ideas in relation to Dubuffet's drawing upon the work of his sitters or the Oceanic and Indonesian cultural forms I consider, Bonnefoi also discusses Dubuffet's work in terms of disorientation and a thematic of movement.

20 For more on culture shock, see Kalervo Oberg, "Culture Shock: Adjustment to New Cultural Environments," *Practical Anthropology* 7 (1960); Rachel Irwin, "Culture Shock: Negotiating Feelings in the Field," *Anthropology Matters* 9, no. 1 (2007), https://www. anthropologymatters.com/index.php/anth_matters/article/view/64/123 (accessed July 18, 2019). This term has fallen out of favor in the field of anthropology due to its appropriation by jingoistic neoconservatives, yet Oberg appears to have attempted to describe many of the same feelings and anxieties Michaux elaborated upon his own unsettling encounters with other cultures in his book *A Barbarian in Asia*. Although the stages of adaptation Oberg first described in 1954 tended to apply to longer-term travelers than Michaux, whose Asian sojourn was characterized more as a whirlwind tour of many destinations than an acclimatizing stay in a given locale (or, indeed, than Dubuffet would have likely experienced during his South American or North African stints), Oberg's discussion also considers short- and long-term reactions that include honeymoon, crisis, recovery, and adjustment to the loss of familiar cultural signs.

21 See also Jill Shaw, *A Coat that Doesn't Fit: Jean Dubuffet in Retrospect, 1944–1951.* Thesis (Ph.D.), University of Chicago, 2013. Shaw discusses Dubuffet's reliance upon a kind of "cultural electroshock" gained from his visits to Algeria. She also discusses Dubuffet's work in relation to the idea of dislocation and to conceptual "breaks" that he benefitted from by introducing them into his oeuvre.

22 James Clifford, "On Ethnographic Surrealism," in *The Predicament of Culture* (Cambridge: Harvard University Press, 1988), 117–151.

23 Gaston Bachelard, *The Philosophy of No: A Philosophy of the New Scientific Mind,* trans. G. C. Waterson (New York: Orion, 1968), a translation of Bachelard, *La philosophie du non: essai d'une philosophie du nouvel esprit scientifique* (Paris: Presses universitaires de France, 1940); see also Mary Ann Caws, "The 'réalisme ouvert' of Bachelard and Breton," in *The French Review* (January 1964): 302–311; and Caws, ed., "Translator's Introduction," in André Breton, *Mad Love* (1937) (Lincoln, Nebraska: University of Nebraska Press, 1987), xi–xii.

24 Dubuffet, "In Honor of Savage Values," 259. For more on Bachelard's conceptual dynamism see Gaston Bachelard, "Introduction," in *The Poetics of Space*, trans. Maria Jolas (New York: Orion, 1964), xiv, xviii, xxii, xxv; Bachelard, *La Terre et les reveries de la*

volonté: Essai sur l'imagination de la matière (Paris: José Corti, 1947), 105, and note 19 above; see also Sarah Wilson, "Paris Post War: In Search of the Absolute," in *Paris Post War: Art and Existentialism 1944–55*, ed. Frances Morris (London: Tate Gallery, 1993), 34; and Marianne Jakobi, "Nommer la forme et l'informe: La Titraison comme genèse dans l'oeuvre de Jean Dubuffet," *Item*, February 19, 2008 http://www.item.ens.fr/index. php?id=187132 (accessed July 2, 2015). Wilson discusses the intertextuality between Dubuffet's painting and Bachelard's ideas on "the dynamic hand" and primordial matter.

25 Henri Michaux, *Émergences—résurgences* (Geneva: Albert Skira, 1972), 9; Jean Dubuffet, "Notes for the Well-Read," in Mildred Glimcher et al., *Jean Dubuffet: Towards an Alternative Reality*, trans. Joachim Neugroschel (New York: Pace Publications, 1987), 81; Dubuffet, *Asphyxiating Culture and other Writings*, trans. Carol Volk (New York: Four Walls, 1986), 60, 62. Michaux writes: "Ne, elevé, istruit dans un milieu et un culture uniquement du 'verbal' je peins pour me deconditionner" (Born, raised, and educated in a environment and a culture solely of the "verbal," I paint to decondition myself). Dubuffet revisits these themes, upon which he first elaborated during the 1940s, in his *Asphyxiating Culture*, writing that "the first step toward deconditioning will consist in distancing oneself from all that is traditionally expected—for example, from painting" (62). He also proposes founding "a school of deculturation" (62).

26 André Breton, "First Manifesto of Surrealism," in Charles Harrison, and Paul Wood, *Art in Theory 1900-2000* (Malden, Mass: Blackwell Publishing, 2003), 452.

27 Gaston Bachelard, *The Philosophy of No* (full citation in note 23 above); Bachelard, "Introduction," in *The Poetics of Space* (1957), trans. Maria Jolas (New York: Orion, 1964), xi–xii, xxix; Bachelard, *La Terre et les reveries de la volonté: Essai sur l'imagination de la matière* (Paris: José Corti, 1942), 105; Bachelard, *Le nouvel esprit scientifique* (Paris: Librairie Félix Alcan, 1934); see also Sarah Wilson, "Paris Post War: In Search of the Absolute," in *Paris Post War: Art and Existentialism 1944–55*, ed. Frances Morris (London: Tate Gallery, 1993), 34; and Marianne Jakobi, "Nommer la forme et l'informe: La Titraison comme genèse dans l'oeuvre de Jean Dubuffet," *Item*, February 19, 2008, http://www.item.ens.fr/index.php?id=187132 (accessed July 2, 2015).

28 I also explore these ideas in the previous chapters of this book and in my dissertation, Stephanie Chadwick, *Disorienting Forms: Jean Dubuffet, Portraiture, Ethnography,* Thesis (Ph.D.), Rice University, 2015. See also Shaw, *A Coat that Doesn't Fit* in note 21 above.

29 Dubuffet, *Asphyxiating Culture and other Writings*, 62.

30 Dubuffet, "Art Brut Chez Dubuffet," in *Prospectus et tous écrits suivants*, 49; also see Shaw in note 21 above.

31 Jean H. Duffy, "Jean Dubuffet's Beautiful People," *Word & Image* 35, no. 2 (June, 2019): 191–209. Duffy discusses Dubuffet's depersonalization of his portrait subjects as a way to suggest fundamental human likenesses and experiences.

32 Antonia Dapena-Tretter, "Jean Dubuffet & Art Brut: The Creation of an Avant-Garde Identity," *Platform* 11, "Authenticity" (Autumn, 2017): 12–33.

33 For more on Homi K. Bhabha's concepts of "interstitial perspective" and "hybridity" see Homi K. Bhabha, *The Location of Culture* (London: Routledge, 1994), 1.

34 Clifford, *The Predicament of Culture*, 117–151.

35 Although I consider Dubuffet's exploration of hybridization of identity in ways that I believe at times approximate some of Bhabha's ideas about "hybridity" (see note 33 above), I refrain from using that term in most of this book due to the vast differences in the timing and motivations of the two men and the fact that, as anticultural as Dubuffet's work was, it was nevertheless structured by an array of dichotomies rooted in Western colonialist culture.

36 Minturn, *Contre-Histoire*, 94.

37 Claude Lévi-Strauss, *The Savage Mind*, trans. George Weidenfeld and Nicolson Ltd. (Chicago: University of Chicago Press, 1962); Jacques Derrida, *Of Grammatology* (Baltimore: Johns Hopkins University Press, 1976); Derrida, "Structure, Sign, and Play in the Discourse of the Human Sciences," in *Writing and Difference,* trans. Alan Bass (Chicago: University of Chicago Press, 1978), 6.

38 Dubuffet, "Anticultural Positions," in Feigen, 19.

30 For more on the concepts of performativity and the performative, see J. L Austin, *How to do Things with Words* (Cambridge: Harvard University Press, 1962); Jacques Derrida, *Of Grammatology* (Baltimore: Johns Hopkins University Press, 1976); Judith Butler, *Gender Trouble: Feminism and the Subversion of Identity* (New York: Routledge, 1990); and Kira Hall, "Performativity," *Journal of Linguistic Anthropology* 9, no. 1–2 (2000): 184–187. Hall discusses the trajectory and wider applications of the concept of the performative in linguistic anthropology and literary studies, considering various approaches to the idea that representation shapes identity. For more on postwar discussions of constituted identity see Caws, "The 'réalisme ouvert' of Bachelard and Breton," 302–311; and Caws "Translator's Introduction," in Breton, *Mad Love* (1937), xi–xii.

40 Dubuffet, "Little Chat," trans. Sara Ansari and Kent Minturn, in *Jean Dubuffet: "Anticultural Positions,"* ed. Mark Rosenthall (New York: Aquavella Galleries, 2016), 66, 69. The full text is translated on pages 63–70. The full "Causette" (Little Chat) contained in Dubuffet's exhibition catalogue can be read in Dubuffet, "Causette," in Dubuffet, *Prospectus et tous écrits suivants*, Vol. II, 67–73; and an image of the announcement can be viewed in Jean Dubuffet and Max Loreau, *Catalogue des travaux de Jean Dubuffet*, Fascicule III, "Plus beaux qu'ill croient, Portraits" (Paris: Fondation Dubuffet, 2003), 13–16.

41 Jean Dubuffet, *Biographie au pas de course* (Paris, Gallimard, 2001), 21; Dubuffet, *Lettres a J.B.*, 1–5, 10–11 (see letters of December 16, 1946, December 25, 1946, and May 29, 1947 cited also in Minturn, *Contre-Histoire*, 94); La Charité, *Henri Michaux*, 22; see also André Masson, *Les Aneé Surréalistes: Correspondences 1916–1942* (Paris:

La Manufacture, 1990), 23, 28–29. Both Michaux and Dubuffet experimented with Surrealist automatism tempered with degrees of artistic control, conceiving of artistic production as also a kind of creative channeling.

42 Ludmila Velinsky-Ondrůjová, *From the Gloom of Today to New Greatness of Man: Itinerary by Henri Michaux, Builder of New Poetry* (New York: Vantage Press, 1977), 18–25. See also La Charité, *Henri Michaux*, 21–23.

43 For more on ambivalence and tensions in Michaux's writing see Velinsky-Ondrůjová, *From the Gloom of Today to New Greatness of Man*, 27–37; La Charité, Henry Michaux, 21–27.

44 Kazuo Nakabayashi, "Henri Michaux: Emerging Figures," in *Henri Michaux: Emerging Figures* (Tokyo: National Museum of Modern Art, Tokyo, 2007), 109.

45 La Charité, *Henri Michaux*, 22.

46 Minturn, *Contre-Histoire*, 94; Dubuffet, *Biographie au pas de course*, 32–36; Edson, *Henri Michaux and the Poetics of Movement*, 50; Nakabayashi, "Henri Michaux: Emerging Figures," 109–110; Noland, *Agency and Embodiment*, 130–133; Nina Parish, *Henri Michaux: Experimentation with Signs* (Amsterdam: Rodopi, 2007), 151–152, 155–157, 166, 187. Dubuffet describes his own interest in researching the so-called pictographic writing of non-Western cultures in his autobiography. For a thorough discussion of Michaux's paintings in relation to his interest in pictograms, see Nakabayashi, "Henri Michaux: Emerging Figures," 109–110; Edson, *Henri Michaux and the Poetics of Movement*, 50; Noland, *Agency and Embodiment*, 133; Parish, *Henri Michaux,* 187.

47 Margaret Rigaud-Drayton, *Henri Michaux: Poetry, Painting, and Universal Sign* (Oxford: Clarendon Press, 2005), 1.

48 Michaux, *A Barbarian in Asia*, 171. Borneo is a Southeast Asian island that is divided between Indonesia, Malaysia, and Brunei. *Dayak* is a term that refers to pre-Muslim indigenous cultures and the *Bahau* is a culture that uses highly stylized pig or boar masks.

49 Prinzhorn, *Artistry of the Mentally Ill*, 108. Illustration 64 on this page is a particularly strong example of work re-articulated in Michaux's 1940s painting, much of which features figures created with smeared paint.

50 Susan Sontag, ed., *Antonin Artaud: Selected Writings* (New York: Farrar, Strauss, and Giroux, 1973), xxvii. I adopt some of Sontag's points of discussion relevant to Michaux and also her use of the notion of "fellow travelers" to Surrealism, which Clifford also considers in *The Predicament of Culture*, 542.

51 Nakabayashi, "Henri Michaux: Emerging Figures," 110–111; Nakabayashi cites Michaux's famous description of his process: "The legs, arms, or bust may be lacking, but through its dynamic interior, warped and exploded, it is a man. I submit them to torsion, stretch, and expansion in all directions . . . A torn man is dashing towards something unknown, for an unknown reason, lashed by something unknown."

52 Dubuffet, *Lettres a J.B.*, 5, 11 (letters of January 13, 1947 and May 29, 1947 cited also in Minturn, *Contre-Histoire*, 94); for quotes, see also note 15 above.

53 Michaux, *A Barbarian in Asia,* 171.

54 Michaux, *A Barbarian in Asia,* 173. See also 174–175 discussing Balinese women and their concern for propriety.

55 Peter Broome, *Henri Michaux* (London: Athlone Press, 1977), 54–56.

56 Edson, *Henri Michaux and the Poetics of Movement*, 53; Parish, *Henri Michaux,* 151–166; Nakabayashi, "Henri Michaux: Emerging Figures," 116. Michaux traveled throughout Europe and extensively in the Americas (1918, 1927, 1936, 1939, 1967, 1969), the Middle East (1930, 1947, 1956, 1974), and Asia (1931–1932, 1966). Like many members of the Parisian avant-garde, Michaux investigated an eclectic blend of Eastern cultures and philosophies beginning as early as the 1920s.

57 Dubuffet, *Lettres a J.B., 1946–1985* (Paris: Hermann, 1991), 5, 11 (letters of January 13, 1947 and May 29, 1947 cited also in Minturn, *Contre-Histoire*, 94). For quotes see my note 14.

58 Michaux, *A Barbarian in Asia,* 171.

59 Michaux, *A Barbarian in Asia*, v.

60 Michaux, *A Barbarian in Asia* v.

61 For the concept of identity I draw from both the writer's descriptions and later developments in Structuralist and Poststructuralist theory. See also notes 33 and 35 above for more on my use of any variation of the term hybrid in relation to Homi K. Bhabha's concept of "hybridity," also see Bhabha, *The Location of Culture*. Although I hesitate to use the term in relation to Dubuffet's figures due to the vast differences in these two men's working context and motives, I am more comfortable using the term here with regard to Michaux's description. Despite the fact that Michaux's writing reveals that his socialization by Eurocentric, colonialist culture is more difficult to escape then he realizes, and is thus at times characterized by crass Eurocentrism, he seems on at least some level to have truly attempted to investigate both cultural difference and interconnectedness.

62 Archives internationales de la danse and Claire Holt, *Théâtre & danses aux Indes néerlandaises, XIIe exposition des Archives internationales de la danse, 1939* (Paris: G.P. Maisonneuve, 1939), 70. For more on the AID see Inge Baxmann, *Les archives internationales de la danse: 1931–1952* (Pantin: Centre National de la Danse, 2006). This group conducted extensive field work in Indonesia and researched and collected Balinese, Javanese, and Sumatran costumes, puppets, and other performance-related artifacts they made publicly available at their Paris headquarters, where they featured a permanent collection, held special exhibitions that attracted the French avant-garde, and maintained a library of photographs, films, audio recordings, and other ethnographic documentation. The AID closed during World War II, at which time member Clair Holt brought many photographs,

negatives, and films to New York, which are now archived at the New York Public Library Dance Division. Others remain at the Bibliothèque Nationale de France, Musée de l'Opéra.

63 My use of the term "mimicry" here is not intended to denote a relationship to the term as used in Bhabha's postcolonial theory and instead attunes to the earlier usage by Caillois and Lacan in notes 6 and 8 above. For more on the 1931 Paris Colonial Exposition see Chapter 3 of this book.

64 Gregory Bateson, Margaret Mead, and D. Carleton Gajdusek, *Balinese Character; a Photographic Analysis* (New York: New York Academy of Sciences, 1942), 16–17. This book is the published findings of joint anthropological field work in Bali and cites prevalent Balinese beliefs concerning the use of gesture. According to these renowned anthropologists, the gestures, in which the arms and hands are held in rigid, angular poses, are highly significant. Also of note: these anthropologists were in direct contact with the multi-national community of artists and ethnographers living in Bali, and the book was published just five years before Dubuffet made his portraits.

65 Other important contemporaneous sources for early twentieth-century European and American interest in Bali are Miguel Covarrubias, *Island of Bali* (1937) (London: KPI, 1986); and Beryl De Zoete and Walter Spies, *Dance & Drama in Bali* (1938) (Hong Kong: Periplus Editions, 2002). For more up to date study, see I. W. Dibia and Rucina Ballinger, *Balinese Dance, Drama and Music: A Guide to the Performing Arts of Bali* (Singapore: Periplus, 2004); and Judy Slattum, *Balinese Masks: Spirits of an Ancient Drama* (Hong Kong: Periplus, 2003). Covarrubias' 1937 book *Island of Bali* was reissued in 1946, just prior to Dubuffet's portrait of Michaux.

66 Bateson, Mead, and Gajdusek, *Balinese Character*, 16–17.

67 Bateson, Mead, and Gajdusek, *Balinese Character*, 91.

68 Bateson, Mead, and Gajdusek, *Balinese Character*, 18. According to this study, even the Balinese hands at rest rarely remain in what Westerners would consider a relaxed position and instead retain angular poses consistent with the cultural value of this form of gesture.

69 La Charité, *Henri Michaux*, 21; Velinsky-Ondrůjová, *From the Gloom of Today to New Greatness of Man,* 29–34.

70 See notes 62–65 above for the variety of visitors publishing on Bali.

71 Dubuffet, "Anticultural Positions," in Feigen, 20.

72 For an example of Michaux's *Movements* performed in the United States, see the Museum of Contemporary Art, Chicago website: https://mcachicago.org/ Calendar/2013/03/Compagnie-Marie-Chouinard-The-Rite-Of-Spring-And-Henri-Michaux-Mouvements (accessed Feburary 2, 2020).

73 Dubuffet, "Anticultural Positions," in Feigen, 21.

74 Dubuffet, *Asphyxiating Culture and other Writings*, 77.

75 Dubuffet, *Asphyxiating Culture and other Writings*, 77.

76 Parish, *Henri Michaux,* 185.

77 Edson, *Henri Michaux and the Poetics of Movement*, 46.

78 Nakabayashi, "Henri Michaux: Emerging Figures," 115; also see Velinsky-Ondrůjová, *From the Gloom of Today to New Greatness of Man*, 264–300 for a thorough discussion of Michaux's experimentation with hallucinogenic drugs.

79 Quted in Nakabayashi, "Henri Michaux: Emerging Figures," 116, from Michaux's Postface in *Movements*, Vol. II, 598. According to Michaux, "The movement of the forms became my movement. The more they moved, the more I existed. I wanted more movement. By doing so I became a complete other. I invaded my body—I carried my body as if I was riding a galloping horse as one. I was possessed by movements, pulled by these forms, which had arrived quickly and rhythmically."

80 Broome, *Henri Michaux*, 40; Edson, *Henri Michaux and the Poetics of Movement*, 46.

81 Broome, *Henri Michaux*, 40.

82 Michaux, *A Barbarian in Asia*, 156–159, 173–177, 182–183: In *A Barbarian in Asia* pages 176–177, Michaux proclaims that "when one arrives in Bali . . . one is enchanted," adding that "there are demons everywhere, at the entrance of temples, of houses." The word *demon* within this context refers to a range of good and evil deities as well as animistic and ancestral spirits. For more on sacred and life-affirming Indonesian performance see the sources listed in notes 62–65 above. See also Matthew Isaac Cohen, "Dancing the Subject of Java: International Modernism and Traditional Performance, 1899–1952," *Indonesia and the Malay World* 35, no. 101 (March, 2007): 10, 13–14.

83 De Zoete and Spies, *Dance & Drama in Bali* (Hong Kong: Periplus Editions, 2002), 112–115; Slattum, *Balinese Masks*, 12, 102, 114; Covarrubias, *Island of Bali*, 356. The *Jero Luh (Djero Loeh)* puppet is one of a pair of (male and female) puppets known as *Barong Landung* enacted in playful, flirtatious activities during processionals that include a variety of characters. According to De Zoete and Spies, this life-sized puppetesque costume is used in sacred shrines, ritual processions, and impromptu community performances. On the Youtube channel of a project called *Bali 1928* that shares film footage taken by Miguel Covarrubias in the company of his wife Rose and the artist Walter Spies, there is a short film of the *Barong Landung* performance that shows both the *Jero Luh's* angular dance pose, in which one arm is pinned to the figure's garment, and its other, loosely swaying arm: https://www.youtube.com/watch?v=ZbkAF9fmTAw.

84 De Zoete and Spies, *Dance & Drama in Bali*, 113–115.

85 De Zoete and Spies, *Dance & Drama in Bali*, 114.

86 Edson, *Henri Michaux and the Poetics of Movement*, 46; Broome, *Henri Michaux*, 40.

87 Michaux, *Plume*, quoted in Broome's "Introduction" to Michaux's *Spaced Displaced* (Newcastle: Bloodaxe Books, 1992), 40.

88 Parish, *Henri Michaux,* 118. Parish argues that Michaux's use of both masculine and feminine agreement in first- and third-person singular usage reflects a deliberate play with androgyny that attuned to his understanding of fluid identity.

89 See Chapter 3 for more discussion of the *Rangda* character in Balinese theater.

90 Although it has been challenging to establish which collections in addition to the AID had access to this Balinese costume in France, it is likely that the Musée national des Arts d'Afrique et d'Océanie, the permanent ethnographic museum built on the site of the 1931 Paris Colonial Exposition, had images of this object, if not the actual artifact. A Swiss venue that would have provided Dubuffet the opportunity to see the costume was the Musée d'ethnographie, de Genève, which he visited with Jean Paulhan and which held an extensive collection of Indonesian artifacts. For more on the Musée d'ethnographie de Genève Indonesian collection, see Musée d'ethnographie de Genève, *Théâtres d'orient: masques, marionnettes, ombres, costumes* (Ivrea, Italy: Priuli & Verlucca, 1997). This book has served as a rich source of information for my research. Although the Musée d'ethnographie de Genève was closed for renovations during the course of my dissertation research, the museum's publications and online resources have been helpful. The example image of this costume that I include here is in the Tropenmuseum, which has maintained an ongoing collection of Indonesian artifacts since 1864. For more information, see the Tropenmuseum website: https://www.tropenmuseum.nl/en/themes/history-tropenmuseum.

91 See notes 62–65 above and note 92 below.

92 Archives internationales de la danse and Claire Holt, *Théâtre & danses aux Indes néerlandaises*, 70. For more on the collecting and documenting activities of the AID see Chapter 3 of this book and note 62 above.

93 I have thus far found no evidence that Michaux collected ethnographic artifacts, though it stands to reason that he would have obtained photographs or post cards during the course of his travels. It is known that he discussed his travels with his friends, including Dubuffet. Moreover, in Dubuffet's "In Honor of Savage Values," 264, the artist mentions a friend who visited Korea (likely Michaux) with whom Dubuffet discussed Korean dance. It thus stands to reason that Dubuffet had opportunities to ask Michaux about the art and cultural forms he encountered during his travels.

94 Clifford, *The Predicament of Culture*, 117–151.

95 Achim Sibeth, Uli Kozok, and Juara R. Ginting, *The Batak: Peoples of the Island of Sumatra: Living with Ancestors* (New York: Thames and Hudson, 1991), 11, 68, 70–71, 77. The traditional *Batak* cultures used carved wooden masks during funeral rituals performed by costumed dancers in the open air. In these ceremonies two masked dancers (one representing a man and one a woman, though both performed by nearly identically outfitted men) encircled a third man costumed as a horse

(*Hoda Hoda*) or a hornbill bird, depending upon which *Batak* clan performed the ritual. The masked dancers then accompanied the kin and the coffin to the burial ground, leaving the masks on the grave or in a small housing above it. Although little is known of the exact details and meanings of these outmoded rites, they are presumed to have served an apotropaic function, keeping evil spirits at bay and escorting the spirits of the dead away. The *Batak* believe in a duality of souls, protecting the primary "life soul" and encouraging the "death soul" to leave and to cease interacting with the land of the living. Despite the efforts of some *Batak* clans to maintain degrees of insularity and ancestral hierarchy, these practices reflect a high degree of heterogeneity and dynamism.

96 Claire Holt, and Arlene Lev, "Batak Dances: Notes by Claire Holt," *Indonesia*, no. 12 (October, 1971): 84; Arlene Lev, "Preface," in "*Batak* Dances: Notes by Claire Holt," *Indonesia*, no. 12 (October, 1971): 65–66; Arlene Lev, "Preface," in "Dances of Sumatra and Nias: Notes by Claire Holt," *Indonesia*, no. 11 (April, 1971): 1–2; Nancy Shawcross and Claire Holt, "The Claire Holt Collection," *Dance Research Journal* 19, no. 1 (Summer, 1987): 25, 27–35; see also Sibeth, Kozok, and Ginting, *The Batak*, 77. For more on the similarities and differences between these practices, see Sibeth, Kozok, and Ginting discuss the similarities and differences among *Batak* practices and provide useful photographs for comparison.

97 Dubuffet, *Biographie au pas de course*, 30.

98 Michaux, *A Barbarian in Asia*, 175. Michaux discusses the boat-shaped Sumatran homes he saw on his trip, examples of which were reconstructed and photographed for the nearly concurrently-held 1931 Paris Colonial Exhibition.

99 Holt, *Théâtre & danses aux Indes néerlandaises*, 75–77. The example of hands shown here are in the collection of the Tropenmuseum.

100 Sibeth, Kozok, and Ginting, *The Batak*, 79; Tibor Bodrogi, *Art of Indonesia* (Greenwich, Conn: New York Graphic Society, 1972), 33–34; Metropolitan Museum of Art, New York, "Puppet Head (Si Gale-gale)", http://www.metmuseum.org/collections/search-the-collections/315894; Metropolitan Museum, http://www.metmuseum.org/toah/works-of-art/1987.453.6. The ritual use of this puppet likely began sometime during the nineteenth century and was relatively short-lived, moving into the realm of tourism in the early twentieth century. Myths related to the use of the puppet vary among the *Batak* peoples. In one version, the jointed puppet is used to revive a mourning king from his malaise after the death of his son, the prince. In some cases these uncanny doubles are also said to be used in ceremonies to trigger the conception of children. The most commonly-held use was for the puppet to stand in for the children of the recently deceased who died childless to perform the funeral rites necessary to transition the spirits and prevent their causing problems in the land of the living. In all cases, however, the puppets stand in for children.

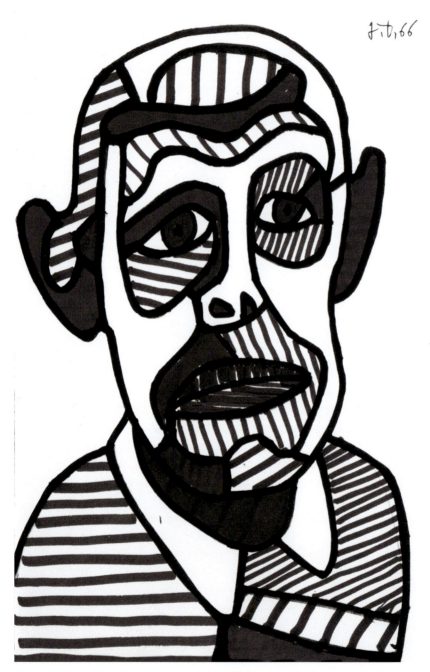

Figure 5.1 Jean Dubuffet, *Autoportrait II* (Self-Portrait II), November 1966, marker on paper, 25 × 16.5 cm. (9.8 × 6.5 in.). Fondation Dubuffet, Paris / © 2020 Artist Rights Society (ARS), New York—ADAGP, Paris. Fondation Dubuffet, Paris. Photograph courtesy of the Fondation Dubuffet, Paris. Reproduced in Jean Dubuffet, *Catalogue des travaux de Jean Dubuffet*, Fascicule XXII (Paris: Fondation Dubuffet, 2003), 70, no. 205.

Conclusion. Animating the Material: Assemblage, Theatricality, and Performativity in Dubuffet's Self-Portraits

In 1966, long after Dubuffet had produced a portrait series of his friends and acquaintances of the immediate postwar era, he created six portraits that differed radically in style. Attuning to a more contemporary design aesthetic, these renderings featured the subject that Dubuffet knew best—himself (Figures 5.1 and 5.2 and color Plate 7). Straddling the line between painting and drawing, these self-portraits were produced on paper and composed of flat, cell-like shapes that were clearly outlined in black and lined through or filled in with red and blue marker. Stylistically these figures were worlds away from his earlier portraits, which were characterized by smears, gouges, thick materiality, and crude slash-like marks. Yet looking closely at these later works reveals important parallels, not least of which is a sense of disjunction that is only enhanced by the multiplicity of these depictions. The late self-portraits relied more overtly upon a collage aesthetic than the other portraits discussed in this book to produce a sense of (anti)cultural displacement. By also suggesting the ideas of creative movement and performance, ideas that necessarily also have cultural components, these and all of Dubuffet's portraits suggest the idea of performativity. They allude, in their way, to the notion that the performance of enculturated roles or, indeed, even of those activities we tend to think of as internally motivated (such as art-making) can either reinforce the status quo or subvert it. Dubuffet's portraits—those that have been discussed in earlier chapters and also his innovative late self-portraits of the 1960s considered in this chapter—demonstrate his commitment to exploring and highlighting the interactive relationships between art, culture, and identity.

Figure 5.2 (and Color Plate 7) Jean Dubuffet, *Autoportrait VI* (Self-Portrait VI), December 1966, marker on paper, 25 × 17.5 cm. (9.8 × 6.9 in.). Fondation Dubuffet, Paris / © 2020 Artist Rights Society (ARS), New York—ADAGP, Paris. Private collection, Canada. Photograph courtesy of the Fondation Dubuffet, Paris. Reproduced in Jean Dubuffet, *Catalogue des travaux de Jean Dubuffet*, Fascicule XXII (Paris: Fondation Dubuffet, 2003), 71, no. 209.

Part I. Identity Along the Way: Strategic Self-Portraits

As Dubuffet focused increasingly, during the latter part of his career, on the extraordinary creative powers that all too often lie dormant in the daily routines of enculturated experience, he renewed his efforts to radically transform his figuration. The six red, white, and blue self-portraits he produced in 1966 participated in the radical break represented by his new *Hourloupe* series of drawings and paintings that, as the story goes, he translated from his ordinary telephone doodles.[1] These works grew to include the addition of not only artistic drawing and painting, but also sculpture, architecture, and even stagecraft. Dubuffet's self-portraits are less substantial than his *Hourloupe* sculptures, just as they are less material, in their paper-thinness, than the *haute pâte* portraits of the 1940s. Smooth and graphically rendered in the palette of the ballpoint pens that inspired the series, these figures are crisper, clearer, and, perhaps, tamer in their organization. They were not scrawled into, or built up from, the layers of his thickly painted strata mixed with cement, paper, or detritus. Nor were they created with harsh, expressive marks, as were his drawn portraits of the postwar era, or his rawer works of the 1960s in series such as *Paris Circus*, which harkened back to his graffiti-like war-time figuration. Yet, these late portraits also convey the sense of tension that characterized his earlier works, including that between flatness and form and between stasis and movement. They too suggest processes of layering to create an impactful artistic encounter. Made of ink and paper, they were drawn, not collaged, yet they more overtly resemble collage than the postwar portraits. Representing the artist himself in a series of drawn assemblages, these late self-portraits re-articulated collage as an active theme in Dubuffet's work, in which he would soon rekindle his engagement with the process of literal collage.

Amplifying an ongoing exploration of collage, which by then had already progressed considerably to include literal collage in some of his works of the 1950s and 1960s, Dubuffet tinkered in his *Hourloupe* cycle to produce a radical hybridization of genres, styles, and media. He blurred these boundaries between genres in order, as he proclaimed in his 1972 *Writings on Sculpture*, to "set off in the viewer's mind a hyperactivation of the visionary faculty."[2] The self-portraits coincided with these efforts and demonstrated his little-acknowledged yet continued engagement with non-Western art, which he adapted, transformed, and covertly infused into his performance of artistic identity.

Dubuffet's late self-portraits transmogrified his consistently held artistic aims to dissociate, dislocate, and, in effect, *move* the viewer in ways that might subvert "asphyxiating culture"—the title he gave to his 1968 book on the subject.[3] These

anticultural aims proved to be both timely and lasting, taking new forms during the 1960s and continuing to resonate until the end of his career. Although the late self-portraits represented a radical break from Dubuffet's early figural style, they, and the *Hourloupe* mode in which they were rendered, also bear the marks of Cubist echoes and Surrealist preoccupations. As this book has elaborated, these interests included his fascination with disjunctive imagery, untrained art, and the art of non-Western cultures. The pages of this book have situated these interests in relation to James Clifford's notion of cultural collage, an interwar phenomenon that emerged as artists and ethnographers explored representations of various cultures previously under-acknowledged by Western cultural institutions that, however surreptitiously, appears to have shaped Dubuffet's postwar practice.[4] The late self-portraits, too, suggest the artist's processes of image-gathering and hybridization in the manner of Claude Levi-Strauss's *bricoleur*.[5] Indeed, these late works relied even more heavily upon fragmentation, juxtaposition, and a multitude of viewpoints. As discussed in Chapter 2, Dubuffet's work appears to have fostered an interactive dialogue with Cubism in the works of his friend Braque and even with Picasso himself (see Figures 2.2 and 2.3), whose late work remained characterized by conglomerate forms with ever more compartmentalizing contours. As Pepe Karmel has noted, and as I have also discussed in Chapter 2, Picasso appears to have actively participated in this dialogue with Dubuffet, visually quoting this artist's style for a late self-portrait of his own (see Figure 2.3).[6]

Although Dubuffet's late self-portraits were emphatically flat, they hinted at his growing interest in three-dimensionality and movement in actual space. In their way, these portraits foreshadowed the artist's foray into large-scale sculpture and actual stagecraft in his *Coucou Bazar* performances of the 1970s—"animated painting [s]," as he described the productions, that featured assemblage, masked performance, and even puppetry.[7] Indeed, the introduction in the 1960s of Dubuffet's *Hourloupe* style, of which the self-portraits were a key (if under-appreciated) component, appears to have instigated this performative metamorphosis.

Resonances of the interwar interest in experimental theater also appear in Dubuffet's late self-portraits, which feature visual similarities to the paintings and stage designs of his old friend Fernand Léger, who had participated in avant-garde theater and promoted world dance when he served on the board of the Archives internationales de la Danse (AID) (Figure 5.3).[8] As Jean H. Duffy observes in "Dubuffet Plays Hide-and-Seek: Lineage, Reflexivity, and Perception in Coucou Bazar," avant-garde performances of the early-twentieth century surely informed Dubuffet's theatrical productions.[9] Indeed, interest in experimental

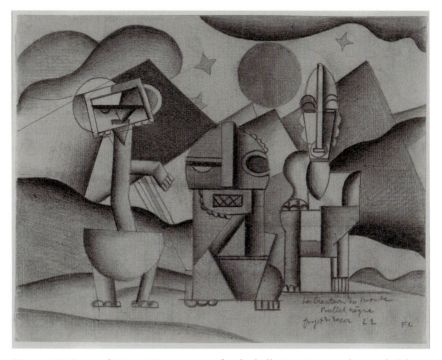

Figure 5.3 Fernand Léger, Mise-en-scène for the ballet *La Création du monde* (The Creation of the World), 1922, 21 × 27 cm. (8 1/4 × 10 5/8 in.). © 2020 Artists Rights Society (ARS), New York / ADAGP, Paris. Museum of Modern Art, New York. Photograph: © The Museum of Modern Art/Licensed by SCALA / Art Resource, NY.

theater saw a resurgence during the 1960s with the rise of NeoDada practices. As an artist who proclaimed his love of the original Dada iterations that conjoined radically experimental performance, the element of chance, and unsettling, anti-rational humor to subvert Western cultural institutions, it makes sense that Dubuffet sought to rejuvenate and even literalize his engagement during the 1960s and 1970s.[10] Although the self-portraits of this period seem static by comparison to his early portraits or his subsequent foray into performance, they, too, explore the themes of movement, relationships between ordinary and extraordinary life, and the potential to form dynamic, hybrid identities that resist institutional control. These ideas loosely coalesce in the portraits, which project the sense of tension between cohesion and fragmentation that characterized Dubuffet's figuration all along. Despite his insistence that his early portraits were meant to be "anti-psychological, [and] anti-individualist," these late self-portraits appear to provide an intimate glimpse into the artist's personal experience and his commitment to exploring the themes of movement, performance, and identity.[11]

The late self-portraits appear, at first glance, to be an anomaly in Dubuffet's oeuvre. Indeed, scholars have debated about the degree to which Dubuffet engaged with self-portraiture within his oeuvre and his ambivalence about this question and proclaimed indifference to the personalities of his subjects have left the matter unsettled. Yet, in addition to these late works, Dubuffet had produced a number of earlier self-portraits. In discussing Art Brut, moreover, he also acknowledged his interest in the personalities behind the art, suggesting also his interest in the identities of his portrait subjects—including himself. "Of course, it isn't so important to establish a connection with the biography," he indicated while discussing Art Brut, adding, however: "I want to link the work with a mind."[12] Not surprisingly, then, some of his renderings have an ambiguous relationship to the genre of self-portraiture, with which he appears to have engaged at transitional or particularly seminal stages of his career.

Double self-portrait au chapeau melon (Double Self-Portrait with Bowler Hat)

Like the masks and puppets with which Dubuffet held nearly concurrent performances at his studio, he rendered his 1936 *Double Self-Portrait with Bowler Hat* naturalistically with a folk art flair. These were trademarks of his work prior to his commitment to "anti-classical" art that coincided with his decision to engage, however fleetingly, it seemed, in theatrical production (see Figures 1.2–1.4).[13] The tipping of this figure's hat tips us off to this engagement. This gesture likewise indicates the artist's eagerness to create a sense of movement in his otherwise static medium and (in stark contrast to the makers of Art Brut he would soon study in earnest) his interest in art as a kind of performance to engage the viewer.

The duplication of the figure in the *Double Self-Portrait* (an expression of experiential duality in the manner of Breton's *Communicating Vessels*) is a product of the interwar Surrealist milieu, an era in which Dubuffet associated with both acquaintances made during the 1920s and friends he had known since his childhood in Le Havre.[14] The theatricality in the portrait is overt, and its dual depictions of Dubuffet reflect the impact of Cubism and the nineteenth-century Chronophotographic effects emulated by Cubo-Futurist painters. Although this early self-portrait is comparatively naturalistic, it already suggested the artist's interest in dislocation, creative movement, and performance. The double figures in the self-portrait also suggest the element of performativity that he, like his postwar portrait subject Antonin Artaud (discussed in Chapter 3), began

investigating between the wars, when Artaud argued that art should *re-produce* life rather than copy it or mimic artistic precedents.[15] Just as Dubuffet's friend Henri Michaux (another postwar portrait subject discussed in Chapter 4) had produced double figures and had featured in a double exposure portrait by Surrealist photographer Claude Cahun, Dubuffet began adopting and translating these ideas about creative momentum and a multiplicity of performed identities in his self-portrait.[16] These were the ideas he would continue to explore and transform as he developed his artistic style.

Deux brigands (Two Brigands)

Having a disputed status as a self-portrait, Dubuffet's 1944 painting *Two Brigands* (Figure 5.4, see also Color Plate 3) nevertheless bears striking resemblances to the artist. It also re-articulates the duality of his *Double Self-Portrait with Bowler*

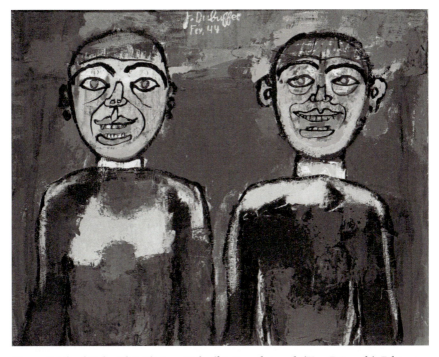

Figure 5.4 (and Color Plate 3) Jean Dubuffet, *Deux brigands* (Two Brigands), February 1944, oil on canvas, 66 × 81 cm. (26 × 31.9 in.). © Fondation Dubuffet, Paris / 2018 Artist Rights Society (ARS), New York—ADAGP, Paris. Private collection, U.S. Photograph courtesy of the Fondation Dubuffet, Paris. Reproduced in Jean Dubuffet, *Catalogue des travaux de Jean Dubuffet*, Fascicule I (Paris: Fondation Dubuffet, 2003), 157, no. 229.

Hat (see Figure 1.2). Although Dubuffet resisted the self-portrait moniker in this case, his American dealer Pierre Matisse insisted that "the image speaks for itself" as self-portraiture.[17] Indeed, the strong resemblance between the figures in this painting and the artist (seen here in a later photograph in Figure 5.5) cannot be denied and neither, this portrait suggests, could his interests in portraiture, the idea of creative doubling, and multi-faceted identity spawned by the early explorations of Surrealism.

Two Brigands is also an interesting work in terms of its situation in between Dubuffet's earlier, more "classical" *Double Self-Portrait with Bowler Hat* and the postwar portraits he began painting not long after completing this 1944 rendering. Although its figural doubling harkens back to Surrealism, the crudeness of the painting looks forward to the raw materiality of the portrait series that comingled an interplay of tensions, including that between crude materiality and the performance of artistic—and cultural—identity. The painting also combined the vivid color that characterized much of Dubuffet's earlier painting with his thick *haute pâte*, for which he often preferred a muddy or fleshy palette (see Color Plates 2 and 3). The painting thus suggests both transitions and continuities in Dubuffet's, practice. Likewise the double figures in the work serve as another testament to the artist's exploration of performance

Figure 5.5 Francis Chaverou, photograph of Jean Dubuffet, 1972. Gamma Rapho Collection © Francis Chaverou / Getty Images.

and dissociative fragmentation. Although this painting has received scant scholarly attention, it serves as a kind of bridge between Dubuffet's early and late works, providing a key to the vacillation between his engagement with anonymous or "archetypal" figures and the genre of portraiture, both of which served him as a means of artistic exploration.[18]

The two Dubuffets in this painting are crudely rendered and virtually identical, though their facial expressions and poses differ slightly. Closer looking reveals other subtle differences; the figure at left is a bit taller and the slack lines describing his cheeks and mouth render his face more placid. In contrast, the arabesques around the mouth of the figure at right suggest the full cheeks of a smile. Perhaps he is even laughing, an idea that is accentuated by the half-circles under the eyes that may indicate mirth. Notice, too, the elongated ears of the figure at left, rendered in such a way as to perhaps suggest the dangling earrings worn by the brigands populating many of the genre paintings in the European museums Dubuffet perused.[19] These differences serve, somehow, to reinforce the overall resemblances of the figures as both smile and gaze directly ahead, yet just past, the viewer. The figures are both hairless, moreover, or have very close-shaved hair like Dubuffet's.

These *Two Brigands* are dressed identically, in familiar, yet ambiguous, Western garb, perhaps in collared shirts topped with sweaters. Strangely, though, the slope of the garments of the figure at right suggests that we are seeing his back, rather than his front, as if he faces toward us while his body moves to turn in the opposite direction. That these Dubuffets appear to go in different directions suggests the artist's exploration of creative movement and the effects of its reproductive doubling. The ambiguity of the poses of these dual and nearly-identical figures gives the work its performative dimension. The effect of the similarities and differences in *Two Brigands* is to reinforce the idea that there is no stable self, that the self is an entity which is always performed, in motion, and in process.

Le Villageois aux cheveux ras (Villager with Close-Cropped Hair)

Dubuffet's 1947 *Villager with Close Cropped Hair* (Figure 5.6) is another of his paintings with an ambiguous status as a self-portrait.[20] Painted in dialogue with his travels in North Africa that year, it is also, unlike the previously discussed self-portraits, a single rather than a double figure. Although it is sometimes

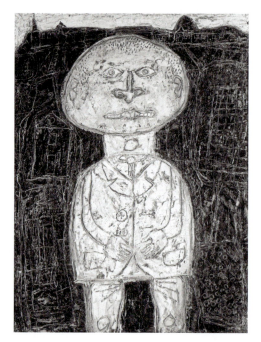

Figure 5.6 Jean Dubuffet, *Le Villageois aux cheveux ras* (Villager with Close-Cropped Hair), oil on canvas, May, 1947, 130 × 97 cm. (51 × 38 in.). Fondation Dubuffet, Paris / © 2020 Artist Rights Society (ARS), New York—ADAGP, Paris. Des Moines Art Center, Nathan Emory Coffin Collection, Des Moines, Iowa. Photograph courtesy of the Fondation Dubuffet, Paris. Reproduced in Jean Dubuffet, *Catalogue des travaux de Jean Dubuffet*, Fascicule IV (Paris: Fondation Dubuffet, 2003), 27, no. 23.

discussed as a self-portrait, bears resemblances to Dubuffet (particularly the shaved head), and was created just prior to his portrait exhibition, this painting did not feature in the show. This was an odd exclusion, given the fact that his exhibition flyer lists some of his North African paintings that less resembled portraiture and were nevertheless featured "outside the program."[21] The omission of this work might preclude self-portraiture as the painting's subject. It might, however, be another instance of Dubuffet's reluctance to highlight his engagement with a genre he associated with the notion of the artist-genius and challenged (if ambivalently) in his anticultural writings and his testaments to the Art Brut of anonymous artists who were neither motivated nor influenced by audience reception or cultural status. Indeed, as Susan Cooke has observed, the crudely-rendered portraits featured in Dubuffet's exhibition subverted the genre of portraiture altogether, poking fun at the genre and offending a good many of his subjects.[22] Perhaps Dubuffet hesitated to be counted among them.

As explored throughout the course of this book, moreover, Dubuffet gravitated toward archetypal forms, asserting that he had little concern with "the small peculiarities (physical or mental) distinguishing one person from another."[23] Indeed, as he wrote in "The Way to Do a Portrait," he "like[ed] to paint universal data."[24] This elision of identity, this "depersonalization," as Dubuffet called it, characterized much of his work and, at times, his portraits—even, as I argue here, this particular image that appears to be a self-portrait of the artist during a period in which he explored cultural identity in the Sahara.[25] The oblique reference to particular identity in this figure that stylistically resembles both a good number of Dubuffet's portraits and his renderings about the Sahara alludes, in its way, to art's ability to both synthesize and subvert culturally prescribed meanings. For Dubuffet, this ability to subvert "asphyxiating culture" (in whatever form) and to (re)produce dynamic life was art's true, performative function, meaning that the artistic processes could be translated to the viewer and transform life through creative contact. Here again, Dubuffet's art theory and practice attuned to Breton's and Bachelard's notions of the poetic image and of pitting dynamic art against static habitude, juxtaposing the Modernist trope of originality with processes of discovery that make use of the conceptual methods of collage.[26] After all, the practice of conjoining diverse imagery and ideas in the same figure was well suited to Dubuffet's purpose of disrupting European cultural norms.

Like many of Dubuffet's portraits, the *Villager with Close Cropped Hair* combines the idea of the archetype with the portrait. It also conjoins imagery from an array of artistic sources, including Oceanic artifacts that have received minimal acknowledgment with regard to his work. Intriguingly, this painting draws upon a variety of Oceanic sources to depict a familiar subject (Dubuffet himself) during a period in which many of his subjects referred to his explorations of North Africa, a context that was unfamiliar to most French viewers outside the realm of colonialism and was utterly foreign to Oceania. The figure's rounded head and curved, limp arms, for example, can be seen in the 1946 *Portrait of Pierre Benoit* (Figure 5.7) and in some of the Oceanic sculptures collected by Surrealists in Dubuffet's sphere of friends and acquaintances (see Figure 2.8). In addition to harkening back to the portrait of Benoit and the Oceanic sculptures collected by Viot and promoted by dealers such as Pierre Loeb and Charles Ratton, the post-like demeanor of this figure also resembles post figures in other parts of Oceania (Figure 5.8) and even the megalithic sculptures of neighboring Indonesia, which were also carved so that the arms appear to wrap and protect the figures.[27]

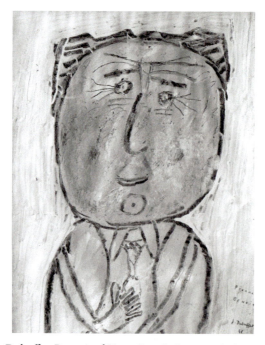

Figure 5.7 Jean Dubuffet, *Portrait of Pierre Benoit*, August, 1946, gouache on paper, 42 × 33 cm. (16.5 × 12.9 in.). Fondation Dubuffet, Paris / © 2020 Artist Rights Society (ARS), New York—ADAGP, Paris. Private collection, France. Photograph courtesy of the Fondation Dubuffet, Paris. Reproduced in Jean Dubuffet, *Catalogue des travaux de Jean Dubuffet*, Fascicule III (Paris: Fondation Dubuffet, 2003), 18, no. 07.

In *Villager with Close Cropped Hair*, Dubuffet blended the gritty figuration of his portrait series with his appreciation of the sandy landscapes he began painting from his North African travels—seen also in paintings such as *Il flûte sur la bosse* (He flutes on the hump), a work shown "outside the program" of Dubuffet's 1947 portrait exhibition that featured a figure in Arab garb playing a flute while sitting astride a camel.[28] That figure too features Oceanic elements, particularly the treatment of the eyes and stitch-like mouth. In both of these paintings, the buildings and roads scratched into the background (perhaps with a palette knife, spatula, or some other sharp implement), are quite different from most of Dubuffet's portraits but attuned to his raw war-time figures enmeshed in French landscapes and cityscapes, which he also revisited in the 1960s (see Color Plate 2). As with the portraits in the 1946–1947 series and the self-portraits of 1966, *Villager* juxtaposes Oceanic imagery, now with Dubuffet's own image and the memories he associated with his North African travels. *Il flûte sur la bosse* is less an archetype than a cultural stereotype. Both figures are depicted by

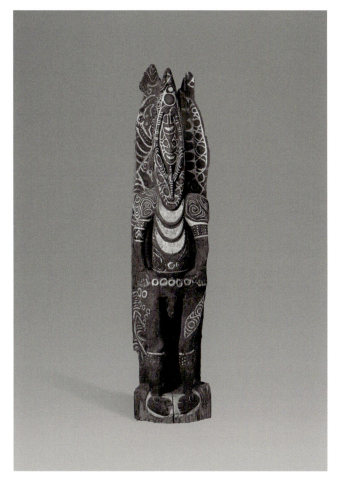

Figure 5.8 House-post figure, Kambot people, Papua New Guinea, nineteenth century, wood, paint, fiber. Ht. 243.8 cm. (96 in.). The Metropolitan Museum of Art, The Michael C. Rockefeller Memorial Collection, Gift of Nelson A. Rockefeller, 1969 (1978.412.823). The Metropolitan Museum of Art. Photograph © The Metropolitan Museum of Art. Image source: Art Resource, NY.

combining a variety of visual source materials. Morphing dissimilar western and Oceanic imagery in another enigmatic portrayal, Dubuffet combined the archetype and the portrait – now of himself as the everyman. *Villager with Close Cropped Hair* exemplified Dubuffet's continued engagement with the practices of bricolage and cultural collage—a fondness for multi-cultural source gathering that James Clifford discusses as integral to the interwar Surrealist milieu.[29] For Dubuffet, the incorporation of this collage aesthetic created another hybrid and culturally disjunctive figure.

Part II. Performativity Enacted:
The Late Self-Portraits and *coucou Bazar*

Throughout many artistic transformations in Dubuffet's long career, his creative goals to revitalize art remained constant. His experimentation with the disjunctive effects of bricolage, which this book began exploring in his *haute pâte* portraits of the 1940s, increased in the following decades to include not only a variety of unorthodox forms of sculpture, but also the literal collage he began with his butterfly works (collages of butterfly wings) and "Imprint Assemblages" (collages of his prints and paintings) in 1953.[30] Describing a second series of "Imprint Assemblages," Dubuffet wrote in 1955 that "certain elements (the figures in the present case) are delineated in a very epitomized and free-and-easy manner," which, he believed "tends to release the creative activity of the imagination of the viewer."[31] Such figuration, created by the acts of both rendering and re-arranging, would interact with the surrounding elements of a collage, according to Dubuffet, endowing it with "a more intense reality and life."[32] Again, the culturally intertwined yet subversive processes of bricolage combined with the themes of animation and creative stimulation to fuel Dubuffet's work.

Collage, movement, and picture writing

Although the legendary telephone doodles are credited as the impetus for Dubuffet's *Hourloupe* series, of which the late self-portraits were a part, and ultimately for his "animated painting" *Coucou Bazar*, the concepts of collage and creative movement also played key roles. In all of these works, Dubuffet sought to revitalize the combined painting and theatrics that he began with his puppets and papier mâché masks of the 1930s and further explored in his postwar portraits. The late self-portraits thus reinforced Dubuffet's proclamation, observed also by many scholars, that despite the diversity of his artistic output, a stylistic progression united his works within a set of overarching themes.[33] The self-portraits continued his exploration of these themes in relation to the theme of identity—in this case his own artistic persona, which was itself an artistic production.

The late self-portraits retained Dubuffet's play with tensions between two- and three-dimensionality, now as pictorial layers rather than a material buildup of paint. Instead, these late figures relied upon graphic strategies, resembling decorative panels cut into shapes and pasted onto the paper. These collage tactics (here in painting-drawings) were key components of his *Hourloupe* series, with

which he sought to create "phantasmagoric" worlds in ever greater and more theatrical scales.[34] As Roja Najafi articulates, Dubuffet's *Hourloupe* figures were each formed by "a compendium of images" that appear as if organized in layers.[35] Over time, Dubuffet thickened the otherwise flat planes of these *Hourloupe* figures, transforming the simple, quasi-automatic telephone doodles (a form of drawing with close ties to Surrealism's automatic writing) into more elaborate graphic depictions, then linear paintings, then three-dimensional "painted sculptures," and finally stage sets, costumes, and even architecture. As they became livelier and more sculptural, these figures, too, morphed over time to become players in *Coucou Bazar,* which was performed in New York and Paris in 1973 and in Turin in 1978 (Figure 5.9).[36]

Experimenting with various processes, Dubuffet translated his "Hourloupe script"—the organizing linear principle that united his composite figures and that he described as "a meandering, uninterrupted, and resolutely uniform line, which brings all planes to the surface" and "abolishes all the usual categories of one notion and another."[37] That Dubuffet used the term "script" suggested his continued interest in language, which, as Kent Minturn observes, informed Dubuffet's postwar figuration and specifically, as both Minturn and I have

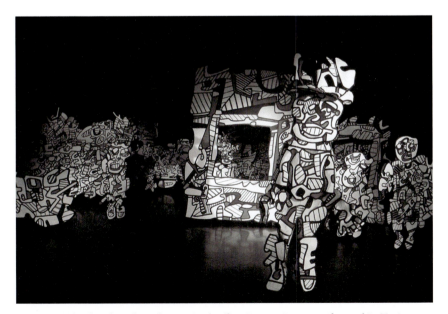

Figure 5.9 (and Color Plate 8) Jean Dubuffet, *Coucou Bazar* performed in Turin, 1978. Photograph: Kurt Wyss © 2021 Fondation Dubuffet, Paris / ARS, New York—ADAGP, Paris. Fondation Dubuffet Archives, Paris.

discussed, the portraits of Artaud and Michaux, both writers/visual artists who also explored relationships between language and figuration, gesture and communication.[38] Judging by Dubuffet's *Hourloupe* series, it appears that he remained intrigued by ancient picture writing and the idea of corporeal signs that had occupied his friends Artaud and Michaux. As discussed with regard to other of Dubuffet's artworks considered in this book, his fascination with language and comingling of writing, painting, and collage call to mind Jacques Derrida's late-twentieth-century discussions of representation as always a process of citation and grafting.[39] In the case of the *Hourloupe* figures, this script—and Dubuffet's outlining, hatching, and filling in of the work's amalgamated components—produced the figures' puzzle- or cell-like effects. Ironically, it is in part the crisp, graphic clarity of these composite faces in the self-portraits that enhances their cut-and-paste effects. Although the crisp linearity of Dubuffet's rendering marks a radical departure from his messy postwar painting, the layering effects of the flat, overlapping planes that distinguish the *Hourloupe* style continue to complicate figure and ground relationships. Although the portraits of Dubuffet in this style are easily distinguishable as figures, many of the figures in his *Hourloupe* cycle appear to both merge with and emerge from their surroundings—a conflation we have seen time and again in Dubuffet's art.

The *Hourloupe* works were created in a variety of ever-increasing scales and could occupy indoor or outdoor spaces. This figure–ground conflation held true either way and even applied to stand-alone sculptures, which conflated body parts and created anomalies of shape, proportion, and figural integrity that, despite their stylistic innovations, call to mind his earlier pictorial conflations. His efforts to attune to a primal core of the creative process also remained integral to his project. Indeed, he described the works in this cycle as "sinuous graphisms responding with immediacy to the spontaneous and, so to speak, uncontrolled impulses of the hand which traces them."[40] The trace of the artist's hand—thus for Dubuffet, the trace of this core creative presence—retained primary importance. Even so, the *Hourloupe* style and the late self-portraits in particular appeared to amplify both his reliance upon a collage aesthetic and his formal and thematic exploration of movement, pictorial hybridity, and the performance of identity, all of which relied upon inescapable cultural interactions.

Combining elements of painting and sculpture, fantasy and reality, Dubuffet created "a world other than our own, or, if you prefer, parallel to ours."[41] It was a simulated world in which the traces of the artist's creative movements could "set off in the viewer's mind a hyperactivation of the visionary faculty" that Dubuffet wanted; this, he asserted, would inspire the viewer to prompt a questioning of

"the legitimacy of what we habitually accept as reality."[42] Thus, as different as these late works appear, they drew from the same pool of artistic aims that informed the postwar portraits—aims to produce art that moves the viewer, so to speak, removing him or her from an ordinary viewing context in order to subvert culturally preconceived notions.

Animated assemblage

While re-envisioning the collage aesthetic that this book argues informed Dubuffet's portraits of the immediate postwar years, the late self-portraits maintain the *mask-like* qualities of those earlier renderings. Although much less rough in appearance than his portraits of Michel Tapié or Jean Paulhan (see Figures 2.1 and 2.9), the emphatic references to collage in these late works, particularly their suggestion of compartmentalized components, also recall the Oceanic masks and other figures explored in Chapter 2 as probable sources for the postwar portraits (see Figures 2.4, 2.5, 2.8, 2.12, and 2.14). Since Dubuffet conceived of the works in the *Hourloupe* cycle to be "linked one to the other, each of them an element destined to become part of the whole," the remaining pages of this book explore the ways in which his late self-portraits participated in the performative goals of this *Hourloupe* cycle and its culmination in *Coucou Bazar*, considering also the ways in which the appreciation of collage practices and non-European artifacts continued to inform his production. [43]

Two of the late self-portraits in particular serve as examples of Dubuffet's late creative processes, the seeds of which were sown early in his career and remained fruitful throughout his oeuvre. They also speak to his continued fascination with a number of artistic tensions—between two- and three-dimensionality, movement and stasis, painting and performance, and, this book has argued, originality and appropriation. Indeed, these two examples seem almost to be in tension with each other, as each appears to explore distinct, yet interrelated themes. One of these portraits appears nearly decorative, moreover, while the other retains the many jarring qualities that characterized Dubuffet's early work.

Self-Portrait II appears as if a patchwork face (see Figure 5.1). Because there are no roughly-hewn, stitch-like marks around the mouth, cheeks, or eyes, this figure lacks the scabrous, Frankensteinesque qualities of Dubuffet's *Tapié Grand Duc*. In keeping with the confrontational gaze of his earlier portraits, this self-portrait, too, gazes wide-eyed, yet more placidly, ahead. It is the only one of the late self-portraits to stare out at us with naturalistic blue eyes; the other portraits'

eyes appear to be filled in or lined out by Dubuffet's red and blue ink. The more natural approach to these eyes in this portrait makes this the least disjunctive of the group. The odd, red, upturned sliver on the figure's forehead is, perhaps, the most disturbing element of this depiction, calling to mind a gash in the head around which the blue-lined shapes suggest an internal space or even brain matter. This feature accentuates the corporeal in this otherwise draftsmanly portrait, highlighting its cellular, rather than puzzle-like characteristics. Despite the creative arrangement of colors, lines, and shapes to create this figure, it appears to suggest the ordinary, everyday Dubuffet. This impression is reinforced, for me, by the figure's plain, white shirt collar, which is so traditional compared to the phallic neckwear of his postwar portraits or the quirky garb of the other portraits in the late series.

Self-portrait VI is more interesting to my eye and is the most artistically impactful of the group (see Figure 5.2 and Color Plate 7). Unlike the second contemporaneous self-portrait, this one has no eyes, *per se*, though the areas where the eyes should be confront us more directly and disturbingly. The figure's right eye (at the left of the portrait) is almond-shaped and filled in red, gaping blankly as though a bloody socket. The one at right, in contrast, is a half-moon, filled sparsely, and underscored by three blue lines that suggest the bag under the eye of a tired man. Indeed, these eyes, or the shapes that stand in for them, slope out and diagonally downward in a way that suggests the fatigue seen in a late photograph of the artist (see Figure 5.5). This weariness is presented so poignantly as to be disconcerting and is a facet that is accentuated by the figure's overall disjunction. Of each of the six self-portraits in the group, this one is the least composed. Appearing to be barely assembled, it suggests instead fragmentation, as if the figure could come undone at any moment. Again, the figure takes on a cellular appearance. But this depiction is even more somatic, and the suggestion of three-dimensional figuration rests in tension with the flat, segmented composition and the suggestion of the figure's potentially imminent split. Despite the portrait's fantastical features, it evokes the idea of a weary body barely holding itself together. It takes on a skeletal aspect, moreover, as if a tricolor *memento mori*; its white cranium is conjoined disjunctively to produce the high cheekbones and jaws that appear to hang, too loosely, from their hinges.

The red, cigar-shaped mouth suggests both a gaping orifice and the phallic Freudian symbol, though if Dubuffet depicts the latter, it is done at least half in jest, as with the phallic neckwear of his postwar portraits. The overall effects of the red marks, though, are not of gashes or gaping holes, but of skin worn thin, the outer mask falling away, so to speak, as the inner face pushes forward to

remake a grim visage. It is a strange image, more jarring than playful, and made even more so, somehow, by the figure's crazy shirt. No plain, white collar here; instead, the shirt is patterned with lines that zig-zag to accentuate the stick-thin figure's form. The sixth self-portrait stands alone in terms of effectiveness. It alone evokes the breakdown of form, a de-composition. Perhaps this is a true self-portrait, the kind Dubuffet liked to avoid, the kind with both physical and psychological references.

As theatrical as the portrait of Tapié, these late self-portraits convey a sense of the fantastic, the slightly humorous, and the tragic, as Dubuffet affirmed when he proclaimed that the *Hourloupe* figures "evoke something rumbling and threatening with tragic overtones."[44] We see hints of these overtones in the self-portraits, yet they emphasize performance more than performativity. Like the postwar portraits, however, these self-portraits engaged the theme of identity *as* performance. Indeed, the pieced-together appearance of these portraits suggests the idea that identity is both constructed and performed.

In some ways, the late self-portraits have come full circle, and this holds particularly true in their resemblances to Oceanic masks. Some of these similarities include the markings over the eyes and around the mouth that resemble the patterned painting and stitching used in the artifacts considered in the previous chapters and in many other Oceanic artifacts, including masks, costumes, and other accoutrements of performance (see Figures 2.9, 2.10, and 2.13). The linear, pieced-together qualities of the late portraits also appear to re-articulate the carved and painted suspension hooks used traditionally in parts of Oceania to store food and valuables and—by some Oceanic cultures—to collect the heads of revered ancestors or conquered enemies (see Figure 2.15).[45] Dubuffet's portraits particularly call to mind the way these hook-figures' heads seem to have been jammed onto rounded shoulders. The parallel stripes in the images are also quite compelling and appear to re-articulate the painted bands encircling many such hooks and the patterning of many Oceanic artifacts in general. But the self-portraits convey more a sense of creative play than cultural or radical Otherness. In their draftsmanly form, they look back also to Dubuffet's pre Art Brut-inspired work and to the period preceding the rawness of his immediate postwar figuration. They thus straddle the line between innovation and formulation, between the unformed and the formed, and between raw painting and, by Dubuffet's own definition, its performance.

The linearity of the *Hourloupe* script makes these works seem more overtly composed and therefore less raw. The jarring tension between corporeal materiality and the stark geometry of the earlier figures' disc-like eyes is gone,

moreover, and is replaced with emphatic tension between the graphic flatness of the drawn figures and the "amoeba-like units" by which, as Najafi notes, they were created.[46] But the composite, brightly-colored figures highlight the continued importance of creative play and the interplay of tensions in Dubuffet's late work. Dubuffet enacted these principles, which can be gleaned in his late self-portraits, to animate his *Coucou Bazar*.

Performance and performativity in *Coucou Bazar*

As he continued to transform Surrealist themes in the ever-changing postwar context, Dubuffet's writings on sculpture, architecture, and, finally, on theater set out his intent to stage "fantastical" encounters.[47] As we have seen, Dubuffet's interest in performance was longstanding. "Even as a young man, before the war," Frédéric Jaeger notes, Dubuffet had "hoped to earn his living by creating masks and puppets for the Grand Guignol theater."[48] Thus, as Jaeger observes, in *Coucou Bazar* Dubuffet "realized an aim that he had pursued for almost forty years."[49]

The portraits considered in this book attest to Dubuffet's long-term interest in the marvelous that was cultivated by Surrealism and that he transformed in his work. Indeed, in writing his "Notes for the Well-Read," Dubuffet cited the Comte de Lautréamont's *Songs of Maldoror* (1869), a Surrealist favourite, as an example of the perfect blend of uncanny humor and disquietude.[50] This text also, in a way, made use of bricolage to unsettle; it was responsible, after all, for the widely embraced image of the marvelous as represented by "a chance meeting on a dissecting table of a sewing machine and an umbrella."[51] Such a description could apply to Dubuffet's *Hourloupe* figures, about which he wrote of his intention to "wipe out [the] categories" that order and thus constrain creative thought.[52]

As has been discussed in previous chapters, the terms "uncanny" (*à la* Freud) and "marvelous" (*à la* Breton) have somewhat different yet interrelated meanings and are sometimes used interchangeably to describe the unsettling sensation that results from unusual juxtapositions and imagery that evokes a sense of both familiarity and mystery. Yet Dubuffet's use of the terms "fantastical" and "fantasmagoric" to describe his *Hourloupe* productions, most notably *Coucou Bazar*, also bear consideration. As elaborated upon by Tzvetan Todorov, the fantastic in literature refers to a mode of writing that confounds the viewer's expectations for either realism or fantasy, conflating the two in order to produce disquieting effects.[53] As interpreted by Pieter Borghart and Christophe Madelein in "The Return of the Key: The Uncanny in the Fantastic," Todorov's use of the

term in this manner attuned to Freud's notion of the uncanny as described above.[54] Hal Foster also discusses the relationships between the notions of the marvelous and the uncanny, both of which contain tensions between opposites that I have argued informed Dubuffet's practice.[55] These approaches could be seen in, and thus these terms could be applied to, Dubuffet's postwar art, which demonstrated the artists' interpretation and translation of dual lived and imagined realities (think Breton's *Communicating Vessels*) and investigated the related theme of dislodging the viewer from encultured experience to problematize the very notion of identity. The intertwined experiences of the uncanny, the marvelous, and the fantastic could be found in the writing (and in some cases the visual art) of many of Dubuffet's friends, including the works of Artaud, Michaux, and Paulhan, that have been discussed through the lens of Dubuffet's portraits in this book. As articulated by Jean-Paul Sartre: "You cannot impose limits on the fantastic; either it does not exist at all, or else it extends throughout the universe" creating "an entire world."[56] Such a world, such a fantastical universe, is what Dubuffet created in *Coucou Bazar*. Although *Coucou Bazar* relied upon the bricolage strategies that informed his uncanny portraits, however, the late work appears to have crossed into the realm of fantasy.

The Hourloupe Ball, as Dubuffet called *Coucou Bazar*, was conceived to be a living tableaux, replete with elaborate stagecraft, including masks, costumes, and mechanized puppets. "Animating his painting," as Dubuffet wrote, he concocted a bizarre and unprecedented bazaar of images in motion. Dubuffet populated his vibrant tableau with fantastical figures and performances that conflated the figure and ground, articulated tensions between movement and stasis, and replaced the world of ordinary experience with a flight of fancy. Perhaps what most distinguished this elaborate stagecraft consisting of these painting-sculptures, background figures, puppets, and puppetesque costumed actors was that each of these elements was virtually indistinguishable from the other due to the building up of form from the amoeba-like units that informed the *Hourloupe* cycle. And these very amoeba-like units that were already in tension with the flatness of puzzle pieces enhanced the tensions between the two-dimensionality of drawing and painting, on the one hand, and the three-dimensionality of sculpture, architecture, and theater, on the other. These units of building form also bear striking resemblances to the painted wooden sculptures and masks that support and adorn the ceremonial houses of Oceania (see Figures 5.8 and 5.9), another suggestion that the art of Oceania resonated, for Dubuffet, after the war.

Like these Oceanic artifacts, which are integrated into important architectural and performative spaces, Dubuffet's figures appeared to vacillate in appearance,

as if they both submerged into and emerged out of his labyrinthine set. He accompanied this visual conflation with the element of motion instilled by the puppets and costumed actors, who alternated between stationary poses and swaying, dreamlike, yet decidedly disjunctive movements. This disjunctive tension between motion and stasis was accentuated by cacophonous music—first by experimental Turkish composer Ilhan Mimaroglu for the 1973 performances in New York and Paris and later, for the 1978 performance in Turin, by the sounds of Dubuffet's flute collaboration with CoBRA artist Asger Jorn.[57]

In tandem with Oceanic art, Dubuffet's earlier dialogue with Artaud also appears to have informed these productions. Just as Artaud had called for music that was "unbearably piercing," Dubuffet wanted the sounds of *Coucou Bazar* to be "loud and crackling."[58] Both men wanted to create glaring contrasts between music and silence as well, another tension that would intensify the performance's disorienting effects. For both men, music was to compliment highly expressive stagecraft, though Dubuffet's was more playful—and less intensely channeled— than Artaud's. For both men, however, what was most important was that the performance *move* the viewer, so to speak, providing momentary—and perhaps lasting—cultural dislocation.

Although *Coucou Bazar* attuned to an aesthetic of the 1960s and 1970s seen in works ranging from the political prints of Black Panther artist Emory Douglas to the poster art of Peter Max, its forms also recalled some avant-garde painting and theater of the early-twentieth century. This was particularly so with regard to the work of Dubuffet's old friend Legér, who created both Cubist-inspired paintings and sets for the Ballets Suédois. Significantly, the forms of *Coucou Bazar* enacted Artaud's early-twentieth-century vision for stagecraft that could envelop and also dissociate the viewer. Dubuffet's studio notes even echo Artaud's *The Theater and Its Double*, elaborating upon a comparably disjunctive interplay of dissonances and resonances written in a comparable form. Artaud had written: "The typical language of the theater will be constituted around the *mise-en-scène* considered not simply as the degree of refraction of a text upon a stage, but as the point of departure for all theatrical creation."[59] Likewise, Dubuffet's "Suggestions for the Mise-en-scène of Coucou Bazar" provided direction for a bizarre and emphatically plastic stagecraft he would animate with disjunctive movements and discordant sounds.[60] As Duffy notes, the production offers insights into the impact of late-nineteenth- and early-twentieth-century theater, including the performances of Artaud and his idol Alfred Jarry, to Dubuffet's late work.[61]

In a twist on Artaudian stagecraft, in which theater relied heavily upon the plasticity of imagery the author had experienced in viewing painting as well as

Balinese theater, Dubuffet brought his painting to life, as if his figures and the worlds they occupied became characters in their own right.[62] *The Hourloupe Ball* was a "phantasmagoric" world populated with strange, conglomerate figures. These he animated by means of physically manipulating his sculptures (some of which were transformed into mechanized puppets) and by adding performers who combined elements of avant-garde choreography with costumes produced by his workshop to resemble the sculptures. These duplications enhanced the figures' appearance of both blending with and emerging from the set. Indeed, this complication of figure and ground represented yet another instance in which Dubuffet's art attuned to French philosopher Roger Caillois's theory of mimicry (adopted from the biological camouflage of animals and insects such as the praying mantis and applied to the human psyche) as a sense of "depersonalization through assimilation into space" and an accompanying "instinct of abandon."[63] Given that Dubuffet was also interested in creative movement and performance, it makes sense that he animated his art with the temporal and spatial dimensions of the theater.

Literalized collage also played a vital role in *Coucou Bazar*. As Andreas Franzke observes, and Dubuffet himself explained, he began his task by outlining his figures on sheets of paper he could then cut out to make his "*découpes,* (cut out images mounted so as to stand upright)" about which he wrote: "The *découpes* do not remain fixed in one place throughout the spectacle."[64] "On the contrary," as Dubuffet specified, "the spectacle itself is organized as a succession of figures (patterns of movements, as in a dance)."[65] Using similar processes, he transferred these images onto the larger and more durable materials with which he created his "*practicables*"—stock characters produced by his assistants of painted wood, resin, and acrylic (see Figure 5.8).[66] Some of these, it is interesting to note, were made as movable figures (hence, the use of the term "puppets"). Some of these figures, it is even more interesting to note, were fixed to rolling carts that could be moved back and forth in a manner akin to the presentation of the life-sized *sigale-gale*, which Chapter 4 discusses in relation to the *Portrait of Henri Michaux*, another of Dubuffet's friends fascinated with creative movement, performance, and disorienting imagery (see Figure 4.1).

The parallels between the large, blocky heads of certain of the *practicables* also bear similarities to many forms of Oceanic masks and even the architecture to which they are sometimes affixed (see Figures 5.8 and 5.9). Also created by collage, the costumes of *Coucou Bazar* were cut out and pieced together by Dubuffet's team of assistants using materials such as sail cloth, polyester, latex, and epoxy board (Figure 5.10).[67] But the addition of actors with bulky masks and

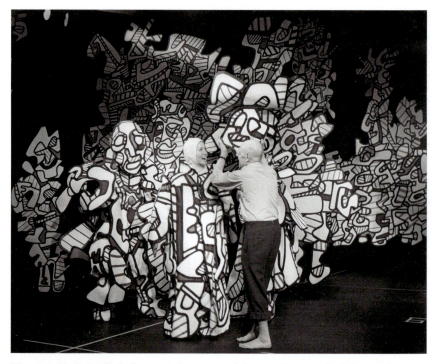

Figure 5.10 Dubuffet before a performance of *Coucou Bazar* at the Solomon R. Guggenheim Museum, New York, 1973. Photograph: Robert E. Mates and Susan Lazarus © 2021 Fondation Dubuffet, Paris / ARS, New York—ADAGP, Paris. Fondation Dubuffet Archives, Paris.

costume hands (Figure 5.11) recalls the masked Sumatran dancers discussed in Chapter 4 (see Figures 4.10–4.12), transforming the costumed actors into something like giant puppets.

Just as Michaux and Artaud had looked to Southeast Asia in their quest for supremely disjunctive art, just as Artaud had envisioned performance dominated by "manikins, enormous masks, [and] objects of strange proportions," Dubuffet injected elements of the extraordinary into his living painting in ways that consciously or otherwise echoed Indo-Oceanic performance.[68] In modernizing these prodigious puppets and having their carts motorized for independent movement, Dubuffet also actualized the uncanny "automatons" with which Artaud had hoped to populate the stage.[69] The figures that were moved by hidden actors recall both the *sigale gale* and the avant-garde theater productions that attracted Dubuffet in the interwar era. As has been previously mentioned in these pages and discussed thoroughly in Chapter 3, these theatrical sources included Artaud's Alfred Jarry Theater and Rolf De Maré's Ballet Suedois, a

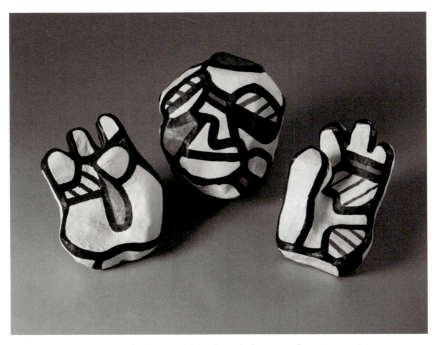

Figure 5.11 Jean Dubuffet, theatrical mask and gloves used in *Coucou Bazar,*
November 1971 (mask), April 1972 (gloves), painted polystyrene. Fondation Dubuffet,
Paris / © 2020 ARS, New York—ADAGP, Paris. Private collection, U.S. Photograph
courtesy of the Fondation Dubuffet, Paris. Reproduced in Jean Dubuffet, *Catalogue
des travaux de Jean Dubuffet*, Fascicule XXVII (Paris: Fondation Dubuffet, 2003), 70,
no. 205.

production that depended upon the efforts of Dubuffet's friend Legér.[70] The
latter figures both combined their interest in experimental art and theater with
world dance when they supported the efforts of the AID, the organization that
had produced films, photographs, and exhibitions of Indonesian dance and
made artifacts such as the carved wooden masks, hands, and puppets of Sumatra
available to interwar Parisian viewers.[71] *Coucou Bazar* thus appears to have
represented a fascinating conglomerate of multicultural performance and
experimental theater. The latter, in particular, gained new appeal as a younger
generation looked to early-twentieth-century avant-garde production to
rejuvenate late-twentieth-century art.

Despite their many creative differences, it is interesting to note the parallels
between the layering effects of Dubuffet's costumes and those Artaud appreciated
in the Balinese theater.[72] Perhaps even more interesting is the fact that the
costumes and puppets were conflated, a tendency seen in various forms of
Indonesian performance. Some of these Indonesian performances marked life-

altering transitions. Others were performed, as Clair Holt of the AID wrote, "just for fun."[73] Dubuffet wanted his figures to do both, providing the viewer with an enigmatic spectacle and a joyful, life-affirming event.

As theatrical as it was, Dubuffet conceived of *Coucou Bazar* to be "the work of a painter and not of a dramatist or choreographer," asserting that it was "not like a theatrical production properly speaking but like a painting."[74] As he sought to "animate" his work, he aimed "to bring, by those means, the mind of the viewer to consider all the elements of the ensemble of paintings (and not only those which do in fact move) as capable of mobility."[75] This was the motivation for and mobility alluded to in the *Hourloupe* self-portraits, which enacted his strategies to creatively move the viewer.

Each of Dubuffet's portraits, and particularly his self-portraits of the 1960s, demonstrate his reliance upon a collage aesthetic in his painting and drawing, an aesthetic he would soon explore more literally in his *Théâtres de mémoire* (Theaters of Memory) collages of his late paintings and drawings.[76] Moreover, all of his works discussed in this book highlight his approach to painting as a kind of performance at key points in his career: as a young man exploring the possibilities of producing theatrical masks for a living, as a mature man taking the leap into an artistic career after laying aside the family business, and as an aging man surveying, and continuing to build upon, a prolific artistic career and a diversity of cultural and specifically theatrical resources. Attuned to the theater, radical reconfiguration, and collage that informed his career, the portraits, even the late self-portraits, are not anomalies. Rather, these images represent different approaches, different translations of the inner creative impetus and the external elements and artistic themes that captured the artist's imagination. His late self-portraits can thus be seen as a logical progression of his interests that stemmed from his interwar formation, that emerged in his postwar figuration, and that set the stage for what became the trademark style of his later years—a style characterized by composite forms, simulated and actual collage, and an ever more theatrical approach.

Notes

1 For a thorough discussion of Dubuffet's progression of styles into the *Hourloupe* and *Coucou Bazar* series, see Jean Dubuffet, "Notes for the Well-Read," trans. Joachim Neugroschel in Mildred Glimcher, Marc Glimcher, and Jean Dubuffet, *Jean Dubuffet: Towards an Alternative Reality* (New York: Pace Publications, 1987); Andreas

Franzke, *Dubuffet*, trans. Robert Wolf (New York: Harry N. Abrams, 1981); Sophie Duplaix and Béatrice Salmon, *Coucou Bazaar* (Paris: Arts décoratifs, 2013); Dubuffet and Max Loreau, *Catalogue des travaux de Jean Dubuffet*, Fascicule XX, "L'Hourloupe I", XXI "L'Hourloupe II", and XXVII, "*Coucou Bazar*."

2 Jean Dubuffet, "Speech, New York, October 24, 1972" (a speech discussing the *Hourlope* series on the occasion of the installation of his *Group of Four Trees* at Chase Manhattan Bank), in *Jean Dubuffet: Writings on Sculpture* (Düsseldorf: Richter Verlag, 2011), 98. For a thorough discussion of Dubuffet's *Hourloupe* and *Coucou Bazar*, see sources in note 1 above. For a thorough treatment of Dubuffet's progression from painting to collage and sculpture in his earlier works, see Peter Selz, *The Work of Jean Dubuffet* (New York: Museum of Modern Art; Doubleday, 1962), 9–62; and Jean Dubuffet, "Memoir of the Development of My Work From 1952," in Selz, 83–85, 103–106, 116–125.

3 Jean Dubuffet, *Asphyxiating Culture and other Writings*, trans. Carol Volk (New York: Four Walls, 1986).

4 James Clifford, "On Ethnographic Surrealism," in *The Predicament of Culture* (Cambridge: Harvard University Press, 1988), 118–121.

5 For more on Lévi-Strauss's concept of bricolage, see Claude Lévi-Strauss, *The Savage Mind*, trans. George Weidenfeld and Nicolson Ltd. (Chicago: University of Chicago Press, 1962), 11.

6 Pepe Karmel, "Jean Dubuffet: The Would-be Barbarian," *Apollo* CLVI, no. 489 (October, 2002): 12–20.

7 For more on Dubuffet's *Coucou Bazar*, see sources in notes 1 and 2 above, esp. Dubuffet and Loreau, *Catalogue des travaux de Jean Dubuffet*, Fascicule XXVII "*Coucou Bazar*". Dubuffet discusses the production as an animated painting throughout.

8 For more on Dubuffet's friendship with Fernand Léger and other members of the interwar avant-garde, see Jean Dubuffet, *Biographie au pas de course* (Paris: Gallimard, 2001), 19–22. For more on Les Archives internationales de la danse (AID), see Sanja Andus L'Hotellier and Dominique Dupuy, *Les Archives internationales de la danse: un projet inachevé, 1931–1952* (Coeuvres-et-Valsery: Ressouvenances, 2012).

9 Jean H. Duffy, "Dubuffet Plays Hide-and-Seek: Lineage, Reflexivity, and Perception in Coucou Bazar," *The Art Bulletin* XCVII, no. 2 (June, 2016): 237–260, esp. 237–238.

10 Jean Dubuffet, "Art Brut Chez Dubuffet," in *Prospectus et tous écrits suivants*, Vol. IV (Paris: Gallimard, 1967), 41. Dubuffet references the influence of Dada on his early work when he proclaims that the "rejection of established culture was 'in the air' when I was a student in the 1920s."

11 Dubuffet's comments in Jean Dubuffet, "Notes Du Peinture: Portraits," were quoted in Kent Minturn, *Contre-Histoire: The Postwar Art and Writings of Jean Dubuffet*,

Thesis (Ph.D.), Columbia University, 2007, 84. This essay originally appeared in
George Limbour, *Tableau bon levain à vous de cuire la pate* (Paris, 1953, 91–92) and
can also be seen in Jean Dubuffet, *Prospectus et tous écrits suivants*, Vol. V (Paris:
Gallimard, 1967), 429–430.

12 Dubuffet, "Art Brut Chez Dubuffet," 41.

13 Dubuffet, *Biographie au pas de course*, 47. Another self-portrait created this same
year in a more traditional style can be seen in the online object files of the
Metropolitan Museum website. Jean Dubuffet (French, Le Havre 1901–1985 Paris).
Date: 1936. Medium: oil on canvas. Dimensions: 25 5/8 × 21 3/8 in. (65.1 × 54.3 cm.),
https://www.metmuseum.org/art/collection/search/491967 (accessed February 16,
2020).

14 Dubuffet, *Biographie au pas de course*, 19–22, 36. As discussed in the previous
chapters, Dubuffet's childhood friends included writers Georges Limbour, Raymond
Queneau, and Armand Salacrou. In Paris, Dubuffet also befriended a number of
avant-garde artist-intellectuals, including art dealer and critic Daniel-Henry
Kahnweiler, the poet Max Jacob, and Juan Gris and other artist-intellectuals
associated with Cubism and Surrealism. After the war he would associate with André
Breton and George Braque.

15 Antonin Artaud, "The Theatre and Its Double," in Claude Schumacher and Brian
Singleton, eds. and trans., *Artaud on Theatre* (London: Methuen Drama, 2001), esp.
97. See also Artaud, *Œuvres complètes*, V (Paris: Gallimard, 1956), esp. 37. For more
on the concept of performativity widely applied see Kira Hall, "Performativity,"
Journal of Linguistic Anthropology 9 (1–2): 184–187.

16 You can see this double exposure photograph of Michaux in the object files of the
Art Institute of Chicago website, "Henri Michaux", https://www.artic.edu/
artworks/222935/henri-michaux (accessed February 9, 2020).

17 Pierre Matisse, letter to Margaret Benette, December 1, 1951; Mrs. Alfred P. Shaw,
President of the Arts Club of Chicago, letter to Jean Dubuffet, March 27, 1974;
Armande de Trentinian, letter to Mrs. Alfred P. Shaw, March 30, 1974; telephone
message taken by the Arts Club secretary from Pierre Matisse, n.d., Arts Club
Records, The Newberry Library, Chicago. A December 1, 1951 letter from Pierre
Matisse to Margaret Benette of the Arts Club of Chicago states: "I would like to have
the No. 2 of my list changed to *Les Deux Brigands (The Two Bandits),* 1944, oil, 36 ×
25 ½, insurance price $565.00." In a March 27, 1974 letter from Mrs. Alfred P. Shaw,
President of the Arts Club of Chicago, she asks Dubuffet for his permission to use
the painting *Les Deux Brigands* in a "portrait show of eminent people who have
spoken at the Arts Club." Dubuffet's secretary, Armande de Trentinian, replies by
stating: "Jean Dubuffet ne pensait nullement faire son auto-portrait en realisant en
fevrier 1944 la peintre *Deux Brigands* (Dubuffet did not at all think to make a
self-portrait in creating his 1944 painting *Two Brigands*)." A telephone message taken

by the Arts Club secretary on behalf of Pierre Matisse countered Dubuffet's comments, however, stating: "Although Dubuffet claims it is not a self-portrait nevertheless it subconsciously is. Some artists have done self-portraits of figures not so called but obviously of the artist himself," adding that it was "acceptable to use – with its own title and no explanations. It speaks for itself."

18 For more on Dubuffet and archetypes discussed throughout the pages of this book, see Dubuffet, "Notes for the Well-Read," in Glimcher, 78.

19 Dubuffet, *Biographie au pas de course*, 35–36. Dubuffet had ample opportunity to peruse museums both in France and during his European travels and he discusses this to some degree in his autobiography.

20 Susan J. Cooke, "Jean Dubuffet's Caricature Portraits," in *Jean Dubuffet 1943–1963: Paintings, Sculptures, Assemblages*, eds. James Demetrion, Susan J. Cooke, Jean Planque, and Peter Schjeldahl (Washington, D.C.: Hirshhorn Museum and Sculpture Garden and Smithsonian Institution Press, 1993), 22–23. Cooke, for one, argues for the validity of this image as a self-portrait. See also Des Moines Art Center, Neal David Benezra, and Terry Ann R. Neff. *An Uncommon Vision: The Des Moines Art Center* (Des Moines: Des Moines Art Center, 1998), 103–104. These pages discuss Dubuffet's painting *Villager*, which is in the Des Moines Art Center permanent collection.

21 Jean Dubuffet, "Catalogue de l'exposition 'Portraits' à la Galerie René Drouin de 7 au 31 octobre 1947," in Jean Dubuffet and Max Loreau, *Catalogue des travaux de Jean Dubuffet*. Fascicule III, "Plus beaux qu-ill croient, Portraits" (Paris: Fondation Dubuffet, 2003), 13–16.

22 Cooke, "Jean Dubuffet's Caricature Portraits," 22–23.

23 Dubuffet, "Notes Du Peinture: Portraits," quoted in Minturn, *Contre-Histoire,* 110.

24 Dubuffet, "Notes for the Well-Read," in Glimcher, 78; see also Dubuffet in Minturn, *Contre-Histoire,* 110.

25 Dubuffet, "Notes Du Peinture: Portraits," quoted in Minturn, *Contre-Histoire,* 110: See also Jill Shaw, Chapter Two, "Electroshock," in *A Coat that Doesn't Fit: Jean Dubuffet in Retrospect, 1944–1951* (Ph.D. diss., University of Chicago, 2013), 52–104. Exploring the works Dubuffet created during or as a result of his trips to Algeria, Shaw considers them in relation to the broader history of Orientalism, arguing that they represent a more complex set of artistic goals that included his efforts to invigorate his processes with the "cultural electroshock" instigated by his North African trips.

26 Gaston Bachelard, *The Poetics of Space*, xiv, xviii, xxii, xxv; André Breton, *Communicating Vessels* (1932), trans. Mary Ann Caws and Geoffrey T. Harris (Lincoln, Nebraska: University of Nebraska Press, 1990). See also Anna Dezeuze, "Assemblage, Bricolage, and the Practice of Everyday Life," *Art Journal* 67 (Spring, 2008), 31–37.

27 For more on Surrealist collecting of Oceanic sculptures, see my discussion in Chapter 2; see also Philippe Dagen and Maureen Murphy, *Charles Ratton. L'invention des arts "primitifs"* (Paris: Skira Flammarion, 2013); Elizabeth Cowling, "'L'Oeil Sauvage': Oceanic Art and the Surrealists," in *Art of Northwest New Guinea*, ed. Suzanne Greub (New York: Rizzoli, 1992), 177–190; Philippe Peltier, "Jacques Viot, the Maro of Tobati, and Modern Painting: Paris–New Guinea 1925–1935," in *Art of Northwest New Guinea*, 155–176. For more on the megaliths of Indonesia see Tara Steimer-Herbet, *Indonesian Megaliths: A Forgotten Cultural Heritage* (Oxford: Archaeopress Publishing Ltd., 2018). To view photographs of these megaliths see Ruslan Sangadji, "Central Sulawesi Megalithic Sites Delineated for World Heritage Status," *Jakarta Post*, July 24, 2018, https://www.thejakartapost.com/life/2018/07/24/central-sulawesi-megalithic-sites-delineated-for-world-heritage-status.html.

28 Jean Dubuffet, "Les Gens sont bien plus Beaux qu'ils Croient," Galerie René Drouin, Paris (August 7 to October 3, 1947).

29 For more on the concept of cultural collage see Clifford, *The Predicament of Culture*, 118–121; for more on Dubuffet, assemblage, and appropriation see also Jean H. Duffy, "Jean Dubuffet's Beautiful People," *Word & Image* 35, no. 2 (June 2019): 191–209, esp. 199, 201; and see Shaw, *A Coat that Doesn't Fit*, 52–104. Duffy discusses Dubuffet's creation of "templates" in producing his portraits. Shaw discusses Dubuffet's art works dealing with his North African travels. Shaw acknowledges that viewing Dubuffet's work through the lens of Clifford's notion of ethnographic Surrealism is helpful but argues that the connection should not be overly relied upon, since the two men's motives and processes were vastly different. In contrast, I contend that the resonance of Surrealist interests in processes of discovery and investigating non-European cultural practices were too great to be denied in shaping Dubuffet's art. These ideas about assemblage and appropriation, and about tension between disrupting processes of enculturation and highlighting relationships between the artist, the artwork, and culture, have informed the pages of this book and are drawn largely from my 2015 dissertation, Stephanie Chadwick, *Disorienting Forms: Jean Dubuffet, Portraiture, Ethnography*, Thesis (Ph.D.), Rice University, 2015.

30 For a thorough discussion of Dubuffet's early work in collage, see Glimcher, 1–12; Franzke, *Dubuffet*, 85–90; Dubuffet, "Memoir of the Development of My Work From 1952," in Selz, *The Work of Jean Dubuffet*, 83–85, 103–106; also see Sarah K. Rich, "Jean Dubuffet: The Butterfly Man," *October* 119 (Winter, 2007): 46–74.

31 Dubuffet, "Memoir of the Development of My Work From 1952," in Selz, *The Work of Jean Dubuffet*, 104.

32 Dubuffet, "Memoir of the Development of My Work From 1952," in Selz, *The Work of Jean Dubuffet*, 104.

33 For a thorough discussion of Dubuffet's progression of styles into the *Hourloupe* and *Coucou Bazar* series, see Glimcher and Franzke (full citations in note 1 above). For a

most thorough treatment of Dubuffet's progression from painting to collage and sculpture in his earlier works, see Selz, *The Work of Jean Dubuffet*, 9–62 and Dubuffet, "Memoir of the Development of My Work From 1952," in Selz, 84–85, 103–106, 116–125.

34 See Dubuffet on the *Hourloupe* works in *Jean Dubuffet: Writings on Sculpture*, 98 and the *Catalogue des travaux de Jean Dubuffet*, Fascicule XX "L'Hourloupe I" and XXI "L'Hourloupe II"; see also Franzke, *Dubuffet*, 159 and the Fondation Dubuffet website, http://www.dubuffetfondation.com/Hourloupe_ang.htm.

35 Roja Najafi, "Our Dubuffet: A Family Matter," a presentation at the Menil Collection in Houston, Texas, June 17, 2014. See also Roja Najafi, "Figuration, Abstraction, and Materiality in the Works of Jean Dubuffet (1901–1985)," Thesis (Ph.D.), University of Texas, 2017.

36 For a thorough discussion of *Coucou Bazar*, see Jean Dubuffet Sophie Duplaix, and Béatrice Salmon, *Coucou Bazar*, Paris: Arts décoratifs, 2013; and "Coucou Bazar," Fondation Jean Dubuffet website, https://www.dubuffetfondation.com/focus. php?menu=40&lang=en (accessed February 16, 2020). See also Dubuffet and Loreau, *Catalogue des travaux de Jean Dubuffet*, Fasicule XXVII "*Coucou Bazaar*".

37 Jean Dubuffet, Letter to Arnold Glimcher, September 15, 1969, quoted in Glimcher 223.

38 Kent Minturn, "Physiognomic Illegibility, Impossible Exchange: Dubuffet's Postwar Portraits," in *Contre-Histoire: The Postwar Art and Writings of Jean Dubuffet*, Thesis (Ph.D.), Columbia University, 2007, 91–94. See also a discussion of Dubuffet's portraits in Kent Minturn, "Physiognomic Illegibility: Jean Dubuffet's Postwar Portraits," in *Jean Dubuffet: "Anticultural Positions"* (New York: Acquavella Galleries, 2016), 37–62, esp. page 50. For more on Dubuffet's interest in picture writing see Dubuffet, *Biographie au pas de course*, 32–36. For more on Artaud's and Michaux's interest in picture writing, see Chapters 3 and 4 of this book. For a thorough discussion of Michaux's paintings in relation to his interest in pictograms, see Nakabayashi, 109–110; Edson, *Henri Michaux*, 50; Noland, 133, Parish, 187.

39 For more on Derrida's notion of citation and grafting see Jacques Derrida, *Of Grammatology* (Baltimore: Johns Hopkins University Press, 1976).

40 Dubuffet, *Jean Dubuffet: Writings on Sculpture*, 98.

41 Dubuffet, *Jean Dubuffet: Writings on Sculpture*, 98.

42 Dubuffet, *Jean Dubuffet: Writings on Sculpture*, 98.

43 Dubuffet, *Jean Dubuffet: Writings on Sculpture*, 98.

44 Dubuffet, "L'Houloupe," in *Prospectus et tous écrits suivants* III, 321. Also quoted in Dubuffet, et al., *Jean Dubuffet 1943–1963: Paintings, Sculptures, Assemblages*, 144.

45 For more on the creation and use of suspension hooks in Oceanic cultures, see Stéphen Chauvet, *Les arts indigènes en Nouvelle-Guinée* (Paris: Société d'éditions géographiques, maritimes et coloniales, 1930); Ralph Linton, Paul S. Wingert, and

René D'Harnoncourt, *Arts of the South Seas* (New York: Museum of Modern Art, 1946); Eric Kjellgren, *How to Read Oceanic Art* (New York: Metropolitan Museum of Art, 2014); Eric Kjellgren, *Oceania: Art of the Pacific Islands in the Metropolitan Museum of Art* (New York: Metropolitan Museum of Art, 2007); and Natasha McKinney, "Ancestral Remains from Oceania: Histories and Relationships in the Collection of the British Musum," in *Regarding the Dead: Human Remains in the British Museum*, ed. Alexandra Fletcher, Daniel Antoine, and J. D. Hill (London: British Museum, 2014), 35–36. See also Duffy, "Dubuffet's Beautiful People," 208 (note 103). Duffy notes the resemblance between the arms in the *Portrait of Jean Paulhan* and an Oceanic suspension hook in the collection of the Musée du Quai Branly (ascension no. 71.1914.1.7). An example from a page in Stephen Chauvet's book documenting some of the Oceanic artifacts he collected and donated to the Trocadéro is shown in Chapter 2 (Figure 2.13). You can see more examples of such hooks on the "Oceanic Collections" page of the Musée du Quai Branly website, http://www.quaibranly.fr/en/collections/all-collections/history-of-the-collections/ the-oceania-collections/.

46 Najafi, "Our Dubuffet: A Family Matter," a discussion at the Menil Collection in Houston, Texas, June 17, 2014.

47 Dubuffet, *Jean Dubuffet: Writings on Sculpture*, 98.

48 Frédéric Jaeger, "L'Hourloupe in Close up (1962–1974)," in *Jean Dubuffet; Trace of an Adventure* (Munich and New York: Prestel, 2003), 42–44. The section referenced appears on page 44. Unfortunately, no citation is given for the reference, though the author cites other information in Glimcher and in Dubuffet's *Biographie au pas de course*. Dubuffet discusses his hopes of earning a living making masks, though without specific reference to the Grand Guignol, in his *Biographie au pas de course*, 36. "Il m'était entré dans l'esprit que je pourrais gagner ma vie en faisant aux gens leur masque." (The idea came to me that I could earn my living by making masks for these people.) Dubuffet then discusses his interest in Guignol puppetry.

49 Jaeger, "L'Hourloupe in Close up," 44.

50 Dubuffet, "Notes for the Well Read," in Glimcher, 81.

51 Lautréamont, Comte de, *Les Chants de Maldoror* (1869) (Brussels: Editions "La Boetie," 1948).

52 Jean Dubuffet, Letter to Arnold Glimcher, September 15, 1969, quoted in Glimcher, 223.

53 Tzvetan Todorov, *The Fantastic: A Structural Approach to a Literary Genre* (Cleveland: Press of Case Western Reserve University, 1973), 25, 33, 46.

54 Pieter Borghart and Christophe Madelein, "The Return of the Key: The Uncanny in the Fantastic," *Image and Narrative: Online Magazine of the Visual Narrative*. ISSN 1780–678X, http://www.imageandnarrative.be/inarchive/uncanny/ borghartmadelein.htm (accessed August 19, 2019).

55 Hal Foster, *Compulsive Beauty* (Cambridge: MIT Press, 1993) 20–28.

56 Jean Paul Sartre, "Aminadab or the Fantastic Considered as a Literary Language," in *Situations I and III*, trans. Annette Michelson (New York: Collier Books, 1955), 74. Sartre also refers to Blanchot's discussion of Paulhan's *Les Fleurs de Tarbes*, a book Dubuffet read and spoofed in his *Fleur de barbe* series of paintings.

57 Nicolai Hartvig, "Dubuffet's Animated Painting Revived in Paris," *New York Times*, October 23, 2013, https://www.nytimes.com/2013/10/24/arts/international/ in-paris-dubuffets-animated-painting-revived.html (accessed February 20, 2020). The *New York Times* article also discusses Mimaroglu's interest in experimental jazz, some of which he composed in response to Dubuffet's paintings.

58 Dubuffet, "Suggestions for the Mise-en-scène of Coucou Bazar," in Franzke, *Dubuffet*, 212.

59 Antonin Artaud, "Metaphysics and the Mise en Scène," in *The Theater and Its Double*, trans. Mary Caroline Richards (New York: Grove Press, 1958), 93–94.

60 Dubuffet, "Suggestions for the Mise-en-scène of Coucou Bazar," in Franzke, *Dubuffet*, 212.

61 Duffy, "Dubuffet Plays Hide-and-Seek," 237–238.

62 For more on the impact of painting on Artaud's theater, see Antonin Artaud, "Metaphysics and the Mise en Scène" (full citation in note 59 above).

63 Roger Caillois, "The Praying Mantis: from Biology to Psychoanalysis" and "Mimicry and Legendary Psychasthenia" in *The Edge of Surrealism: A Roger Caillois Reader*, ed. Claudine Frank (Durham: Duke University Press, 2003), 69–102; Hal Foster, "Blinded Insights: On the Modernist Reception of the Art of the Mentally Ill," *October* 97 (Summer, 2001), 16. Foster focuses on the ways in which the art of mental patients indicates trauma. Foster does not reference Caillois in his discussion of Dubuffet, trauma, and the art of mental patients, though there are parallels between the trauma experienced by some mental patients and Caillois's theories of mimicry. See also Sarah K. Rich, "Jean Dubuffet: The Butterfly Man," *October* 119 (Winter, 2007): 46–74. Rich discusses Dubuffet's butterfly collages in relation to theories of mimicry such as Caillois's.

64 Dubuffet, "Suggestions for the Mise-en-scène of Coucou Bazar," in Franzke, *Dubuffet*, 212.

65 Dubuffet, "Suggestions for the Mise-en-scène of Coucou Bazar," in Franzke, *Dubuffet*, 212.

66 Franzke, *Dubuffet*, 209.

67 Franzke, *Dubuffet*, 210.

68 Artaud, *The Theater and Its Double*, 97.

69 Artaud, *The Theater and Its Double*, 54, 97–98. Artaud had written of using "mannequins" and "enormous masks" (97) and argued that the actor should function much like an automaton, serving as both "an element of first importance" and "a kind

of passive and neutral element" who is "rigorously denied all personal initiative" (98). He was so taken by the Balinese theater precisely because, to him, the actors served, in and alongside puppet-like costumes, as "animated mannequins" moving to bold gamelan music he likened to "robot squeaking" (54).

70 See also Duffy, "Dubuffet Plays Hide-and-Seek," 237–260.

71 For more on the Archives internationales de la danse (AID), see Archives internationales de la danse and Claire Holt, *Théâtre & danses aux Indes néerlandaises, XIIe exposition des Archives internationales de la danse, 1939* (Paris: G.P. Maisonneuve, 1939), 70; see also Inge Baxmann, *Les archives internationales de la danse: 1931–1952* (Pantin: Centre National de la Danse, 2006). This AID group conducted extensive field work in Indonesia and researched and collected Balinese, Javanese, and Sumatran costumes, puppets, and other performance-related artifacts they made publicly available at their Paris headquarters, where they featured a permanent collection, held special exhibitions that attracted the French avant-garde, and maintained a library of photographs, films, audio recordings, and other ethnographic documentation. The AID closed during World War II, at which time member Clair Holt brought many photographs, negatives, and films to New York, which are now archived at the New York Public Library Dance Division. Others remain at the Bibliothèque Nationale de France, Musée de l'Opéra.

72 Antonin Artaud, *The Theater and Its Double*, 61. Artaud discusses the layering effects of the costumes in Balinese theater, stating that "the actors with their costumes constitute veritable, living, moving hieroglyphs."

73 Claire Holt Papers, New York Public Library Dance Division; reprinted in Arlene Lev, "Preface," in "Batak Dances: Notes by Claire Holt," *Indonesia*, no. 12 (October, 1971); 1–2; Lev, "Preface," in "Dances of Sumatra and Nias: Notes by Claire Holt," *Indonesia*, no. 11 (April, 1971): 1–2.

74 Dubuffet, *Catalogue des travaux de Jean Dubuffet*, Fascicule XXVII "*Coucou Bazaar*", 211; quoted also in Franzke, *Dubuffet*, 220.

75 Dubuffet, *Catalogue des travaux de Jean Dubuffet*, Fascicule XXVII "*Coucou Bazaar*", 211; quoted also in Franzke, *Dubuffet*, 220.

76 For more information on this body of work, see Jean Dubuffet, *Catalogue des travaux de Jean Dubuffet*, Fascicule XXXII and Fascicule XXXII (Paris: Minuit, 1982). Also found of the Fondation Dubuffet website http://www.dubuffetfondation.com/fondation.php?menu=19&lang=fr.

Bibliography

Archives, libraries, and museums

Archives de la Ville de Genève
Bibliothèque Armand Salcrou, Le Havre
Bibliothèque Littéraire Jacques Doucet, Paris
Bibliothèque Nationale de France, François-Mitterrand, Paris
Bibliothèque Nationale de France, Richelieu Library, Paris
Bibliothèque Nationale de France, Musée de l'Opéra, Paris
Claire Holt Papers, New York Public Library, Dance Division
Collection de l'Art Brut, Lausanne
Fondation Dubuffet, Paris
Getty Research Institute, "Jean Dubuffet Correspondence and Papers, 1944–1984"
Institut National d'Histoire de l'Art, Paris
Musée des Arts Décoratifs, Paris
Musée du Quai Branly, Paris
Musée National d'Art Moderne, Centre Pompidou, Paris
Museum of Modern Art, New York
Newberry Library, Roger and Julie Baskes Department of Special Collections, Chicago
Pierre Matisse Papers, Morgan Library, New York

Writings by Jean Dubuffet in French

Dubuffet, Jean. *Prospectus et tous écrits suivants*. Paris: Gallimard, 1967.
Dubuffet, Jean. *Jean Dubuffet, L'homme du commun à l'ouvrage*. Paris: Gallimard, 1973.
Dubuffet, Jean. *Chambres pour Dubuffet* (Rooms for Dubuffet). Paris: Editions de la Réunion des musées nationaux, 1995.
Dubuffet, Jean. *Biographie au pas de course*. Paris, Gallimard, 2001.
Dubuffet, Jean, and Jacques Berne. *Lettres à J.B.: 1946–1985*. Paris: Hermann, 1991.
Dubuffet, Jean, and Philip Kaplan. *Quelques introductions au cosmorama de Jean Dubuffet, satrape*. Paris: Collège de Pataphysique, 1961.
Dubuffet, Jean, and Max Loreau. *Catalogue des travaux de Jean Dubuffet*. Paris: Fondation Dubuffet, 2003; first published J.J. Pauvert, 1966.
Dubuffet, Jean, Jean Paulhan, Julien Dieudonné, and Marianne Jakobi. *Correspondance: 1944–1968*. Paris: Gallimard, 2003.

Dubuffet, Jean, Alexandre Vialatte, Delphine Hautois, and Marianne Jakobi. *Correspondance(s): lettres, dessins et autres cocasseries, 1947–1975*. [Clermont-Ferrand]: Au signe de la licorne, 2004.

Writings by Jean Dubuffet in English

Dubuffet, Jean. "Statements and Documents: Artists on Art and Reality, on Their Work, and on Values." *Daedalus* 89, no. 1 (Winter, 1960): 95–96.

Dubuffet, Jean. "Anticultural Positions," a speech delivered to the Arts Club of Chicago on December 20, 1951 in English. In Richard L. Feigen, *Dubuffet and the Anticulture*. New York: R. L. Feigen & Co., 1969.

Dubuffet, Jean. Foreword to *Art Brut*. Trans. James Emmons. New York: Rizzoli, 1976.

Dubuffet, Jean. *Asphyxiating Culture and other Writings*. Trans. Carol Volk. New York: Four Walls, 1986.

Dubuffet, Jean. "Art Brut Preferred to the Cultural Arts." In *Jean Dubuffet: Towards an Alternative Reality*. Ed. Mildred and Marc Glimcher. Trans. Joachim Neugroschel, 101–104. New York: Pace Publications, 1987.

Dubuffet, Jean. "Notes for the Well-Read." In *Jean Dubuffet: Towards an Alternative Reality*. Ed. Mildred and Marc Glimcher. Trans. Joachim Neugroschel, 68–86. New York: Pace Publications, 1987.

Dubuffet, Jean. "In Honor of Savage Values." Trans. Kent Minturn. *RES: Anthropology and Aesthetics*, no. 46 (Autumn, 2004): 259–268.

Dubuffet, Jean. *Jean Dubuffet: Writings on Sculpture*. Düsseldorf: Richter Verlag, 2011.

Books, exhibition catalogues, and articles

Abadie, Daniel. *Dubuffet*. Paris: Centre Pompidou, 2001.

Andus L'Hotellier, Sanja, and Dominique Dupuy. *Les Archives internationales de la danse: un projet inachevé, 1931–1952*. Coeuvres-et-Valsery: Ressouvenances, 2012.

Antona-Traversi, Camillo. *L'histoire du Grand Guignol: théâtre de l'épouvante et du rire*. Paris: Librarie théatrale, 1933.

Archives internationales de la danse, and Claire Holt. *Théâtre & danses aux Indes néerlandaises, XIIe exposition des Archives internationales de la danse, 1939*. Paris: G.P. Maisonneuve, 1939.

Artaud, Antonin. "Le Théâtre balinais, à l'Exposition Coloniale." *La Nouvelle Revue Française* no. 217 (October, 1931).

Artaud, Antonin. *Le théâtre et son double*. Paris: Gallimard, 1944.

Artaud, Antonin. *Œuvres complétes*. Paris: Gallimard, 1956.

Artaud, Antonin. *The Theater and Its Double*. Trans. Mary Caroline Richards. New York: Grove Press, 1958.

Artaud, Antonin. *Nouveaux écrits de Rodez: lettres au docteur Ferdiére, 1943–1946, et autres textes inédits, suivis de six lettres à Marie Dubuc, 1935–1937*. Paris: Gallimard, 1977.

Artaud, Antonin, and Evelyne Grossman. *Œuvres*. Paris: Gallimard, 2004.

Artaud, Antonin. Claude Schumacher, and Brian Singleton. *Artaud on Theatre*. Chicago: Ivan R. Dee, 2001.

Asia-Europe Museum Network, *Virtual Collection of Masterpieces*, "The Batak." Http://old.vcm.asemus.museum/stories.aspx?id=b907d16f-c746-40c2-95bb-b86ca023124c.

Association Atelier André Breton. Http://www.andrebreton.fr/desktop (accessed November 21, 2017).

Austin, J. L. *How to Do Things with Words*. Cambridge: Harvard University Press, 1962.

Bachelard, Gaston. *Le nouvel esprit scientifique*. Paris: Librairie Félix Alcan, 1934.

Bachelard, Gaston. *La philosophie du non: essai d'une philosophie du nouvel esprit scientifique*. Paris: Presses universitaires de France, 1940.

Bachelard, Gaston. *La Terre et les reveries de la volonté: Essai sur l'imagination de la matière*. Paris: José Corti, 1947.

Bachelard, Gaston. *The Poetics of Space*. Trans. Maria Jolas. New York: Orion, 1964.

Bachelard, Gaston. *The Philosophy of No: A Philosophy of the New Scientific Mind*. Trans. G. C. Waterson. New York: Orion, 1968.

Ball, David. "Introduction" in *Darkness Moves: An Henri Michaux Anthology, 1927–1984*, ix–xxiii. Berkeley, Calif: University of California Press, 1997.

Balme, Christopher B. *Pacific Performances: Theatricality and Cross-Cultural Encounter in the South Seas*. Houndmills, Basingstoke: Palgrave Macmillan, 2007.

Barber, Stephen. *Antonin Artaud: Blows and Bombs*. London: Faber and Faber, 1993.

Bataille, Georges. *Lascaux, or, The Birth of Art: Prehistoric Painting*. Lausanne: Skira, 1955.

Bataille, Georges. *Vision of Excess: Selected Writings, 1927–1939*. Ed. Allan Stoekl. Trans. Allan Stoekl Carl R. Lovitt, and Donald M. Leslie Jr. Minneapolis: University of Minnesota Press, 1985.

Bataille, Georges. *Le Dictionaire critique*. L'Écarlate: Orléans, 1993.

Bateson, Gregory, Margaret Mead, and D. Carleton Gajdusek. *Balinese Character; a Photographic Analysis*. New York: New York Academy of Sciences, 1942.

Baxmann, Inge. *Les archives internationales de la danse: 1931–1952*. Pantin: Centre National de la Danse, 2006.

Bergson, Henri. *The Creative Mind: An Introduction to Metaphysics*. Trans. Mabelle Addison. Secaucus, NJ: Citadel Press, 1946.

Bergson, Henri. *Matter and Memory*. Trans. N. M. Paul. New York: Zone Books, 1991.

Bergson, Henri. *Time and Free Will: An Essay on the Immediate Data of Consciousness*. Trans. F. L. Pogson. Mineola, NY: Dover, 2001.

Berrebi, Sophie. "Writings and Correspondence: 1961–1985: Hubert Damisch and Jean Dubuffet." Trans. Nicholas Huckle and Molly Stevens. *October* 154 (Fall, 2015): 8–68.

Bhabha, Homi K. "The Third Space. Interview With Homi Bhabha." In *Identity: Community, Culture, Difference*. Ed. Jonathan Rutherford, 207–221. London: Lawrence and Wishart, 1990.

Bhabha, Homi K. *The Location of Culture*. London: Routledge, 1994.

Blake, Jody. "The Truth about the Colonies, 1931: Art indigene in Service of the Revolution." *Oxford Art Journal* 25, no. 1 (2002): 35–58.

Bodrogi, Tibor. *Art of Indonesia*. Greenwich, Conn: New York Graphic Society, 1972.

Bois, Yve-Alain. "To Introduce a User's Guide," *October* 78 (Fall, 1996): 21–37.

Bois, Yve-Alain, and Rosalind E. Krauss. *Formless: A User's Guide*. New York: Zone Books, 1997.

Bois, Yve-Alain, Dennis Hollier, and Rosalind Krauss, "A Conversation with Hubert Damisch," *October* 85 (Summer, 1998): 3–17.

Bonnefoi, Geneviève. *Jean Dubuffet*. Caylus: Association mouvements, 2002.

Bounoure, Vincent. *Le Surréalisme et les arts sauvages*. Paris: L'Harmattan, 2001.

Borghart, Pieter, and Christophe Madelein. "The Return of the Key: The Uncanny in the Fantastic." *Image and Narrative: Online Magazine of the Visual Narrative*. ISSN 1780-678X, http://www.imageandnarrative.be/inarchive/uncanny/borghartmadelein.htm (accessed August 19, 2019).

Brand-Claussen, Bettina, Inge Jádi, and Caroline Douglas. *Beyond Reason: Art and Psychosis: Works from the Prinzhorn Collection*. London: Hayward Gallery, 1996.

Brandon, James R. *Theater in Southeast Asia*. Cambridge, Mass: Harvard University Press, 1967.

Bréchon, Robert. *Henri Michaux: la poésie comme destin: biographie*. Croissy-Beaubourg: Aden, 2005.

Breton, André. *Nadja* (1928). New York: Grove Press, 1960.

Breton, André. "Surrealism and Painting" (1928), in *Surrealism and Painting*. Trans. Simon Watson Taylor. Boston: Museum & Fine Arts Publications, 2002, 1–48.

Breton, André. *Mad Love* (L'amour Fou) (1937). Trans. Mary Ann Caws. Lincoln: University of Nebraska Press, 1987.

Breton, André. *Les pensées d'André Breton: guide alphabétique*. Ed. Henri, Béhar. Lausanne: L'Age d'Homme, 1988.

Breton, André. *Communicating Vessels*. Trans. Mary Ann Caws and Geoffery T. Harris. Lincoln: University of Nebraska Press, 1990.

Breton, André. "First Manifesto of Surrealism" (1924). In Charles Harrison and Paul Wood, eds., *Art in Theory 1900-2000*, 447–453. Malden, Mass: Blackwell Publishing, 2000.

Breton, André, and Paul Éluard. *Collection André Breton et Paul Éluard. Sculptures d'Afrique, d'Amérique, d'Océanie*. Paris: n.p., 1931.

Breton, André, and F. H. Lem. *Océanie*. Paris: A. Olive, 1948.

Brinkgreve, Francine, and Retno Sulistianingsih. *Sumatra: Crossroads of Cultures*. Leiden: KITLV Press, 2009.

Broome, Peter. *Henri Michaux*. London: Athlone Press, 1977.

Brun, Baptiste. "Réunir une documentation pour l'Art Brut: les prospections de Jean Dubuffet dans l'immédiat après-guerre au regard du modèle ethnographique." *Cahiers de l'École du Louvre, recherches en histoire de l'art, histoire des civilisations, archéologie, anthropologie et muséologie*, no. 4, (April, 2014): 56–66.

Brun, Baptiste, and Isabelle Marquette. "Portrait de Jean Dubuffet en anthropographe." In *Jean Dubuffet, un barbare en Europe*, 9–20. Marseille: Musée des civilisations de l'Europe et de la Méditerranée, 2019.

Bryce, Kristy and Mary Ann Caws. *Surrealism and the Rue Blomet*. New York: Eklyn Maclean, 2013.

Bürger, Peter. *Theory of the Avant-Garde*. Minneapolis: University of Minnesota Press, 1984.

Butler, Judith. *Gender Trouble: Feminism and the Subversion of Identity*. New York: Routledge, 1990.

Caillois, Roger. "Mimicry and Legendary Psychasthenia." Trans. John Shepley. *October* 31 (1984): 17–32, doi: 10.2307/778354 (originally published in *Minatoure* 7, 1935).

Caillois, Roger. *The Edge of Surrealism: A Roger Caillois Reader*. Ed. Claudine Frank. Durham: Duke University Press, 2003.

Carter, Curtis L., and Karen K. Butler. *Jean Fautrier, 1898–1964*. New Haven: Yale University Press, 2002.

Cartier-Bresson, Henri, and Antonin Artaud. *Les danses à Bali*. Paris: R. Delpire, 1954.

Caws, Mary Ann. "The 'réalisme ouvert' of Bachelard and Breton." *The French Review* (January, 1964): 302–311.

Chadwick, Stephanie. *Disorienting Forms: Jean Dubuffet, Portraiture, Ethnography*. Thesis (Ph.D.), Rice University, 2015.

Chadwick, Stephanie. "Radical Reconfiguration: Appropriation, Assemblage, and Hybridity in Jean Dubuffet's Portrait of Jean Paulhan." *Art Inquiries*, xvii, no. 3 (Fall, 2018); 47–66.

Chaleix, Pierre. "Presentation" in *Nouveau écrits de Rodez* by Gaston Ferdière. Paris: Gallimard, 1977.

Chauvet, Stéphen. *Les arts indigénes en Nouvelle-Guinée*. Paris: Société d'éditions géographiques, maritimes et coloniales, 1930.

Cheng, Joyce. "Mask, Mimicry, Metamorphosis: Roger Caillois, Walter Benjamin and Surrealism in the 1930s." *Modernism/modernity* 16, no. 1 (January 2009): 61–86.

Chin, Michelle. "Bali in Film: From the Documentary Films of Sanghyang and Kekak Dance (1923) to Bali Hai in Hollywood's *South Pacific* (1958)," http://michellechin.net/writings/04.html (accessed January 21, 2018).

Chu, Petra ten-Doesschate. "Scatology and the Realist Aesthetic." *Art Journal* 52, no. 3 (Autumn, 1993): 41–46.

Clark, T. J. "Clement Greenberg's Theory of Art." *Critical Inquiry*, vol. 9, no. 1, "The Politics of Interpretation" (September, 1982): 139–156.

Clifford, James. *The Predicament of Culture*. Cambridge: Harvard University Press, 1988.

Cohen, Matthew Isaac. "Dancing the Subject of Java: International Modernism and Traditional Performance, 1899–1952." *Indonesia and the Malay World* 35, no. 101 (March, 2007): 9–29.

Cooke, Susan J. "Jean Dubuffet's Caricature Portriats." In *Jean Dubuffet 1943–1963: Paintings, Sculptures, Assemblages: an Exhibition*, eds. James Demetrion, Susan J. Cooke, Jean Planque, and Peter Schjeldahl, 20–33. Washington, D.C.: Hirshhorn Museum and Sculpture Garden in association with the Smithsonian Institution Press, 1993.

Covarrubias, Miguel. *Theater Arts Monthly: The Theater in Bali*, xx, no. 8 (August, 1936).

Covarrubias, Miguel. *Island of Bali* (1937). London: KPI, 1986; first published 1946.

Cowling, Elizabeth. "'L'Oeil Sauvage': Oceanic Art and the Surrealists." In *Art of Northwest New Guinea: From Geelvink Bay, Humboldt Bay, and Lake Sentani*. Ed. Suzanne Greub, 177–190. New York: Rizzoli, 1992.

Cronan, Todd. *Against Affective Formalism: Matisse, Bergson, Modernism*. Minneapolis: University of Minnesota Press, 2013.

Culbert, John. "Slow Progress: John Paulhan and Madagascar." *October* 83 (Winter, 1998): 71–95.

D'Souza, Aruna. "I Think Your Work Looks a Lot Like Dubuffet: Dubuffet and America, 1946–1962." *Oxford Art Journal* 20, no. 2 (1997): 61–73.

Da Costa, Valérie, and Fabrice Hergott. *Jean Dubuffet: Works, Writings, and Interviews*. Trans. Ann King. New York: Distributed Art Publishers, 2006.

Dagen, Philippe, and Maureen Murphy. *Charles Ratton. L'invention des arts "primitifs."* Paris: Skira Flammarion, 2013.

Damisch, Hubert and Sophie Berrebi. "Writings and Correspondence: 1961–1985: Hubert Damisch and Jean Dubuffet." Trans. Nicholas Huckle and Molly Stevens. *October* 154 (Fall, 2015): 8–68.

Dapena-Tretter, Antonia. "Jean Dubuffet & Art Brut: The Creation of an Avant-Garde Identity." *Platform*, vol. 11, "Authenticity" (Autumn, 2017): 12–33.

Derrida, Jacques. *Of Grammatology.* Baltimore: Johns Hopkins University Press, 1976.

Derrida, Jacques. *Writing and Difference*. Trans. Alan Bass. Chicago: University of Chicago Press, 1978.

Derrida, Jacques, and Paule Thévenin. *The Secret Art of Antonin Artaud*. Trans. Mary Ann Caws. Cambridge, Mass: MIT Press, 1998.

Deschênes, Bruno. "Javanese and Balinese Gamelan Music." in *All Music Guide*. Http://pages.infinit.net/musis/matsu_take_eng/3_AMG_Java_Bali.html (accessed March 21, 2011).

Dezeuze, Anna. "Assemblage, Bricolage, and the Practice of Everyday Life." *Art Journal* 67 (Spring, 2008): 31–37.

De Zoete, Beryl, and Walter Spies. *Dance and Drama in Bali* (1938). Kuala Lumpur: Oxford University Press, 2002.

Dibia, I. W., and Rucina Ballinger. *Balinese Dance, Drama and Music: A Guide to the Performing Arts of Bali*. Singapore: Periplus, 2004.

Douglas, Caroline. "Precious and Splendid Fossils." In *Beyond Reason: Art and Psychosis: Works from the Prinzhorn Collection*, Ed. Bettina Brand-Claussen, Inge Jádi, and Caroline Douglas. London: Hayward Gallery, 1996.

Duffy, Jean H. "Dubuffet Plays Hide-and-Seek: Lineage, Reflexivity, and Perception in Coucou Bazar." *The Art Bulletin* XCVII, no. 2 (June, 2016): 237–260.

Duffy, Jean H. "Jean Dubuffet's Beautiful People." *Word & Image* 35, no. 2 (June, 2019): 191–209.

Duffy, Jean H., *Perceiving Debuffet: Art, Embodiment, and the Viewer*. Liverpool: Liverpool University Press, 2021.

Dubuffet, Jean, and Jean-Louis Prat. *Jean Dubuffet: rétrospective: peintures, sculptures, dessins, 6 juillet–6 octobre 1985, Fondation Maeght*. Saint-Paul: Fondation Maeght, 1985.

Dubuffet, Jean, and Daniel Abadie. *Dubuffet*. Paris: Centre Pompidou, 2001.

Dubuffet, Jean, and Jean Hubert Martin. *Dubuffet & l'art brut*. Milan: 5 continents, 2005.

Dubuffet, Jean, James Demetrion, Susan J. Cooke, Jean Planque, and Peter Schjeldahl. *Jean Dubuffet 1943–1963: Paintings, Sculptures, Assemblages: an Exhibition*. Washington, D.C.: Hirshhorn Museum and Sculpture Garden in association with the Smithsonian Institution Press, 1993.

Dubuffet, Jean, and Françoise Cohen. *Le théâtre de Jean Dubuffet: Musée Malraux, Le Havre, 19 mai–3 septembre 2001*. Paris: Réunion des musées nationaux, 2001.

Dubuffet, Jean, Sophie Duplaix, and Beatrice Salman, *Concou Bazar*. Paris: Arts décoratifs, 2013.

Edson, Laurie. *Henri Michaux and the Poetics of Movement*. Saratoga, Calif: ANMA, 1985.

Edson, Gary. *Masks and Masking: Faces of Tradition and Belief Worldwide*. Jefferson, NC: McFarland, 2005.

Einstein, Carl. "Art exotique, 1930," *Gradhiva* 14 (2011), 194–197, https://journals. openedition.org/gradhiva/2204 (accessed August 26, 2017).

Ellmann, Richard. "Introduction." In *Selected Writings: Henri Michaux*, VII–XXI. New York: New Directions, 1968.

Esman, Aaron H. "Images in Psychiatry: Adolf Wölfli, 1864–1930." *American Journal of Psychiatry* 161, no. 9 (September, 2004): 1574.

Fau, Guillaume, and Jean-Noël Jeanneney. *Antonin Artaud*. Paris: Bibliothéque Nationale de France, 2006.

Fondation Jean Dubuffet, Http://www.dubuffetfondation.com/bio_set_ang.htm (accessed January 20, 2011).

Feigen, Richard L. *Dubuffet and the Anticulture*. New York: R. L. Feigen & Co., 1969.

Ferdière, Gaston. *Nouveau écrits de Rodez* (Paris: Gollimard, 1977).

Forshee, Jill. *Cultures and Customs of Indonesia*. Westport, Conn: Greenwood, 2006.

Foster, Hal. "Convulsive Identity." *October* 57 (Summer, 1991): 18–54.

Foster, Hal. *Compulsive Beauty*. Cambridge: MIT Press, 1993.

Foster, Hal. "Blinded Insights: On the Modernist Reception of the Art of the Mentally Ill." *October* 97 (Summer, 2001): 3–30.

Franzke, Andreas. *Dubuffet*. Trans. Robert Wolf. New York: Harry N. Abrams, 1981.

Freud, Sigmund. *Civilization and Its Discontents*. Trans. Joan Riviere. London: Hogarth Press and the Institute of Psycho-analysis, 1930.

Freud, Sigmund. *The Standard Edition of the Complete Psychological Works of Sigmund Freud*, vol. XVII. Ed. and trans. James Strachey. London, Hogarth Press, 1974.

Fried, Michael. *Absorption and Theatricality: Painting and Beholder in the Age of Diderot*. Berkeley and London: University of California Press, 1980.

Fried, Michael. "How Modernism Works: A Response to T.J. Clark." *Critical Inquiry* 9, no. 1 (September, 1982): 217–234.

Fried, Michael. *Manet's Modernism*. Chicago: University of Chicago Press, 1998.

Fried, Michael. "Three American Painters." In *Art in Theory 1900–2000*, Ed. Charles Harrison, and Paul Wood, 787–793. Malden, Mass: Blackwell Publishing, 2000.

Gallimard. "Collection Métamorphoses," http://www.gallimard.fr/Catalogue/GALLIMARD/Metamorphoses (accessed December 7, 2017).

Glimcher, Mildred, Marc Glimcher, and Jean Dubuffet. *Jean Dubuffet: Towards an Alternative Reality*. New York: Pace Publications, 1987.

Graver, David. *The Aesthetics of Disturbance: Anti-Art in Avant-Garde Drama*. Ann Arbor: The University of Michigan Press, 1995.

Greenberg, Clement. *Art and Culture: Critical Essays*. Boston: Beacon Press, 1961.

Greene, Naomi. *Antonin Artaud: Poet Without Words*. New York: Simon and Schuster, 1971.

Greub, Suzanne. *Art of Northwest New Guinea: From Geelvink Bay, Humboldt Bay, and Lake Sentani*. New York: Rizzoli, 1992.

Gross, Kenneth. *Puppet: An Essay on Uncanny Life*. Chicago: University of Chicago Press, 2011.

Grossman, Evelyne. *La défiguration: Artaud, Beckett, Michaux*. Paris: Minuit, 2004.

Grossman, Evelyne, ed. *Antonin Artaud: 50 Drawings to Murder Magic*. Trans. Donald Nicholson-Smith. New York: Seagull, 2008.

Guerlac, Suzanne. *Thinking in Time: An Introduction to Henri Bergson*. Ithaca, NY: Cornell University Press, 2006.

Guerlac, Suzanne. "The Useless Image: Bataille, Bergson, Magritte." *Representations* 97 (Winter, 2007): 28–54.

Hall, Kira. "Performativity." *Journal of Linguistic Anthropology* 9, no. 1–2 (2000): 184–187.

Hall, Michael D., E. W. Metcalf, and Roger Cardinal. *The Artist Outsider: Creativity and the Boundaries of Culture*. Washington: Smithsonian Institution Press, 1994.

Hamdan, Dima. *Victor Segalen et Henri Michaux: deux visages de l'exotisme dans la poésie française du XXe siècle*. Fasano: Schena, 2002.

Hamilton, Scott B. *Dubuffet and Ubu Roi: The Influence of Antonin Artaud on Jean Dubuffet*. Thesis (M.F.A.), Ohio University, August, 1996.

Harrison, Charles, and Paul Wood. *Art in Theory 1900–2000: An Anthology of Changing Ideas*. Malden, Mass: Blackwell Publishing, 2003.

Hartvig, Nicolai. "Dubuffet's Animated Painting Revived in Paris." *New York Times*, October 23, 2013, https://www.nytimes.com/2013/10/24/arts/international/in-paris-dubuffets-animated-painting-revived.html (accessed February 20, 2020).

Haslam, Malcolm. *The Real World of the Surrealists*. New York: Rizzoli, 1978.

Healey, Kimberley J. *The Modernist Traveler: French Detours, 1900–1930*. Lincoln: University of Nebraska Press, 2003.

Heppell, M., Robyn J. Maxwell, Sai Hock Goh, and Paul Zach. *Borneo and Beyond: Tribal Arts of Indonesia, East Malaysia, and Madagascar*. Singapore: Bareo Gallery, 1990.

Heppell, M., Limbang anak Melaka, and Enyan anak Usen. *Iban Art: Sexual Selection and Severed Heads: Weaving, Sculpture, Tattooing and Other Arts of the Iban of Borneo*. Amsterdam: KIT Publishers, 2005.

Hobart, Angela. *Dancing Shadows of Bali: Theatre and Myth*. London: KPI, 1987.

Hobart, Mark. *Music and Ritual*. Ed. Keith Howard. The Hague: Semar Publishers, 2006.

Hollier, Denis, and R. Howard Bloch. *A New History of French Literature*. Cambridge, Mass: Harvard University Press, 1989.

Holt, Claire, and Arlene Lev. "Dances of Sumatra and Nias: Notes by Claire Holt." *Indonesia*, no. 11 (April 1971): 1–20.

Holt, Claire, and Arlene Lev. "Batak Dances: Notes by Claire Holt." *Indonesia*, no. 12 (October, 1971): 65–84.

Hopfengart, Christine, and Michael Baumgartner. *Paul Klee: Life and Work*. Ostfildern: Hatje Cantz, 2012.

L'Illustration 32 (May 1931), celebrating the Paris Colonial Exposition.

Irwin, Rachel. "Culture Shock: Negotiating Feelings in the Field." *Anthropology Matters* 9, no. 1 (2007): 1–11.

Jaeger, Frédéric. "L'Hourloupe in Close up (1962–1974)." In *Jean Dubuffet Trace of an Adventure*. Munich and New York: Prestel, 2003, 42–46.

Jakobi, Marianne. "Nommer la forme et l'informe: La Titraison comme genèse dans l'oeuvre de Jean Dubuffet." *Item* 19 (February, 2008), http://www.item.ens.fr/index.php?id=187132 (accessed July 2, 2015).

Jamieson, Graham A., ed. *Hypnosis and Conscious States: The Cognitive Neuroscience Perspective*. Oxford: Oxford University Press, 2007.

Jung, C. G. *The Archetypes and the Collective Unconscious*. Princeton, NJ: Princeton University Press, 1968.

Karmel, Pepe. "Jean Dubuffet: The Would-be Barbarian." *Apollo* CLVI, no. 489 (October, 2002): 12–20, as.nyu.edu/docs/IO/3644/Karmel_The_Would-Be_Barbarian.pdf.

Kjellgren, Eric. *Oceania: Art of the Pacific Islands in the Metropolitan Museum of Art*. New York: Metropolitan Museum of Art, 2007.

Kjellgren, Eric. *How to Read Oceanic Art*. New York: Metropolitan Museum of Art, 2014.

Kleitman, Nathaniel. *Sleep and Wakefulness*. Chicago: Chicago University Press, 1939.

Kooijman, Simon. *The Art of Lake Sentani*. New York: Museum of Primitive Art, 1959.

Kooijman, Simon, and Jac Hoogerbrugge. "Art of Wakde-Yamna and Area and Humboldt Bay." In *Art of Northwest New Guinea: From Geelvink Bay, Humboldt Bay, and Lake Sentani*. Ed. Suzanne Greub, 57–126. New York: Rizzoli, 1992.

Krauss, Rosalind. "Photographic Conditions of Surrealism." In *The Originality of the Avant-Garde and Other Modernist Myths*, 87–118. Cambridge, Mass: MIT Press, 1985.

Krauss, Rosalind. The Originality of the Avant-Garde and other Modernist Myths. Cambridge, Mass: MIT Press, 1985.

Kürtös, Karl. *Henri Michaux et le visuel: ekphrasis, mimésis, énergie*. Berne: Peter Lang, 2009.

La Charité, Virginia A. *Henri Michaux*. Boston: Twayne Publishers, 1977.

Lacan, Jacques. "*La Famille*" in *Encyclopédie francaise*. Paris: A. de Monzie, 1938.

Lacan, Jacques. *The Four Fundamental Concepts of Psycho-Analysis*. Trans. Alan Sheridan. New York: Norton, 1978.

Lacan, Jacques. *Ecrits: the first complete edition in English*. Trans. Héloïse Fink and Bruce Fink. New York: W.W. Norton & Co., 2006.

Lanchner, Carolyn, and Sophie Taeuber-Arp. *Sophie Taeuber-Arp*. New York: Museum of Modern Art, 1981.

Laügt, Elodie. *L'Orient du signe: réves et dérives chez Victor Segalen, Henri Michaux et Emile Cioran*. Oxford: Peter Lang, 2008.

Lautréamont, Comte de. *Les Chants de Maldoror* (1869). Brusseles: Editions "La Boetie," 1948.

Le Miroir du Monde 80 (Septembee 12, 1931), 321.

Lev, Arlene. "Preface," in "Dances of Sumatra and Nias: Notes by Claire Holt." *Indonesia*, no. 11 (Apr., 1971): 1–2.

Lev, Arlene. "Preface," in "Batak Dances: Notes by Claire Holt." *Indonesia*, no. 12 (October, 1971): 65–66.

Lévi-Strauss, Claude. *The Savage Mind*. Trans. George Weidenfeld and Nicolson Ltd. Chicago: University of Chicago Press, 1962.

Leys, Ruth. "The Turn to Affect: A Critique." *Critical Inquiry* 37, no. 2 (Springn 2011): 434–472.

Limbour, Georges. *Tableau bon levain à vous de cuire la pate: l'art brut de Jean Dubuffet*. Paris: René Drouin, 1953.

Limbour, Georges. *Georges Limbour: le songe autobiographique: essai comportant des lettres inédites échangées avec Jean Dubuffet et une bibliographie de l'œuvre*. Paris: Lachenal & Ritter, 1994.

Linton, Ralph, Paul S. Wingert, and Rene D'Harnoncourt. *Arts of the South Seas*. New York: Museum of Modern Art, 1946.

Loreau, Max. *Catalogue des travaux de Jean Dubuffet. Fascicule I–III*. Paris: J.-J. Pauvert, 1966.

Maclagan, David. *Outsider Art: From the Margins to the Marketplace*. London: Reaktion Books, 2009.

Maier, Andrea Nicole. *Dubuffet's Decade*. Thesis (Ph.D.), University of California, Berkeley, 2009.

Maizels, John. *Raw Creation: Outsider Art and Beyond*. London: Phaidon Press Limited, 1996.

Maizels, John. *Outsider Art Sourcebook: Art Brut, Folk Art, Outsider Art*. [Radlett], Herts: Raw Vision, 2009.

Martin, Jean-Pierre. *Henri Michaux*. Paris, Gallimard, 2003.

Masson, Andre, *Les Aneé Surréalistes: Correspondences 1916–1942*. Paris: La Manufacture, 1990.

Massumi, Brian. *Parables for the Virtual: Movement, Affect, Sensation*. Durham, NC: Duke University Press, 2002.

Massumi, Brian. *Semblance and Event: Activist Philosophy and the Occurrent Arts*. Cambridge, Mass: MIT Press, 2011.

McBride, Henry. "Four Transoceanic Reputations." *Art News* xxxxix, no. 9 (January, 1951): 28–29.

McKinney, Natasha. "Ancestral Remains from Oceania: Histories and Relationships in the Collection of the British Museum," In *Regarding the Dead: Human Remains in the British Museum*. Ed. Alexandra Fletcher, Daniel Antoine, and J. D. Hill, 34–42. London: British Museum, 2014.

Merleau-Ponty, Maurice. *Phénoménologie de la perception*. Paris: Éditions Gallimard, 1945.

Merleau-Ponty, Maurice. *Phenomenology of Perception*. Trans. Colin Smith. London: Routledge, 1962.

Merllié, Dominique. "Durkheim Lévy-Bruhl and 'Primitive Thinking': What Disagreement?" *P.U.F. L'Année sociologique* 62, no. 2 (2012): 429–446.

Metropolitan Museum of Art, New York. "Puppet Head (Si Gale-gale)," http://www.metmuseum.org/collections/search-the-collections/315894.

Meyer, Anthony J. P. *Oceanic Art*. Köln: Könemann, 1995.

Michaux, Henri. *Darkness Moves: An Henri Michaux Anthology, 1927–1984*. Trans. David Ball. Berkeley: University of California Press, 1994.

Michaux, Henri. *Un barbare en Asie* (1933). Paris: Gallimard, 1945.

Michaux, Henri. *Ailleurs*. Paris: Gallimard, 1948.

Michaux, Henri. *Mouvements: soixante-quatre dessins, un poème, une postface*. Paris: Gallimard, 1951.

Michaux, Henri. *A Barbarian in Asia* (1933). Trans. Sylvia Beach. New York: New Directions, 1986.

Michaux, Henri. *Émergences—résurgences*. Geneva: Albert Skira, 1972.

Michaux, Henri. *Spaced Displaced*. Trans. David and Helen Constantine. Newcastle: Bloodaxe Books, 1992.

Michaux, Henri, and Richard Ellmann. *Selected Writings: the Space Within* (1944). Trans. Richard Ellmann. New York: New Directions, 1968.

Michaux, Henri, Raymond Bellour, and Ysé Tran. *Œuvres complètes*. Paris: Gallimard, 1998.

Mileaf, Janine. "Body to Politics: Surrealist Exhibition of the Tribal and the Modern at the Anti-Imperialist Exhibition and the Galerie Charles Ratton." *RES: Anthropology and Aesthetics*, no. 40 (Autumn, 2001): 239–255.

Minturn, Kent. "Dubuffet, Lévi-Strauss, and the Idea of Art Brut." *Anthropology and Aesthetics*, no. 46 (Autumn, 2004): 247–258.

Minturn, Kent. *Contre-Histoire: The Postwar Art and Writings of Jean Dubuffet*. Thesis (Ph.D.), Columbia University, 2007.

Minturn, Kent. "Greenberg Misreading Dubuffet." In *Abstract Expressionism: The International Context*. Ed. Joan M. Marter, 125–137. New Brunswick, NJ: Rutgers University Press, 2007.

Minturn, Kent. "Dubuffet avec Damisch." *October* 154 (Fall, 2015): 69–86.

Minturn, Kent. "Physiognomic Illegibility: Jean Dubuffet's Postwar Portraits." In *Jean Dubuffet: "Anticultural Positions."* Ed. Mark Rosenthall, 37–62. New York: Acquavella Galleries, 2016.

Morfee, Adrian. *Antonin Artaud's Writing Bodies*. Oxford: Clarendon Press, 2005.

Morgenthaler, Walter, Aaron H. Esman, and Elka Spoerri. *Madness & Art: The Life and Works of Adolf Wölfli*. Lincoln: University of Nebraska Press, 1992.

Morris, Frances, ed. *Paris Post War: Art and Existentialism 1945–55*. London: Tate Gallery, 1993.

Morton, P. A. *Hybrid Modernities: Architecture and Representation at the 1931 Colonial Exposition, Paris*. Cambridge, Mass: MIT Press, 2000.

Murphy, Carol J. "Re-presenting the Real: Jean Paulhan and Jean Fautrier." In *The Power of Rhetoric, the Rhetoric of Power: Jean Paulhan's Fiction, Criticism, and Editorial Activity*. Ed. Michael Syrotinski, 71–86. New Haven, Conn: Yale University Press, 2004.

Musée des Arts Africains, Océaniens et Amérindiens à la Vieille Charité de Marseille. *Collections Permanetes*, http://culture.marseille.fr/les-musees-de-marseille/musee-d-arts-africains-oceaniens-amerindiens-maaoa (accessed January 15, 2019).

Musée d'Ethnographie de Genève. *Théâtres d'orient: masques, marionnettes, ombres, costumes*. Ivrea, Italy: Priuli & Verlucca, 1997.

Musées Gadagne, http://www.gadagne.musees.lyon.fr/index.php/puppets_en/Puppets/The-world-puppets-museum (accessed March 15, 2011).

Musée du Quai Branly. Collection, http://collections.quaibranly.fr/pod16/#a4a58ca2-351c-44e1-826b-ea1cba50bdad (accessed March 10, 2014).

Musée du Quai Branly. "Charles Ratton: The Invention of Primitive Arts. An exhibition: June 25 – Sept. 22, 2013", Http://www.quaibranly.fr/en/programmation/exhibitions/last-exhibitions/charles-ratton-the-invention-of-the-primitive-arts.html (accessed March 10, 2014).

Najafi, Roja. "Figuration, Abstraction, and Materiality in the Works of Jean Dubuffet (1901–1985)." Thesis (Ph.D.), University of Texas, 2017.

Nakabayashi, Kazuo. "Henri Michaux: Emerging Figures," In *Henri Michaux: Emerging Figures*. Tokyo: National Museum of Modern Art, 2007.

Noland, Carrie. *Agency and Embodiment: Performing Gestures/Producing Culture*. Cambridge, Mass: Harvard University Press, 2009.

O'Reilly, Patrick. Le "documentaire" ethnographique en Océanie: Étude, suivie d'un Répertoire analytique et critique de vingt-cinq films." *Journal de la Société des océanistes* 5 (1949); 117–144; doi: 10.3406/jso.1949.1630, https://www.persee.fr/doc/jso_0300-953x_1949_num_5_5_1630?q=Le+%E2%80%9Cdocumentaire%E2%80%9D+ethnographique+en+Oc%C3%A9anie:+%C3%89tude (accessed November 22, 2017).

O'Reilly, Patrick. "Stephen Chauvet, 1885–1950." *Journal de la Société des océanistes* 7 (1951): 219–222, http://www.persee.fr/doc/jso_0300-953x_1951_num_7_7_1703 (accessed November 21, 2017).

Oberg, Kalervo. "Culture Shock: Adjustment to New Cultural Environments." *Practical Anthropology* 7 (1960).

Ogilvie, Robert D. ed. *Sleep Onset*. Washington, D.C.: American Psychological Association, 1994.

Parish, Nina. *Henri Michaux: Experimentation with Signs*. Amsterdam: Rodopi, 2007.

Paulhan, Jean. *Guide d'un petit voyage en Suisse*. Paris: Gallimard, 1947.

Peiry, Lucienne. *L'Art brut*. Paris: Flammarion, 1997.

Peiry, Lucienne. *Art Brut: The Origins of Outsider Art*. Paris: Flammarion, 2006.

Peiry, Lucienne. "Le rôle d'Eugène Pittard dans l'aventure de l'Art Brut." In *TOTEM* 67 (October–December 2014), 10–11.

Peltier, Philippe, "Jacques Viot, the Maro of Tobati, and Modern Painting: Paris–New Guinea 1925–1935." In *Art of Northwest New Guinea: From Geelvink Bay, Humboldt Bay, and Lake Sentani*. Ed. Suzanne Greub, 155–176. New York: Rizzoli, 1992.

Perry, Rachel E. "*Paint Boldly!*: Dubuffet's DIY Manual," *October* 154 (Fall, 2015): 88–89.

Perry, Rachel E. "Painting in Danger: Jean Dubuffet's Hautes Pâtes." *RIHA Journal* 221 (August 30, 2019). URL: https://www.riha-journal.org/articles/2019/0221-perry (accessed February 23, 2020).

Pippin, Robert B. *After the Beautiful: Hegel and the Philosophy of Pictorial Modernism*. Chicago: University of Chicago Press, 2014.

Prinzhorn, Hans. *Artistry of the Mentally Ill; A Contribution to the Psychology and Psychopathology of Configuration*. Trans. Eric von Brockdorff. New York: Springer-Verlag, 1972.

Random House Webster's Unabridged Dictionary. New York: Random House Reference, 2001.

Ratliff, Floyd. "The Influence of Contour on Contrast: From Cave Painting to Cambridge Psychology." *Transactions of the American Philosophical Society* 75, no. 6 (1985): 1–19.

Rhodes, Colin. *Outsider Art: Spontaneous Alternatives*. New York: Thames & Hudson, 2000.

Rhodes, Colin. "Jean Dubuffet, Paris." *The Burlington Magazine* 143, no. 1185 (December, 2001): 779–781.

Rich, Sarah K. "Jean Dubuffet: The Butterfly Man." *October* 119 (Winter, 2007): 46–74.

Ries, Martin. "André Masson: Surrealism, and His Discontents." *Art Journal* 61, no. 4 (Winter, 2002): 74–85.

Rigaud-Drayton, Margaret. *Henri Michaux: Poetry, Painting, and Universal Sign*. Oxford, Clarendon Press, 2005.

Rolland, Romain. *Prophets of the New India*. New York: Boni, 1930.

Rolland, Romain. *Selected Letters of Romain Rolland*. Delhi: Oxford University Press, 1990.

Rowell, Margit, ed. *Artaud: Works on Paper*. New York: Museum of Modern Art, 1996.

Sartre, Jean Paul. *Situations I and III*. Trans. Annette Michelson. New York: Collier Books, 1955.

Savarese, Nicola. "Antonin Artaud Sees Balinese Theater at the Paris Colonial Exposition." *TDR* 45, no. 4 (Autumn, 2001): 51–77.

Schildkraut, Joseph J. "Beyod Reason: Art and Psychosis: Works from the Prinzhorn Collection." *American Journal of Psychiatry* 157, no. 12 (December, 2000): 2068.

Schneider, Norbert, and Iain Galbraith. *The Art of the Portrait: Masterpieces of European Portrait-Painting, 1420–1670*. Köln: Benedikt Taschen, 1994.

Schumacher, Claude, and Brian Singleton, eds. and trans. *Artaud on Theatre*. Chicago: Ivan R. Dee, 2001.

Selz, Peter. *The Work of Jean Dubuffet*. New York: Museum of Modern Art; Doubleday, 1962.

Selz, Peter. "Surrealists and the Chicago Imagists of the 1950s: A Comparison and Contrast." *Art Journal* 45, no. 4 (Winter, 1985): 303–306.

Shaw, Jill Allison Eva. *A Coat that Doesn't Fit: Jean Dubuffet in Retrospect, 1944–1951*. Thesis (Ph.D.), University of Chicago, 2013.

Shawcross, Nancy, and Claire Holt. "The Claire Holt Collection." *Dance Research Journal* 19, no. 1 (Summer, 1987): 25, 27–35.

Sherman, Daniel J. *French Primitivism and the Ends of Empire, 1945–1975*. Chicago: University of Chicago Press, 2011.

Sibeth, Achim, Uli Kozok, and Juara R. Ginting. *The Batak: Peoples of the Island of Sumatra: Living with Ancestors*. New York: Thames and Hudson, 1991.

Simmel, Georg. "The Metropolis and Modern Life" (1903). In German History in Documents and Images (GHDI), http://germanhistorydocs.ghi-dc.org/about.cfm (accessed January 10, 2020).

Singleton, Brian, "Artaud, East and West." In *Artaud on Theatre*. Ed. Claude Schumacher, xxix–xxxvi. London: Methuen Drama, 2001.

Slattum, Judy. *Balinese Masks: Spirits of an Ancient Drama*. Hong Kong: Periplus, 2003.

Société d'editions geographiques maritimes et coloniales, 1930. "Stephen Chauvet 1885–1950," http://www.etab.ac-caen.fr/lebrun/histoire/affiche.php?choix=1 (accessed January 9, 2014).

Sontag, Susan, ed. *Antonin Artaud: Selected Writings*. New York: Farrar, Strauss, and Giroux, 1973.

Sorell, Walter. *The Other Face: The Mask in the Arts*. Indianapolis: Bobbs-Merrill, 1973.

Soussloff, Catherine. *The Subject in Art: Portraiture and the Birth of the Modern*. Durham: Duke University Press, 2006.

Spies, Walter, and Beryl De Zoete. *Dance and Drama in Bali* (1938). Hong Kong: Periplus Editions, 2002.

Spoerri, Elka, Adolf Wölfli, Daniel Baumann, and Edward M. Gomez. *The Art of Adolf Wölfli: St. Adolf-Giant-Creation*. New York: American Folk Art Museum, 2003.

Steimer-Herbet, Tara. *Indonesian Megaliths: A Forgotten Cultural Heritage*. Oxford: Archaeopress Publishing Ltd., 2018.

Steinberg, Leo. "Reflections on the State of Criticism." In *Robert Rauschenberg*, Ed. Brandon W. Joseph. Cambridge, Mass: MIT Press, 2002, 7–38.

Tapié, Michel. *Mirobolus Macadam & Cie: hautes pâtes de J. Dubuffet*. Paris: René Drouin, 1946.

Tapié, Michel. *Un art autre: où il s'agit de nouveaux dévidages du réel*. Paris: Gabriel-Giraud et fils, 1952.

Tapié, Michel. "A New Beyond" (1952) in Herschel B. Chipp, *Theories of Art*, 60–64. Berkeley: University of California Press, 1968.

Tapié, Michel. "Un art autre: où il s'agit de nouveaux dévidages du réel" (1952). In *Art in Theory 1900–2000: An Anthology of Changing Ideas*. Ed. Charles Harrison and Paul Wood, 629–631. Malden, MA: Blackwell Publishing, 2003.

Tate Collection. "Typist [from 'Matter and Memory'] 1944," http://www.tate.org.uk/servlet/ViewWork?cgroupid=999999961&workid=4015&searchid=9975&tabview=text (accessed May 9, 2010).

Tate Modern, "*Art informel*," http://www.tate.org.uk/collections/glossary/definition.jsp?entryId=28 (accessed March 15, 2011).

Terrell, John Edward, Kevin M. Kelly, and Paul Rainbird. "Foregone Conclusions?: In Search of Papuans and Austronesians." *Current Anthropology* 42, no. 1 (2001): 97–124, doi:10.1086/318436.

Thévoz, Michel. "An Anti-Museum: The Collection de l'Art Brut in Lausanne." In *The Artist Outsider: Creativity and the Boundaries of Culture*. ed. Michael D. Hall, E. W. Metcalf, and Roger Cardinal, 62–75. Washington: Smithsonian Institution Press, 1994.

Thévoz, Michel. "Dubuffet: The Nutcracker." *Yale French Studies*, no. 84 (1994): 198–221.

Thévoz, Michel, and Jean Dubuffet. *Collection de l'art brut: Château de Beaulieu*. Lausanne: La Collection, 1976.

Todorov, Tzvetan. *The Fantastic: A Structural Approach to a Literary Genre*. Cleveland: Press of Case Western Reserve University, 1973.

Tropenmuseum website, https://www.tropenmuseum.nl/en/themes/history-tropenmuseum (accessed January 21, 2019).

Velinsky-Ondrůjová, Ludmila. *From the Gloom of Today to New Greatness of Man: Itinerary by Henri Michaux, Builder of New Poetry*. New York: Vantage Press, 1977.

Vercruysse, Thomas. *La cartographie poétique: tracés, diagrammes, formes: Valéry, Mallarmé, Artaud, Michaux, Segalen, Bataille*. Genéva: Librairie Droz, 2014.

Watkins, Nicholas. "1946: Fautrier, Antibes, and Biot." *The Burlington Magazine* 138, no. 1122 (September, 1996): 625–627.

"Welcome to Balinese Dance." In *Balinese Dance*, http://www.balinesedance.org/About_Theatre_and_Dance_in_Bali.htmm (accessed March 8, 2011).

Wheeler, Monroe. *20th Century Portraits*. New York: MoMA, 1942.

Whitford, Frank. *Expressionist Portraits*. New York: Abbeville Publishers, 1987.

Wilson, Sarah. "Paris Post War: In Search of the Absolute." In *Paris Post War: Art and Existentialism 1944–55*. Ed. Frances Morris, 25–52. London: Tate Gallery, 1993.

Worringer, Wilhelm. *Abstraction and Empathy; A Contribution to the Psychology of Style*. New York: International Universities Press, 1953.

Zurbuchen, Mary Sabina. *The Language of Balinese Shadow Theater*. Princeton, NJ: Princeton University Press, 1987.

Index

The letter *f* following an entry indicates a page that includes a figure